PHANTOMS OF ASIA

MAMI KATAOKA

ALLISON HARDING

PHANTOMS OF ASIA *contemporary awakens the past*

V **Asian** Asian Art Museum | San Francisco

The Asian Art Museum–Chong-Moon
Lee Center for Asian Art and Culture is a
public institution whose mission is to lead
a diverse global audience in discovering the
unique material, aesthetic, and intellectual
achievements of Asian art and culture.

Published on the occasion of the exhibition
*Phantoms of Asia: Contemporary Awakens the
Past*, presented at the Asian Art Museum–
Chong-Moon Lee Center for Asian Art and
Culture, May 18–September 2, 2012.

All photographs of objects from the
collections of the Asian Art Museum
are by Kazuhiro Tsuruta.

The *Phantoms of Asia* exhibition was
organized by the Asian Art Museum,
San Francisco, in collaboration with the
Mori Art Museum, Tokyo. The exhibition
was curated by Mami Kataoka, chief curator
of the Mori Art Museum, in collaboration
with Allison Harding, assistant curator of
contemporary art, Asian Art Museum, with
assistance from other museum curators.

Presentation at the Asian Art Museum was
made possible by support from the Bernard
Osher Foundation, the W.L.S. Spencer
Foundation, Koret Foundation, Columbia
Foundation, the Henri and Tomoye
Takahashi Charitable Foundation, the
National Endowment for the Arts, Credit
Suisse, United, Union Bank, Christie's,
Pacific Gas and Electric Company, and an
anonymous foundation, with additional
support from the Dedalus Foundation, Inc.

Front cover: Poklang Anading, *Anonymity*,
2008–2011 (detail, see pages 58–59).
Back cover: Varunika Saraf, *Untitled*, 2010
(detail, see page 28).

Page 291 constitutes an extension of this
copyright page.

3 5 7 9 10 8 6 4 2

First Printing

Charwei Tsai *Bonsai III from the Bonsai Series*, 2011 (detail, see page 71).

Contents

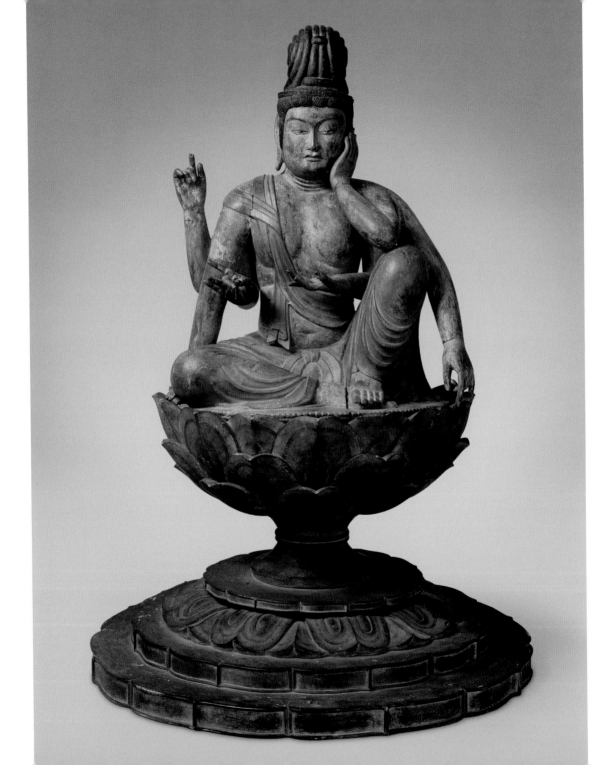

Director's Preface

Jay Xu

Spirits and ghosts everywhere," wrote the Tang-dynasty Chinese poet Li He, describing the discovery of an arrowhead on the site of an ancient battlefield. Fast-forward twelve hundred years, and we find the American poet Gary Snyder reflecting on the "ceaseless wheel of lives," while the Spanish poet José Ángel Valente sees how "another life unfolds its truth" in an earthenware vessel. What these poets detected across the centuries were phantoms of the past—perhaps the same phantoms that inspired Mami Kataoka, chief curator at the Mori Art Museum in Tokyo, to conceive the exhibition *Phantoms of Asia*. Mami wrote that she wanted "to explore a sensory, nonrational, and spiritual understanding of the universe that bridges premodern times and the present, to explore surviving vestiges of Asia's premodern past."

The resulting exhibition was not simply an international collaboration—as Mami teamed up with our own hardworking assistant curator of contemporary art, Allison Harding, to take overall direction of the project—but a collaboration in many ways. To realize our shared vision, we had to develop an innovative collaborative curatorial model. Curators from each of the museum's main cultural areas suggested objects and offered ideas for the exhibition. You will find contributions on these pages from curators in our Himalayan, Chinese, South Asian, and Japanese art

The bodhisattva Avalokiteshvara in the form of the wish-fulfilling Chintamani-chakra (Japanese: Nyoirin Kannon), 900–1000. Japan. Gilding and pigments on wood. H. 43.5 × DIAM. 34 in.

departments, as well as from our librarian and our director of creative services. We are grateful to all these colleagues for their inventive and productive work.

The museum's contemporary art program is itself a kind of collaboration. As we sought to expand and deepen our engagement with contemporary art, we called upon a distinguished group of experts. The members of this contemporary art advisory panel included Bob Ackerman, managing director and founder of Allegis Capital and a member of the board of trustees of the Asian Art Museum; Leeza Ahmady, independent curator and director of Asian Contemporary Art Week; Stephen Beal, president of California College of the Arts; Gordon Chang, professor of American history at Stanford University; René de Guzman, senior curator of art at the Oakland Museum of California; Cheryl Haines, executive director of the FOR-SITE Foundation and director of Haines Gallery; Ann Hatch, member of the boards of trustees of the Walker Art Center, Oxbow School, and California College of the Arts; Fred Martin, emeritus dean of Academic Affairs and associate professor of painting and drawing of the San Francisco Art Institute; Dipti Mathur, art collector; Mary-Ann Milford, Carver professor of East Asian studies and chair, department of art and art history, Mills College; Misako Mitsui, president of Mitsui Fine Arts; Zheng Shengtian, independent curator and editor of *Yishu* magazine; and Jack and Susy Wadsworth, art collectors. All freely contributed their time and shared their wisdom, for which we are deeply grateful.

Without the generous assistance of several organizations and individuals, this exhibition would not have taken place. Its presentation at the Asian Art Museum was made possible by support from the Bernard Osher Foundation, the W.L.S. Spencer Foundation, Koret Foundation, Columbia Foundation, the Henri and Tomoye Takahashi Charitable Foundation, the National Endowment for the Arts, Credit Suisse, United, Union Bank, Christie's, Pacific Gas and Electric Company, and an anonymous foundation, with additional support from the Dedalus Foundation, Inc. To all of these we extend our deepest thanks.

The exhibition represents a dialogue between past and present, as traditional works inform contemporary ones, and contemporary works resituate ancient ones. This too is a kind of collaboration. One of our main goals at the Asian Art Museum is to emphasize the interconnectivity of Asian art and culture—both the links between contemporaneous cultures across space and the links within cultures across time. We seek to explore artistic connections between Asia and the rest of the world, and also within the many cultures of Asia itself. By doing so, we embrace the work of Asian American artists as well as those resident in Asia, and we seek to engage our local Bay Area community and our wider community of museum visitors by connecting art to daily life.

Phantoms of Asia accomplished these goals brilliantly. For the first time, the museum's special exhibition galleries were fundamentally connected to the

collection galleries on the second and third floors, as the work of contemporary artists from throughout Asia engaged in dialogue with the museum's traditional artworks throughout—and even outside—the museum. Such a dialogue was essential to the concept of this show, which included more than sixty bold contemporary artworks—some made expressly for this exhibition—juxtaposed in thematic groupings with more than eighty works from our world-renowned traditional art collections.

To bring such an ambitious exhibition to fruition required contributions from numerous people: many curators, as I have mentioned, but also registrars, preparators, conservators, educators, and experts in design, image services, and publications. And a big show like this one required fundraising by our development department, and extra effort by our marketing and public relations departments in order to get out the word to the new audiences such a show might interest. Each of the museum's four main divisions—arts and programs, audience and business development, finance, and human resources, led by Robin Groesbeck, Dori Sera Bailey, Mark McLoughlin,

and Valerie Pechenik, respectively—contributed to the success of the show. To all these colleagues from around the museum I extend my sincere thanks.

Others outside the museum also contributed substantially to the exhibition and this publication. We are above all indebted to the artists and their galleries and collectors for lending works of the highest possible quality, and for providing information and images for use in this catalogue. With respect to the catalogue, particular thanks go to Christine Taylor of Wilsted & Taylor Publishing Services and her colleagues Jody Hanson and Melody Lacina for excellent design and editorial work. Thanks too to the copyright holders who generously granted permission for materials reprinted here, and to Regal Printing Ltd., Hong Kong, for their high-quality printing on a tight schedule.

These individuals and groups made *Phantoms of Asia* a uniquely collaborative production. It shows that by working together we can help the contemporary to awaken the past and, we hope, to inspire the art that is still to come.

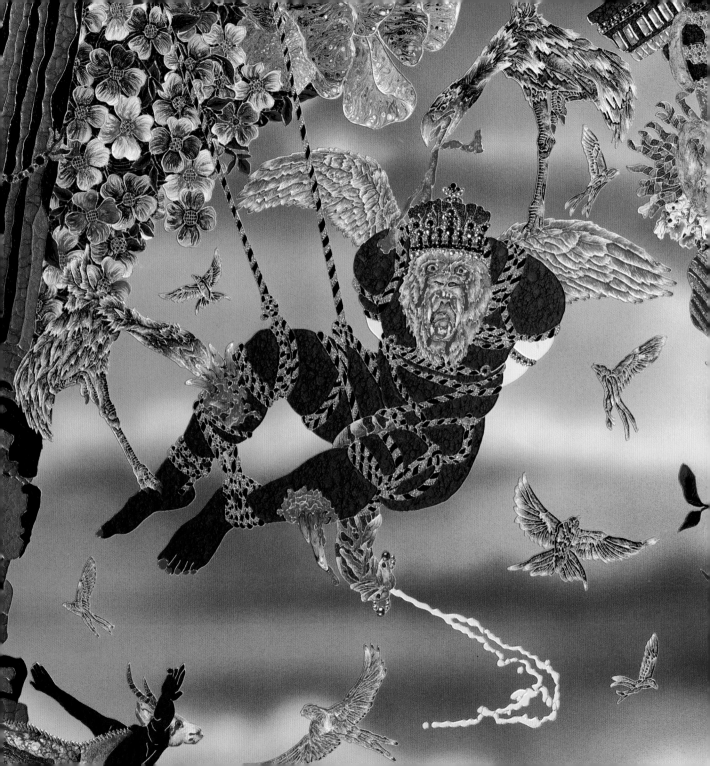

PHANTOMS OF ASIA Sensory Perception and Interconnectivity

Mami Kataoka

Where did we come from? Where are we going? We all ask such questions, using as our reference the "here and now"—often our imagination is constrained within a remarkably narrow range. If we broaden our viewpoint somewhat, the majority of the people in the world today will situate themselves in "Asia." But Asia is not a timeless construct. Asia has changed. New prosperity in China, India, and other industrializing countries in the region—Asian countries are achieving GDP growth across the board of 6 to 14 percent as well as making their presence felt politically in the international community—has both changed Asia and altered the way the world perceives Asia. This is the Asia of the present-day political and economic world map. It is easy to forget that since the modern period Asia has struggled to catch up with the West. And even as Asia continues to change, so too does Europe and the rest of Western society.

If we further expand our awareness along the temporal dimension to reach back to the origins of human civilization and along the spatial dimension to encompass the entire universe, we realize that our presence in the "here and now" is as tiny and fleeting as a speck of dust. And we realize that what we think of as "Asia" is in fact a succession of states of being in which different cultures have continually evolved, been influenced

Raqib Shaw
Absence of God VII, 2008
(detail, see page 156)

by outside forces, and merged, all the time interacting with one another, like a phantom whose outline remains unclear no matter how hard we try to grasp it.

"Asia is one," wrote the Japanese art historian and curator Kakuzo Okakura in his book *The Ideals of the East* (1903). Okakura, who worked in the department of Oriental art at the Museum of Fine Arts, Boston, for six months of every year from 1905 until his death in 1913, developed a close association with India, including a friendship with Rabindranath Tagore, and became deeply versed in pan-Asian scholarship through his art-related investigations in China, Japan, and other Asian countries. In *The Ideals of the East*, Okakura summed up what he saw as a common trait of the various peoples of Asia:

> The Himalayas divide, only to accentuate, two mighty civilizations, the Chinese with its communism of Confucius, and the Indian with its individualism of the Vedas. But not even the snowy barriers can interrupt for one moment that broad expanse of love for the Ultimate and Universal, which is the common thought-inheritance of every Asiatic race.[1]

For Okakura, a diverse range of ethnic groups, cultures, languages, and religions exist in Asia as if folded one on top of the other, maintaining a fluid and amorphous influential relationship. The notion that "Asia is one" penetrated his consciousness, as he enjoyed many rich pan-Asian experiences in an age when there was no air travel.

Asian civilizations cannot be reduced to a clearly divided modern-day map such as that devised by Samuel P. Huntington in his book *The Clash of Civilizations* (1993), for they came into being on the basis of a polytheistic, pantheistic, multitiered, intertwined coexistence. They share a presence that is essentially formless, perceived and experienced more intuitively than a map such as Huntington's would suggest. But what exactly is this presence?

We could begin by considering the climate of Asia, understanding that term in its broadest sense. In his book *Climate: A Philosophical Study* (1935), the Japanese philosopher Tetsuro Watsuji approached ontology from the perspective of *fudo*, or "climate," which he used as a general term for such things as a place's weather, geology, and topography. Influenced by Heidegger's *Being and Time*, Watsuji delved into the nature of human existence. He conjectured that people's spacial and temporal positions affected their sense of their role in the world. Looking back to the ancient view of nature as made up of the four elements of earth, water, fire and air, Watsuji identified three broad types of climate: monsoon, which is characterized by the combination of heat and humidity typical of the area stretching from coastal East Asia to India; desert, which is found in places like Africa and Mongolia; and pastoral, which includes Europe. For example, in discussing the "monsoon" climate, Watsuji wrote:

> While [humidity] is difficult both to tolerate and to take measures against, it does not arouse

within man any sense of a struggle against nature. One reason is that in the eyes of those who lie in the monsoon belt, humidity, or moisture, is nature's gift to man. . . . Thus, to these people, the world becomes a place teeming with plant and animal life; for them, nature is not death but life, death stands, instead, by the side of man. Hence the relationship between man and his world is not that of resistance, but that of resignation. . . . The second reason is that this humidity typifies the violence of nature. Humidity often combines with heat to avail man with violent deluges of rain of great force, savage storm winds, floods and droughts. The power is so vast that man is obliged to abandon all hope of resistance and is forced into mere passive resignation. . . . But the violence of nature typified in the form of humidity holds a threat filled with power—a power capable of giving life. It is not the threat of a death that stands by the side of nature. . . . The distinctive nature, then, of human nature in the monsoon zone can be understood as submissive and resignatory. It is the humidity that reveals this character.[2]

The monsoon climate includes places such as Japan, which has four seasons and where the sometimes unpredictable multiplicity of seasonal winds, typhoons, and heavy snows gives rise to emotions that are sensitive to change as well as to short-lived resignation. It also includes the Indian subcontinent, where the instability of the cycle of dry and wet seasons and the

combination of heat and humidity, Watsuji believed, encourage resignation and create both exuberance and submission. Just as in Japan, against a backdrop of nature worship and animism, people's relationship with the mystical forces of nature led to the development of a religion without a personal god (Shintoism), so in India people looked to nature deities and prayed for abundant harvests. According to Watsuji:

> The power of conjecture in the Vedas indicates the high degree to which Indian sensibility was [re]fined. All the forces of nature were deified in virtue of their mysterious character. Sun, moon, sky, storm, wind, fire, water, dawn, earth, anything similarly conspicuous and attractive, as well as the forest, the plain, animals and everything, provided only that it obliged a sense of some aspect of its power in resignatory humans, became a spirit of a demon. Hence the world of Brahman myth is probably more richly inhabited than that of the myths of any other culture.[3]

In fact, in Thailand, Indonesia, and other parts of Southeast Asia, one can find examples of syncretism in which mountain worship, animism, and folk religions have amalgamated with such religions as Buddhism, Hinduism, and Islam. That same tendency is apparent in Japan's Shinto/Buddhist syncretism[4] and in Korea's mix of Buddhism and shamanism. Perhaps this multiplicity could also be linked to the idea that gods can change their appearance, as seen in the ten avatars, or incarnations, of Vishnu in Hinduism.[5]

Could space characterized by "humidity" aid the perception of some kind of invisible beings? Greek mythology contains beings such as Hades, the god of the underworld, who preside over darkness, although, according to Watsuji, "Where there is a high humidity content in the atmosphere, even on a clear day there is a shadowy gloom and it is hard to escape a feeling of oppressiveness; but there is none of this about Greece's brightness. So there was no strong inclination to seek for the unseen, the occult, or the illogical within nature."⁶ He went on to state, "In just this way the beacon of reason shines most brightly in a meadow climate [such as Europe's], [while] in the monsoon zone it is the refinement of 'feeling' that is best recognized."⁷

If Watsuji is correct, aspects of ancient Asian worldviews, including a tendency toward polytheistic and pantheistic religious outlooks, may be linked to the region's climate. These views of nature are based on a mode of spatial awareness and a way of intuitively perceiving phenomena. Yes, Asia today is changing politically, economically, and socially in ways that cannot bear comparison with ancient times or even one hundred years ago. But by awakening primordial sensibilities that lie dormant in the deepest layers of our consciousness and memory, those of us living today might tap into vast systems of time and space that extend beyond human imagination and will. Such an awakening need not be restricted to the Asian region—it might be linked to premodern sensibilities around the world, raising the possibility that the yearning for the realm of a supralogical, supra-rational universe is quietly building once again.

The first major exhibition at the Asian Art Museum in its home in San Francisco's Civic Center dedicated to Asian contemporary art, *Phantoms of Asia: Contemporary Awakens the Past* explores how Asian cosmologies, views of nature, and religious outlooks are being carried on in the practice of artists "here and now." Further, it shines a light from "here and now" on the history and traditions of Asia, expanding our imagination into a realm that transcends space and time and awakening the receptivity that enables us to sense the invisible forces that resound to this day like a basso continuo. In the exhibition, the works of thirty-one Asian artists resonate with approximately eighty artworks selected from among the seventeen thousand pieces in the museum's collection that spans six thousand years of Asian history. Perhaps these works—regardless of region or time—will stir visitors' sensibilities, helping them to become aware of phantomlike beings of Asia that defy comprehension as fixed forms.⁸

The exhibition will envelop the entire museum in invisible forces. Visitors will first encounter installations outside the museum, in the entrance lobby, and in North Court. Artworks in the temporary exhibition galleries on the first floor will explore the links and interconnectivity between ourselves and the universe in three sections entitled "Asian Cos-

mologies: Envisioning the Invisible," "World, After-world: Living Beyond Living," and "Myth, Ritual, Meditation: Communing with Deities." In addition, in the permanent exhibition galleries on the second and third floors, pieces from each of the seven cultural regions represented in the museum's collection (South Asia, West Asia, Southeast Asia, the Himalaya, China, Korea, and Japan) will be displayed alongside works by contemporary artists from the same areas. In the Tateuchi Gallery on the second floor, the focus will be on mountain worship, nature worship, and spatial perception, in a section entitled "Sacred Mountains: Encountering the Gods." (Note that, while this essay considers the works in the exhibition in accordance with the themes mentioned above, all four are interrelated and are not intended to limit interpretation.)

ASIAN COSMOLOGIES: ENVISIONING THE INVISIBLE

A source of many premodern Asian cosmologies can be traced to the cosmology of the Upanishadic philosophy of the Vedic period of ancient India. According to this view, the fundamental principles of the universe consist of Brahman, the universal spirit, and Atman, or true self, which are linked and unified by invisible forces. It is held that emancipation from the cycle of birth and rebirth known as *samsara* can be achieved through this unification. The idea of nondualism resonates with Brahmanism, Hinduism, Jainism, and other religions. In Jainism, the universe is depicted as a giant icon of a cosmic man, or *lokapu-*

rusha, in which a microcosmos in the form of the Atman appears inside the torso of the macrocosmos. As for Buddhism, while the cycle of transmigration and emancipation is retained, the Buddha himself denied the existence of the Atman as an everlasting soul. The *I Ching*, one of the five classics of Confucianism, attempts to decipher the laws of heaven, earth, and nature; in his "Interactions Between Heaven and Mankind," the Han dynasty Confucian scholar Dong Zhongshu expounded on the relationship between natural phenomena, human activity, and politics. In these texts one can see a correspondence between a microcosmos in the form of the human body and a macrocosmos in the form of natural phenomena.

I would like to focus on the energy that unifies Brahman and Atman, the universe and the self. In Western traditions of mysticism and Neoplatonism, all things in heaven and earth are filled with spiritual energy. This way of thinking is still deeply rooted in Asia today in the *qi* (chi) and *qi gong* that form the basis of traditional East Asian medicine, as well as in the *pranayama* breathing technique of yoga, which is permeating contemporary culture around the world. Many Buddhists expounded theories of causality in place of the Atman and utilized the concept of dependent origination to explain the connections or relationships between all things on earth. The term *shunyata* (emptiness) was used to describe this condition of selflessness, and the concept of zero in India can be traced back to it. While *shunyata* refers to an emptiness devoid of both visible and invisible forces, one might

speculate that in the popular mind the notion of emptiness could lend itself to a perception of the existence of invisible forces of some kind.

The spatial sense of scale of the ancient Asian cosmographies is impressive. According to Hinduism, Jainism, and Buddhism, the center of the universe is Mount Meru (or Sumeru), which is vital to many Asian cosmologies. According to the *Vishnu Purana*, a giant egg (Brahmanda) floats in the universe, surrounded by seven layers consisting of water, air, fire, ether, the origin of the elements (*bhuta-adi*), and the great principle or intellect (*mahat*). These strata are in turn surrounded by infinite space in the form of primary matter (*prakriti*). In the middle of the egg lies a disc-shaped continent with a diameter of 100,000 *yojanas*[9] (approximately 1.5 million kilometers) known as Jambudvipa. Six other continents are arranged around it concentrically, making a total of seven continents with a diameter of 76,300,000 or 500,000,000 *yojanas*, according to different theories. And rising from the center of the land of Jambudvipa is Mount Meru.

Buddhism encompasses many views of the universe. Around the fourth century, the Indian monk Vasubandhu summarized the Buddhist view of the universe in the *Abhidharma-kosha*, according to which the world centered on Mount Meru is singular, although within the universe there are countless such worlds. One thousand of these worlds make up the thousand-fold world, and one thousand of those make up the millionfold world. The Buddhist cosmology consists of a thousand of these millionfold worlds, meaning that the number of worlds in the entire universe is one thousand cubed, or one billion. Each of the one billion worlds is independent, but at the same time they exist as one world. Whereas the seven mountain ranges and seven seas of the Hindu cosmology are circular, according to the *Abhidharma-kosha* Mount Meru is shaped like a rectangular column, and the seven mountain ranges and seven seas extend out from it in a square. The circumference is supported by a gold ring, below which layers of a water ring and a wind ring float in the void.

In esoteric Buddhism—which evolved from Indian Buddhism around the seventh century—earth, water, fire, wind, and ether make up the universe and are known as the five elements. In one ritual, adherents direct symbolic hand gestures that represent each of the five elements to the feet, the navel, the chest, the forehead, and the top of the head to signify oneness with the Buddha. This structure is linked to that of the universe, in which the earth ring forms the basis and layered beneath it are, from top to bottom, the water ring, the fire ring, the wind ring, and the ether ring. Representing a similar structure in reverse is the five-ring pagoda, which consists of, from bottom to top, rings of earth, water, fire, wind, and ether in the shapes of a cube, a sphere, a pyramid, a crescent, and a lotus flower, respectively.

Such Asian cosmologies are reflected in some of the contemporary artworks in this exhibition. The *Seascapes* series by Hiroshi Sugimoto, who was born in Tokyo and is based in New York and Tokyo,

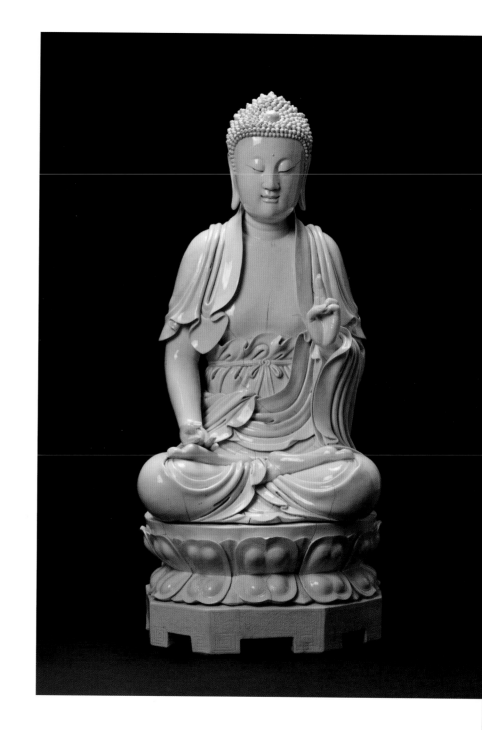

The bodhisattva Avalokiteshvara (Guanyin), approx. 1900–1940. China; Dehua, Fujian province. Late Qing dynasty (1644–1911) or Early Republic period. Porcelain with creamy glaze. H. 21¼ × W. 12¾ × D. 11½ in. (figure).

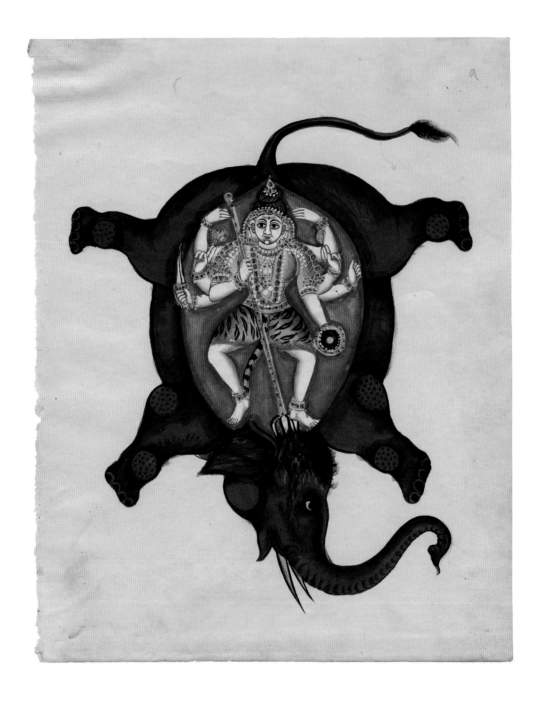

is a collection of photographs taken in various locations around the world that depict only the sea and the sky below and above the horizon. One could say these photographs are the result of the artist envisioning sceneries witnessed by humans living in the remote past and recreating those images. Sugimoto's latest installation, *Five-Element Pagoda*, consists of a photograph from this *Seascapes* series embedded in the "water ring" layer of a tiny five-ring pagoda made from crystal. In this respect the work symbolizes this exhibition by combining a seascape with the ancient esoteric Buddhist view of the universe.

Cosmographies composed of geometrical shapes can be observed in the *yantra* of Hinduism and the mandalas of Tibetan Tantric Buddhism. They find an analogy in the bronze mirrors seen mainly in China and in Korea and Japan as well.[10] One surface of these mirrors usually contained cosmological diagrams, while the other was polished and reflected the real world. The polished surface also symbolized light and the sun, and together the two surfaces in addition symbolized the solar deity. As suggested by the use of the name Amitabha (the Buddha of Infinite Light) or Amitayus (the Buddha of Immeasurable Life) to describe Amida Nyorai in Pure Land Buddhism, the Pure Land was deemed to be a world of boundless

light and time. Capturing this light has been an aim of photography since the days of the camera obscura, and in the *Anonymity* series by Poklong Anading from the Philippines one senses this same desire. In the manner in which the subjects' identity is outshone by light acting in concert with the universe by means of a circular mirror held in front of their faces, it is possible to see a connection with the ideas ancient people associated with bronze mirrors. The paintings of Palden Weinreb, an artist of Tibetan descent who lives in New York, are tranquil works suggestive of minimalism, although one might say they are inspired by the structure of the universe and light, boundless time and space, and other concepts associated with Eastern philosophy, such as the endless cycle of death and rebirth, or *samsara*.

The invisible forces that unify the universe and the human body, and the worldview that everything is constantly changing and impermanent, can be seen in the work of a number of the contemporary artists in this exhibition. A good example is the dynamic, site-specific installations of Korean-born Sun K. Kwak, who uses masking tape to create artwork that records the unification of space and the artist's body. Through her process of improvised responses to the space she has been allocated, arise new ripples of energy. The drawings of Chinese artist Guo Fengyi offer insights into the relationship between the universe and the human body, and between spirituality and the human body. The works by Guo, who studied *qigong*, clearly represent mappings of the human nervous system or

The Hindu god Shiva slaying the elephant demon,
approx. 1850. India; Mysore, Karnataka state.
Opaque watercolors on paper. H. 8¾ × W. 7 in.

the internal energy systems of Eastern medicine or the flow of chi according to feng shui, although they also call to mind cosmographies such as the *lokapurusha* of Jainism. Charwei Tsai of Taiwan seeks to establish a rapport with Buddhist impermanence and invisible forces. Known for her installations in which she writes excerpts from the Heart Sutra—which epitomizes the Mahayana Buddhist concept of emptiness—on ephemeral materials such as lily pads and tofu that are not usually used in contemporary artworks, Tsai draws our attention to the fleeting nature of existence. Enlivening both the interior and the exterior of the Asian Art Museum for *Phantoms of Asia*, Choi Jeong Hwa of Korea focuses on what is perhaps the most important symbol of cosmology in Asia, the lotus. His *Breathing Flower*, a three-yard-diameter lotus flower made of sheets of fabric, mimics the movements of a live lotus flower. In nature, the lotus pad seems to come about spontaneously, rising from the water of its own accord. Choi Jeong Hwa's lotus does much the same thing, emerging from the cityscape seemingly out of nowhere, moved by an unseen motor.

NS Harsha of southern India traverses a variety of mediums, including painting, drawing, and installations. As suggested by the titles of his new pieces, *Distress call from Jupiter's neighborhood* and *Distress*

Guo Fengyi
Energy Channel Decomposition Diagram #1, 1989.
Mixed media on paper. H. 47¼ × W. 21¼ in.

call from Saturn's neighborhood, his work stems from an awareness of the relationship between humans and the wider world. The paintings, which depict the heads (and occasionally the bodies) of several hundred people floating in space mingled with eggplants, express the grand illogicality of the universe and are positioned opposite each other as if exchanging signals. A similar floating sensation can be seen in the works of Varunika Saraf, also from India. Multiple overlapping patterns and motifs float across picture planes suggestive of a gravity-free space. In the details of the mysterious, dreamy spaces lurk skeletons, monsters, and other such creatures, offering clues to the story behind each piece.

In the art practice of Singapore's Heman Chong, rational, conceptual aspects and more intuitive, irrational aspects coexist. One of Chong's works in this exhibition is a site-specific mural made of original stickers. Geometric shapes suggestive of directional movement such as stars, triangles, and teardrops are applied to a wall in an impromptu manner, giving the space a dynamic power. The other piece by Chong is a conceptual work titled *Calendars*, which consists of 1,001 photographs in the form of pages of calendars of the future, representing the seventy-seven years from 2020 to 2096. Among the photographs are images of deserted common space in ordinary apartment blocks in Singapore, which exude a static energy that encourages viewers to think about emptiness and time.

These works are displayed alongside sculptures from the museum's collection spanning various regions, periods, and faiths, including images that depict mythological gods and goddesses, Amitabha, bodhisattvas, and guardian deities. Considering that these sculptures were originally produced as objects of faith or prayer rather than as artworks, one can imagine that people of those areas and times sensed in them a connection between themselves and the vast universe, and believed they could commune with the spirit world through them.[11] Even today, hundreds of years after they were produced, these sculptures still serve as intermediaries linking us and the universe. Perhaps the invisible forces generated by this communion will also envelop the work by contemporary artists that share the space, giving rise to a forceful flow of chi.

WORLD, AFTERWORLD: LIVING BEYOND LIVING

Many Asian cosmologies regard the realm of the gods and the afterworld as a part of the same spatial structure as this world. Of course, views of the afterworld are closely related to religious outlooks, but the concepts of transmigration of the soul and karma, according to which one's deeds in this life affect one's existence in the next, encourage a strong awareness of the connection between this world and the afterworld. The *lokapurusha* of Jainism portrays a world that extends vertically, which is a manifestation of the belief in a lower world, a middle world, and an upper world. Such tripartite conceptions are common in Asia, as elsewhere. In the Balinese cosmology, the universe is

divided into a high world, a human world, and a low world. "The mountains are the dwelling place of the gods, or *swarloka*; the villages where people live are *bhuloka*; and the ocean is the dwelling place of the demons, or *bhuvarloka*."[12] This triple nature is reflected as well in the view of human beings as comprising *sthula sarira* (the physical body), *sukshma sarira* (the astral body), and *karana sarira* (the causal body). The Ainu people of Japan call their gods *kamui*, and their cosmology also divides the world into three: the land of the gods, or *kamui moshiri*; the land where people live, or *ainu moshiri*; and the netherworld, or *pokna moshiri*. In Buddhism, a transmigrating soul may be born into one of three realms—which are, from bottom to top, the realm of desire, the realm of form, and the realm of non-form—or one of six domains: the hell domain, the hungry ghost domain, the animal domain, the jealous god domain, the human domain, and the god domain. The lowest of the six domains, the hell domain, is presided over by the lord of death, or Yama, who plays a similar role in Hinduism. Yama is also one of the so-called ten rulers of the afterlife in Confucianism and Buddhism. These concepts of the afterworld and hell have inspired not only visual representations of the structure of the universe in the form of mandalas and *thangkas*, for example, but also numerous illustrations of hell. One example included in this exhibition is A King of Hell (approx. 1600–1700), a Korean work from the museum's collection.

Views of life and death are connected to such concepts as phantoms and ghosts as departed souls still wandering this world, beliefs that exist in harmony with nature worship, spirit worship, ancestor worship, and shamanism. In contrast to the idea of hell as a place where people are punished for their sins, in Japan the terms *yominokuni* and *meikai* describe places where souls go after death, while in Ryukyuan religion there is the mythical realm of Nirai Kanai. Objects that are buried along with the dead in graves or mausoleums in some cultures suggest a sense of an afterworld continuing on from this world, with items ranging from clothing, accessories, pieces of craftwork, and other possessions of the deceased to articles for protecting the deceased in the afterworld, such as the terra-cotta army of the first Qin emperor. Other examples of this practice include the Haniwa clay images unearthed from burial mounds in Japan, although this custom is not confined to Asia; the burial accessories in the pyramids of Egypt serve as another well-known example. In addition, the numerous objects excavated from the massive tombs and other sites built in China from the Shang dynasty to the Warring States period are monumental reminders of the prestige of the deceased.

Within the contemporary art world, artists from Thailand create a large number of works that deal with the afterworld. In Thailand, where more than 90 percent of the population is Buddhist and Theravada Buddhism is widely practiced, funerals usually last from three to seven days, after which the deceased are enshrined, sometimes in the home, for approximately one hundred days before being cremated. This experience

is precious for the deceased's survivors, enabling them to visualize or share the transition to the afterworld. In the video series *The Class, The Class II,* and *The Class III* by Araya Rasdjarmrearnsook (of which the first is part of this exhibition), Araya herself appears on sets that resemble school classrooms and speaks to dead bodies about such subjects as hell on earth, the afterworld, the irreversibility of rebirth and death, and funerals. Araya once commented, "Death becomes a feather in the wind," a statement that transforms the oddity of someone in this world speaking to the dead and the seriousness of death into a light, floating sensation. Apichatpong Weerasethakul, also from Thailand, encourages viewers to think about ideas concerning life and death with his series *Primitive.* Weerasethakul—who, when his feature film *Uncle Boonmee Who Can Recall His Past Lives* won the Palme d'Or Prize at the 2010 Cannes Film Festival, commented, "I would like to thank all the spirits and all the ghosts in Thailand"—weaves into his languidly paced visuals explorations of personal memories and political problems peculiar to northeast Thailand, where he is based. In *Phantoms of Nabua,* which forms part of the *Primitive* series, flames symbolizing wild, primitive light are contrasted with fluorescent lamps that represent modernization and industrialization. As Weerasethakul hinted at when he said, "The film portrays a communication of lights, the lights that exude, on the one hand, the comfort of home and, on the other, of destruction,"[13] light serves as a medium for a discussion about change, loss, and memory. In the opinion of Jakkai Siributr, another artist from Thailand, the Thai view of life and death is heavily influenced by pantheistic, animistic cultures such as nature worship and the belief in ghosts or spirits (*phi*) as well as the teachings of Buddhism. In *Karma Cash & Carry*—part of which is modeled on the spirit houses (*san phra phum*) seen in homes and on street corners in Thailand—Siributr, himself a practitioner of Buddhism, alludes to the commercialization of these gateways to the afterworld or places of communion with spirits. Ringo Bunoan of the Philippines undertook her *Passage: The Blanket Project* in Briddhashram, a social welfare facility in Nepal. To create the installation that lasted only one day, the artist stacked woolen blankets rolled up by facility residents to resemble the firewood used in Hindu cremations. The work encourages viewers to reflect on the transient nature of life, the transition from life to death, and, by extension, the very existence of life.

One is often surprised at people's power of imagination with respect to views of the afterworld and the composition of hell, although it should probably be considered in the context of our instinctual fear of death. Takayuki Yamamoto begins his workshops by showing children a copy of the *Kumano Kanjin Jikkai Mandala,* a collection of paintings used in Japan from the fifteenth century until the Edo period (1603–1868) to explain by way of pictures the teachings of Buddhism. After thus arousing curiosity about the afterworld—the medieval works depict "life" from birth to old age above and the "afterworld" as various

Jakkai Siributr
Karma Cash & Carry, 2010–2012. Bamboo, eucalyptus,
found objects, gold leaf, and cheesecloth with embroidery
(not seen in this image). Approx. H. 59 × W. 47 × D. 39 in.

kinds of hell below—Yamamoto then invites participants to create their own versions of hell. For this exhibition, children from the Bay Area will take part in the workshops.

Howie Tsui from Ottawa has not decided whether he is an atheist or a romantic agnostic, but the influences he cites range from ghost stories, Buddhist paintings of scenes in hell, feng shui, Hokusai, and Toriyama Sekien's illustrations of *yokai* (imaginary creatures that usually have various human and animal parts) to Jim Henson and Barry McGee. His paintings portray a world in which ghosts and *yokai* float around in complete harmony. In fact, the culture of ghosts and *yokai* is well developed in Japan; the country has a long history of art that deals with these subjects. Ancient views of nature and religion are reflected as well in the works of the young *nihonga* artist Fuyuko Matsui. Matsui's paintings, which often feature ghosts, give expression to such feelings as fear, pain, and depression. They are charged with powerful forces, including an obsession with a world occupied by spirits that have separated from physical bodies.

MYTH, RITUAL, MEDITATION: COMMUNING WITH DEITIES

In Brahmanism, Hinduism, Shinto, and other pantheistic faiths that originate from a belief in nature deities, the invisible forces and irrational phenomena of the natural world are expressed as gods with different names and forms, whose existence is repeatedly alluded to and passed down through parables, paint-

ings, performances, and other art forms. Examples include ancient Indian epics such as the Ramayana and Mahabharata. In modern times the characters in such films as *Princess Mononoke* and *Spirited Away* by the Japanese animation artist and film director Hayao Miyazaki seem to be attempts to visually depict the invisible presences many of us perceive outside the bounds of established religions. Tales of ghosts and *yokai* have abounded since ancient times in Japan, and the Edo-period ukiyo-e artist Toriyama Sekien, who compiled the *Gazu hyakki yako* (The Illustrated Night Parade of a Hundred Demons), is said to have been heavily influenced by the deities and characters referred to in the Chinese classic *Shan hai jung* (Collection of the Mountains and Seas).

Thought-provoking myths about the creation of heaven and earth are found in different regions, and many refer to a nebulous, egglike universe split into heaven and earth, or yin and yang. The *Sanwu liji* (Record of Cycles in Threes and Fives) of China chronicles the Pangu myth, while Japan's *Nihon shoki* (Chronicles of Japan) describes how the three creator deities emerged from this chaos. In the *Rigveda*, the sun, moon, and gods emerged from *purusha*. Among Hindu creation myths, the story of the "churning of the ocean of milk" in the Puranas is well known, having been featured in numerous paintings and sculptures over the centuries.

Traditional festivals, dancing, and other performing arts are opportunities to commune with the gods or with the spirits of ancestors. In Indonesia, arts such as shadow-puppet theater (*wayang kulit*), rod-puppet theater (*wayang golek*), and dance (*wayang orang*) are regarded as mediums for communion with ancestral spirits; they relate to that country's syncretism of Hinduism, Buddhism, and Islam, which occurred against a backdrop of ancestor worship. Japanese Noh plays, and in particular such programs as Okina and Kamiuta, often take as their subject matter myths, folk beliefs, supernatural phenomena, or omens. A large number of the approximately 250 varieties of Noh masks depict vengeful spirits, souls of the dead, and demons. The *cham* masked and costumed dance of Tibet is a Tibetan Buddhist religious ceremony and as a rule is performed by Buddhist monks. Puppets, masks, and other items used as part of such communions with the gods often are thought to have souls. Motohiko Odani has taken Noh masks as his subject matter, carving their inner surfaces to resemble anatomical drawings of muscle and flesh. The way he compares masks and humans, life and death, conjures images of the invisible world or the world of the occult.

Anno Domini by Agustinus Kuswidananto, also known as Jompet, of Indonesia, is a part of the artist's most recent project, *Java's Machine: Family Chronicle*. The performative installation consists of five bodiless Javanese soldiers represented by pieces of their uniforms arranged within a three-dimensional space that resembles a stage set, leaving viewers to imagine the invisible bodies or departed souls of the soldiers. The work blends issues surrounding the cultural and

Jagannath Panda
The Cult of Survival II, 2011 (detail, see page 40).

Sarasvati, meanwhile, was introduced via China to Japan, where she was transformed into the Buddhist goddess Benzaiten and the Shinto goddess of harvests and wealth, sometimes assuming the form of a white snake. Reminiscent of these snakes of mythology, Jagannath Panda's snake sculpture *The Cult of Survival* expresses the idea that we are in danger of becoming addicted to the cycle of production and consumption in our rapidly changing world. According to Panda, "The inter-entangled form of sewerage-pipes awakes the human condition, instinct of survival, and ecology of death and renewal of life." Monkeys, butterflies, birds, and other animals appear in the paintings and sculptures of London-based Raqib Shaw, who also hails from India. In Shaw's work, though—which takes as its theme John Milton's *Paradise Lost*—these dazzling enameled creatures are suggestive of hidden anxiety and instability.

religious syncretism of Java with those of modernization, memory, and new encounters.

In myths, communication between animals, plants, and humans is often possible. Here, too, an animistic, pantheistic context exists. In the Old Testament's Book of Genesis, the cunning serpent is banished from the Garden of Eden as a symbol of evil, but in Hinduism the serpent appears as a snake deity, or naga, and as a five- or seven-headed snake symbolizes mystery and immortality. The sworn enemy of the King of Snakes (nagaraja) is the eagle deity Garuda, who provides transport for Vishnu. In Buddhism, the naga is also a guardian deity. The Hindu goddess

Adeela Suleman of Pakistan uses ordinary items and found objects to depict the inner human world. In her beautiful, handicraft-like artworks made by linking together stainless-steel reliefs, natural motifs such as birds, trees, and flowers are contrasted with the likes of missiles and suicide vests, calling to mind the everyday that exists alongside death, the transience of life, and loss. Prabhavathi Meppayil of India, who uses traditional metalwork techniques, creates her two-dimensional works by embedding delicate strands of metal in gesso in a manner reminiscent of the work of minimalist artist Agnes Martin. From this tranquil space arise images not only of a world of repetition,

eternity, and illusions but also of the artist's meditative process. Working with objects originally intended for prayer, Pouran Jinchi of Iran transforms text into image with her series of prayer stones. Baked clay stones such as these were used as a place to rest one's head while prostrating during prayer; in Pouran's hands, they become luminous surfaces of decoration and calligraphy. This play between ritual and decoration, functional object and work of art, helps to bridge the gap between the spiritual world and our own, encouraging viewers to make deeper connections between faith, ritual, and beauty. In the work of the Japanese artist Yoshihiro Suda, who is known for his hyperrealistic wooden sculptures of plant life, one senses a process into which the artist puts his heart and soul, which perhaps explains why these sculptures seem to have a life of their own. Suda's sculptures are displayed throughout the Japanese art galleries.

Whereas Raqib Shaw says that his art evokes shamanic practices in which people dance wildly or use channeling to establish contact with the other side,[14] Hyon Gyon—a Korean artist based in Japan—is interested in the shamanism that is deeply embedded in Korean daily life. Shamans, who act as intermediaries in communing with gods or the spirits of ancestors, have an energy that causes human emotions to well forth, and Hyon Gyon's paintings overflow with a similar concentrated power.

Feng shui, a traditional Chinese system of geomancy, employs a different force. Related to the theories of the five elements and of yin and yang (which in

Pouran Jinchi
Prayer Stones 1 and *2*, 2011 (see page 172).

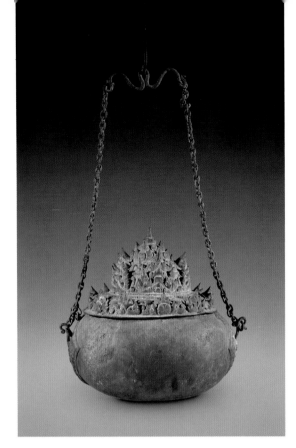

Hanging container with mountain-shaped lid, 1000–1500. Indonesia; East Java. Bronze. H. 8 × DIAM. 7 in.

turn are closely related to ancient Chinese philosophy and the ancient Chinese view of the universe), feng shui links the flow of chi with topography, the orientation of buildings, and other such features. In East Asia, it heavily influences urban planning, architecture, housing, the interior decoration of public spaces, and garden design. The practice is also rooted in places such as Taiwan, Singapore, and South Korea, as well as in the cornerstone of the Asian economy, Hong Kong. Adrian Wong, who was born in the United States and lives in both Los Angeles and Hong Kong, investigated the geomancy of the Asian Art Museum with the help of several feng shui experts from the Bay Area and used the results to come up with suggestions for the exhibition space.

SACRED MOUNTAINS: ENCOUNTERING THE GODS

The Asian views of the universe and of nature we have examined include a belief in gods who dwell on mountains. As mentioned above, Mount Meru is the center of the universe in Jainism, Hinduism, and Buddhism, and such concepts as holy mountains and mountain gods came to be shared by different peoples throughout Asia. Well-known holy mountains in China include the Kunlun Mountains, which from around the third century BCE to the Earlier Han dynasty were believed to be the paradise of Taoism; the Three Sacred Mountains (Mounts Penglai, Fangzhang, and Yingzhou), thought to have been located in eastern China; and Mount Taishan, which is also a sacred place in Taoism. The list of holy mountains outside China is almost endless. It includes Mounts Halla, Jiri, Geumgang, and Baekdu on the Korean peninsula; Mounts Lawu and Semeru in Indonesia; and Mount Fuji (Japan's highest peak) as well as Mounts Tate and Osore in Japan. These and other holy mountains gave rise to various tales of paradise or Shangri-La. The story of how the first emperor of a unified China, Qin Shi Huang (259–210 BCE), sent

Xu Fu and hundreds of young men and women in search of the mythical Mount Penglai in the hope of discovering the fabled elixir of life is well known.

Mount Meru and the other holy mountains have been used as motifs in a variety of paintings, sculptures, and other artworks over the centuries. The mountain-shaped *boshanlu* incense holders that became popular in China in the Han dynasty were modeled on Mount Meru, which was often shown supported by a turtle floating in the ocean. When incense was burned in these holders, the smoke gave the appearance of clouds rising from the mountain or the energy of the universe. Among the scenes depicted in the Indian miniatures in the museum's collection are Lord Shiva and his family engaging in ascetic practices on Mount Kailash—which is a holy mountain in Buddhism, Hinduism, Jainism, and Bon—and Muhammad receiving his first revelations at the cave of Hira on Mount Al-Nour.

Contemporary artists also are attuned to the presence of spirits in mountains. According to Lin Xue, a self-taught artist from Hong Kong, from a young age he has sensed an overwhelming energy in nature and has perceived sounds and vibrations emitted by plants and insects. Lin Xue started painting when he was a student. Using thin, sharpened bamboo as a stylus, he creates highly detailed works that reflect his lifestyle, which centers on hiking in the mountains, contemplation, and art. In *Untitled* (2010-9)—which he produced during a visit to Mount Kinabalu, a holy mountain in Malaysia, an island floats in an ocean swirling with marine life, within which is condensed all manner of microscopic plants and insects. If one looks at Lin's paintings with a magnifying glass, one can often observe tiny smiling characters, which the artist says are symbols of the joy and invisible, spiritual energy of life.

Lin Chuan-chu was born into a Taiwanese farming household and grew up surrounded by nature. One of his projects involved creating a temporary rice field on a piece of urban land that was under development and inviting people to visit and reflect on nature. Given that Lin Chuan-chu's mountains are the work of someone whose ideal lifestyle is that of a literary artist equally versed in calligraphy, Buddhism, nature, poetry, and painting, perhaps they represent both an imagined landscape and the holy mountains of Asia.

Aki Kondo was born in Hokkaido, Japan, and she still lives surrounded by nature. She once heard the following story from a man who practices asceticism in the mountains. "From long ago the mountain gods have been regarded as female deities, and men who practice asceticism in these mountains have likened them to birth canals and felt a female presence there. There is also a theory that mountain gods are ugly women, which is why practices such as prohibiting women going into the mountains and employing phallic images when praying for bumper harvests remain. So even today, many mountain-worshipping faiths are discussed in terms of male and female metaphors." The motivation for Kondo's latest work, which depicts mountain deities, came from the Tohoku earthquake and tsunami of March 2011. "That

day, when I felt the earth shake so much I thought it would never stop, I was in Yamagata, which isn't that far from the quake's epicenter, although the tsunami didn't reach us," explains Kondo, who was obviously affected by the loss of so many lives on the other side of the mountains. In fact, although many people in the Tohoku region seem to have accepted silently the natural disasters of the earthquake and tsunami, the man-made disaster at the Fukushima Daiichi nuclear power plant has been difficult to accept. "The mountains know about everything that's happened from the day the earth was created," says Kondo.

Bae Young-whan of South Korea also possesses a keen sensitivity toward nature's power and supernatural forces. His tiny ceramic mountain ranges based on the form of his own brain waves and his wooden tables, for example, may be seen as results of the unification of the vibrations of the microcosmos of the artist's body and the workings of the macrocosmos, as expressed in the Asian views of the universe discussed above.

SENSING THE PHANTOMS OF ASIA

Interpreting contemporary art from the perspective of invisible forces that pervade space in Asian views of the universe may raise questions regarding how much recent art from Asia expresses reactions to political,

Lin Chuan-chu
Book, 2008. Oil on canvas. H. 79⅞ × W. 17⅜ in.

economic, and social changes. Perhaps the perspective offered here represents a return to intuition in response to an overabundance of conceptualism. It certainly highlights the need for embracing the imaginative powers that have enabled people since ancient times to understand phenomena beyond human control and to address our fear of the afterworld. Access-

ing these powers involves the inheritance not only of established forms and subject matter but also of a sensitivity toward invisible forces. This effort connects to the search for the essence of creative activity in Asia, a region that is rapidly changing but where ancient phantoms still linger and spread their spells.

NOTES

1 Kakuzo Okakura, *The Ideals of the East with Special Reference to the Art of Japan* (London: John Murray, 1903), 1.

2 Tetsuro Watsuji, *Climate: A Philosophical Study* (Japanese title: *Fudo*, 1935), trans. Geoffrey Bownas (Westport, Conn.: Greenwood Press, 1961), 19–20.

3 Ibid., 29.

4 This theory, which originally held that the nature deities and myriad other Shinto deities were local manifestations of the universal Buddhist deities, continued up until the Edict for Separation of Shinto and Buddhism (1868) of the Meiji Restoration. However, both Buddhism and Shinto remain deeply rooted in Japanese culture.

5 In Hinduism, the Buddha, the founder of Buddhism, is regarded as one of the avatars.

6 Watsuji, *Climate*, 78.

7 Ibid., 117.

8 Coincidentally, San Francisco was the center of the counterculture of the 1960s and of the New Age movement of the 1970s, making it a fertile breeding ground for the kind of discussion the organizers hope to deepen with this exhibition.

9 In Hinduism 1 *yojana* is approximately 15 kilometers, while in Buddhism it is approximately 8 kilometers.

10 Although various deities are worshipped at the spiritual fountainhead of Shinto, the Ise Grand Shrine, the main object of worship believed to contain the spirit of the sun goddess Amaterasu Omikami is the Yata no kagami, or sacred mirror.

11 The gateways through which the human body communes with the gods and Buddha, or the focal points through which energy permeates the body, are called *chakra* in India and Tibet, and *dantian* in China.

12 Translated from the Japanese translation of I Ketut Ginarsa, "Bari hindukyo no uchukan" (Balinese-Hindu Cosmology), in *Ajia no uchukan* (Asian Cosmology) ed. Keiji Iwata and Kohei Sugiura (Tokyo: Kodansha, 1989), 91.

13 From the artist's statement for the work.

14 Homi K. Bhabha, "An Art of Exquisite Anxiety," in *Raqib Shaw: Absence of God* (London: White Cube and Kunsthalle Wien, 2009), 9. "I needed a space to deal with this anxiety. The paintings are based on channeling that anxiety, on concentrating on something. It is very much like those Shamanic practices where people beat the drums so that they go on to another reality, another space. And that is why you see [in my work] this constant obsession with detail, this constant craziness."

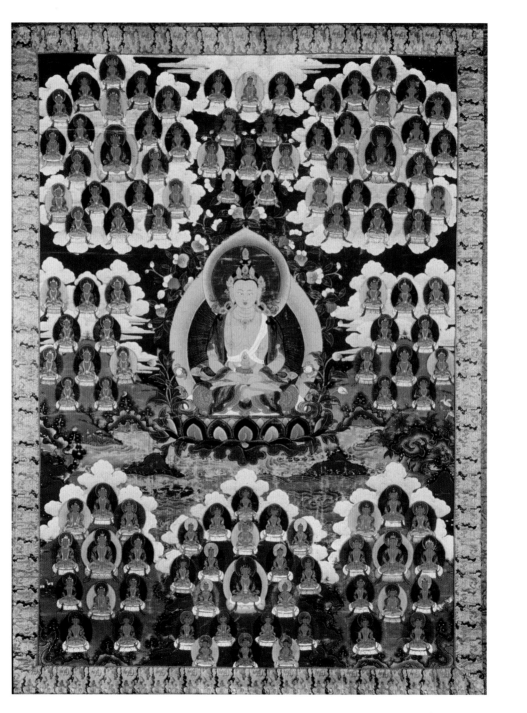

SEEING WITH PHANTOMS OF ASIA

Allison Harding

The visible in the profane sense forgets its premises; it rests upon a total visibility which is to be recreated and which liberates the phantoms captive in it.

MAURICE MERLEAU-MONTY[1]

What does it mean to see the invisible? How is that possible? And how do such questions fit into a discussion of the visual arts, which appeal foremost to the eye? While the objects in *Phantoms of Asia* manifest rich and unexpected interconnections of cultures, histories, discourses, and traditions, what intrigues me more than the (valuable) question of how these objects connect with each other is how these objects connect with us, and we with them. I am interested in what these objects *do* to us, how they allow us to access parts of the world unreachable with our eyes alone, and whether this access is universally granted to those who seek it. In other words, to borrow from Merleau-Ponty, can objects lead us to "a total visibility"?

Together with recent work by thirty-one contemporary artists, *Phantoms of Asia* includes more than eighty traditional objects from the Asian Art Museum's collection, shown in thematic, cross-cultural groupings that explode geographical and historical boundaries of art historical convention.[2] A mandala from Nepal, a *thangka* from Tibet, a miniature painting from India, bronze mirrors from China, and a series of light boxes by Filipino artist Poklong Anading explore cosmologies. A group of sculpted deities from China, Japan, India, Nepal, Burma, Thailand, and Cambodia examines ways of connecting to the

The cosmic Buddha Amitayus, 1800–1900. Central Tibet. Colors on cotton. H. 31½ × w. 22¾ in. (unmounted).

Poklong Anading
Anonymity, 2008–2011. From series of nine light boxes
(see pages 58–59).

of art history—subject and object, linear and spatial, naturalistic and abstract, to name just a few. Intended to address a universal category of art, but determined by Western perspective, these oppositions become doubly problematic; not only do they frame non-Western objects outside their cultural codes, but also the very act of framing objects creates limitations not intrinsic to the objects themselves.

These practices of boundary-making are absent in this exhibition, an absence through which Mami Kataoka calls our attention to the limitations they have long placed on our experience of art. Rather than viewing the traditional objects for their "pastness," looking backward with the linear perspective of history, we are challenged to view them as part of our present, as contemporary objects able to communicate in the "here and now." The suggestion seems to be that freeing art from the categories of context—the "who? what? when? where? why?"—for a moment might open us to new perspectives found within the sensorial, enigmatic spaces of the universe that lie beyond observable facts.

I have been fascinated by two Himalayan Buddhist *thangkas* that open the first thematic gallery of *Phantoms of Asia*. Learning about what those complex

spiritual realm, a theme extended to the contemporary works that surround them. These contiguities of past and present are not mere juxtapositions demonstrating difference. Neither are they meant to suggest that all the objects in the groupings are alike, for even the most comprehensive collections cannot represent "one Asia." Nor are the traditional items solely meant to imply influence on or affinity with contemporary art, reinforcing a linear historical narrative upheld by neatly constructed binaries

paintings are intended to *do* to the viewer has provided one model for thinking about the elusive question of how one might experience art's transformative potential beyond language and context. Visualization practice transforms *thangkas* from two-dimensional maps of the cosmos into vehicles that transport you inside the three-dimensional existence of the cosmos.[3] According to Himalayan Buddhist tradition, this journey can reveal the "nondual" nature of the universe: categories that structure the everyday world are constructs that do not actually exist in opposition, but are, instead, part of one indivisible continuum where subject and object simultaneously fuse and differentiate. One traditional visualization of this principle is the *taiqi* symbol of Taoism, which depicts yin and yang eternally merging with and separating from one another.

Thangkas challenge us to see not only with our eyes but also with our bodies, to suspend reassuring contextual touchstones and symbolic language that imprint preconceptions upon us, estranging us from the inherent oneness of everything that exists. Opening ourselves to the unconscious realm long enough to lift the veil of these illusions allows us to reenter the realm of language aware that we are all, as Jeff Durham explains, "conscious creators of our own experience." This awareness—initiated by the artwork—alters our perspective of the world, bringing us closer to the real.

Sun K. Kwak's installation similarly transforms experience of time and place. Using masking tape to trace the invisible energy of a space, Kwak blurs boundaries between the two dimensions of drawing and the three dimensions of sculpture. "My drawings are born through the communion between the material and the spiritual, wherein my own self is constantly reflected emptying itself. . . . Through these series of these drawings on space, I visualize previously unseen space and time that existed only in our imagination and subconscious realm."[4]

Modern inquiries into spirituality, experience, consciousness, language, and aesthetics explore nonduality in various contexts, many of which apply to the question of how we connect with art. For me, the philosophy of Maurice Merleau-Ponty provides a particularly useful complement to *thangkas'* activated mode of looking. Merleau-Ponty defined his theoretical area in terms of "the essence of perception" and "re-achieving a direct and primitive contact with the world."[5] He looked to Lascaux's cave paintings from 30,000 BCE to explore the ancient roots of people's drive to visually represent and experience the invisible. Like that of *thangkas*, the power of these cave drawings lies in their activation—in this case, their transformation from representation of an animal into that animal's essence:

> The animals painted on the walls of Lascaux are not there in the same way as are the fissures and limestone formations. Nor are they *elsewhere*. Pushed forward here, held back there, supported by the wall's mass they use so adroitly, they radiate about the wall without ever breaking their

elusive moorings. I would be hard pressed to say *where* the painting is I am looking at. For I do not look at it as one looks at a thing, fixing it in its place. *My gaze wanders within it as in the haloes of Being. Rather than seeing it, I see according to, or with it.*[6]

Seeing "according to" or "with" the painting not only conflates subject and object in a shared moment of time and space but also resonates with cosmological relationships between the body as microcosmos and the universe as macrocosmos.[7] On one hand, the body and the painting gaze upon each other, circumscribing experience within the body itself. On the other hand, the space of this experience is infinite, endless, and invisible, reflecting the world all around it. "I do not see [space] according to its exterior envelope," wrote Merleau-Ponty. "I live it from the inside; I am immersed in it. After all, the world is all around me, not in front of me."[8]

Merleau-Ponty's formulation of a reciprocal gaze parallels the Hindu concept of *darshan*—the act of seeing and being seen by the divine as manifest in statues called *murti*. Just as intense eyes activate an Indian stone sculpture of the Hindu deities Vishnu and Lakshmi (1500–1700), focusing our awareness on the divine, so floating eyes that gaze upon the viewer in Varunika Saraf's paintings *Cloudburst*, 2010, and *Untitled*, 2010, acknowledge us on our journey into Saraf's otherworld. Similarly, Filipino artist Poklong Anading manipulates properties of light energy and reflection as a metaphor for people's position within, or surrounded by, the universe's forces. Haloes of energy overlay his subjects' heads, the site of identity and of consciousness, obscuring any duality of subject and object and of body and space.

These artworks—and all objects in *Phantoms of Asia*—extend beyond the frame, communicating to us in the present an accumulation of all past moments activated "according to" and "with" the bodies with whom they have exchanged gazes. Traditional objects are not relics of the past. Instead, like contemporary art, they are alive in the present; their transformative potential is dynamic and endless. The objects' rituals may have changed, but they embed their past meaning as phantoms and carry them forward to be retrieved in anticipation of an inexhaustible future.[9]

From this perspective, we can meet Mami Kataoka's call to "[awaken] the receptivity that enables us to sense the invisible forces that resound to this day."[10] Yet, as *thangkas* have suggested to me, simply connecting ourselves to the past is insufficient to experience a total visibility of the unseen. We must also recognize that our position within the cosmological "here and now" is a liminal space between all oppositions. Art "happens to us" in this threshold. Here, the

Varunika Saraf
Cloudburst, 2010. Watercolor, metal tacks, and plastic eyes on rice paper overlaid on cotton cloth. H. 68½ × W. 70¾ in.

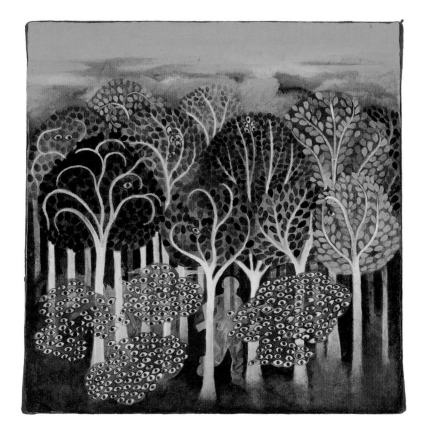

Varunika Saraf
Untitled, 2010. Watercolor on rice paper overlaid on canvas. H. 7 × W. 7 in.

viewer and artwork gaze upon each other, dissolving subject and object. Unconscious thought replaces language, and we can add our experiences to an ancestry of moments and meanings that travel backward and forward in time "like the branches of a vine, a vine the size of the universe."[11]

Phantoms of Asia challenges us to acknowledge facts and interpretations, and then move beyond them, allowing art to inspire our imaginations and reveal the unseen. Otherwise, the phantoms we gaze upon remain imprisoned inside the frame. From within the boundaries, we put ourselves in a unique position to absorb new experiences that, in turn, change our perspectives of the world. We can not only see

what is before our eyes but also sense what surrounds our bodies, moving outside of a two-dimensional, ordinary world and into the "spherical field of the ancients."[12] The contemporary art entries that follow reflect this way of seeing. They assume that both contemporary and traditional art come from a universal drive to understand and depict parts of the world that are not fully within our grasp. If humans have used art since the caves of Lascaux to articulate ideas that fall between the gaps of language, then perhaps art is the closest we can come to understanding the deepest parts of ourselves.

NOTES

1 Maurice Merleau-Ponty, "Eye and Mind," in *The Merleau-Ponty Aesthetics Reader: Philosophy and Painting*, ed. Galen A. Johnson (Evanston, Ill.: Northwestern University Press, 1993), 128.

2 See Qamar Adamjee's text elsewhere in this catalogue discussing the cross-cultural, cross-historical grouping of sculptural deities.

3 In the visualization process, one visualizes a virtual body, transfers one's awareness into that body, and then returns to the world with *pristha-labdha-jnana*, the awareness that what one is presently seeing before oneself as an ordinary, subject-object world is in fact images-only (*vijnapti-matra*).

4 Sun K. Kwak, artist's statement (not dated).

5 Maurice Merleau-Ponty, *Phenomenology of Perception*, trans. Colin Smith (London: Routledge and Kegan Paul, 1962), vii.

6 Merleau-Ponty, "Eye and Mind," 126; italics added.

7 See Mami Kataoka's discussion of microcosmic and macrocosmic relationships in her essay.

8 Merleau-Ponty, "Eye and Mind," 138. For Merleau-Ponty, the gaze is linked to the body, not only to the eye. "The visible world and the world of my motor projects are both total parts of the same Being"; "Eye and Mind," 124. Bronze Chinese mirrors in *Phantoms of Asia* also suggest this idea of reflecting not only the viewer's image but also the surrounding world.

9 My use of the words "anticipation" and "inexhaustibility" parallels Wolfgang Iser's in his formulation of the reading process. Iser theorizes that literary works are dynamic and active. He discusses a virtual space between the reader and the text, in which each reader participates in the construction of meaning by filling in portions "unwritten" in the text through a "process of anticipation and retrospection." See "The Reading Process: A Phenomenological Approach" in *Reader-Response Criticism: From Formalism to Post-Structuralism*, ed. Jane P. Thompkins (Baltimore: Johns Hopkins University Press, 1980), 50–64.

10 See her essay in this catalogue. Mieke Bal and Norman Bryson issue a similar challenge: "We should remember that the reserve of unheard viewers is there, even when they cannot be retrieved; notice the absences in the record as much as what survives"; "Semiotics and Art History," *The Art Bulletin* 73 (1991): 186.

11 Bal and Bryson, "Semiotics and Art History," 183.

12 Merleau-Ponty, "Eye and Mind," 135.

ASIAN COSMOLOGIES *envisioning the invisible*

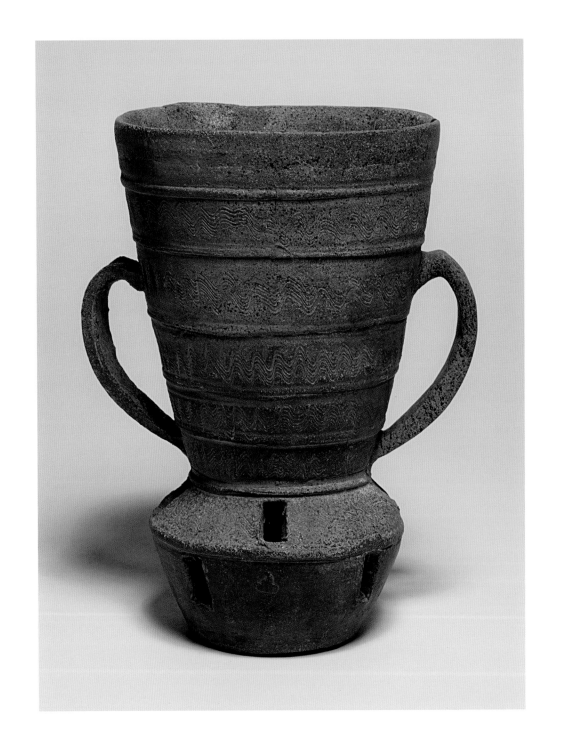

THE SIGN

José Ángel Valente

Translated by Thomas Christensen

In this slight object
shaped by man,
a bowl of sun-baked mud,
where the endurance of anonymous material
forms a signal or a sign,
its fragile form compacted across generations,
surviving against time,
the gaze slowly reaches
around the thin invention
formed by hand with a fragment of earth,
rough and alive.

Here, in this object
on which the pupil pauses and returns
and seeks the axis of proportion, resides
for a moment our being,
and from it another life unfolds its truth
and another pupil and another dream find
their most direct response.

Bell cup with handles, approx. 400–500.
Korea. Stoneware. H. 7⅜ × W. 5¾ × D. 4⅜ in.

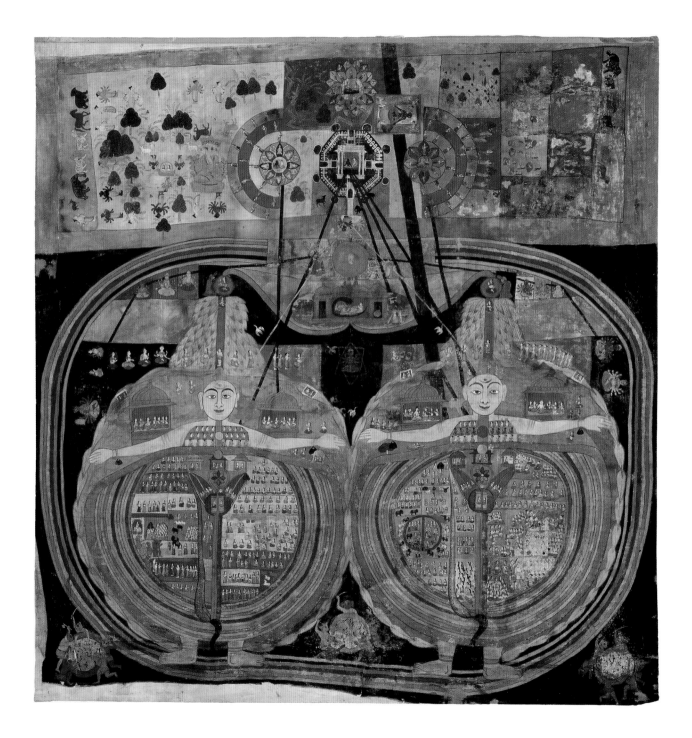

ASIAN COSMOLOGIES

Jeffrey S. Durham

Where did we come from? Where are we going? Many of us have asked ourselves these questions with which Mami Kataoka begins her essay (page 1). Did everything come into existence by accident, or should we read the universe as exhibiting some sort of intelligent design? And, perhaps most important, how do we figure into the process? Are we active agents, passive spectators, or something altogether more interesting? Cosmology represents human communities' attempts to answer such fundamental questions. Whether understood literally or metaphorically, cosmological accounts involve far more than idle speculation: they shape present experience, working like magic mirrors that act back on those who gaze into their depths, charting the future as they reveal the deep past. Cosmologies bring the unknowable within range of our senses, encoding it within a kaleidoscopic array of myths and images. In addition to revealing the origin of the universe, cosmologies show why it's reasonable for the world to appear as it does, in the process suggesting strategies for addressing existence's most problematic aspect—its tendency to fall apart.

Cosmologies occur at the genesis of every civilization, as if each beginning required a story about the beginning. But we obviously cannot directly see these beginnings. All cosmology is therefore visionary rather than perceptual; instead of directly representing the event, it uses narrative and imagery braided together to weave stories about the beginning. This

Cosmological painting, approx. 1750–1850. India; Rajasthan. Opaque watercolors on cloth. H. 94¼ × W. 90½ in.

is true whether the cosmology in question focuses on clearly symbolic elements—such as the Genesis cosmology in the Hebrew Bible—or if the cosmology is less obviously symbolic, like the various versions of the big bang origin story.

Whatever systems of maps and metaphors shape their trajectories, all cosmologies share three characteristics. Every cosmology is human, since it is born from the human nervous system. Every cosmology is visionary, since it is impossible to directly see and transcribe the beginning. And since a cosmology must account for everything in the cosmos, its account must include the creator of the account—so every cosmology is recursive as well.

LOTUS

In Asia, perhaps the single most important cosmological symbol is the lotus plant. In its natural setting, the lotus pad emerges from murky waters by itself, as if spontaneously generated. In this imagery, the waters are an undifferentiated sea of possibility preceding the creation of anything. The leaves of the lotus float without any apparent support. Charwei Tsai uses them to show how definite forms and the emptiness from which they emerge cannot be separated. In a work in the same series as those in the exhibition, she uses the lotus leaf as her blank slate—a plane, the first form to emerge from emptiness. On it, she repeatedly writes the words of the Lotus Sutra, a Buddhist text that shows how form and emptiness are never separate, and always arise together. The seeds in the lotus pod symbolically encode another abstract concept: how all manifest forms like the lotus bloom unfold their potential in a regular, ordered manner consistent with specific causes. The petals of the lotus bear a further symbolic message. They seem to be multiple entities, yet each can be traced back to a common center.

Finally, the lotus stalk represents one of the most significant symbols in the history of human cosmology: the cosmic axis. Like the earth's axis, the cosmic axis is a line envisioned as running through the center of the universe. The axis, by its mere appearance, divides a plane into halves, thus establishing a bilateral symmetry along that plane. It also establishes directionality—up and down, the summit and the deep, connecting these two regions by its very form.

TREE

By itself, though, the axis is merely a geometric concept. When clothed with imagery, the axis becomes a living thing: the world tree. In cultures that embrace shamanism, the world tree links heaven to earth as the highway between worlds. By altering their state of awareness, shamans use this world tree to travel between ordinary reality and visionary worlds beyond the five senses. Varunika Saraf knows that this tree is a vision tree, that it comes into existence as it is envisioned, and that it therefore can be reconstituted wherever its axial symbolism is recreated. The tree-centered cosmos has its center everywhere, and its circumference nowhere, a perspective shared by cosmologists from Hermes Trismegistus to Blaise Pascal.

Shamanistic traditions are characteristic of hunter-gatherer societies who travel for a living. In settled civi-

lizations, the center takes on a more fixed character. Adrian Wong's work reveals this transition by showing how an axial tree organizes space in terms of the four directions. This is more than a mere metaphor. In fact, astronomical observation is how the four directions were seen into existence historically; the people of Chaco Canyon did that a thousand years ago in New Mexico. There, perpendicular walls oriented to the cardinal directions mark the center of space. At the equinoxes, the east–west wall marks the ecliptic—the path along which the sun travels through the sky. At noon every day, the north–south wall casts no shadow, since the sun is directly overhead. So Pueblo Bonito's walls also mark the center of time, and the entire complex becomes the literal center of space-time. In addition to the four directions marked by the Pueblo Bonito walls, the sun overhead marks a fifth axial dimension. Together, these five directions link earth directly to the apparently changeless stellar patterns. With heaven and earth coordinated, vision can exert concrete effects in the world. Cycles of planting, harvest, and transport can be coordinated. In this way, the visionary center of the cosmos becomes the economic center of a civilization—exactly what Chaco Canyon represented to the ancient Americans.

MOUNTAIN

The circle around the center enters the third dimension of space as a mountain. The sacred mountain pins cosmology to ordinary reality, thereby functioning as a gateway between heaven and earth. Ancient Greece's famous sacred mountain was Olympus, simultaneously mythic and material. From its summit, one can see the entire lay of the land, allowing one to step outside the system and grasp it as a whole. For this reason, Zeus, the lord of Olympus, is both the "highest" (*hypatos*) and the "all-seeing" (*panoptikos*). But exactly what could he see from his palace atop the world? It was the subtle order of the world, the creative force behind its forms, that lay before the Greek god.

The connection between cosmic order and vision is certainly not limited to Greece. In ancient Egypt, the subtle order of the universe, called *maat*, is literally seen (*maa*) into existence. Interestingly, Sun K. Kwak is doing exactly that—seeing the subtle order behind manifestation into existence.

In India, seeing and being seen are so important that they weave between them the fabric of the cosmos. India's cosmic mountain, called Meru, is explicitly mythical; it doesn't correspond to any particular physical mountain. But far from being a flaw, its character makes Meru all the more flexible, for it can theoretically appear as any specific sacred mountain. Like the lotus, Mount Meru in India floats on the cosmic ocean. Around it in the cardinal directions are arrayed the four continents that compose ordinary reality.

REPETITION

Taken together, the axis and the four directions articulate a new form that precipitates the axis into the three-dimensional world of sensory experience. This precipitation happens through the iteration of simple forms. For example, at the Mahabodhi temple in the Indian state of Bihar, self-similar geometries that become smaller as one goes "up" toward the

summit form the body of the mountain. A similar pattern appears in the temple of Somnathpur near the city of Mysore, where the body of the temple seems composed of small-scale temples. Under these conditions, the temple is effectively made out of itself, built up from itself—and thus inherently recursive, like all cosmology. Pouran Jinchi employs this principle in her work, as in a series of prayer stone rubbings on Japanese paper. Such work shows how small-scale forms can self-organize to produce an emergent form.

Cosmological themes fundamentally inform all aspects of the Indian temple. In the tiny inner sanctum at the heart of the temple, one finds the embryo-chamber, the singularity from which individual life emerges. Above is the summit, the singularity into which all forms dissolve. Between them are simple, iterated forms stacked on ever-smaller versions of themselves, an architectonic that presents a clear analogy to human gestation, in which geometric growth occurs by fission of self-similar cells.

ENTROPY

Temples "grown" in this way perform a further cosmological function: they mark the center of creation. For just as the temple builds up ordered, three-dimensional space through the repetition of simple forms, so does the temple provide a place in which ritual can build up ordered time through a kind of repetition of the cosmology. Indeed, hidden behind the structure of every temple is a series of mythic events that took place "in the beginning." Such creation myths lie at the genesis of every civilization, seeming to express an order-imperative built into the human organism. And although such stories occur across a wide cultural range, they share a strange commonality: each one describes how the creation of the cosmos involved a sacrifice. In other words, death, or more generally entropy—the tendency of ordered systems to lose coherence over time—is built into such worlds.

To defeat entropy, the events that conquered chaos "in the beginning" must be ritually reiterated. This is exactly what happens when an Indian temple is constructed. In the Indian temple, the foundation is a sacrifice, the Vastu Purusha or "Enterprise Person," whose schematic presence under the temple's foundation recapitulates the cosmological sacrifice of a being called Purusha, "the Person." According to the ancient myth, Purusha's sacrifice occurred "in the beginning," and his quartered body became the ancient Indian cosmos. By virtually repeating this universe-creating sacrifice every time a temple was constructed, ancient Indians could pour the infinite creative power of "the beginning" into ever-decaying form. To keep the world going in this manner is cosmology as a civilizational project. It recurs in similar forms across the world, in cultures that share no historical connection. In ancient Sumeria, knowledge of "the beginning" derives from a cosmology called the *Enuma Elish*, which translates as "Once, on high . . ." In this account, the cosmos as we know it was born at the center of the world: a mound called the Duku. Here, the hero-god Marduk slew the demoness Tiamat; from her body, he created the natural world. Due to her demonic nature, however, the creation is shot through with

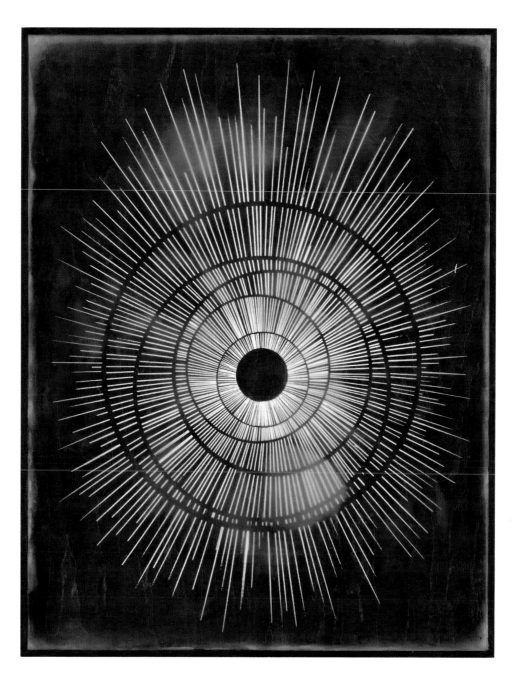

Palden Weinreb
Astral Invert, 2011. Encaustic, wood, and LEDs. H. 22½ × W. 17½ in.

Jagannath Panda *The Cult of Survival II*, 2011. Plastic pipe,
acrylic, fabric, glue, rexine, and plastic flowers. H. 105 × W. 74 × D. 69 in.

chaos and entropy. To banish chaos, the Akitu must be performed every year. In so doing, the ancient Sumerians reaffirmed what they called "me," the regular order of the world, an order similar to what India called *dharma*, China called *dao*, and Egypt called *maat*.

When the cosmology is repeated, chaos is banished to the margins of the world. In Greece, chaotic forces are thrown into a great abyss. In Tibet, chaotic forces appear at the edges of the mandala, which geometrically depicts a self-contained world explored in meditation. Today, Jagannath Panda shows how the organization of chaotic forces ties the world together. The intestinal form of his work simultaneously reveals ordure and order. The blue-green world is just the output of a much larger and more convoluted process.

ALIENATION

"Me" is clearly and obviously a culturally constructed idea, a dynamically created world image. To the Sumerians, however, it was the form and substance of the real. How might something humanly created appear as independently real? The answer will be familiar: repetition. "Me" seemed a fact to the Sumerians because it made multiple self-similar appearances—just as we conclude that we ourselves are "facts" because we repeatedly appear in a self-similar form.

This ability to create meaningful worlds and then forget how they were made is called "alienation." This magical ability is as basic to the human organism as it is to culture. From a physiological perspective, alienation informs every normal visual perception. First,

patterns of light generate a two-dimensional pattern on the retina. Then, the visual cortex of the brain synthesizes this pattern into a three-dimensional model. Finally, the brain projects its self-generated pattern externally as the world of objects and subjects, so that the world of experience appears to exist "outside" of the body, even though it is synthesized by the brain.

Alienation takes place through linguistic means as well. Words give perceptions stability as the entity they name. When a language is fully formed, it organizes a world of coordinated percepts and ideas; this is the world of ordinary reality, full of subjects and objects, where different people and things have regular, orderly names. Such a world would seem to exist by itself, to be independently real. In fact, this alienated world is built from human activity, both physiological and cultural—so its appearance as "real" is an illusion. How can this be the case?

It may be difficult to understand why a reliable world of subjects and objects might be illusory, but luckily an important analogy explains the situation. In a normal dream, a brain-generated simulation appears as a manifold world of experience filled with different subjects and objects, however bizarre its contours might seem to outsiders. You might say that the dreamer unconsciously mistakes a virtual map for actual territory. In ordinary dreams, bizarre incongruities are glossed over, and the experience of a self-existent dream "reality" is born. Bae Young-whan shows us that collapse of map and territory that generates our experience of a "real" world.

MEDITATION

Our alienated worlds of experience can involve us in situations as bizarre and troubling as those of any dream. To overcome the problems associated with these situations, Asian traditions offer the practice of meditation. Meditation is the process of reversing alienation consciously, of tracing the steps of creation back to their source, and it has two elements: a meditation object, and psychological concentration on that object. The meditation objects called mandalas combine these two elements. They operate as maps when looked at, and they operate as vehicles when concentrated upon. As with Poklong Anading's work, the goal of mandala meditation is transformative—to make the place of looking a place of meditation, moving from the peripheral manifold to the luminous center.

The most salient feature of the mandala is its geometric structure. The Tibetan mandala organizes its imagery in terms of quadrants around a central point. When concentrated upon, it exerts a similar effect on the mind, turning from map to vehicle. The classical five-pointed form, however, is not essential to the mandala's meditative functionality. Palden Weinreb's finely geometric lines reveal structures hidden behind the senses. At the same time, they represent "physical traces of a meditative state." Thus to view his work is both to participate in a meditation and to see the world it reveals. But exactly how does the concentration that turns it from map to vehicle take place?

It may be impossible to discursively say how to

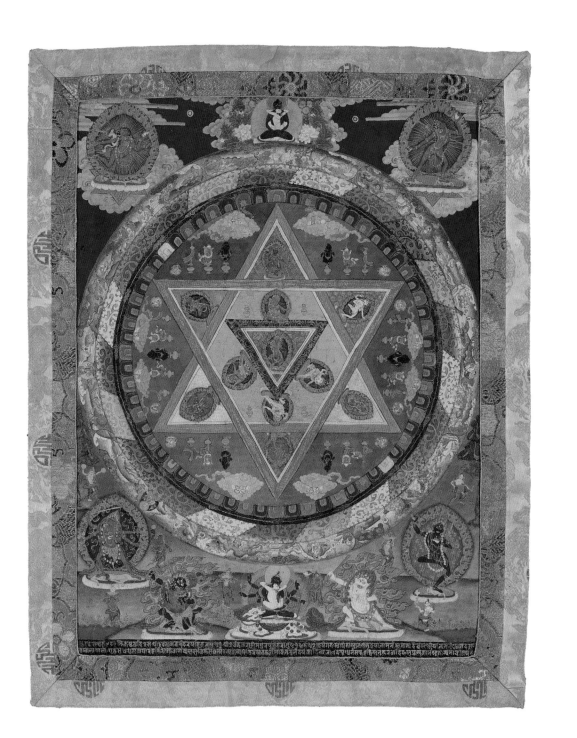

"concentrate," but it can be imaged and experienced. In Buddhist Asia, a specific form arises when you put awareness into itself, when you center awareness on itself. This image is the stupa, and it is called literally a "concentration" (*samadhi*). A hemispherical superstructure called an "egg" (*anda*) is a hieroglyph of generation and growth. From the summit protrudes the cosmic axis, the center of the cosmic egg. The stupa is a cosmological structure with an implicit fivefold structure as yet unexpressed. Although a hieroglyph of fixity, the stupa undergoes many metamorphoses as it enters different art worlds. Hiroshi Sugimoto stacks the five elements of the cosmos as a pagoda, the East Asian form of the stupa. Ascending from earth and water through fire and air to the luminous ether, Sugimoto's crystal stupa represents the progressive subtilization of matter that takes place in specific forms of Buddhist meditation. At the same time, it shows how a sustained inquiry into the elements that comprise the sensory world reveals no core but rather a creation—in this case, a depiction of the cosmic ocean from which the lotus and the temple both spring.

Sugimoto's work represents a synchronistic echo from other crystal stupas created two millennia ago.

These first-century crystal stupas were created as reliquaries for the physical remains of great meditators, composed of the same five elements that Sugimoto's pagoda incarnates. Interestingly, they exhibit the fivefold form of cosmological structures, four directions around an axis. Moreover, they appear in a curious architectural context: the stupa complex. The best example of such a place is Taxila, a Buddhist site on the ancient Silk Road. Here, the great Dharma King Stupa establishes the spatial center of the complex. Surrounding the Dharma King Stupa is a series of chapels that house smaller stupas. In these smaller stupas were sealed a third series of stupas. So we have a stupa in a stupa in a stupa, a stupa made of stupas, a concentration of stupas.

Taxila's stupa complex represents a system whose various components are small-scale refractions of the large-scale entity. In such a system, to insist on real differences between elements is to miss the subtle order. Here there are no ultimate substances, only self-similar forms repeated at different scales. This exact situation one finds in the Mandelbrot set of fractal images. And the metaphorical force of the image here will not be lost—the Mandelbrot set looks just like a stupa. So is it any coincidence that the image of the stupa is also the image of the mind of the Buddha? That concentration reveals a fractal world made of only one thing, endlessly iterated inside and out? To answer definitively, of course, would indicate that we have missed the lesson that the creative moment described "in the beginning" is actively created here. This is the lesson of meditation, of concentration. As Guo Fengyi understands, the secret of creation is hidden within the human organism.

And to access it, all that need be done is to recognize it, to see it into existence.

A mandala of the Buddhist deity Vajravarahi, 1869. Nepal. Colors on cotton. H. 21½ × W. 16½ in.

FIVE ELEMENTS IN OPTICAL GLASS

Hiroshi Sugimoto

I have been photographing seascapes for more than thirty years now. It's not a passing interest: by now I can see it will be a lifelong effort. I became interested in seascapes because they relate to memories from infancy; the very earliest thing I can picture is the sea.

A sharp horizon line and a cloudless sky—here began my consciousness. From there my thoughts race to the origins of human consciousness. The sea reminds me that within my blood remain traces of human evolution over hundreds of thousands of years. Humans outstripped other species intellectually and developed civilization, art, religion, and science, spinning out the strands of history. It seems to me that seascapes have the latent power to reawaken an awareness of the origins of consciousness in this present day.

The outlines of memory grow indistinct with time. I almost think that memories are merely visions conjured up by the brain. People see the world they want to see, whereupon imagination, hallucination, and projection go to work. Whenever I stand on a cliff looking at the sea, I envision an infinite beyond. The horizon lies within bounds and the imagination stretches to infinity. Did we discover mathematical concepts within our own minds, or did our minds simply tap into the mathematic order that abounds in the universe? Astrophysics tells us the universe

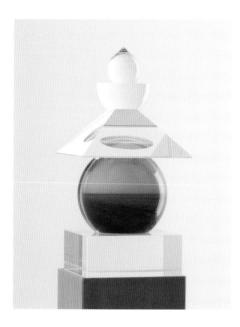
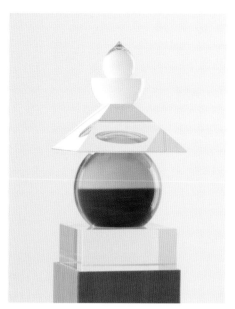

has been steadily expanding since the big bang, its edges ever retreating from us—which would mean "beyond infinity" gets further away from one moment to the next.

The idea of "zero" is said to have been discovered—or, rather, invented—in India, perhaps in contrast to "one." I exist and the world exists; with that awareness begins objectification, which is also the budding of self-consciousness. Only with this awareness of "one" did the world become countable. Our ten fingers were literally the first calculator. When things to be counted exceeded ten and became uncountable, we created "infinity." Likewise, tracing back in the reverse direction, the notion of absence or nonpresence led to an awareness of nonbeing or "zero." Zero might seem like a natural number, but it is not. It is neither negative nor positive, but rather an even number extracted from the human imagination.

Religion may also be an externalization of human consciousness. In the Neolithic Age, animistic or shamanistic beliefs flourished in all parts of the world. Such pantheistic ideas of spirits manifesting in diverse

Hiroshi Sugimoto
Five Elements: Sea of Okhotsk, Hokkaido, 2011.
Optically clear glass with black-and-white film (from *Seascapes* series, 1989); plinth: unvarnished cypress with metal base. H. 59 × W. 11¾ × D. 11¾ in.

Five Elements: Tasman Sea, Ngarupupu, 2011.
Optically clear glass with black-and-white film (from *Seascapes* series, 1990); plinth: unvarnished cypress with metal base. H. 59 × W. 11¾ × D. 11¾ in.

phenomena gradually shifted toward that of an absolute singular deity. This image of a monotheistic god compounding transcendent powers with the human form represented both exaltation and boastful exaggeration of human consciousness. Then from among the ranks of humanity we chose persons with godlike qualities and idolized them, raising them onto the altars of the divine—Zarathustra (Zoroaster), Siddhartha Gautama (Shakyamuni Buddha), Yeshua bar Miriam (Jesus Christ), and Muhammad (Mohammed).

The process by which Shakyamuni Buddha was deified is clearly reflected in changes in the pagoda reliquaries erected to enshrine his *sarira* (Japanese: *shari*), "remains." During his lifetime, worshipping graven images was forbidden in keeping with the precept of *anicca* (Japanese: *mujo*), "impermanence." After his death, however, followers fought over his ashes and bones, their emotional adherence to the holy man reaching such heights that the image of the Buddha took on a life of its own and pictorial representations appeared. At first the Buddha's footprints were carved in stone, then whole-body portrait sculptures followed. Over the next few centuries the Buddha's words were widely interpreted and codified into the Tripitaka, or "Three-Basket," canon of Buddhist philosophy, cosmology, and law. Buddhist reliquaries likewise were originally little more than earth mounds upon which were planted umbrellas to shade the harsh Indian sun—an honor traditionally reserved for royalty—and which multiplied into nine umbrellas to show even greater respect. These in turn transformed into an ornamental *sarin*, or "ringed spire," atop layered roofs added in China. And so the delineations of what we now recognize as pagodas or *sharito*, "relic towers," were born.

The outward forms created by the faithful were not imbued with any magic significance at first; they simply had to look resplendent to inspire reverent awe. Yet over generations of worship the crafting naturally became more graceful as the iconography took on a mystic aura identified with the object of devotion. By the early Nara period (645–794) in

Hiroshi Sugimoto
Five Elements: Irish Sea, Isle of Man, 2011.
Optically clear glass with black-and-white film (from *Seascapes* series, 1990); plinth: unvarnished cypress with metal base. H. 59 × W. 11¾ × D. 11¾ in.

Five Elements: Indian Ocean, Bali, 2011.
Optically clear glass with black-and-white film (from *Seascapes* series, 1990); plinth: unvarnished cypress with metal base. H. 59 × W. 11¾ × D. 11¾ in.

Five Elements: English Channel, Weston Cliff, 2011.
Optically clear glass with black-and-white film (from *Seascapes* series, 1994); plinth: unvarnished cypress with metal base. H. 59 × W. 11¾ × D. 11¾ in.

Five Elements: Baltic Sea, Rugen, 2011.
Optically clear glass with black-and-white film (from *Seascapes* series, 1996); plinth: unvarnished cypress with metal base. H. 59 × W. 11¾ × D. 11¾ in.

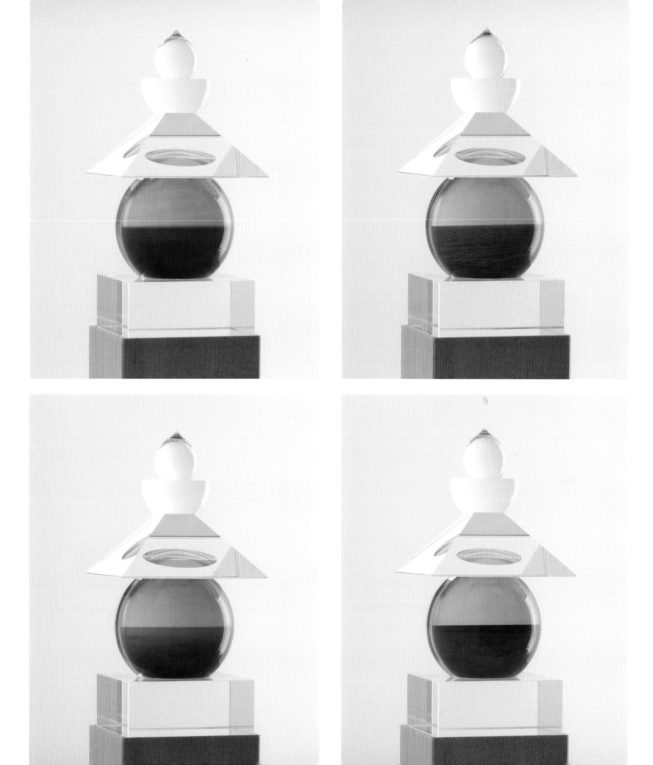

Japan, the Five-Story Pagoda of Horyuji temple embodied the latest in a long line of Buddhist reliquaries transmitted from the Asian continent.

If today we find pleasing the proportions of the Horyuji Pagoda, exhibiting a perfect balance of architectural members, how much more so must the building have appealed to those in ancient times who revered the untold relics inside? No doubt the depth of their Buddhist faith owed a great deal to the aesthetics of the towering structure, for once such a beautiful form was created it conversely called for an investment of transcendent meanings.

With the advent of the Heian period (794–1185), the shape of *sharito* took on a unique new sculptural direction based upon esoteric Buddhist scriptures, namely the cosmological doctrine of Five Universals: the elements of earth, water, fire, wind, and emptiness. In a bold attempt to make the Buddha's relic container symbolize the very cosmos, the *gorinto*, "five-element pagoda," was to express tenets of pure faith in purest geometric forms: earth as a cube emphasizing materiality; water as a sphere of self-evident clarity, fire as a pyramid in imitation of pointed flames; wind as a hemisphere expressing its power to cut through whole matter; and emptiness—formlessness—paradoxically in the form of a *cintamani* (Japanese: *hoju*), "mystic gem," whose dropletlike shape disappears instantly into a perfect globe, an image of the cosmic void closing upon itself.

Mathematics attempts to represent the world by substitution in numeric notation, a scheme of understanding I would liken to my own wont to trace everything back to questions of aesthetics and belief. I, however, no longer have anything to idolize. With deity and Buddha both vanished from this day and age, in what can I take refuge? Perhaps the only object of devotion I have left is the origin of my consciousness, the sea. And so in this Five-Element Pagoda made of optical glass I enshrine a seascape within the water sphere.

HIROSHI SUGIMOTO

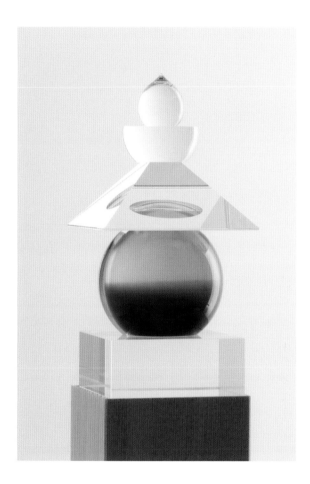

Hiroshi Sugimoto's installation for *Phantoms of Asia* transforms the gallery space into a shrine to the origins of existence. In a single line across the gallery, seven crystal pagodas made from optical-quality glass rest on top of wooden plinths. The pagodas take their form from the Japanese "five-element pagoda," thirteenth-century Buddhist stupas that visualize the cosmological doctrine of Five Universals using pure geometric components. As the object of devotion within his crystal cosmos, the artist enshrines a single film from his ongoing *Seascapes* series begun in 1980. Not only do Sugimoto's iconic seascapes mark the passage of his own life but also, through capturing the sea and the air—the origins of all life—they "reawaken an awareness of the origins of consciousness in this present day."[1]

A.H.

1 Hiroshi Sugimoto, "Five Elements in Optical Glass"; the artist's statement appears in this catalogue.

Five Elements: Mediterranean Sea, La Ciotat, 2011. Optically clear glass with black-and-white film (from *Seascapes* series, 1989); plinth: unvarnished cypress with metal base. H. 59 × W. 11¾ × D. 11¾ in.

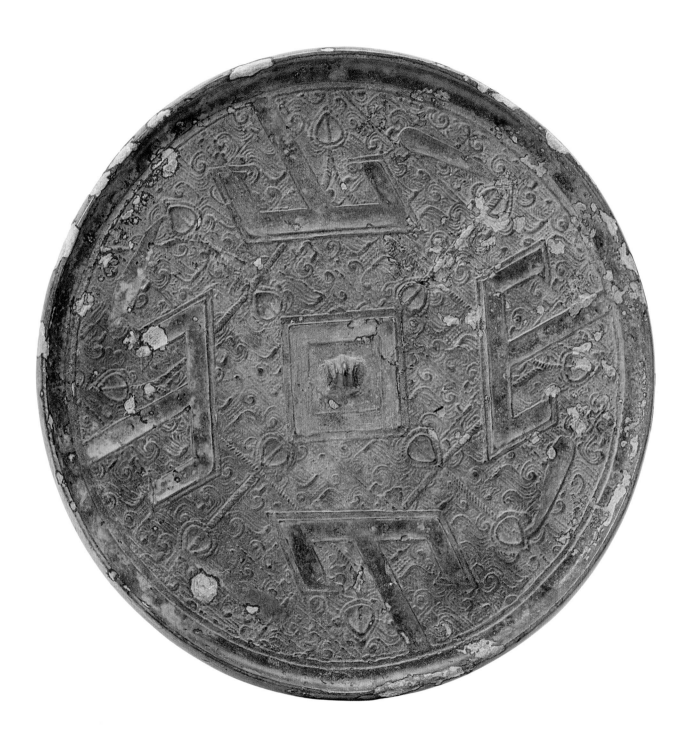

CHINESE BRONZE MIRRORS

Dany Chan

Did you know that the universe can be found on the back of a mirror? In China, visions of the universe indeed decorated ancient bronze mirrors. The earliest mirrors in this exhibition were most likely intended as funerary art, made specifically for burial. Later mirrors primarily began as objects of daily use and then accompanied the deceased in burial. The mirror's dual functions of serving both the dead and the living contributed to the great variety in these ancient visions of the cosmos. What follows is a sample of the main features of cosmological imagery that appeared on the backs of Chinese bronze mirrors. Consider how an image of the cosmos may serve a deceased person; along the same lines, how might a depiction of the universe decorating a mirror be appreciated by its living, breathing owner?

The earliest imagery related to visions of the universe came in the form of geometric shapes, as seen in the mirror with the design of four mountains. This mirror is decorated with an imagined universe composed of geometric shapes: the circle of the mirror designates the heavens, and the square within represents the earth, with the central boss as the *axis mundi*. The four large T-shaped motifs may be read as the upside-down Chinese character for "mountain" (*shan*) and thus symbolize the mountains that demarcate the boundaries of the earth.[1]

Mirror with four mountains, approx. 400–300 BCE. China; Warring States (475–221 BCE). Bronze. DIAM. 5½ in.

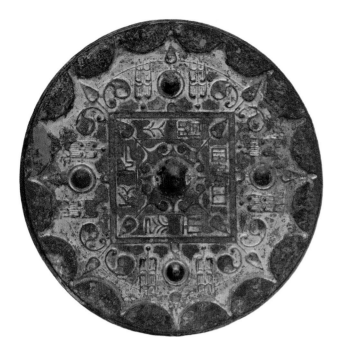

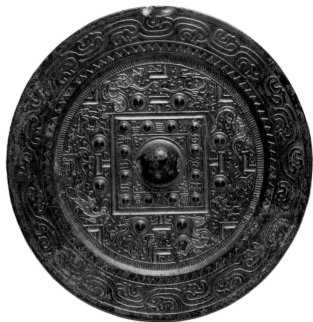

The T shapes have been angled so that their horizontal bars form a square corresponding to the central square of the boss. From the corners of the central square radiate four small petal motifs connected by narrow bands to four more petal motifs in a symmetrical arrangement. Four elongated teardrop motifs extend from the outer petals and follow the curve of the mirror's rim. Mirrors bearing this design are well represented in both U.S. and Chinese collections, with the number of T shapes varying from three (most rare) to four (most numerous), five, six, and even eleven!

Writing began to be incorporated into mirror design, and such inscriptions tend to reinforce cosmological associations. The inscription of the mirror with the grass leaf design does precisely that. The inscription appears along the square around the central boss; it reads, "May you (or this mirror) see the light of the sun and the great brilliance of the world."

LEFT

Mirror with cosmological designs and inscriptions. China; Western Han dynasty (206 BCE–9 CE). Bronze. DIAM. 5⅜ in.

ABOVE

TLV mirror with twelve early branches. China; Xin Mang (9–25) or Eastern Han dynasty (25–220). Bronze. DIAM. 5⅝ in.

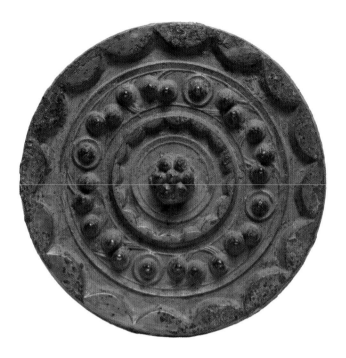

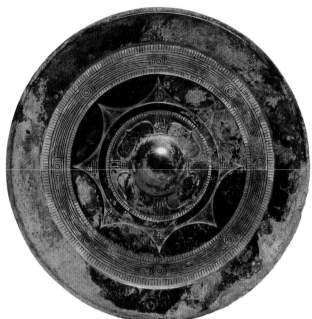

It can also be read as "The morning sunlight shines, and the world is very bright."[2] One can speculate that the described powers of the sun are contained in the mirror itself.

The design on this mirror also features sixteen joined arcs on the outer edge and four small bosses between the "grass leaf" (*caoye*) motifs that resemble stylized sheaves of grain.[3] The joined arcs represent the rays of the sun, illustrating an early example of the mirror's function as an object associated with the sun, the moon, and the virtues of light.

Inhabitants of the cosmos in the form of figures and animals make appearances on popular mirror designs such as the so-called TLV mirror, named for its design motifs shaped as the three alphabetical letters T, L, and V.[4] Along the four sides of the central square are depicted the Four Directional Animals (*Siling* or *Sishen*) and their companions. The animals

LEFT

Mirror with cosmological designs, approx. 100 BCE–9 CE. China; Western Han dynasty (206 BCE–9 CE). Bronze. DIAM. 3¼ in.

ABOVE

Mirror with cosmological designs and inscriptions, approx. 9–100 CE. China; Xin Mang (9–25) or early Eastern Han dynasty (25–220). Bronze. DIAM. 7½ in.

include the Blue Dragon of the East, the Red Bird of the South, the White Tiger of the West, and the Dark Warrior Turtle of the North.[5] These animals possess their own cosmological attributes. They are traditionally associated with the *Wuxing* system of correlative thought that was a foundation of Han-dynasty cosmology. A large body of research exists on this philosophy, so the following merely outlines its main points. The interdependent activities of the universe are determined by the two basic complementary forces of *yin* and *yang* working through five phases.[6] Each phase became assigned with an element, a direction (the four cardinal points and the center), a planet, a musical tone, a ruler, an assistant, and a guardian animal.[7]

Although not in animal form, the twelve animals of the Chinese zodiac (*shengxiao*) also appear in this mirror. Alternating between the

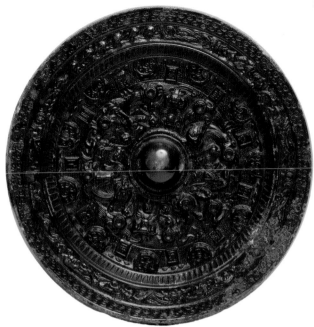

nipples along the central square band are their names, in a clockwise sequence: rat (*zi*), ox (*chou*), tiger (*yin*), hare (*mao*), dragon (*chen*), snake (*si*), horse (*wu*), sheep (*wei*), monkey (*shen*), cock (*you*), dog (*xu*), and boar (*hai*). Popularized as early as the Han dynasty,[8] the group came to correspond to the twelve divisions, or "earthly branches" (*dizhi*), of the celestial equator, and each animal corresponded to a direction.[9]

One of the most discussed features of the TLV mirror design associates it with a board for the game known as *liubo*. The excavated examples of the board and related imagery suggest an undeniable similarity between the TLV patterning of the square gameboard and the TLV patterning of the circular mirror. Popularly represented in Han funerary art were depictions of humans and immortals playing this game, and arguments have been made for the game's cosmological symbolism.[10] The

LEFT

Mirror with Taoist deities, mythical beasts, and inscriptions. China; Eastern Han dynasty (25–220). Bronze. DIAM. 8¼ in.

ABOVE

Mirror with Taoist deities and mythical beasts, approx. 196–280. China; Late Eastern Han dynasty (25 BCE–220 CE) or Three Kingdoms period (221 BCE–419 CE). Bronze. DIAM. 4½ in.

design has also been related to a conception of a cosmograph that was used to track celestial movements.[11]

Cosmological imagery decorating the later mirrors, such as the Five Dynasties–era lobed mirror, illustrates a new interest in incorporating ideas from the emerging philosophy-religion of Taoism. The innermost square has graphic representations of four sacred mountains and a primordial beast as the central boss, and around them flow the cosmic seas; the twelve animals of the zodiac run clockwise along the surrounding square band. Along the sides of this square are motifs of the sun (a dot within a circle), the moon (a crescent within a circle), and two constellations. The outermost eight lobes of the mirror depict the eight trigrams associated with Taoist concepts of perpetual change.

The constellations are two of the twenty-eight lunar lodges (*xiu*), "the constellations through which the moon passes on its circuit through

Mirror with designs of eight trigrams and twelve animals of the zodiac. China; Five Dynasties (907–960). Bronze. DIAM. 6 in.

the sky."[12] From at least the Western Han period (206 BCE–9 CE) on-ward, the lunar lodges were important for defining the coordinates of other celestial bodies and were significant in astrology.[13] Furthermore, the stylized manner in which the lunar lodges are depicted in this Tang mirror—as lines connecting dots—arguably appeared during the Han period as well.[14] Extant mirrors also indicate that cardinal correspondences for the sun, moon, and lunar lodge motifs were inconsistent, suggesting variations of the design's iconography during this period.

NOTES

1 John S. Major, *Heaven and Earth in Early Han Thought: Chapters Three, Four, and Five of the "Huainanzi"* (Albany: State University of New York, 1993), 34.

2 Toru Nakano, *Bronze Mirrors from Ancient China: Donald H. Graham Jr. Collection* (Hong Kong: Orientations, 1994), cat. no. 28.

3 Suzanne E. Cahill, "All Is Contained in Its Reflection: A History of Chinese Bronze Mirrors," in *The Lloyd Cotsen Study Collection of Chinese Bronze Mirrors Volume I: Catalogue*, ed. Lothar von Falkenhausen (Los Angeles: Cotsen Occasional Press and UCLA Cotsen Institute of Archaeology Press, 2009), 37.

4 Wong Yanchung, "Bronze Mirror Art of the Han Dynasty," *Chinese Bronzes: Selected Articles from "Orientations," 1983–2000*, trans. Christopher Homfray (Hong Kong: Orientations Magazine Ltd., 2001), 61.

5 Ju-hsi Chou, "Catalogue no. 27," in *Circles of Reflection: The Carter Collection of Chinese Bronze Mirrors* (Cleveland: The Cleveland Museum of Art, 2000), 44.

6 Michael Loewe, *Ways to Paradise: The Chinese Quest for Immortality* (Taipei: SMC Publishing Inc., 1994), 6. More recent research has questioned the traditional association between *wuxing* and "five phases," instead offering a reinterpretation of *wuxing* as corresponding to "five planets." See Marc Winter, "Suggestions for a Re-Interpretation of the Concept of *Wu Xing* in the *Sunzi bingfa*," *The Museum of Far Eastern Antiquities* 76 (2004): 147–180.

7 J. Keith Wilson, "Powerful Form and Potent Symbol: The Dragon in Asia," *The Bulletin of the Cleveland Museum of Art* 77, no. 8 (October 1990): 299.

8 Nancy Thompson, "The Evolution of the Tang Lion and Grapevine Mirror," *Artibus Asiae* 29, no. 1 (1967): 29n22.

9 Stephen Little with Shawn Eichman, *Taoism and the Arts of China* (Chicago: The Art Institute of Chicago, in association with University of California Press, 2000), cat. no. 15.

10 A list of the vast body of scholarship on the *liubo* game is provided in Cary Y. Liu, Michael Nylan, and Anthony Barbieri-Low, *Recarving China's Past: Art, Archaeology, and Architecture of the "Wu Family Shrines"* (Princeton: Princeton University Art Museum; New Haven and London: Yale University Press, 2005), cat. no. 37.

11 Major, *Heaven and Earth in Early Han Thought*, 40–41.

12 Little, *Taoism and the Arts of China*, cat. no. 12.

13 F. Richard Stephenson, "Chinese and Korean Star Maps and Catalogs," in *Cartography in the Traditional East and Southeast Asian Societies*, ed. J.B. Harley and David Woodward (Chicago and London: The University of Chicago Press, 1994), 517.

14 A Tang-dynasty mirror with the earliest surviving stylized design of the complete lunar lodges appears in Little's *Taoism and the Arts of China*, cat. no. 16.

POKLONG ANADING

Anonymity, 2008–2011. Eight from series of nine light boxes;
black-and-white Duratrans print, exhibition copy.
Light boxes, each H. 24⅝ × W. 19⅝ × D. 7⅞ in.

Poklong Anading's *Anonymity* series manipulates our expectations of portraiture to explore "the politics and metaphysics of representation."[1] He photographs everyday people in Metro Manila holding circular mirrors in front of their faces. The mirrors reflect sunlight back to the camera lens, concealing the subjects' identities with a flash of energy that surrounds them. Each face is transformed from a place of recognition to a "vanishing point"—a field of forces that conjures associations to spiritual illumination, transcendence, and religious iconography. Unable to gaze upon the subject, viewers are left to meditate upon the reflection of light that focuses their eye within the frame. As Anading tells us, "[I] aim to transform the time and place of looking into the time and place of meditation, where it becomes possible to re-imagine and reorient our relation to others and the things in the world." Using the Philippines as a locus, the *Anonymity* photographs question how we construct identity locally and universally, ultimately exploring how we situate ourselves as individuals within cosmic time and place.　　A.H.

1 All quotes are from Poklong Anading's artist's statement for *Anonymity* (not dated).

PALDEN WEINREB

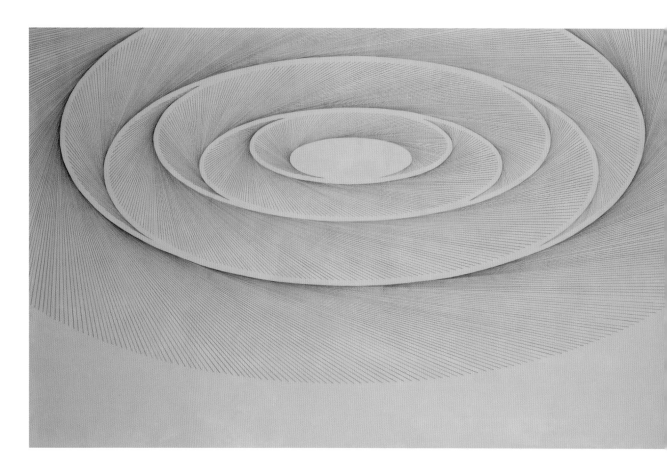

*Envelop (**Current Sweeping**)*, 2011. Graphite
and encaustic on board. H. 50 × W. 80 in.

Palden Weinreb's works reveal the delicacy and power held within the most minimal forms. Through abstract repetition of lines, he seeks to deconstruct visual systems to their simplest components, eliminating the illusion of earthly references and exposing the ethereal and the sublime. "I see my work as meditations on space and movement, looking for truth in form."[1] Like mandalas and cosmic maps, which may suggest geometric perfection and scientific undertones similar to those found in Weinreb's compositions, his works attempt to comprehend the universe and our existence. They act as tools for contemplation on how all things may be interconnected. While his meditative practice shares commonalities with Buddhism's path to a higher consciousness—"there is an ethereal nothingness in abstraction that parallels the sublime emptiness in Buddhism"—Weinreb's deconstruction of form to its pure essence ultimately examines the universal human experience connecting all religions and cosmologies. A.H.

1 All quotes are from Palden Weinreb, e-mail correspondence with the author, October 13, 2011.

Entry (Gradation), 2011. Graphite and encaustic on paper and board. H. 80 × W. 40 in.

SUN K. KWAK

Ernesto Menéndez-Conde

In September 2010, Sun K. Kwak and Cuban dancer Judith Sánchez presented an homage to Ana Mendieta, at the Guggenheim Museum in New York City. The performance started with the Korean artist sticking masking tape on the stage floor. As she worked, three dancers arrived, led by Sánchez, and continued with the choreography. Although Kwak does not usually collaborate with dancers, this joint effort helps demonstrate the performative side of her installations. Kwak's intense focus gives the impression that she is exteriorizing an intuitive and expressive world as she moves her body in a rhythmic manner that could easily be associated with the gestures of a dancer.

This performative character highlights a number of noteworthy features of Kwak's work. Besides showing her obvious enjoyment, Kwak invites viewers to visualize the technique and the handcrafting that go into her installations. Since the late nineteenth century, one of the most common misconceptions about new art has been the belief that it tends to hide a lack of technical skills. Some viewers dismiss contemporary art with such comments as "everyone can make it." This way of judging art is based on the old-fashioned notion of a genius gifted with the ability to make a representative painting or sculpture. It does not take into account the artistic experiments that have developed since the early twentieth century. The notion that an artwork does not demand any particular talent, craft, or training has been one of the criticisms against artistic productions that are not based on realism and academia.

This critique is far from accurate. Although skills required of traditional mediums are no longer prevalent, the art world has seen a remarkable proliferation of new methodologies and materials. Artists have been exploring beyond painting and sculpture, inventing a wide variety of techniques that demand particular, sophisticated skills. However, to a certain extent, cynical viewers are right. Everyone can apply masking tape to a wall, as Kwak does, or drop ink on a piece of cardboard, but anyone can also try to depict a landscape on canvas with oil paints and brushes. Harder to achieve are the countless hours—even years—of practicing, the familiarity with materials, the devotion of the artist to his or her artistic proposal. Seeing a visual artist in action may not be that different from watching a virtuoso play a musical instrument.

The performative side of Sun K. Kwak's installations also points to duration. She likes to think of her work as a living being, its embryonic stage engendered in her studio as she brainstorms ideas she will develop in the site. Before starting an installation, she makes innumerable preparatory sketches. She visits the space and takes pictures of it. She thinks about scale, and how viewers might relate to the space. She studies how to take advantage of architectural peculiarities, how to integrate her work with floors, stairs, doors, windows, and columns. Surfaces of walls and the structure of the building become important mediums for what she calls "space drawings."

After this preliminary research comes the performative phase, which can be compared to birth and childhood. *Enfolding 280 Hours*, the title of her solo show at the Brooklyn Museum in 2009, encapsulates this stage of the work's development. Two hundred eighty hours was approximately the amount of time that Kwak invested in completing her installation—for which she used more than three miles of masking tape. The work in progress is the show. Viewers can watch the piece growing, flooding the space. Somehow hours become visible as the piece expands.

Sun K. Kwak experiences time as a stream of consciousness/unconsciousness through which she tries to achieve a meditative, indescribable

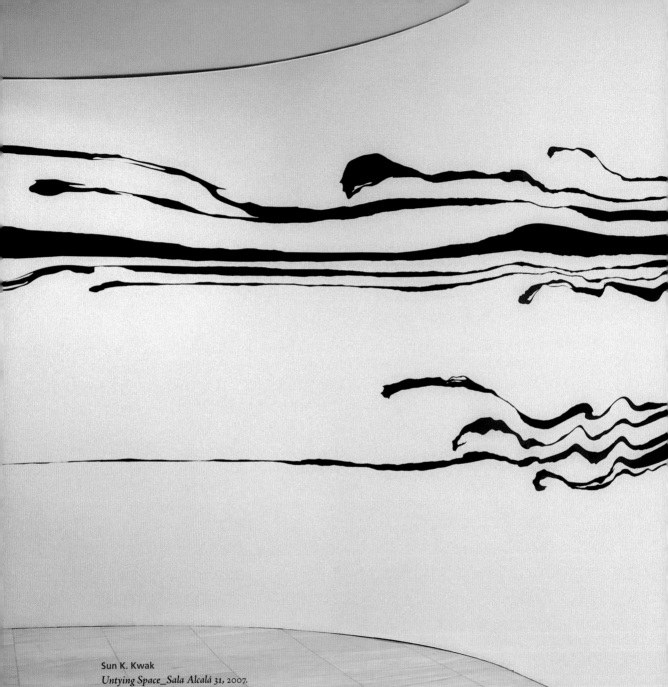

Sun K. Kwak
Untying Space_Sala Alcalá 31, 2007.
Masking tape, adhesive vinyl, and wooden panel.
Installed at Sala Alcalá 31, Madrid.

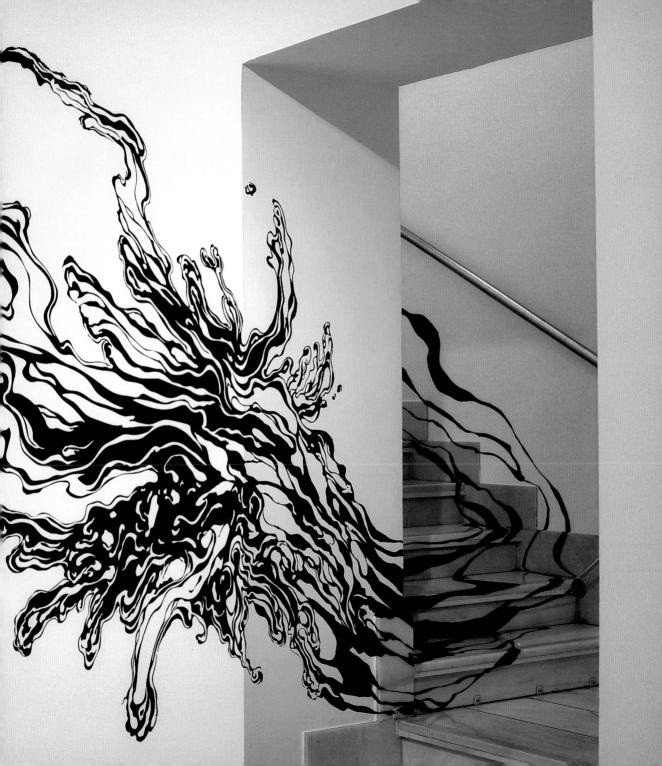

openness to the present. Time is also suggested through rhythms. In many cases, Kwak intends to construct visual analogies with three-quarter time, which is a way of structuring tempo in many musical compositions.

In its third stage, the artwork is complete as a contemplative piece. In Kwak's large-scale solo shows, the emptiness of the rooms becomes part of her "space drawings." Art critic Boris Groys claims that the installations create an enclosure, and by doing so, they also create an outside. According to Groys, this enclosure produces a "reauratization," which—contrary to Walter Benjamin's idea of the "loss of aura"—seems to emerge in contemporary art. He argues that the space of the installation shows objects and images as true beings. In Sun K. Kwak's work, emptiness becomes a sort of magnetic field or—to use the term Groys borrowed from Heidegger—is unconcealed and taken to the realm of the visible.[1]

Kwak's work alludes to natural forces, such as the flow of water, or fire, or the bark of a tree. But it is nonetheless abstract. Her installations utilize negative and positive spaces and create expressive bursts by playing with visual emphasis.

Finally, the masking tape is removed. This stage could be regarded as a way of dying. The nature of the material Kwak uses in her installations emphasizes this ephemeral condition. The masking tape is not meant to last once the show is over. Pictures, videos, and written texts will be all that remains.

Sun K. Kwak's "space drawings" integrate performance art with site-specific installations and the use of unconventional materials. Like other contemporary artists, Sun K. Kwak is exploring new approaches to abstract art, liberating it from theoretical, transcendental, and formalist approaches.

NOTE

1 Boris Groys, "The Topology of Contemporary Art," in *Antinomies of Art and Culture: Modernity, Postmodernity, Contemporaneity*, ed. Terry Smith, Okwui Enwezo, and Nancy Condee (Durham and London: Duke University Press, 2008), 71–80.

FACING

Sun K. Kwak

Untying Space_Salvatore Ferragamo, 2007. Masking tape and mixed media. Installed at Salvatore Ferragamo Gallery, New York.

SUN K. KWAK

Sun K. Kwak's installations explore the energy that invisibly surrounds us, silently influencing our perception of time and space. Through a process she describes as a "lyrical meditation,"[1] Kwak studies the visual and emotional qualities of a given area and then—wearing only black as she works—rhythmically and meticulously applies black masking tape onto walls, spontaneously tearing the tape's edges in response to her experience within the architecture. Kwak calls her installations "drawings on space," a phrase that appropriately highlights the seeming impossibility of such a feat. Yet Kwak's work situates itself on a psychic plane, oscillating between sculpture, drawing, and performance. Using her body as a conduit that reveals the flow of energy within a space, she manifests subtle tensions and sensations that register on the subconscious but may be overlooked in everyday life. While Kwak intends that her "space drawings" forever transform an experience of space and time, the destruction of her work at the close of an exhibition ultimately serves as a reminder of the ever-changing nature of energy and the transitory quality of perceptions, and of life. "The process of emptying the space is a metaphor for the ephemeral nature of life and my acceptance of that nature. Yet the drawing lives on in viewers' memories as an imprint that leaves the space forever altered." A.H.

1 All quotes are from Sun K. Kwak's artist's statement (not dated).

GUO FENGYI

"I draw because I do not know. I draw to know."[1] This statement captures the spiritual and metaphysical journey documented in Guo Fengyi's drawings, which derive their subject matter from traditional Chinese philosophy, cosmology, mysticism, and medicine. Attempting to alleviate a personal illness, Guo Fengyi began practicing *qi gong*, a fusion of medicine, martial arts, and philosophy that seeks, through regulation of the mind, body, and spirit, to manipulate and balance the energy that sustains life. Guo Fengyi described an irresistible impulse to draw mystical visions that she received while in a meditative state. The resulting compositions—essentially mappings of the energy flow within her body—translate the spiritual, inner realm into a visible form and trace the self-trained artist's process of understanding relationships between her body and universal forces. Her ritual of notating the duration of the drawing process on each work, as if to initiate and seal a journey into her own mind, reminds us that, for Guo Fengyi, artistic practice and spiritual practice are synchronous.

A.H.

1 Guo Fengyi, quoted in Lu Jie, "Who Is Guo Fengyi?," in *Who Is Guo Fengyi?*, exh. cat., ed. Johnson Tsongzung and Shiming Gao (Beijing: Long March Space, 2005).

ACING
ar, 1990. Mixed media on paper.
. 39⅛ × w. 29½ in.

GHT
ngming Point, 1990.
olored ink on found calendar
aper. H. 82⅝ × w. 56¾ in.

CHARWEI TSAI

"Spirituality and art are inseparable" for Charwei Tsai, whose meditative art-making process engages the Buddhist notion of emptiness, as articulated in the Heart Sutra. Thought to originate in the first century CE, the Heart Sutra describes the liberation of the bodhisattva of compassion through his insight into the ephemeral nature of all that exists. As a child, Tsai memorized the 262 Chinese characters of the Heart Sutra, which is among the best-known Buddhist scriptures. Selecting specific materials that relate to the site of her work, she writes the Heart Sutra in calligraphy on organic objects such as mushrooms, tofu, and, significantly, lotus leaves, which symbolize enlightenment, the feminine, and the cosmos in various traditions. Like all matter and perception, Tsai's work will disappear as her materials inevitably wither and die. The work, an exercise of the Buddhist precept of nonattachment that is believed to relieve suffering, will exist only through its documentation. As the artist explains: "To be attached to the beauty of a blossoming flower may cause suffering if one is not aware that the physical form of the flower is constantly changing and that the flower will eventually wither and die. On the other hand, if one understands the ephemerality as a necessary condition of the flower's being then as one observes the same phenomenon of a flower withering, one is relieved of the unnecessary suffering that arises from an attachment to its temporal state of beauty." Through the life cycle of her process, Tsai tells us, she reaches "a purer state of consciousness."[1]

A.H.

1 From Charwei Tsai's interview with Lesley Ma, April 5, 2009; http://www.charwei.com/interview.1.lesley.ma.html. Excerpts from the interview appear in this catalogue.

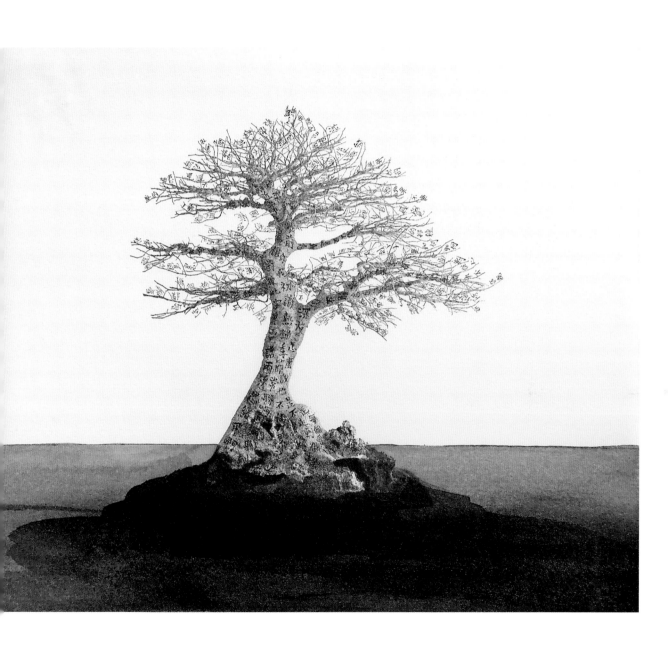

EXCERPTS FROM AN INTERVIEW WITH CHARWEI TSAI

Lesley Ma

Lesley Ma: How did you come to use the Heart Sutra in your work in 2005, to transcribe it onto ephemeral objects, first an iris and then a block of tofu? What were some of the reasons and factors that led to this work?

Charwei Tsai: I developed my interest in Buddhism through a Tibetan friend I met in college. We never spoke much about religion or politics, I was just really moved by the serenity of his presence. This may seem like a simplistic trait, but I have never met someone who is so at peace with himself. Then I moved to New York after college in 2002, and came across an opportunity to volunteer for Tibet House and worked on archiving their repatriation collection. It was then that I began to learn more about the religion and its intricate system of art and symbolism. My interest in Buddhism is intertwined with my practice in art. For me, art and spirituality are inseparable. Through art, I am able to reach a purer state of consciousness that I cannot do through the chaos of daily life. However, I do not consider myself religious, as my appreciation of the religion is merely based on a philosophical approach. Thinking back, it is odd that I wanted to be initiated as a Buddhist since I was a teenager, as now, the more I learn about the religion, the more I feel that it does not make sense to attach oneself to an identity or a system of thought.

Charwei Tsai
Olive Tree Mantra, 2006.
Black ink on olive tree. Bratsera Hotel,
Hydra School Project, Hydra, Greece.

Charwei Tsai
A Pilgrimage through Light and Spells—Bamboo Mantra I, 2012.
Lithograph with handwriting in black ink. H. 37⅜ × W. 26⅜ in.

In any case, my exposure to Buddhism and to contemporary art in New York around that time led me to start the Heart Sutra series. Also, during this time, the opportunity to exhibit at Fondation Cartier arose while I was working for artist Cai Guo-Qiang. This

was my first time exhibiting and subsequently became the platform for *Flower Mantra* (2005), as well as for creating new works, including *Tofu Mantra* (2005) and the *Mushroom Mantra* (2005).

LM: Apart from the Heart Sutra, you have also used other texts, such as the numbers and the "One China" policy. These texts are quite diverse. How do you see the relationship between these texts and your work?

CT: The Heart Sutra is something that I have learnt to memorize by heart as a child in Taiwan. My family is not particularly religious, so it is curious, even to me, how I became attracted to the scripture at a young age. I used to recite it when I was scared, or simply to calm the mind. The appreciation of the text evolves through different stages of my life, and I am still examining it. The scripture describes the Buddhist concept of emptiness and a meditative state in which all phenomena are nondual. All forms, feelings, perceptions, impulses, and consciousness—the ways by which we relate to the world—are interdependent, and each cannot exist on its own. Therefore, the state of emptiness is an understanding of the interdependence between oneself and the universe, and the transient nature of this relationship. This is not a mystical concept and is in fact very logical. For example, to be attached to the beauty of a blossoming flower may cause suffering if one is not aware that the physical form of the flower is constantly changing and that the flower will eventually wither and die. On the other

hand, if one understands the ephemeral as a necessary condition of the flower's being, then as one observes the same phenomenon of a flower withering, one is relieved from the unnecessary suffering that arises from an attachment to its temporal state of beauty. This is the basic concept behind the series of works where I write the Heart Sutra onto ephemeral objects such as flowers, mushrooms, and tofu, and which epitomizes the materialization of spiritual truth through the decay and deterioration of the objects.

As for numbers, I am interested to explore how our understanding of the world is dominated by them: time, distance, temperature, size, money, population, religion, etc. For example, for the work *Étrangère* (which means stranger, foreigner, or outsider in French), I wrote my passport numbers onto alien-like raw baby octopus to express the alienation that I felt when I first moved to France. I was constantly identified through my passport numbers, the district number that I live in, the amount of money I have on me, which are all so impersonal, yet they somehow represent me. Around this time, I published an issue of *Lovely Daze* entitled *Numbers*, in discussion of other artists' engagement with this subject, such as Cory Arcangel, who composed a page of numbers to program two pixels on the opposite page, and Jennifer Wen Ma, who examined the relationships between monotheistic religions.

While the use of text from the Heart Sutra and numbers in my works can be seen as a reflection of my spiritual development and personal curiosities,

Charwei Tsai
A Pilgrimage through Light and Spells—Bamboo Mantra II, 2012. Lithograph with handwriting in black ink. H. 37⅜ × W. 26⅜ in.

the use of text from the "One China" policy takes on a more critical note. The "One China" policy is the expression of the country's ideology for uniting their people under one nation. For *Fish Project*, I wrote the text onto a live fish while it struggled to survive out

of water. For another project, I made the official map of China out of sliced meat and wrote the text onto the map, more recently, with pig's blood. By using text from the "One China" policy, it is not to single out China in my critique of blind ideology, but to use it as an example to illustrate the unnecessary sufferings and deaths caused by the pursuit of nationalism. Also, as China establishes itself as one of the most important powers in the world, their influence on these issues will inevitably increase.

LM: What about the materials that you use? You have used flowers, tofu, mushrooms, lotus leaves, olive trees, and animals such as octopus, fish, meat, and even pig's blood. What are some of the factors that determine the materials you choose to use in your work? And how do you view the transformation of materiality in your work?

CT: I tend to work with materials that are abundant in the location where the work is being presented. This is a way for my viewers to relate to the work and their physical environment. I am not interested in fabricating monumental installations. I prefer to create works on a more intimate scale and stimulate moments of contemplation on the ephemeral qualities of our environment and history. For example, when I made *Lotus Mantra* for the Singapore Biennale in 2006, where I wrote on the lotus plant at a popular Buddhist temple, I found that temple visitors who were not familiar with contemporary art related to

the work even more than the biennale visitors. They would take time to examine the scripture written on the plant and the relationship between the text and the impermanence of the plant. A lady who worked in the temple even brought little fish from her house to feed from the water in the lotus plant while some others bought flowers to worship. I was very moved by the reaction of the people and, in particular, how the work became integrated into their daily lives.

On the rare occasion that I did not use locally found materials, such as when I showed *Tofu Mantra* in Paris (the tofu was purchased from Chinatown there), it was because the idea was preconceived in New York. But in this situation, I was also interested in how the use of an unfamiliar material would be received. And there were certainly some interesting reactions. Some Parisian visitors thought it was a block of cheese, and some even thought it was a slab of marble because of its shiny and smooth texture. However, even without familiarity and understanding of the text, the initial and intuitive response to seeing an inscribed text was so strong that viewers found their own way to relate to the work.

Perhaps it is because I did not come from a traditional fine-arts background that I explored more spontaneously with atypical art materials, which were part of my daily life. I never thought about how to maintain the works that I make as objects and to preserve them. Instead, I am more fascinated by observing the unexpected changes that these works undergo. For example, the first time after I wrote on a piece of

tofu, I wanted to keep watching how the text mutates with the rotting tofu. This was based on the idea of contradiction between a spiritual truth and the actual practice. To prolong the process, I kept the tofu in my freezer. In fact, it is still there today. Freezing the tofu was less about preservation, but more about seeing another stage of the material when its condition changes. Another example is the *Love Until I Rot* (2007) project, where I was approached with the curatorial question "How far would you go for love?" I responded by making a foot out of cheese, using a mold of my own foot, then tattooed on the ankle the text, "Love until I rot." The work was to question the concept of everlasting love. In this work, I captured the transformation of the material by filming the cheese foot rotting from heat, as well as the changes to the text. Apart from what was filmed, I would also like to emphasize the nonmaterial changes, where the reception of the work is less about possessing a visual form, but rather through accepting the changes of these forms.

LM: What do you usually think about when you write these texts? Are you meditating, focusing on your brushwork, or paying attention to the passersby? Do you feel alienation or anxiety when you are working in an unfamiliar environment? Do people interrupt and question you about the text?

CT: I always try to concentrate on the meaning of the text and the relationship to the materials when I make the works. Most of the materials I write on have their own natural textures, so I try to follow the texture with my brushstroke. This is one of the reasons why I choose to write mostly in Chinese, because the characters are legible from left to right, right to left, up to down, and work well with organic surfaces. I remember one time when I stayed up all night trying to finish the *Mushroom Mantra* for the *J'en Rêve* exhibition at Fondation Cartier, because there were not many people left at the museum space that night and I was able to concentrate really well. The following day, even after almost no sleep the previous night, I did not feel tired and felt really clear minded. When I am making the work in front of an audience, I still try to concentrate, but also be open to people asking me questions. Most of the time, I do enjoy having discussions with people about the work while making it. I am always intrigued by the varied perceptions of my work by visitors. I don't mind working at unfamiliar environments at all, because when I don't know anyone, I let my guard down and I can be more open. Anyway, I always tend to be trapped in my own thoughts, so once I actually enter a work mode, I can adapt to anywhere.

NS HARSHA

In Hindu mythology, Lord Krishna gives
an awe-inspiring vision of the cosmos,
which contains all people, planets, spir-
its, and powers in one universal form.
Deliberately contrasting the grandeur
of traditional narrative, NS Harsha uses
absurdity as a means of celebrating
humans' relation to the cosmos. A single
sketch of a image with multiple heads
sparked his twin paintings: "I enjoyed
the presence and form of the image,
which somehow reflects humans' collec-
tive existence in this vast space."[1] Each
work depicts more than five hundred
heads linked as a single garland, danc-
ing among eggplants. "I was interested
to use a futile device for a cosmic call!
'Eggplant' came in! . . . Almost a
'Sisyphean chant' with eggplants!"
A drum accompanies each painting,
symbolically uniting the figures in a
single rhythm to summon cosmic forces.

A.H.

1 All quotes are from NS Harsha, e-mail correspon-
dence with the author, October 15, 2011.

FACING
Distress call from Jupiter's neighborhood,
2011. Acrylic on canvas and gold foil
on processed leather, with wood.
H. 114⅛ × w. 66⅛ in.

ABOVE AND RIGHT
Distress call from Saturn's neighborhood,
2011. Acrylic on canvas and gold foil
on processed leather, with wood.
H. 114⅛ × w. 66⅛ in.

VARUNIKA SARAF

Varunika Saraf's paintings follow the Indian miniature traditions of Mughal and Kangra courts while also exploding them into new scales, literally and metaphorically. Trained in traditional Wasli painting, the artist creates both small compositions that can be held in two hands and large works that fill entire walls. She uses traditional subjects from mythology and nature that evoke specific associations and stir emotion, but only as players in an imagined, otherworldly cosmos. Throughout Saraf's compositions of supernatural hybrids and impossible landscapes, she references well-known works of art from all over the world that become a point of entry for viewers, giving them a lifeline amid the cosmic journey into the artist's imagination. In *Cloudburst*, 2010, a large-scale painting with a traditional Indian approach to pictorial space, we see the iconic Indian image, *Dying Inayat Khan*, painted in 1618 to record the Mughal court official's death. Saraf shows us Inayat Khan flying through her swirling cosmos, presumably to heaven. Hokusai's familiar waves from eighteenth-century woodblock prints surround *Island*, 2010, while other compositions recall works of Frida Kahlo, Hieronymus Bosch, and Marc Chagall—all of which conjure a sense of mythological surrealism. As clouds of peering eyes encircling a forest in *Untitled*, 2010, suggest, Saraf's paintings gaze back upon us, becoming a "third eye" to transport us into an inner realm of higher consciousness. A.H.

Ankhon Hi Ankhon Mein, 2010. Watercolor on rice paper overlaid on found textile. H. 7 × w. 7 in.

FACING
Island, 2010. Watercolor on rice paper and cotton cloth. H. 73¾ × w. 62½ in.

HEMAN CHONG

Heman Chong's sticker installations use repetition to spark a meditative mode of production. As he places stickers one by one on a wall, the stickers accumulate to form geometric shapes that guide and constrain the artist. These forms may conjure associations with nature, atomic structures, or cosmic symbols that balance tensions between order and chaos. The resulting accumulation becomes a diagram that traces the artist's interaction with the space in a given time. Marking time and repetition are also essential preoccupations of Chong's installation *Calendars (2020–2096)*. The artist hangs 1,001 consecutive month-by-month calen- dar sheets, each including a photograph of a space in Singapore taken by the artist between 2004 and 2009. While all the images are different, humans are never present, giving the images a haunted stillness that challenges us to find in them an imaginary or spiritual energy that is not readily visible. His images are both somewhere and nowhere. Amid recognizable "Asian" elements, we see influences of modernism, kitsch, and other regions, unsettling our sense of place and suggesting slippages in our definition of "Asia." Chong's "future archive" is not a documentation of the past but an imagined narrative of the future. A.H.

Star(Burst), 2012. 3,000 self-adhesive stickers applied directly onto the wall. Dimensions variable.

EXCERPTS FROM AN INTERVIEW WITH HEMAN CHONG

Ahmad Mashadi

Ahmad Mashadi: Let's discuss . . . the current *Calendars (2020–2096)* project, conceived sometime back before you left Singapore for New York. You had undertaken a number of photographic book projects focusing on Singapore sites to initiate the series. What were they? What did you aim to achieve in these book projects?

Heman Chong: I never have a master plan for anything in my life. Mostly, I just improvise and adapt along the way. The reason why I mention this is because, when you look at *Calendars (2020–2096)*, you will get the impression that, from the very beginning of the project, I knew what I wanted to do, which is completely not the case at all. When I began to photograph these interior spaces—these interiors accessible to all (most) people—I did it because I was searching for a new idea, a new beginning, a new way to collect images. I believe very strongly in the power of observation, where you will, literally, just look at something, break it down in your head, in the most logical way possible, and then "archive" that sensation of that image. I don't have a photographic memory, and that is why I rely on photography for that part of the process. These spaces intrigue me on a structural level and also on an emotional level. Somehow, I know that they are so susceptible to change, to every sway of policy, to every

Heman Chong
Calendars (2020–2096), 2004–2010.
Offset prints on paper. 1,001 sheets,
each H. 11¾ × W. 11¾ in.

new wave of capital. In a way, it was the same with the books I made about specific sites in Singapore. The first was about Telok Blangah Hill Park, where the National Parks Board commissioned this totally insane structure which runs from the foot of the hill to the top, something we have come to know of as *Forest Walk*. I am inherently interested in how ideas affect spaces, and how spaces can be representative of certain things that we (or, more aptly, "they") would be concerned with, at a certain point of time. In this case, somebody really had this idea of a nature reserve that is accessible to ALL, including the least attractive people of society, the handicapped—people without any means of mobility. They built a huge metal structure, which functions as a giant meandering ramp up (and down) this hill. I find this completely fascinating, how they even could start to conceive of such an idea. How does a conception about a GIANT RAMP UP A HILL start?

AM: From the perspective of production, the project is unburdened by any assumptions on outcomes. I understand that it is largely conceived along the need to generate fresh trajectories of practice, but the notion of a city suddenly emptied of its inhabitants is rich in potential, not least in science fiction. You spent time in places like shopping centers during opening hours, waiting for just the right moment to capture a scene without anyone present. Is there a conceptual underpinning here defined by ideas connected to plausible settings in science fiction? Or is there a commentary element—a dystopia of sorts?

HC: I would say that *Calendars (2020–2096)* locates itself within a conceptual framework of utilizing gestures, in this case, that of waiting and appropriating images within a specific moment, that moment of absolute emptiness, which can be quite rare, considering how densely populated Singapore is. But at the same time, it has this dimension where I am also interested in formulating a kind of fictional landscape, one that reflects all the concerns of dystopian narratives, especially of the "last man on earth" genre, This genre often deals with a global cataclysm that results in the near-annihilation of the human race. Whether it is an ecological disaster or a full-blown biochemical infection, the stories usually become humanitarian; they are stories about how humans can survive the worst possible situations. So in a way, I am interested in staging the landscapes in which these stories occur, and to use them as banal images for a banal activity, that of recording time.

AM: Based on your earlier remarks, the Telok Blangah project seems to conceptually point toward the ironies and contradictions of "spatial production," and in some ways in the same manner in which we regard science fiction as having its furtive roots of criticality relating to the contemporary, the Telok Blangah and *Calendar* projects seek a placement into the current day.

HC: But to suggest as well that our imaginations are also important in placing ourselves into the everyday, that we have possibilities to imagine ourselves inside and outside of situations. For this is one of the crucial skills of a good artist.

AM: Was the decision to present those images as calendar illustrations made during the period of photography?

HC: Yes. I took seven years to complete the entire project, and a huge part of it was to allow for a series of digressions to occur without any kind of prior planning involved. A lot of it was left to chance, and one of the results, for example, was to use the photographs as accompanying objects to the actual marking of time.

AM: How many images are there in total? How are these images according to the years, and are there particular ways in which the images are being clustered? At some point you decided that the large body of images is best mobilized as an exhibition. Earlier on, you mentioned about the forms of subjectivities and your wish to facilitate through these images. How do you intend to display them? It seems that placing the images into a calendar format allows you to move toward some of the conceptual interests you were talking about. The subject of postapocalyptic (or even postrapture) world may directly be inferred. The calendar, the suggestion

of an impending event, gives a millenarian tinge to the work, and the condition of the present as another.

HC: There are 1,001 images in all. I arranged the photos according to a series of categories, which are evident in the spaces themselves. Corridors, shop fronts, big rooms, small rooms, etc. There are also some categorized by sites. Depot Road, Haw Par Villa, IKEA, etc.

There's a lot of contestation with the actual presentation, and I think it might be best at this point to follow a certain grid within the space, and to show all 1,001 pages containing all 77 years of calendars within a single plane. I chose the year 2020 to start the calendars as a result of an observation about the idea of 2020 as the year of how all the problems in the world could possibly be "solved." In many political press releases, we can notice this kind of promise, and of course, we now understand that these projections do not necessarily mean that any of the promises can or will be fulfilled. We constantly have to manage this sense of disappointment when it comes to such statements from the people we thought we could place our trust in.

AM: In that respect the images can also be taken in relation to specific potentials, beyond a universalizing notion of time markers resplendent in economic or social programs. These are specific locations whose economic, social, and even political utilities are shaped

APRIL 四月　　　　2020 二〇二〇

01 02 03 04 05 06 07 08 09 10 11 12 13 14 15
16 17 18 19 20 21 22 23 24 25 26 27 28 29 30

AUGUST 八月　　　　2020 二〇二〇

01 02 03 04 05 06 07 08 09 10 11 12 13 14 15
16 17 18 19 20 21 22 23 24 25 26 27 28 29 30 31

OCTOBER 十月　　　　2021 二〇二一

01 02 03 04 05 06 07 08 09 10 11 12 13 14 15
16 17 18 19 20 21 22 23 24 25 26 27 28 29 30 31

APRIL 四月　　　　2022 二〇二二

01 02 03 04 05 06 07 08 09 10 11 12 13 14 15
16 17 18 19 20 21 22 23 24 25 26 27 28 29 30

APRIL 四月　　　　2023 二〇二三

01 02 03 04 05 06 07 08 09 10 11 12 13 14 15
16 17 18 19 20 21 22 23 24 25 26 27 28 29 30

AUGUST 八月　　　　2023 二〇二三

01 02 03 04 05 06 07 08 09 10 11 12 13 14 15
16 17 18 19 20 21 22 23 24 25 26 27 28 29 30

SEPTEMBER 九月　　　　2023 二〇二三

01 02 03 04 05 06 07 08 09 10 11 12 13 14 15
16 17 18 19 20 21 22 23 24 25 26 27 28 29 30

FEBRUARY 二月　　　　2024 二〇二四

01 02 03 04 05 06 07 08 09 10 11 12 13 14 15
16 17 18 19 20 21 22 23 24 25 26 27 28 29

OCTOBER 十月　　　　2024 二〇二四

01 02 03 04 05 06 07 08 09 10 11 12 13 14 15
16 17 18 19 20 21 22 23 24 25 26 27 28 29 30

by prevailing structures and responses to the same. Does that put you in an uncomfortable position as observer/commentator of offering a critique on the politics that informed the production of such spaces and their dystopian inevitabilities?

HC: I don't see it as an uncomfortable position at all. I think art is a language in itself, and has its own potentials. I don't want to apologize for speaking this language, but at the same time, I acknowledge that this language can only be understood by a very limited community, often causing a lot of misunderstanding when art projects are discussed within other fields like sociology or politics. In recent years, a lot of artists have been working in this field of producing knowledge, and while I appreciate a lot of the materials generated from these projects, it is something that I don't want to do, at least not in the way of produc-

ing knowledge the way an academic would. I prefer to work along the lines of subjectivity and speculation, and mostly, I just let things go wild, let them become hysterical. In my work, I don't want to place the emphasis on "making sense."

AM: Yet there are formal elements that insist we look at them as inquiries of spatial organization, order, placement, tonal value, etc. In that sense there is a generosity that imbibes the viewer's place. These images can be "free-floating" too, their significations negotiated by the viewers themselves. Their postapocalyptic reference inflected by conditions of spectatorship.

HC: It is about constructing a kind of dream machine, a space that allows for dreaming of all sorts. How these spaces, dislocated as photographs, immediately become empty stages where all kinds of things can occur.

Heman Chong
Calendars (2020–2096), 2004–2010.
Offset prints on paper. 1,001 sheets, each H. 11¾ × W. 11¾ in.

GIVING FORM TO THE UNSEEN Traditional Devotional Sculpture in *Phantoms of Asia*

Qamar Adamjee

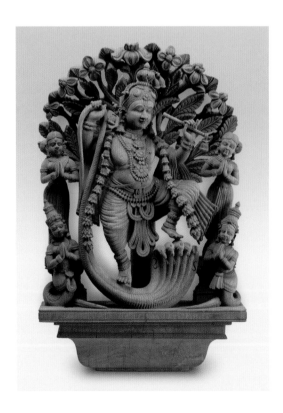

What does a grouping of traditional religious sculpture from Asia communicate to an art lover visiting an exhibition of recent contemporary art from Asia? One could ask what meaning these sculptures are intended to convey in this context, or what relevance such an intersection of the religious and the secular has in our world today. Is it, moreover, even meaningful to view together religious sculptures from across Asia that vary so profoundly in their context, culture, and time, while remaining free of oversimplifications and generalizations?

These works would never have been assembled in their original, historical, devotional settings in Asia (in which they obviously no longer function). Neither would they typically be in proximity in a Western ahistorical, museum context. In a normal museum setting, each sculpture would likely be displayed in a gallery devoted to its region of origin; and even within those spaces, each would likely be separated from other related works according to their relative dates.

And yet, by seeing them in this new juxtaposition in the *Phantoms of Asia* exhibition, new dialogues and associations emerge that go beyond simplistic polarities of old and new, temple and museum, traditional and contemporary art.

An immediate observation can be made about this group of devotional sculptures: they possess many similarities despite their origins in different places, cultures, and times. This raises the question of why certain images are reproduced consistently over time, which may be followed by a stereotype-based judgmental observation that "Asian art" is highly traditional, static, and nonrealistic (in the sense of Western, post-Renaissance ideals of realism). But can more be said about these artworks as a group and about their relevance in this display?

Indeed, the scope of work on display here is broad, with artworks from Japan, China, India, Thailand, Cambodia, and Burma, spanning a period of more than one thousand years, from the seventh through the twentieth centuries. Sizes and materials vary widely, too, from an intimate rock crystal figure to a nearly life-sized wooden piece. Eight of the twelve artworks in the group represent divinities or deities: the Buddha in his different aspects, bodhisattvas, and the Hindu god Krishna; the others are guardian figures or devotees.

The Buddha is featured with archetypal iconography: he wears a monastic robe and is seated or standing on a lotus flower, a symbol of enlightenment. His eyes are cast downward in a state of meditation, and

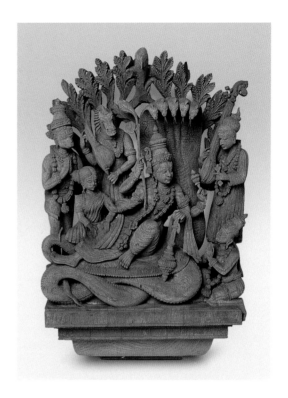

Vishnu on the serpent in the cosmic ocean, with Lakshmi, Hanuman, and other figures, 1850–1950. Southern India. Wood. H. 19 × W. 11½ × D. 4½ in.

FACING
Krishna overcoming the serpent Kaliya, 1850–1950. Southern India. Wood. H. 19½ × W. 12½ × D. 4½ in.

ABOVE LEFT AND RIGHT

Two of a set of four seated guardian figures, approx. 1550–1600.
China; Ming dynasty (1368–1644). Copper.
LEFT: H. 7⅝ × W. 5⅛ × D. 3¼ in.
RIGHT: H. 7¾ × W. 5⅜ × D. 3¾ in.

FACING

The Hindu deities Vishnu and Lakshmi on Garuda,
approx. 1500–1700. India; perhaps Arthuna,
Rajasthan state. Stone; enameled metal modern eyes.
H. 31½ × W. 18 × D. 9½ in.

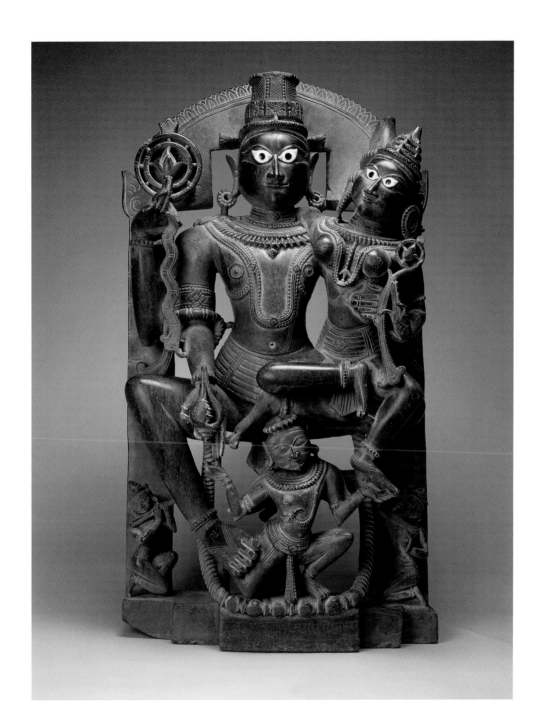

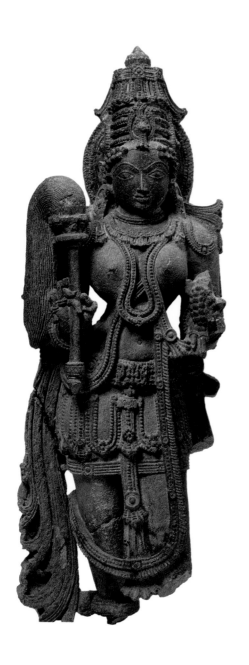
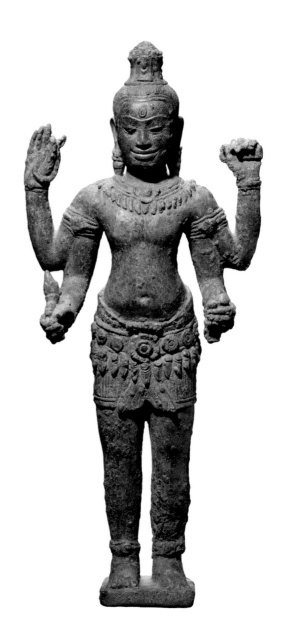

various hand gestures convey the mood and meaning of a particular image. The Buddha's marks of superhuman perfection include the *ushnisha* on the head, a reference to his divine wisdom (and transformed by artists into a hair knot); elongated earlobes indicate renunciation of material desire; a mark between the eyebrows signifies enlightened vision and designates his status as a divine being.

Bodhisattvas—enlightened beings on the threshold of Buddhahood who chose to remain in this world to assist other beings to attain salvation—share several iconographic features with Buddha images in painting and sculpture. The Hindu deity Krishna is seen here crowned with a peacock feather headdress and holding a flute, signifying his role as a divine lover; the primary narrative with the snake-demon shows Krishna as the divine protector from forces of evil. The devotee figures, regardless of whether Buddhist, Hindu, or from different parts of Asia, are shown with their hands clasped and heads bowed in a gesture of humility and submission.

In their original settings of a temple or altar, for devotional purposes either by many worshippers or by an individual, these figures served different functions. They were not intended as "artworks" per se. They could be a focal point upon which worshippers fixed their mental gaze as an aid to meditation (a modern yoga practitioner would be familiar with such a device). Through their physicality, they gave form to abstract concepts and served as visual shorthand for recalling

FACING LEFT
Female figure, 1250–1300. India; Belur, Karnataka state. Chloritic schist. H. 32 × W. 11½ × D. 9 in.

FACING RIGHT
The bodhisattva Avalokiteshvara, approx. 1180–1220. Cambodia; former kingdom of Angkor. Bronze. H. 14¼ × W. 6¼ × D. 4 in.

ABOVE
Monk in worshipful posture, 1600–1800. Burma. Dry lacquer with traces of gilding. H. 23¾ × W. 12 × D. 15 in.

stories that instructed, inspired, or provided codes for moral conduct.

Despite their surface simplicity, these devotional images are anything but simple. Each of these sculptures—regardless of size, material, or specific religious meaning—has a strong physical presence. As a group, the works gain even more strength that derives only in part from their three-dimensionality or "sculpture-hood." Their power is conveyed through the abstraction of individual physical features and the reduction of visual information to that which is essential. Posture, gaze, and hand gestures are the principal communicators of mood and meaning. Each image is self-contained, quiet, and inspires contemplation. These works are not portraits, in the sense of being likenesses of specific individuals, yet they are immediately identifiable. Their recognizability depends on a long history of shared meaning that has been established by religious and cultural practices and represented through specific details of costume, gesture, stance, and the absence or presence of certain elements. The decoding of the shared visual language provides a particular image with its complexity and multiple layers of meaning. This characteristic also gives these works the immediate impression of similarity, even though they are stylistically different and respond to the time and culture in which they were produced. These sculptures, in which the human form is idealized and encoded with religious signifiers, thereby become vessels of deep spiritual meaning and repositories of cultural memory.

But what can they communicate to a modern

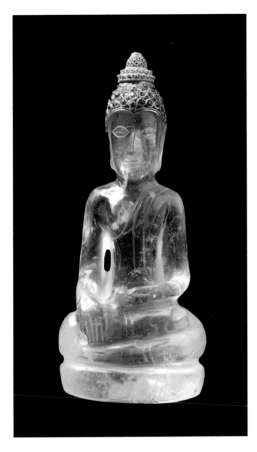

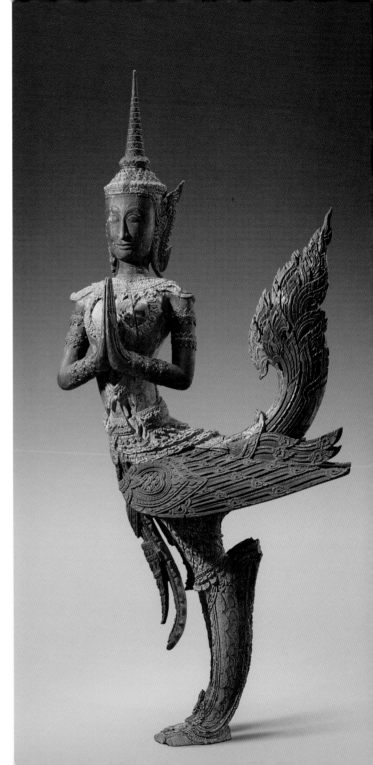

FACING

Bodhisattva, approx. 600–700. Thailand;
Plai Bat Hill, Buriram province. Bronze. H. 9 in.

ABOVE

Seated Buddha, perhaps 1400–1500. Thailand. Rock
crystal with gold and ruby. H. 4¼ × W. 1¾ × D. 1½ in.

RIGHT

Mythical bird-man, approx. 1775–1850. Central
Thailand. Wood with remnants of lacquer, gilding,
and mirrored-glass inlay. H. 50½ × W. 11 × D. 25 in.

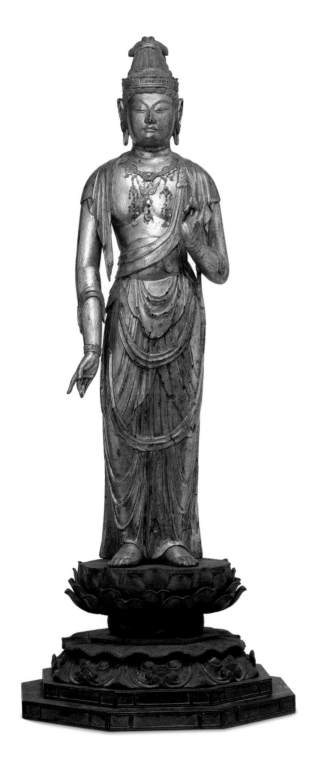

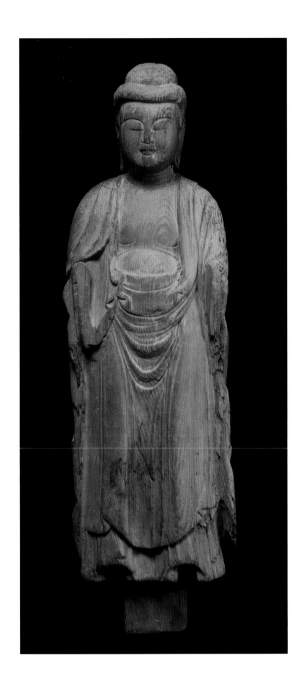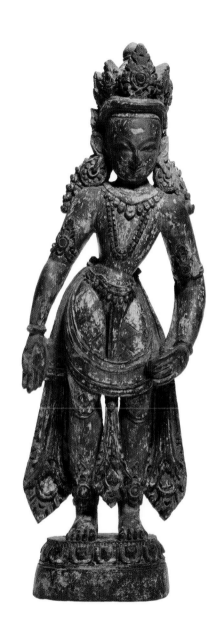

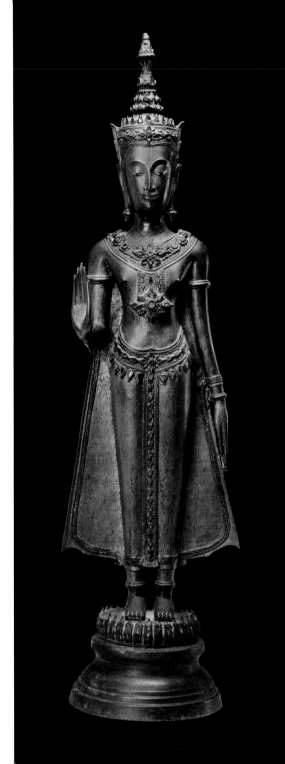

LEFT

Standing crowned and bejeweled Buddha, 1600–1700.
North-central Thailand. Bronze or other copper alloy
with mother of pearl and glass inlay and traces of lacquer.
H. 29½ × W. 8¾ × DIAM. 7¼ in.

ABOVE

**The guardian kings of the four directions presenting begging
bowls to the Buddha,** approx. 1650–1750. Burma. Bronze.
H. 4⅛ × W. 5½ × D. 2½ in.

FACING

**The Hindu deity Vishnu reclining on the serpent in the cosmic
ocean,** perhaps 1150–1250. Cambodia; Northeastern Thailand.
Sandstone. H. 13 × W. 34 × D. 5 in.

viewer in the context of a contemporary art exhibition? In a sense, the traditional artworks represent the efforts of artists over time and across cultures to give form to and to access the divine. Similar concerns are reflected in the works of these contemporary artists. They use different techniques and mediums but continue to pursue the quest to understand and relate to unseen forces in the world around us. Common threads of abstract forms, quietness, and contemplation become evident through this juxtaposition of the old and the new, enabling both the past and the present to be experienced afresh.

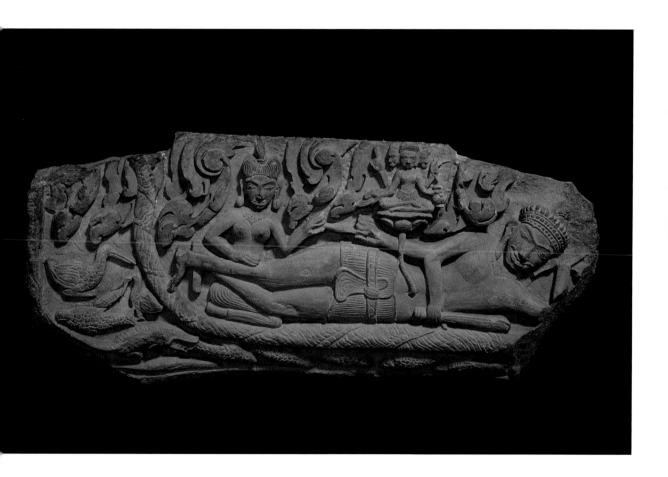

WORLD, AFTERWORLD *living beyond living*

ENDLESS-PEACE ARROWHEAD SONG

Among lacquer ash, bone dust, cinnabar river-stone,
ancient bitter-ice blood spawning bronze blossoms,

rain dissolved white feathers and thin gilt bamboo:
nothing left but a battered old three-spine wolf-fang.

I took two horses, scoured a battleground, flat rocky
fields east of a post-station, below weed-choked hills,

sun cut short. Wind blew on and on, stars moaning,
black cloud-banners hung drenched in empty night,

spirits and ghosts everywhere, emaciate, crying out.
I offered sacrificial cream, a jarful, and roast lamb.

Insects silent, geese sick, spring reeds red. Tangled
gusts bid a traveler farewell, feeding shadow-flames.

I searched antiquity in tears, and found a loose barb,
tip broken, cracked red. It sliced through flesh once,

and in South Lane at the east wall, a boy on horseback
wanted my bit of metal, offered me a bamboo basket.

Li Ho
Translated by David Hinton

Endless-Peace was the site of a vast battle in 260 BCE. It is said that more than 400,000 soldiers died, and relics were apparently still turning up in Li Ho's time, a thousand years later.

A King of Hell, approx. 1600–1700. Korea; Joseon dynasty (1392–1910). Hanging scroll; ink and colors on silk. H. 45¼ × W. 34¼ in. (image); H. 86 × W. 46 in. (overall).

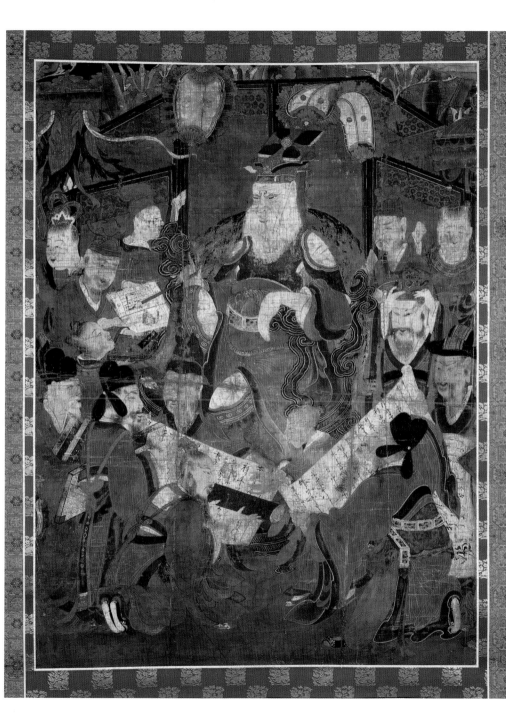

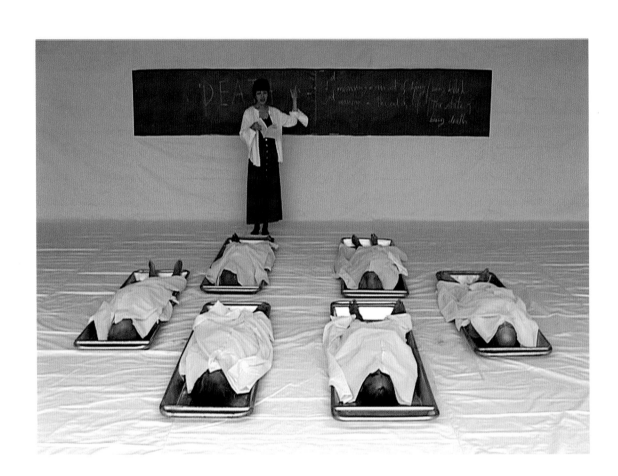

ARAYA RASDJARMREARNSOOK

The Class documents artist Araya Rasdjarmrearnsook's giving a seminar about death to an audience of shrouded corpses. She communicates with the corpses, presumably teaching them a subject that, ironically, her students know better than she does. Engaging her audience with a mix of austerity and humor, Araya discusses different meanings of dying, talks of how living people speak of death, and asks her students about their expectations of the afterlife. She concludes by offering that, for her own death, she would prefer to simply disappear.

The Class is part of Araya's ongoing exploration of culturally specific customs and reactions to death, an interest prompted by her own experience as a child: when she was three, her mother died.[1] Viewers are challenged to consider what happens after the end of life, to confront their own feelings of loss and melancholy associated with death, and to contemplate how they may want to die. Within the context of Thai Buddhism and its belief in the afterlife, the artist's seminar teaches her students lessons for the next life, her way of fulfilling the Theravadin ritual of caring for the deceased.
A.H.

1 Oliver Benjamin, "Grave Concerns: The Art of Death," *Citylife Magazine*, October 2005; http://www.oliver benjamin.net/articles/grave_concerns.html.

The Class, 2005. Single-channel video. 16 min., 25 sec.

THE CLASS

Araya Rasdjarmrearnsook

Translated by Jan Theo De Vleeschauwer

Good evening! I would like to welcome everyone to this talk.

First of all, I would like to introduce myself.

I am presently here standing in front of you as a living person. Ah . . . my standing position is between you and a green board behind me. I am standing here with only one purpose in mind: to have a talk. I am willing to accept the fact that this talk might be without any form of discussion, that it might be only half a conversation. So be it.

Would you mind if this kind of talk is not perfect? You wouldn't, would you?

And anyway, what is a perfect talk?

Death: D E A T H is today's topic.

Tell me what you think. Ah! You need some more time to think. How about you? Do you have something to say about today's topic? You also need some more time to think.

Very well, as the atmosphere here is very quiet, it may help a little if I begin: I seriously think that today's topic may help us to cut straight to close ties and connections that do exist between the living and the dead.

Like the ties between us, you and me.

I hope you do realize now how important this issue is?

Araya Rasdjarmrearnsook
The Class, 2005. Single-channel video.
16 min., 25 sec.

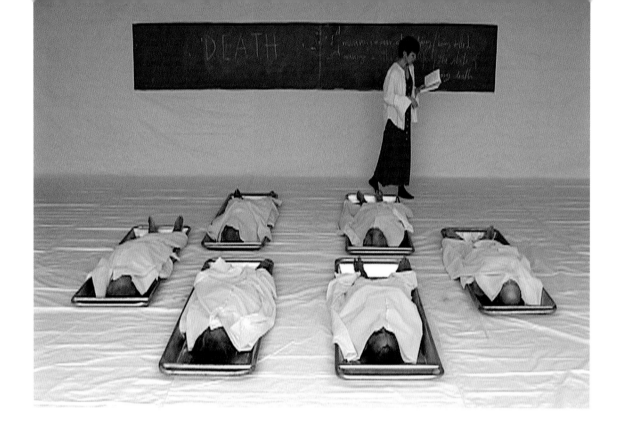

There are many kinds of definitions of Death. I am going to write this on the board behind me so that all of us can clearly see what death is.

(As a living person I hate writing on a board. I prefer the computer. It doesn't show my dreadful handwriting.) Now, about the meanings of the word DEATH.

First meaning: an act of dying or being killed. There are different kinds of death: a sudden death, a horrible death, a peaceful death, which is what most people prefer.

Second meaning: the end of life; the state of being dead.

There is power in death. A very interesting point indeed, death as a kind of power. What kind of power, then? you may ask.

The power that destroys life. What did you say?

Someone could say, Life can be destroyed without death, and he would be right. I agree with you. But we are not talking about life here; we are talking about the word *death*.

Death is not always connected to life. The word *death* is also used for something's ending or destruction of something, like the death of hopes, the death of capitalism, the death of one's plan.

Someone has a question again. Does DEATH only have negative meaning? No, it does not. I think you know that already. It all depends how the word is used, of course. If we say death of death, it could mean new life. Most people would believe this to be positive. But please note, not according to the Thai Buddhist way of thinking and not for people who commit suicide.

People also use the word *death* in other contexts, such as at death's door, in at the death, dead of night, dead of winter, dead in the water, etc.

Now may be a good time to see what Thai culture says about death. There are some verses or sentences about death, such as "To hen kan yoo lad"/Oh! I just saw him. This short Thai sentence also has a double meaning that implies: Oh! I just saw him, and now he is dead.

Another expression is "Tai Tang Pen." This is an expression used to indicate people who die while still being alive, people who must endure extreme suffering, but only for a short time. Because there is always sunshine after the rain.

I am wondering if there could be a similar expression for death, like "Tai Tang Tai," death while being dead.

I am sure that you may know more about this than I do. What is it like? No need to explain it right now.

Let's talk a little about living people now and what they believe dead people want. We as living persons often pray for the dead and hope that they could go to "Sukati," meaning the realms of bliss and/or heaven, with no way to ask them if they really want to go to heaven. This can show that the living persons are having hell now in this life.

Did you reach "Sukati" or heaven after departure from this life?

Ah! You just die. You don't know now. What do you want to say? It takes time to reach heaven, It could be a long time, I agree.

If there is a heaven for the dead or not is a question we will not try to answer here.

Death as part of some wonderful literature is, in my opinion, much more interesting than questions concerning heaven.

In the novel *One Hundred Years of Solitude*, an old man, once a general, is sitting one evening in the front of his old house when a man from a passing parade who recognizes him asks: "What are you doing here, General?" "I am here to wait for my funeral parade," the General said.

In an article I once read, the process of individual dying is compared to dying en masse—like the tsunami victims. It says that disasters like tsunamis deprive the victims of the mystery and the secret of death. The charm of death becomes charm-less.

This reminds me of the last scene where the same general dies in a standing position under a tree behind his house. His relatives know that he is dead because they see the vultures circling the garden. Scenes like this bring us back to reality.

Could it be that death connects us closer to reality than life?

Did you experience a charming death? Who are the ones to experience the charm of death, the living or the dead?

Anyway, it might be difficult to answer. It's a very thin line between life and death. One of Napoleon's statements illustrates this very well: "The wink of an eye, a momentary sigh: such is the height of happiness, or the instant of death."

What do dead persons expect? Are your expectations different from the time when you were alive? Do you expect to reach heaven like we pray you to? I don't know. All of you may know, though.

Your answer could be very different. How about you, or you?

A person who died had the ability to die. The ability to die may be subject to conditions that are similar to the ability to live.

What does death mean to you now that you have reached it?

Does death give you more space than life did? Or is it something limited, like living people believe it to be?

I would like to suggest that maybe there is more freedom in dealing with death in art and literature. In my opinion, art can play with the meaning of death. Art can approach it from different angles. Death becomes a feather in the wind.

Are you tired, you persons who had the ability to die?

This class may have been too long for you. I am sure, however, that this has been the first time you have had the chance to talk about death. In case your death was horrible or sudden, there may have been no time to reflect upon what happened.

In case you died peacefully, you may have been too absorbed by it to think clearly. Before the class ends, does anybody have questions?

Ah! You want to know if I could choose, what kind of death I would prefer? Thank you for your question. I would like the end of my life to be like the last scene in the life of this pilot who also happened to be a writer. Nobody ever saw him again.

He disappeared, just like that.

Thank you very much for your attention. Goodbye for today.

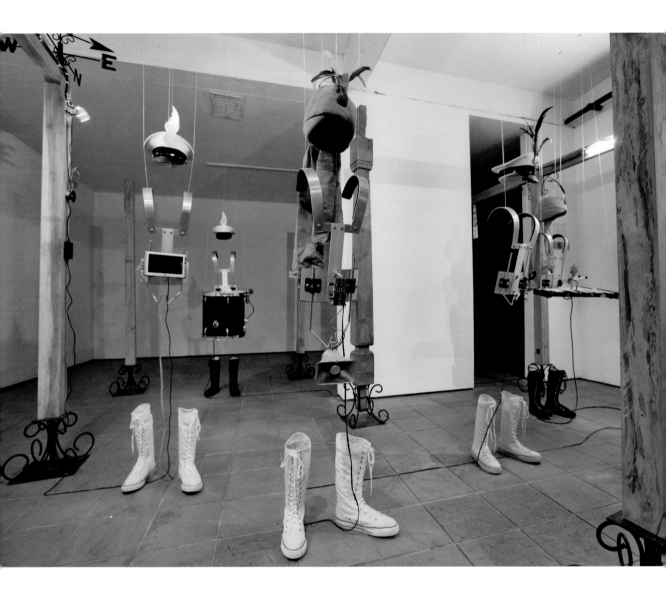

JOMPET

Jompet (aka Agustinus Kuswidananto) explores Java's fusion of traditions— "from Hindu religion to Islam, from colonial to post-colonial, traditional to modern, dictatorship to democracy"[1]— which constitutes its identity. Jompet situates this identity as a "third realm," where the tensions and transitions of contradictory beliefs and cultural influences are continually negotiated. This in-between realm is illusory, "a phantasmagoria of ancient symbols and ghosts" that creates, through a constant reenactment of past mythologies in the present, a "protective shield" from the effects of modernization and colonialization. In *Anno Domini*, Jompet adopts the form of a royal soldier to symbolize Java's syncretic identity. Since Dutch colonialization in the mid-eighteenth century, Java's royal soldiers have not had a military function. Yet to this day they symbolically guard the Javanese kingdom wearing ceremonial military costumes that—like Java's own culture—combine Hindu, Islamic, Western, and local traditions. Placed within the wooden frame of a traditional Javanese home, Jompet's soldiers hang bodiless like ghosts, signified only through the cultural symbols of their costumes as protectors of the "third realm."

A.H.

1 All quotes are from "Jompet, Java's Machine: Phantasmagoria," http://universes-in-universe. org/eng/nafas/articles/2009/jompet.

Anno Domini, 2011.
Wooden pillars, sound installation, text, soldier figures, and video components.
H. 98¾ × W. 275⅝ in.

THIRD REALM

Jompet and Yudi Ahmad Tajudin

The history of Indonesia, as part of the Third World and former colonized countries, can be read as narratives of a nation that is perpetually in a state of transition—from precolonial to colonial, from colonial to postcolonial, from agrarian to industrial, from industrial to postindustrial (an information era that gives weight to information and services), from rural to urban.

In a nutshell, the history of Indonesian culture is an "in-between" cultural history, one that is located between two cultural spaces: between the traditional and the modern, the original and the alien, the inside and the outside, the high-brow and the low-brow. It never (again?) stays and grows inside one cultural space that is specific and sharply different from another specific culture. It builds on a mix (and excess) of cultures. Its "body" is constituted by many different cultural layers.

As a cultural entity, Indonesia is never singular, but the in-betweenness and the transitional conditions have become the overarching and constructing frame that covers all the (sub)cultures within.

Questions then arise: How are subjects or spaces formed "in between," or in excess of, the sum of the parts of difference? How do the notions of subjectivity and spatiality get formulated in this place where the exchange of values, meanings, and priorities may not always be

collaborative and dialogical, but may instead be pro-foundly antagonistic, conflictual, and even incommensurable?

Referring to the spatial realities and identity formulation created, developing, and persisting in Java, the answers to these questions could be perceived from the creation of third realities—third space, third body, third identity. Third reality is hybrid, a reality made from a blend of many things. Third reality is a postcolonial/Third World/Indonesian reality composed from elements that are contradictory to each other, unfinished, half-done, confusing, and transitional or liminal.

As a metaphor, the third reality is a temporary and flexible term that attempts to capture what is actually a constantly shifting and changing milieu of ideas, events, performances, and meanings.

Pertinent to the understanding of the metaphor is the insight that there is not just one single definition of body and identity but rather a multitude of approaches and perspectives.

In Java's case: where one can be a Muslim (or any other religion) and a Javanese animist at the same time; local and global; modern and traditional. Where one is something in between different things.

As Homi K. Bhabha once said, "The 'in-between' space provides the terrain for elaborating strategies of selfhood—singular or communal—that initiate new signs of identity and innovative sites of collaboration, and contestation, in the act of defining the idea of society itself."

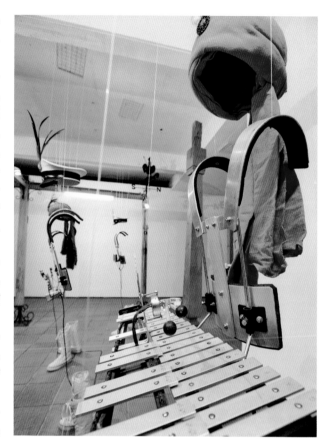

Jompet
Anno Domini, 2011 (detail, see page 112).

JAKKAI SIRIBUTR

Jakkai Siributr's artwork explores the interactions of materialism, popular culture, and religion in contemporary Thailand, where an indigenous blend of animism, superstition, and Theravada Buddhism characterizes spiritual life. Jakkai's commentary critically yet empathetically points to the tensions among these influences. *Karma Cash & Carry*, 2010–2012, is based on a well-known manifestation of animism in Thai life: the ritual of constructing "spirit houses" to shelter celestial beings or spirits of the land and appease them with regular offerings so that they will provide protection from misfortune. As Jakkai explains, "A personal shrine such as *Karma Cash & Carry* is a way to pay respect to my ancestors and a step toward a spiritual path through mindful living."[1] Fabric embroidered with images of his ancestors shrouds the structure. "As a practicing Buddhist, my goal in life is to find the path to spiritual enlightenment. So these images of my ancestors that I have meditatively embroidered on the fabric and used to shroud this spirit house become a reminder of how I should conduct myself. Gilded dolls inside the shrouded structure allude to rebirth, the many reincarnations one has to endure before achieving nirvana." Jakkai invites viewers to make offerings—small figurines of the artist on which they can write their good deeds—and help guide the artist on his spiritual path. A.H.

1 All quotes are from Jakkai Siributr's artist's statement (February 2012).

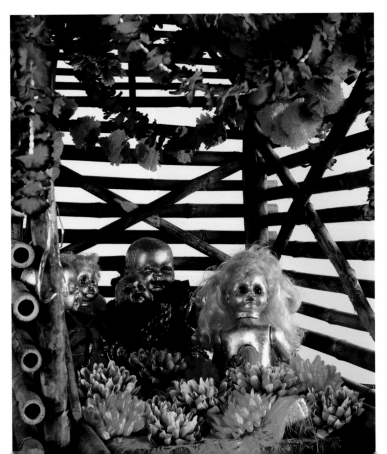

Karma Cash & Carry, 2010–2012.
Bamboo, eucalyptus, found objects, gold leaf, and cheesecloth with embroidery.
Approx. H. 59 × W. 47 × D. 39 in.

RINGO BUNOAN

For one afternoon in March 2007, Ringo Bunoan collaborated with elderly and terminally ill residents of an ashram in Pashupati, Nepal, to create a work of art that contemplates death and existence. She invited the residents to roll their blankets like logs and assemble them into a pyre in the ashram's open courtyard. The accumulation of blankets directly refers to the Hindu cremation ritual of burning funeral pyres on *ghats*, the steps leading into a body of water. Bunoan writes, "For three years, from 2004 to 2007, I lived in Nepal, where I witnessed and experienced itinerancy and ephemerality as part of everyday life. Possessions are few and basic, which are necessitated by poverty, but at the same time rooted in a more spiritual kind of detachment from tangible, worldly things. A blanket, being somewhat like an extension of the body, is a fitting metaphor in this study of the cycle of life. At birth and upon death, bodies are often wrapped in blankets; they are our first and last skins."[1] Once symbols of warmth, comfort, and rest, the blankets in *Passage* signify the bodies they covered. Partly memento mori and partly the artist's farewell to Nepal, the documentation of Bunoan's work from a single afternoon reminds us that after death, traces of us may remain. A.H.

Passage: The Blanket Project, 2007.
Duratrans print and light box.

1 From Ringo Bunoan's artist's statement for
 Passage: The Blanket Project (not dated).

PHANTOMS OF NABUA

Apichatpong Weerasethakul

Phantoms of Nabua, 2009.
Single-channel video installation.
Digital, 16:9/Dolby 5.1/Color.
10:56 min.

 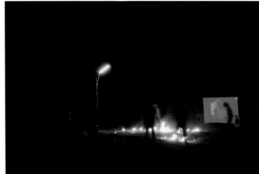 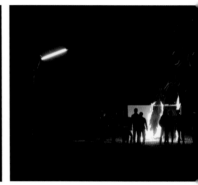

APICHATPONG WEERASETHAKUL

Apichatpong Weerasethakul sets the film *Phantoms of Nabua* in the northeastern Thai village of Nabua, a site of fierce oppression and violence from the 1960s through the early 1980s during an occupation by the Thai army. Mostly women and children remained in the town, inspiring a local legend about a "widow ghost" who abducts any man who enters her domain. *Phantoms of Nabua* reimagines the village as a "town of men, freed from the widow ghost's empire."[1] The film's nonlinear narrative structure shifts between fiction and documentary to explore the notion of home, and how memories and ideologies can both shape and destroy place.

A.H.

1 http://www.kickthemachine.com/works/Primitive %20sub_website/Primitive_Project.html. The film can be viewed at http://www.animateprojects.org/.

a large tree. No matter how many years I pass by, I always have to stop and look whenever I go running. The lamp is always blinking on and off, as if its ballast is in a state of permanent decline. The lamp light is momentarily reflected in the large tree nearby, briefly revealing its green leaves in the darkness. I call it "the flash of lightning on the banks of the swamp."[2]

Perhaps for economic reasons, most of the houses in Asia are illuminated by fluorescent lights. Even though these lights make the skin look pale, even dead, for me they relate to home, to being home.

The film's setting is a rear projection of Nabua (from the *Primitive* installation) and a recreation of a fluorescent light pole back in my hometown. I used this setting as a playground for the teens who emerged from the dark with a football raging with fire. They took turns kicking the ball that left illuminated trails on the grass. Finally they burned the screen, which revealed behind it a ghostly white beam of a projector.

Like another film in the same series, *A Letter to Uncle Boonmee*, *Phantoms of Nabua* is a portrait of home. The film portrays a communication of lights, the lights that exude, on the one hand, the comfort of home and, on the other, destruction.

1 Film synopsis from video specifications; also online at http://www.animateprojects.org/films/by_date/2009/phantoms.

2 *Gagarin: The Artists in Their Own Words* 9, no. 1 (March 2008).

SYNOPSIS

A fluorescent tube illuminates an empty playground in the evening. Nearby a flash of light is projected on a makeshift screen. This outdoor movie is a portrait of a village repeatedly struck by lightning. As night falls, the silhouette figures of young men emerge. They are playing with a football raging with fire. They take turns kicking the ball, which leaves illuminated trails in the grass. The lightning on the screen flickers amid the fire and the smoke rising from the ground. The game intensifies with each kick that sends the fireball soaring into the air. Finally the teens burn the screen and crowd around it to witness the blazing canvas, behind which is revealed the ghostly white beam of a projector.[1]

Phantoms of Nabua is part of the multiplatform *Primitive* project, which focuses on a concept of remembrance and extinction and is set in northeast Thailand.

ARTIST'S STATEMENT

A few years ago, as a tribute to a place I often visit, I wrote an article called "Wing Rim Beung" (Jogging Around the Swamp). It's an impression of a swamp in my hometown in the northeast. In one paragraph there's a description of a light near the swamp:

> *There is something more beautiful at this swamp, however: a wooden pole with a soft white neon lamp attached to it, located at one corner next to*

TAKAYUKI YAMAMOTO

Takayuki Yamamoto engages children with conversation and games to explore "the particularities of social systems and customs by which people are raised."[1] His video projects tap into the innocent, unfiltered imaginations of children to satirize decidedly adult themes with a cynical edge. For *Phantoms of Asia*, the artist collaborated with ArtSeed, an after-school program in San Francisco's Bayview neighborhood for public school children between ages seven and eleven, to create a new version of his ongoing project, *What Kind of Hell Will We Go*. During workshops with the artist, the children were shown examples from the *Kumano kanjin jikkai mandara*, or Kumano mandalas, a group of Japanese paintings from the seventeenth and eighteenth centuries that depict the ten worlds of enlightened and nonenlightened existence, including the realms of heaven, humans, animals, ghosts, and hell. Some examples illustrate the temporal course of human life from birth to death to judgment in the afterlife, where various "hells" are gruesomely depicted throughout the bottom half of many tableaux. According to this tradition, while every soul is sent to a hell in the afterlife, all ultimately end up in heaven.

Using these traditional paintings to encourage their creative thinking, the children were asked to imagine their own versions of hell. They built cardboard dioramas of their "hell" and were videotaped explaining why they might be sent there and how their structures work. The cute, matter-of-fact tone of the children's commentary contrasts starkly with their descriptions of punishment, inciting viewers to laugh and leaving them to question the perversity of their response. Mimicking the compositions of the Kumano mandalas, Yamamoto installs the children's models scattered at various levels, suggesting multiple realms of hell. A.H.

1 From Takayuki Yamamoto's artist's statement (not dated).

What Kind of Hell Will We Go, 2012.
Video and mixed-media models.
Dimensions variable.

HOWIE TSUI

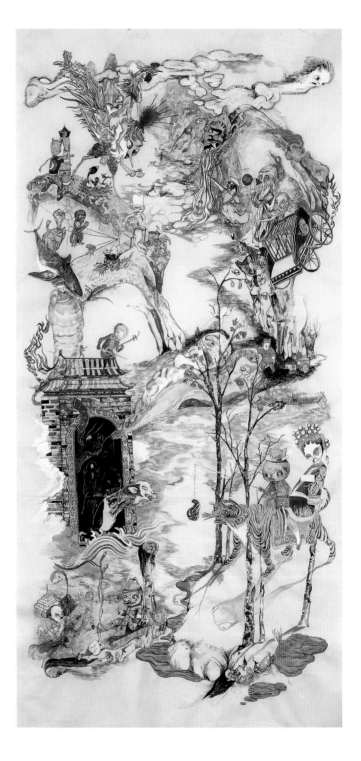

Mount Abundance and the TipToe People #1, 2010.
Chinese pigments, acrylic, and ink on mulberry paper.
H. 75 × W. 37 in.

Howie Tsui's fantastical scroll paintings explore interconnections among cultures and through history. In his *Horror Fables* series, the surrealistic, quasi-narrative scrolls combine imagery from traditional Asian folklore and rituals, Buddhist hell scrolls, and *ukiyo-e* prints with contemporary pop culture, such as anime, manga, horror stories, and various underground aesthetics. With influences ranging from Hokusai to Jim Henson to a nameless Ming engraver to Barry McGee, he creates human, monster, and ghost hybrid characters set within colorful natural settings. Like good horror films, his scrolls are both beautiful and grotesque—they draw viewers closer, only to turn them away in shock or disgust. As Tsui explains, his cultural and historical combinations "emphasize the disjunction between how fear is administered in folklore to encourage morality as opposed to its deployment in modern society, where a pervasive climate of terror is used to further partisan political and economic interests."[1] A.H.

1 Jeff Hamada, "Howie Tsui/Interview," July 14, 2011; http://www.booooooom.com/2011/07/14/interview-with-canadian-artist-painter-howie-tsui/.

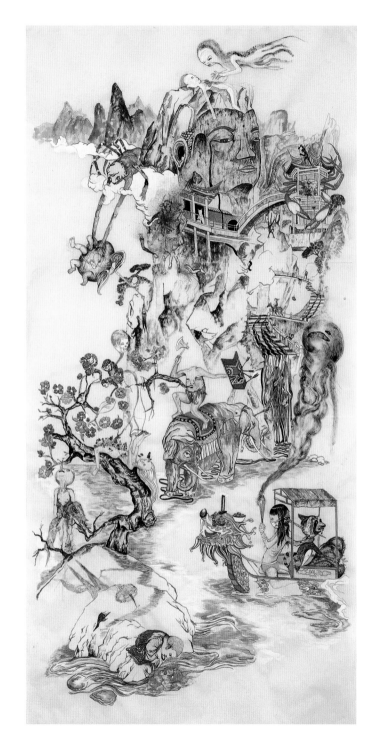

Mount Abundance and the Tip Toe People #2, 2010. Chinese pigments, acrylic, and ink on mulberry paper. H. 75 × W. 37 in.

FUYUKO MATSUI

Fuyuko Matsui's works of grotesque and supernatural figures fit into the long history of ghost painting (*yūreiga*) within the Japanese painting tradition, known for its dark depictions of the spiritual realm. Her painstakingly precise brushstrokes follow the formal standards of this tradition, and familiar details—such as women, animals, and other aspects of nature—fill her compositions. However, there the similarities between her paintings and traditional works end. Says the artist, "I am not trying to replicate traditional ghost paintings. I want to express something in a very modern way."[1] Matsui's horrific images express fears of the unknown, of the inner self, and of the "ghosts" that haunt our personal and collective pasts. Her paintings force viewers to face the inevitability of death, a dark reminder that feels even more ominous in sharp contrast to the refined beauty and skill of her technique. "I want to create a sympathy, a strong feeling, between the viewer and myself. . . . In a way, I am doing something that the viewer can't do himself. It's like people who occasionally think about jumping under a train. In my art I am actually jumping under the train. That shock— I am doing that for you."[2] A.H.

1 Quoted in Donald Eubank, "Tilting the Balance Back to Darkness," *Japan Times*, January 31, 2008.
2 Quoted in C. B. Liddell, "Pinpricks in the Darkness: The Beautiful and Disturbing Art of Fuyuko Matsui," *Culture Kiosk*, October 9, 2007; www .culturekiosque.com/art/interview/fuyuko_matsui .html.

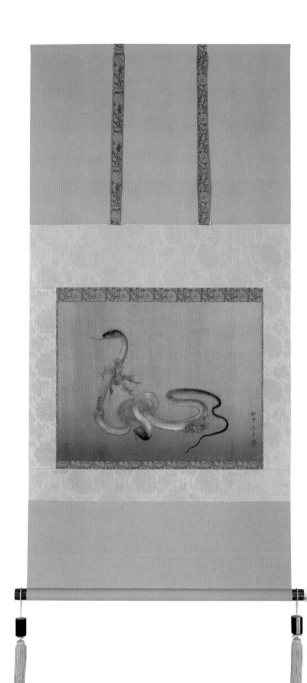

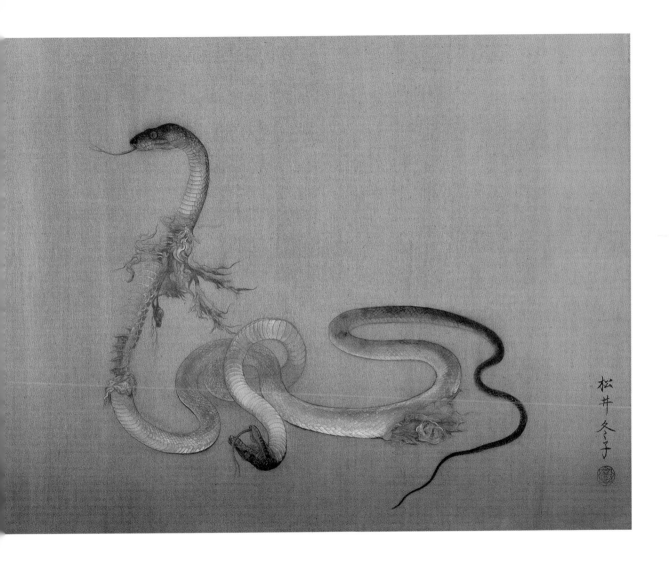

Daily Consumptions of Smooth Affections, 2007.
Hanging scroll; colored pigment on silk. H. 22⅞ × W. 16⅞ in.

Narcissus, 2007. Hanging scroll; colored pigment
on silk. H. 52⅜ × W. 19⅜ in.

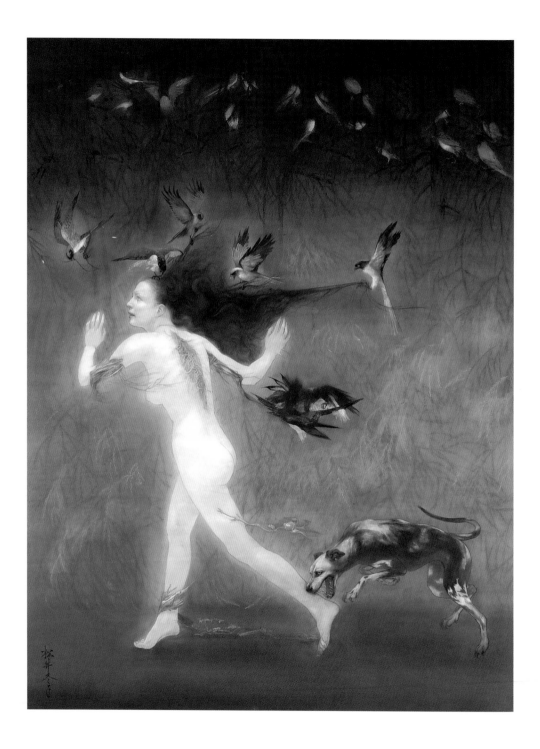

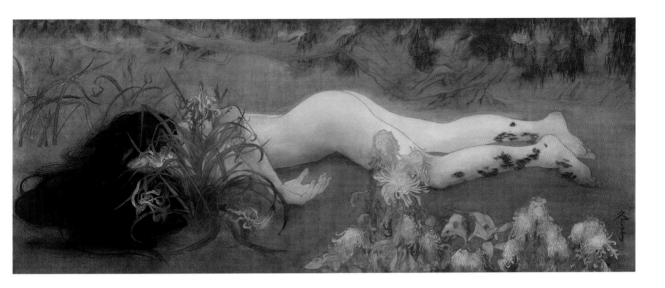

FACING
Scattered Deformities in the End, 2007.
Hanging scroll; colored pigment on silk.
H. 49 × W. 38⅜ in.

TOP
Crack in the Ashes, 2006.
Hanging scroll; colored pigment on silk.
H. 14¾ × W. 32¼ in.

ABOVE
The Parasite Will Not Abandon the Body, 2011.
Hanging scroll; colored pigment on silk.
H. 11¾ × W. 31½ in.

MYTH, RITUAL, MEDITATION *communing with deities*

When I am in a painting, I'm not aware of
what I'm doing . . . because the painting
has a life of its own. I try to let it come
through . . . there is pure harmony, an easy
give and take, and the painting comes out well.

—JACKSON POLLOCK[1]

I can only believe in a God who dances.

—FRIEDRICH NIETZSCHE[2]

Meditation helps us to understand that
body and mind are one, with no division
between action and rest.

—ZONGZE CHANSHI[3]

Where do all painting methods come from?
They all come from a single brushstroke.

—SHITAO[4]

THE STILL DANCE

John Stucky

In this world we live by distinctions. Distinctions help us get through each day. From this perspective, conceiving of an activity that requires complete stillness—such as meditation—cannot be confused, much less equated, with dance. Then again, dance can't be confused with meditation. Both require the same discipline: concentration and focus. Even so, we cannot say this is all that meditation and dance have in common. The essence of dance is the act of pointing to stillness; the essence of meditation is seeking the dance of all things. Yet even this comparison is superficial. The problem is in making any comparison at all. The issue is in seeing contrast where there really is none. Distinctions are merely convenient and useful abstractions of what the world really is.

Once an artist moves his or her brush across a surface, making a line or mark, the movement aspect of making the line is done. What remains is the line itself, yet the line does not seem to contain any movement, just the result of movement. Still, can one truly distinguish between the line made and the action of making the line? It is all part of the same thing, that of the movement, the dance. Stillness and movement are all part of one continuum.

Throughout time, the apparent paradox of cause and effect, action and result, has intrigued artists. In making a static work, one can create the

Dakini, approx. 1600–1800. Nepal. Gilded bronze. H. 7¼ × W. 5 in.

illusion of movement, and that movement can seem preserved, frozen. Such preserved movement can be found throughout the history of Asian art, as in sculpture or Arabic or East Asian calligraphy. This phenomenon is found in the work of many of the artists represented in this exhibition: the influence of meditation and dance, stillness and movement . . . thing and no thing, existence and nonexistence . . . a quiet that is verbose . . . an emptiness that is filled.

The challenge that many of the selected artists have set for themselves is to confront their own traditions—Buddhist, Taoist, Hindu, or Islamic—and present them in a personal and contemporary way, a way that speaks to us whether it is seemingly still or filled with movement. Among these artists are those who demonstrate an amazing and intrinsically unique ability to reveal or embody their meditations.

One of the more immediately impressive artists

to demonstrate the unity of dance and meditation with articulate power is Sun K. Kwak. Her flowing calligraphic lines may initially remind us of some of Roy Lichtenstein's large pop versions of brushstrokes. Yet that similarity is superficial, as they seethe with movement and flow like water. She describes her work as "lyrical meditation." Certainly, dance and meditation are simultaneously expressed. In her work, we can see thousands of years of East Asian calligraphic tradition combined with an awareness of the space around her. All of this derives from her own meditative interaction with each space. Her work is the realization of the dance of meditation.

Lin Chuan-chu shows the dichotomy of form as both solid and ephemeral. In his paintings of mountains and large rocks, he reveals these firm shapes, which echo the strange, convoluted rocks that Confucian scholars admired and collected—shapes that

grow and writhe out of vaporous clouds. Whole ranges emerge in the smoke from a stick of incense. His rocks and mountains are not depictions of nature so much as they are depictions of his interior vision. What is solid is not solid, what is not solid is solid. On one level his pieces illustrate the famous and pivotal Buddhist observation made in the Heart Sutra: "Form is emptiness, emptiness is form."

Lin's works reflect the tradition of landscape painting by Confucian scholars, as their compositions were meant to reveal their own inner and individual qualities, not simply actual landscapes. Still, the artist's fascination with natural forms has its roots in Taoism. Lin admits his works express his meditative and personal dialogue with landscape. Here, then, embodied in the work of this contemporary artist are these ancient traditions: Buddhism, Confucianism, and Taoism. His clouds move slowly through the atmosphere,

gradually becoming solid, gradually revealing their own nature, all in a swirling dance.

The spiritual and the aesthetic are also joined in the work of Guo Fengyi. Her deeply personal drawings graph her meditation and, at the same time, reveal the actual meditation itself. The drawing of each line is part of the process of her meditation. Her drawings are charts of her inner space, her inner workings and deeply personal feelings all transcribed like ghost writing to paper. In each work there is flow and movement, yet each reveals an unfolding of inner stillness.

The unity of calligraphy and meditation, line and dance, is dealt with again by Pouran Jinchi. In Islam, writing itself is a manifestation of both God and one's own inner being as revealed through meditation and prayer. Each of her works is a private prayer, a little meditation. The overall effect is of the stillness of the

act of prayer, yet within is the dance of calligraphy. It is as if the lines themselves reveal the communion between God and the artist while remaining partially hidden as well, like a mystery with only vague clues. These clues may be quiet or subtle, but they resonate.

In contrast, the works of Prabhavathi Meppayil provide large but simple and fine surfaces that draw us in, demanding our introspection. At close range, we get caught up in the delicacy of the copper wires embedded throughout the surface of her panels. She is depicting silence, pointing a finger to it, and allowing it to speak to us. While in her quiet, we are calm. Here again, the artwork is synonymous with the artist's meditation, not illustrating but being the meditation itself.

The delicately carved wooden flowers and plants of Yoshihiro Suda are like another finger pointing to stillness. The detail of his sculptures is exquisite. Yet the power of Suda's works resides especially in their placement: in a quiet corner, on a shelf, or scattered across a floor. They sneak up on us in a way that implies they don't quite belong, like graffiti. But their statement, like graffiti's, can be profound, if we pay attention. It is all about seeing something that we don't expect at all, yet makes us smile. Beyond time or space, suddenly we are surprised and suspended. His work expresses the well-known statement on aesthetics made by the Japanese medieval playwright Zeami: ". . . if you hide it, it is a flower. If you reveal it, it is nothing."[5]

Bae Young-whan also uses a mix of traditional and contemporary materials to tell his stories and deal with age-old questions. Although some of Bae's works are rooted in the current scene of his native Korea, others reflect more timeless themes. In recent years he has been working not only with wood, building rolling mountain landscapes on the surface of tables, but also with clay.

Bae creates whole ranges from clay, many of which he finishes in traditional glazes, such as the classic Korean celadon. His mountains are like waves . . . mountains to waves and back to mountains. The confusion is intentional, as Bae is concerned with the fluid quality of both nature and time. As the great Japanese Buddhist teacher Dogen Zenji observed in his *Mountains and Rivers Sutra*, "The green mountains are always walking."[6]

Bae also had training in traditional East Asian landscape painting, which is evident in these recent works. Like Lin Chuan-chu, Bae claims that one distinctive thing about the old paintings is that the landscapes are generally complete inventions; the artists created mountains of their minds or dreams. In his work, Bae refers to imaginary mountains and the liquid quality of mountains as being a part of him. Usually, he replicates graphs of his brain waves in his forms. That is pure mind.

Likewise obsessed with the natural and spiritual world, the Taiwanese artist Charwei Tsai expresses traditional ideas in her very contemporary work. Her subtle work demands that the viewer slow down and spend time with it, for quiet, intimate things are revealed. A spiritual artist, Tsai frequently incorporates the entire Heart Sutra into her art. At other times she uses Sufi prayers and poems. Her work invites us to join in her meditation.

Tsai's compositions are often made of materials that will naturally fall apart or decompose. Like the Scottish artist Andy Goldsworthy, she is concerned with ephemerality as well as interdependence. Everything depends on everything else in order to exist, and existence is fleeting. Her works are meant to decay, cease to be, or maybe feed and become the next life. This temporary quality helps reveal the great value of each thing.

In his unique way, Palden Weinreb illustrates meditation and invites us to become part of it. Weinreb's abstractions—built of parallel lines, or partly erased, cloudlike shapes—reflect his idea of forms emerging from that which has no form. Many of his drawings also have the illusion of forms emerging from his arrangement of lines. By tracing these forms, we see the process of his meditation.

In Weinreb's pieces, the appearance of form unfolds, much as it does in traditional Tibetan *thangka* paintings. The artist claims that traditional *thangkas* were indeed an early source of inspiration, though his works themselves are not *thangkas*. Using abstraction as his primary tool, he asks us to leap beyond iconographic form to explore. As the artist states, "I look to shed (the) illusion of earthly references and expose the bare visual framework."[7]

Concern with timelessness and quiet is apparent as well in the work of the photographer and installation artist Hiroshi Sugimoto. Well known for his series of photos of oceans meeting the horizon and of the interiors of old movie theaters, Sugimoto is also interested in his Buddhist and Shinto heritage. His installations of crystal stupa-shaped reliquaries evoke both Buddhist practice and death, to which such items are indelibly connected. His work points out the connection between the past and the present. Here is an artist who knows the timelessness of art, and that history is manifest in the eternal present.

The work of all these artists reflects the sense that time is the dance, meditation is the dance; that movement and stillness are the same. Everything changes. Movement and transformation are our only true constants.

Bugaku dancers, 1408.
By Abe Suehide (Japanese, 1361–1411).
Handscroll; ink and colors on paper.
H. 11⅛ × w. 165 in.

NOTES

1. *Possibilities* 1, no. 1 (Winter 1947–1948). The premier volume of this occasional journal—edited by Robert Motherwell and others—was the only one ever produced.

2. Friedrich Nietzsche, *Thus Spoke Zarathustra: A Book for All and None*, trans. Walter Kaufmann (New York: Penguin Books, 1978), part 1, chapter 7.

3. Zongze Chanshi, from "Zuochan" in *Chanyuan Qinggui* (Pure Rules for the Chan/Zen Monastery). This work is presented in full in *Sources of Chinese Tradition*, 2nd ed., comp. William Theodore de Bary and Irene Bloom, trans. Carl Bielefeldt (New York: Columbia University Press, 2000), 522–524. See also *The Origins of Buddhist Monastic Codes in China: An Annotated Translation and Study of the "Chanyuan Qinggui"* (Honolulu: University of Hawai'i Press, 2002).

4. Shitao, from *Hua Yu Lu* ([Shanghai]: Shanghai Guji Chubanshe, [1990]), chapter one, "Yihua, Zhang yi" (A Single Brushstroke (my translation).

5. From Motokiyo Zeami, *The Flowering Spirit: Classic Teachings on the Art of No*, trans. William Scott Wilson (Tokyo: Kodansha International, 2006), 134.

6. From *Treasury of the True Dharma Eye: Zen Master Dogen's "Shobo Genzo,"* ed. Kazuaki Tanahashi (Boston: Shambhala, 2011), vol. 1, 154.

7. From an e-mail to Allison Harding, quoted with permission from the artist.

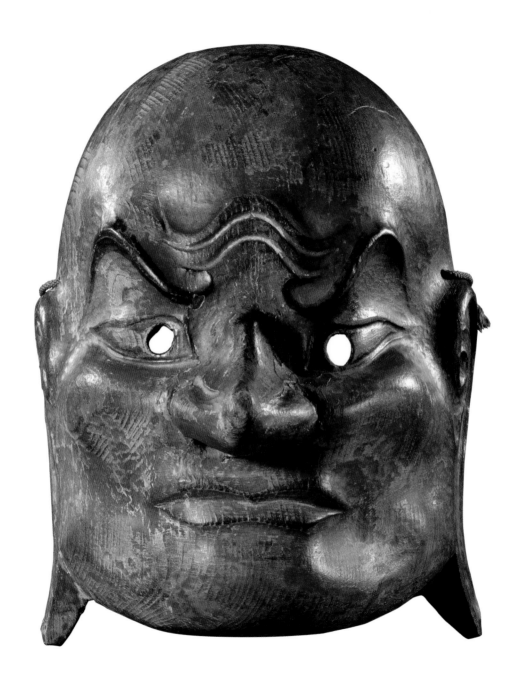

THE SPIRITUALITY OF JAPANESE MASKS

Melissa M. Rinne

The long history of Japanese masks is closely tied to religious ritual and offering. Ancient archaeological masks dating from the late Jōmon period (10,500–300 BCE) may have been used for shamanistic rituals, to cover faces of the dead, or for other mystical purposes.

Japan's masked performance traditions are also closely associated with spirituality and religion. Beginning in the seventh century, large masks with exaggerated features were used in temples in Nara for performance offerings of comical dance plays called Gigaku. This theatrical tradition came from China and entered Japan from Korea, together with Buddhism. Some of the original Gigaku masks survived over the centuries in the Hōryūji treasury and are now kept in the Tokyo National Museum.

A later but connected tradition is Bugaku, the dance element of Gagaku court music. Bugaku is linked with Shinto temples and Buddhist shrines, where it was performed for the imperial court and aristocrats who patronized such religious organizations. Bugaku dances—which are related to early dance traditions of China and Korea—can be comical, lively, or stately. Like Gigaku, Bugaku dances require specific masks and costumes for each role.

Gigaku mask of the Suikojū type, approx. 1868–1926. Japan. Wood with colors. H. 10 × W. 7¾ in.

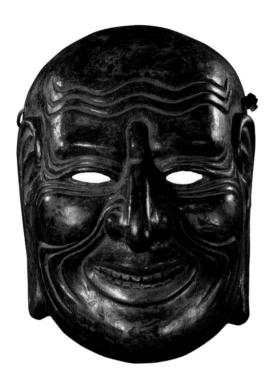

Processional (Gyōdō) masks were used for a wide range of Buddhist and Shinto rituals. Gyōdō masks might represent actual Buddhist or Hindu deities, demons, lions, or various other characters. Kagura, Dengaku, and Sarugaku are other examples of masked theatrical dances or plays that were performed as ritual offerings in temples and shrines before the advent of Noh and Kyōgen.

During the Muromachi period (1392–1573), the actors and playwrights Kan'ami and Zeami developed the theatrical tradition known as Noh. Noh plays,

too, were originally performed as religious offerings, and they are marked by a profound sense of spirituality. The highly poetic librettos are performed using a multilayered and complex system of music, rhythm, and dance. They are often imbued with Buddhist, especially Zen, references or undertones. Many of the plays begin with the meeting of an unmasked traveling priest and a mysterious masked figure—often a young woman, though always played by a man—who tells him a story about the particular locale. In the second act, the mysterious character returns to reveal his

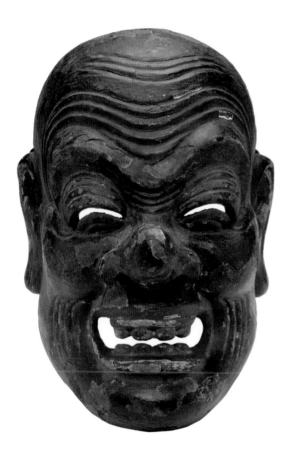

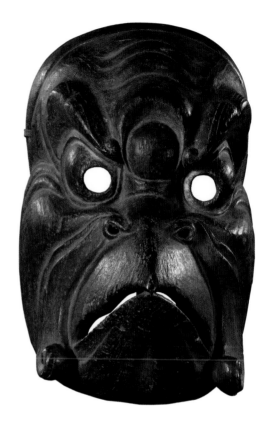

FACING LEFT

Gigaku mask of the Suikojū type, approx. 1868–1926. Japan. Wood with colors. H. 10 × W. 6½ in.

FACING RIGHT

Gigaku mask of the Konron type, approx. 1868–1926. Japan. Wood with colors. H. 9½ × W. 7⅝ in.

ABOVE LEFT

Bugaku mask of the Emimen type for the Ninomai dance, approx. 1800–1900. Japan. Wood with colors. H. 11¾ × W. 7¾ in.

ABOVE

Tengu-type mask, possibly Sarutahiko Enmei, 1700–1850. Japan. Wood with colors. H. 11⅝ × W. 6¾ in.

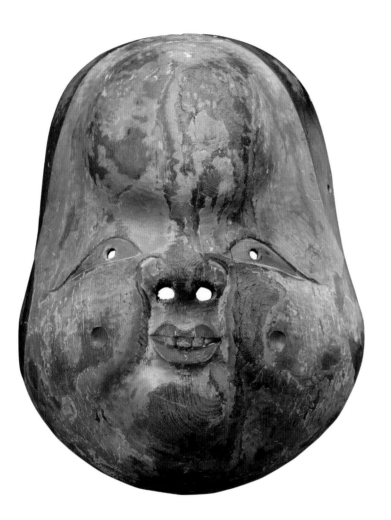

Kyōgen mask of the Oto type, approx.
1868–1926. Japan. Wood with colors.
H. 9⅛ × W. 7⅛ in.

or her true form: a ghost or a deity who revisits the past or celebrates the gods through song and dance. Noh plays are often slow and stately, but they almost always build in speed and dramatic intensity within the individual plays and within the selection of plays chosen for a day's program.

Kyōgen, a sister tradition to Noh, is presented in a more vernacular and less poetic language. Kyōgen plays are performed in the same program with Noh plays, but they serve as comic interludes; accordingly, Kyōgen masks are often comical and distorted. Masks are used less frequently in Kyōgen than in Noh, and with less obvious mystical intent. But the combination of the sacred quality of Noh and the profane quality of Kyōgen in itself evokes a fundamental Buddhist concept expressed in the Heart Sutra, that emptiness (enlightenment) and form (human worldliness) are in fact one and the same. The Kyōgen actor, while a comedian, is acutely aware of the seriousness of his undertaking.

The masks used in Noh generally fall into specific types, based on early prototypes, which can be grouped into larger categories. While the masks

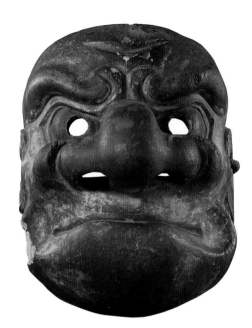

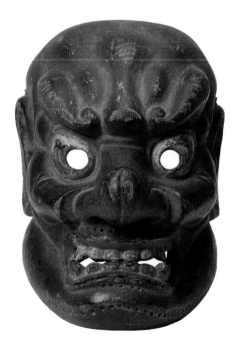

TOP RIGHT
Noh mask of the Beshimi type, approx. 1600–1800. Japan. Wood with colors. H. 9⅛ × W. 7⅜ in.

RIGHT
Demon mask, approx. 1868–1926. Japan. Wood with colors. H. 9⅓ × W. 7⅛ in.

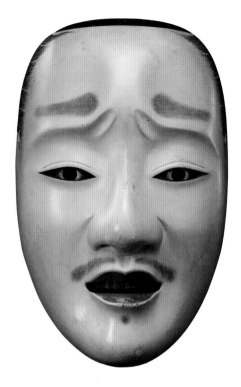
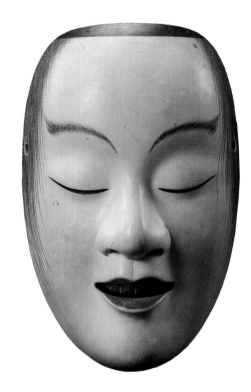

suited to specific roles are usually limited, an actor can choose the individual masks he will wear onstage. His mask and costume choices greatly impact his presence onstage and thus reveal to the audience his interpretation of a role.

Noh masks are carved to reveal a range of sensitively expressed emotions as the actor turns on the stage. If a mask is viewed flat from the front, it may express one emotion, while if it is turned to the left or right, or if it is tilted up or down, it may reveal different traits—sadness, regret, anger, joy. The emotions expressed in the masks relate closely to the choreography of the dances, which in turn are based on the meaning of the lyrics, sung by an unmasked chorus sitting on the side of the stage. The narrative and emotional content of the lyrics are also expressed through the rhythms and melodies of the drums, flute, and vocals.

In many of these performance traditions, the mask itself represents the presence of a god or otherworldly being. Indeed, the prototypes for the earliest Noh masks are thought to have been wooden

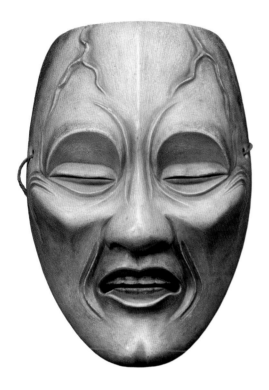

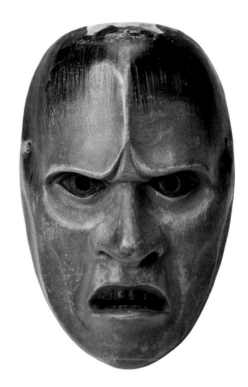

sculptures representing Shinto deities. In Noh plays, the unmasked characters represent ordinary human beings. The wearing of a mask thus signifies the presence of a ghost or deity; the mask itself is accordingly treated as a sacred object imbued with spirit by the actor who wears it. Before putting on a mask, an actor holds it carefully and bows to it with reverence. When he puts it on, he is transformed. Perhaps this transformation is why it is said that in Noh, it is not the actor who dances but the mask that dances. Through the mask, humanity connects with the divine.

FACING LEFT
Noh mask of the Chujō type, approx. 1868–1926. Japan. Wood with colors. H. 8 × W. 5¼ × D. 3 in.

FACING RIGHT
Noh mask of the Semimaru type, approx. 1868–1926. Japan. Wood with colors. H. 8 × W. 5¼ × D. 2¾ in.

ABOVE LEFT
Noh mask of the Kagekiyo type, approx. 1868–1926. Japan. Wood with colors. H. 8½ × W. 5⅛ × D. 3 in.

ABOVE
Noh mask of the Yaseotoko type, approx. 1868–1926. Japan. Wood with colors. H. 8¼ × W. 5¼ × D. 3 in.

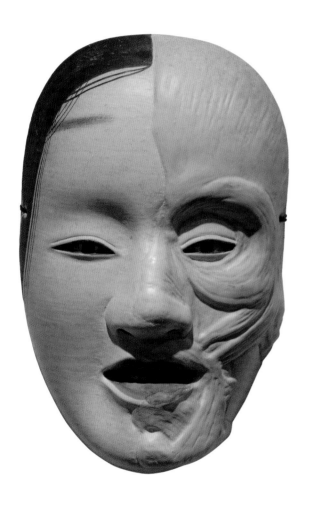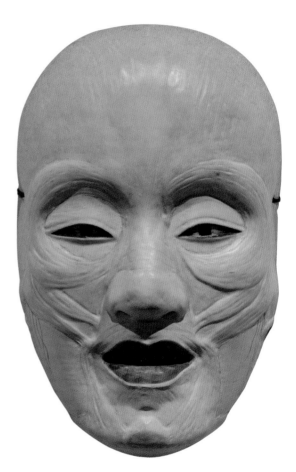

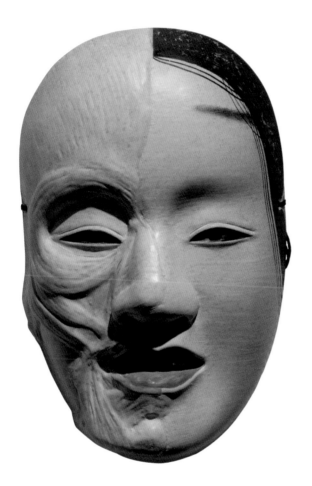

MOTOHIKO ODANI

Using diverse mediums, Motohiko Odani explores mutations of nature, physical sensations, and psychological states. His imagined hybrid creatures trigger ambiguous and visceral reactions with their eerie combinations of beauty and the grotesque. *SP Extra: Malformed Noh Mask Series: San Yugo*, 2008, reinterprets traditional Japanese Noh masks to examine transformations of the psyche and the spirit. Noh plays depict one all-encompassing emotional state of a main character. Actors wear masks to disguise the ordinary and to elevate action to a spiritual, psychological plane with a sense of *yugen*—an ineffable mystery and profound beauty that is evoked rather than stated. On one hand, the evocative power of Odani's masks honors this aesthetic tradition. On the other hand, his malformed faces disrupt it by revealing what lies beneath the surface. A.H.

SP Extra: Malformed Noh-Mask Series: San Yujo, 2008. Wood, natural mineral pigment, and Japanese lacquer. Set of three; each H. 8⅞ × W. 4⅞ × D. 2¾ in.

Animal mask, approx. 1800–1900.
Probably India. Wood. H. 8½ × W. 8 × D. 4 in.

Human mask, approx. 1800–1900.
Probably India. Wood. H. 9 × W. 8 × D. 6½ in.

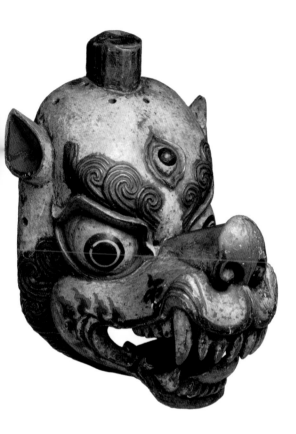

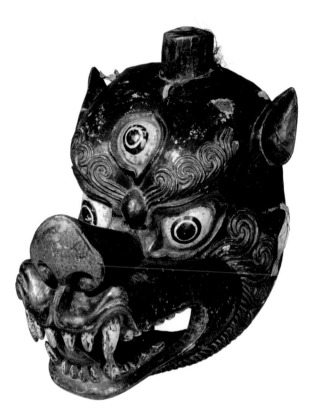

Animal head mask, 1700–1800.
Tibet. Wood. H. 14½ × W. 9½ × D. 10½ in.

Blue lion mask, approx. 1700–1800.
Tibet. Painted wood. H. 12½ × W. 9¼ × D. 11½ in.

JAGANNATH PANDA

Jagannath Panda casts symbolic animals and other creatures as "actors" in his painted works inspired by the rapid overdevelopment of his hometown just south of New Delhi. In his compositions, shifting scales and perspectives that recall traditional Indian paintings combine with modern symbols of urbanism, offering an ambivalent view of cultural development that reenacts the past in the present. Using a collage process that echoes his layered references, the artist embellishes the surface of his canvas with everyday materials and fabrics to suggest textures found in nature, grounding one foot in reality during the viewer's trip in the mythological world. Oscillating between traditions, meanings, and moments in time, Panda's works visualize how imagined and real symbols, like life itself, are constantly changing.

The Cult of Survival II (pages 16, 40), Jagannath Panda's coiled serpent sculpture, combines the most banal of materials—plastic pipe, car paint, and plastic flowers—with the serpent's multicultural spiritual and mythological symbolism, which is often linked to the creature's ambivalent nature. In various cultures, serpents represent death and desire, creation and the underworld, protection and deceit. In the Indian context, serpents are neither wholly positive nor wholly negative; they are respected and revered as a form of the divine as well as feared for their power. Overlapping these ambiguous mythological meanings with everyday realities, Panda's snaking pipes form an Ourobouros that questions humans' "instinct of survival and ecology, of death and renewal of life."[1] A.H.

The Cult of Appearance III, 2012.
Acrylic, fabric, plywood, glue, and paper, with glass
and plastic gems on canvas. Diptych; overall H. 81 × W. 165 in.

1 Jagganath Panda, e-mail correspondence with the
 author, September 14, 2011.

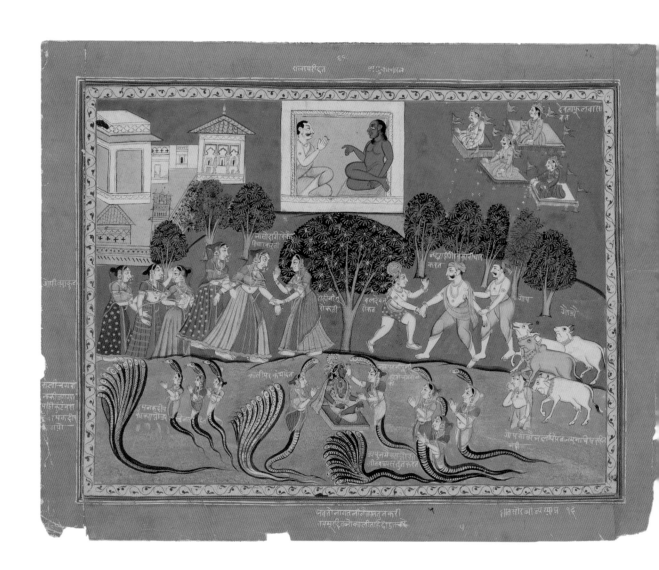

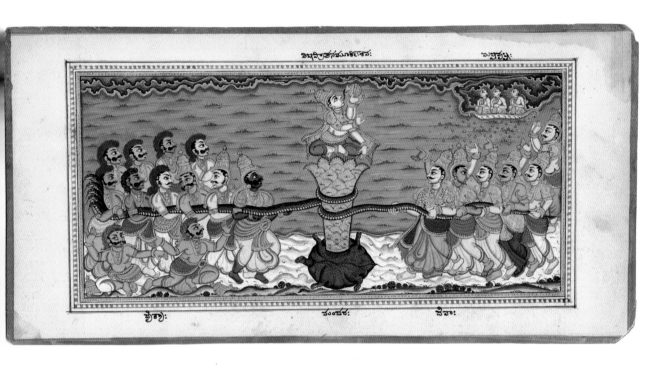

ABOVE

The gods and demons churn the ocean of milk, approx. 1800. India; Mysore, Karnataka state. Opaque watercolors on paper. H. 7¼ × W. 14¾ in.

LEFT

Vishnu asleep on the serpent in the cosmic ocean, 1850–1900. India or Pakistan; Kashmir region. Opaque watercolors on paper. H. 2⅜ × W. 3½ in.

FACING

The encounter between the Hindu god Krishna and the serpent Kaliya, from a manuscript of the Bhagavata Purana (the story of Lord Vishnu), approx. 1800. India; Madhya Pradesh state, former kingdom of Datia. Opaque watercolors on paper. H. 12 × W. 15¼ in.

RAQIB SHAW

Raqib Shaw's intricate paintings draw us into a part-fantastical, part-naturalistic universe often described as "phantasmagorical." In *Ode to the Lost Moon of the Lesser Himalayas on the Banks of the Lidder*, hybrid animal-human figures inhabit a landscape that has elements of reality—a starry night sky, a luminous moon, and dense green trees, all set on a river known for picturesque, peaceful banks protected by mountains. Yet these scenes also seem to depict another reality envisioned in the artist's mind. With a surrealistic touch, Shaw's compositions are at once sensual and grotesque. His methods and materials—glitter, rhinestones, and industrial paint applied painstakingly with a porcupine quill—are both banal and refined. He mixes inspiration from Kashmir decorative arts with Japanese screens, Mughal miniatures, Milton's *Paradise Lost*, and the works of northern European painting masters such as Hieronymus Bosch, Hans Holbein, and Lucas Cranach. The results are formal and narrative combinations that reflect the artist's global biography. Born in Kashmir, Shaw was raised in a Muslim family of mercantile traders but moved to London to attend art school in 1998. Shaw's fusion of cultural and historical source materials questions how one situates oneself in today's interconnected global culture. His precise ornamentation beckons us to immerse ourselves in his alternate realities and challenges us to find our own connection to—and transformation within—the irrational realm.

A.H.

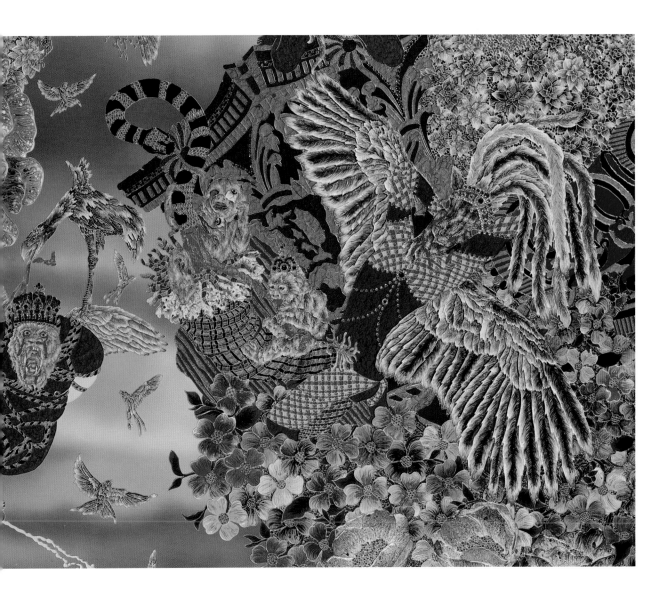

Absence of God VII, 2008 (detail above). Acrylic, glitter, enamel, and rhinestones on board. H. 96 × w. 60 in.

Ode to the Lost Moon of the Lesser Himalayas on the Banks of the Lidder, 2009.
Watercolor, acrylic, enamel, glitter, and rhinestones on paper mounted on panels.
One panel: H. 32¹³⁄₁₆ × W. 43⅝ × D. ½ in. Two panels: each H. 43⅝ × W. 32¹³⁄₁₆ × D. ½ in.

ADEELA SULEMAN

Adeela Suleman's steel relief integrates traditional motifs from nature with symbols of its destruction, a jarring combination that references the political violence of her native Pakistan. "The current turbulent political situation is ever present. It has taken over our existence,"[1] describes Suleman of Pakistan's Islamic state, where everyday life is, for many, inseparable from religion. The artist integrates her response to contemporary life with imagery of her childhood: auspicious banana plants; peacocks, symbols of beauty associated with bad luck; parrots, storytellers of both the good and the bad in life. Along the same lines, one cannot help but notice the missiles and suicide jacket of Suleman's work that suddenly declare themselves in stark opposition to their beautifully ornamented surfaces. These tragic symbols of war and death make reference to violent religious extremism, martyrdom, and the perversion of Islam's true principles and remind us that "death is all around us. The most certain thing in life has become uncertain."[2] A.H.

1 Adeela Suleman, from "Death and the Maiden: Quddus Mirza in Conversation with Adeela Suleman," in *After All, It's Always Somebody Else . . .*, exh. cat. (London: Aicon Gallery, 2010). The conversation is reprinted in this catalogue.

Untitled 1 (Peacock with Missiles), 2010. Steel. Edition 1 of 3. Dimensions variable.

DEATH AND THE MAIDEN A Conversation with Adeela Suleman

Quddus Mirza

There is a strong link between meditation and mortality. While the practice of meditation often involves concentration on and control of breath—the essence of life—the contemplation of death is a corresponding component of many meditative traditions.

Quddus Mirza: Death seems to be a constant and recurring motif in your work; can you please share your views on this, which, it appears, has lately become a main concern for you?

Adeela Suleman: Death is all around us. The most certain thing in life has become uncertain. Life and death are running parallel to each other. If we compare it with history, contemporary society has increased our capacity to destroy life in various horrific schemes, but we have also found ways to have longer, happier, and healthier lives. Still, unexpected, shocking, and horrendous deaths have been glamorized by the media to the extent that these have turned into entertainment, whereas natural death has become so subtle and comfortable that it's nearly invisible—or impossible!

Adeela Suleman
Sketch of *Untitled 1* (*Peacock with Missiles*) with added elements, 2011. Ink on paper.

QM: It appears that your recent work is deeply rooted in the situation in your surroundings. In your opinion, how is a work of art linked to its immediate environment or to political conditions, or to politics in general, because political situations keep on changing, while the work of art is supposed to be the creation for a wider and lasting effect?

AS: To have a longer and lasting effect does not mean that you can't produce works of art that won't change in one's lifetime. Life is all about the process, it is never the end. It's an accident of history that I was born in a certain class, city, and country. My political awareness as an urban being, my cultural affiliations, and my upbringing all feed into the way I think. I, as a person, am constant in my work, but life moves and subsequently the work is altered. That's what makes the situation and relationship of life and art challenging and interesting.

QM: Do you think "the political" matters, especially the grim scenario of our urbanity, which provides an easily available subject matter to some of our artists? If so, how do you analyze or differentiate between a genuinely felt feeling and an obligation assumed mainly for the outside public?

AS: For me it does. I have been to many discussions where the artists were questioned about their creativity when the subcontinent was divided, during the two wars between India and Pakistan, and when Dhaka was surrendered by the Pakistan army and millions were massacred in East Bengal. We were always questioned why artists were not commenting on those events. Yet there were very few artists who experienced those incidents and reacted to them. But now things have changed. The current turbulent political situation is ever present. It has taken over our existence. It's impossible not to think about it. In the past, what was happening in Bangladesh was not known to the people living in the other part (West Pakistan) of the country; but now you drop a bomb in Bajaur, Damadola, Waziristan, any place in the northwest of Pakistan or anywhere in the world, it's shown live on television. Death has come closer, at our threshold, in our living rooms. You can't ignore it; it's in your face. How can you not talk about it in/through your work?

QM: Can you please share your creative process? How do you start work? Does the idea emerge first, or does the image take shape before other elements? Or are you inspired from a certain material or technique before anything else, especially in reference to your present body of work?

AS: Of course, the thought process starts way before anything. Something that bothers me or affects me usually becomes my work. I draw on whatever comes to my mind. I always think in 3D terms; thus, the materials play a very important part, as sometimes, I look at something and I know exactly what I want to do with it.

As far as this body of work is concerned, I did small drawings and those drawings were then transferred onto the computer. I researched and tried to find similar things from the Internet, books, craft books, and different other sources. After that, the elements were juxtaposed with each other til they looked the way I wanted them to appear. Then, they were composed on the computer, made to size, and printed. Lastly, the rest of the details were added and the process of physical execution began.

QM: Do you get influenced or inspired from text, which can be in the form of literature, newspapers, or merely words and certain phrases that catch your attention and ignite ideas?

AS: Daily comments, people talking, newspapers, and books certainly feed into my thought process. My critical discussions with my husband, friends, and family play a very important role.

QM: What is the role of your childhood, memories, and maybe stories told by your mother and grandparents in shaping your aesthetics?

AS: Childhood experiences and memories are always there with me and in my art. I remember my grand-

mother telling us stories or *qissas* about everything that we did as children. There would be either a lesson in her story or a moral/warning to learn from it. I can't remember a single summer vacation when my mother did not make me do a course in sewing, embroidery, and cooking. She used to tell us that there is no such thing as getting bored. Find your passion and you will enjoy life.

My grandmother was so funny. She was like a "finishing" school. She made sure that we were never idle. She used to make us do household chores again and again til we achieved perfection. We always made something with her. She had these strange combinations of doing things. For example, she would always plant a banana tree in our house but then she used to say that the snake would come because of it so she would grow *nagphali* (a kind of plant [literally, a snake fruit or snake plant]) all around the house as an anti-snake thing. Our neighbors had a peacock as a pet and she used to warn them all the time not to keep it, as it cries in the night and brings bad luck.

QM: How do you place yourself in today's Pakistani art? Do you link yourself with the region, its cultural identity, or a certain artistic movement?

AS: I was born and have always lived in this part of the world. I was raised in a Muslim family, and Pakistan is an Islamic state, so religion is a part of me. All my experiences and upbringing are deeply rooted in this culture—which is not limited to this location,

since it is a north Indian culture that we share with India. In any case, my family migrated from India, and half of our family is still on the other side of the border. So all the stories told to me, my growth as a person, and my socialization are deeply rooted in this tradition, custom, and religion—which are beyond a specific border. And on top of it, I studied art from David Alesworth (an English sculptor working in Pakistan), so if you trace the work, you will find the roots everywhere.

QM: Does the question of tradition and modernity, especially its fine balance, interest you or do you find it not very relevant as a practicing artist?

AS: Tradition is often considered as a "thing of the past" without any contemporary legitimacy. But in a country like Pakistan, where tradition and modernity run parallel to each other, I feel the balance comes automatically, relying on the tradition while making something modern.

QM: Do you define yourself as a Pakistani artist? And do you think an artist's origin or bond with a region is necessary or important in order to evolve as a maker and for others to understand the artist's ideas, images, and approaches?

AS: I think my art would have been completely different if I had been born in some other part of the world. The very fact that my art is of a certain type

leads it to be labeled as Pakistani art. But once the artwork is made I feel it should have no boundaries; it can be viewed by any audience. An artwork should not be dependent on a location for its viewing or for its understanding.

QM: How has the experience of exhibiting and interacting with a broader audience manifested in your work?

AS: It has become more challenging. When you put your artwork out internationally, I guess one tends to become more responsible.

QM: In that sense, are issues such as originality, authenticity, and ethnicity relevant in today's art world/artworks?

AS: When one is true to one's self, one experiences authenticity as a self-reflective and emotional experience. If it is true, originality will come automatically. Ethnicity is for self-identification.

QM: Do you believe that artworks, regardless of their diversity of concerns and appearances, are autobiographical in one way or another? If so, how does it happen in your case?

AS: I believe whatever I create is who I am, what I am thinking, and what I believe in. If you want to say that artworks are autobiographical, then I guess yes, they are. They tell you the twists and turns in one's life and how one has developed as an artist, but then they also reflect the society in which we live.

QM: In what way do you think your previous body of work, particularly the appropriation of popular art and artifacts, is connected to your new works?

AS: In the past and even now, I work with found objects. I used to change them to the extent that they became my own, and then they were embellished with the available craft. The difference now is that craft itself is employed as an object. The form has come out of the craft rather than the former becoming the skin of an object.

QM: In the new works, the choice of imagery is specific, and one can trace a shift in your preference for the picture plane—which, compared to your earlier works' three-dimensionality, is more flat. How can you describe the reasons for this development?

AS: It's like telling a story. There are parrots, peacocks, and other entities. It's like having totem poles. Each element chosen has some bizarre connection to what I am thinking and with how I have been raised.

For example, the parrot is always there to witness the event, and it is said that parrots travel from place to place telling stories. It's like seizing the moment. Like a snapshot. Narrative, a sequence of events, is now playing an important role in my work.

All the childhood stories, *qissas*, *kahawatain* [proverbs, anecdotes], they are all present in the times in which I live.

QM: Who do you think is your preferred audience? or your ideal audience?

AS: Everyone. Whoever sees the work is the ideal audience. I have no distinctions in my mind. Unfortunately, in our part of the world, art is still not public due to the lack of public museums and public art. Because of this, art is still an elitist activity shown in enclosed environments to the select few. In addition to this, art is now being exported. So what we see locally is either through a website/catalogue or in printed format.

QM: What can be a perfect blend of content and form, particularly in reference to your work?

AS: I think of the "dead bird curtain." It is a perfect blend of content and form for me. In contemporary Pakistan, death surrounds us, so the birds are dead; and like any other "thing" they make a pattern, a simple pattern that silently repeats itself. Their presence indicates silence, a silence that haunts you. A silence that is disturbing, because you always associate noise with birds. In that way I have tried to incorporate image, idea, and form into one entity.

QM: How and when do you decide that an artwork is complete?

AS: I guess never. It just happens. Sometimes, I complete the work and then dismantle it and start fresh. It's a never-ending process!

PRABHAVATHI MEPPAYIL

Prabhavathi Meppayil treats wooden panels with lime gesso and embeds metallic wire into their perfect surfaces with ritualistic precision. Her minimal compositions and subtle use of color draw in viewers, initiating a meditative interaction that transmutes metal and gesso into forms that emerge from and fade back into the surface, hovering between material and line, sign and signifier, absence and presence. Meppayil challenges us to grasp her works' "resonance of silence"[1]—a contradiction suggesting that neat resolutions to these oppositions are not the point. The daughter of a goldsmith, she uses traditional Indian goldsmiths' tools to apply material to her panels and in doing so connects to long-held indigenous craft methods. At the same time, her surfaces bring to mind Renaissance frescoes, Indian temple murals, Islamic ornament, and the minimal aesthetics of the 1960s and 1970s—all visual traditions that, like Meppayil's practice, seek to inspire connection to the metaphysical in various ways. A.H.

1 Prabhavathi Meppayil, e-mail correspondence with the author, August 25, 2011.

LEFT

Untitled—CU1—2011, 2011 (detail above).
Copper wire embedded in lime
gesso panel. H. 48 × W. 72 in.

Untitled—CU2—2011, 2011.
Copper wire embedded in lime
gesso panel. H. 48 × W. 72 in.

Untitled—CU3—2011, 2011.
Copper wire embedded in lime
gesso panel. H. 48 × W. 72 in.

POURAN JINCHI

Arabic calligraphy not only preserved and transmitted the Koran, but also represented Allah in lieu of figurative images considered idolatrous. Pouran Jinchi's *Prayer Stones* explore this translation of text and image to examine broader relationships between aesthetics and faith. Jinchi created a group of eight prayer stones for *Phantoms of Asia*. She begins with traditional Shia Muslim prayer tablets (*mohr*)—used as headrests while prostrating during prayer—from the holy city of Mashhad, Iran, where she was trained as a calligrapher. Employing cobalt blue and white glass lacquer paint reminiscent of Persian glaze developed in Iran during the ninth century, Jinchi transforms their baked clay surfaces. By accentuating the prayer stones with calligraphy and decorative elements, she highlights their spiritual and ritual purposes to focus meditation on God during prayer. A.H.

Prayer Stones, 2011. Collection of eight works; baked clay and lacquer paint.
BOTTOM TO TOP
Prayer Stone 1: H. 3½ × W. 6 × D. ¾ in.
Prayer Stone 2: H. 4 × W. 4 × D. ¾ in.
Prayer Stone 3: H. 3 × W. 3 × D. ½ in.
Prayer Stone 4: H. 2¼ × W. 3 × D. ½ in.
Prayer Stone 5: H. 2 × W. 2 × D. ½ in.
Prayer Stone 6: H. 1¾ × W. 1¾ × D. ¼ in.
Prayer Stone 7: H. 1¾ × W. 1½ × D. ½ in.
Prayer Stone 8: H. 1½ × W. 1½ × D. ¼ in.

YOSHIHIRO SUDA

Yoshihiro Suda hand-carves and paints wooden plants and flowers with meticulous, realistic precision and subtly places them in surprising locations, such as in the corner of a room or inside a gallery vitrine. His process recalls Japanese *netsuke*: miniature, hand-carved figures of extraordinary craftsmanship that were especially popular during the Edo period (1615–1868). Suda's intent is not simply to replicate nature but to create circumstances for a dramatic discovery of the unexpected. Within the space they quietly inhabit, the carved plants provoke an emotional response to that space and challenge viewers to pause and reconsider their surroundings in that moment. While the delicate beauty of Suda's flowers remind us of the cycle of life, and of our own place within this cycle, their exquisite craftsmanship epitomizes the hand's potential to elevate the simplest of materials to a spiritual plane.

A.H.

Kasuga deer deity. Deer: Heian period, pigment on wood; Monju Bosatsu: Kamakura period, pigment on wood; Negoro lacquer tray: Kamakura period, the second year of Tokuji (1307), former collection of Sankei Hare; Sakaki plant and antlers, 2010, by Yoshihiro Suda, pigment on wood. H. 13⅜ × W. 16½ × D. 11⅝ in.

173

CONVERSATION WITH YOSHIHIRO SUDA

Laurie Britton Newell
Translated by Toru Senso

Yoshihiro Suda works from his apartment in the Yanaka district of Tokyo, a low-rise residential area full of temples. When I visited him he was in the process of redecorating the flat. A beautiful wooden floor had recently been laid and Suda said that he was reluctant to varnish it, preferring to wait and see how it would warp with time. His studio is a modest-sized room with a workbench, a bookshelf, and a large window that looks out over a balcony and neighboring rooftops. Two weeds have poked themselves out between the balcony tiles. He works sitting in an office chair, the plastic armrests of which he has replaced with wood, preferring the feel of it. To the right of his bench, planks of magnolia wood rest against the wall; to the left, a large vise stands on the floor. Suda demonstrated his method for cutting wood using the vise. By pressing a sharp blade into a block and tightening the vise, he is able to split the wood without disturbing the neighbors with banging. His carving tools are laid out on the desk, a small handsaw and a collection of different-sized chisels. Also on the table is an unpainted flower. The petals are paper-thin, and when you hold them up to the light they are almost translucent.

Yoshihiro Suda
Tulip, 2007. Paint on wood.
Size varies according to site.

174

Yoshihiro Suda
Weeds, 2008. Paint on wood.
Size varies according to site.

Laurie Britton Newell: Why are you preoccupied with the ordinary?

Yoshihiro Suda: Probably because of my personality—I am interested in ordinary things, not only in my artistic life but also in my daily life. I like ordinary things, not the special or the particular. I want to feel their reality so it is from my life, the things that I can see with my eyes, through windows, while I'm walking.

LBN: Do the particular types of weed that grow in some districts of Tokyo have a special significance for you?

YS: I don't know many names of plants, like weeds on the ground, so I just give my works the title "weed." I don't signify special meanings, just the things that are generally there, that's what I make. It doesn't mean that the name of the plants has a particular meaning or something. Of course if I check in the botanical books, I can find out. But is it so important to know the "what" of the weed?

LBN: Perhaps the opposite—it's more important that you don't, that they are anonymous?

YS: I just find them in the street, and I think it's nice, and that's why I made it. Simply.

LBN: Is your preoccupation anything to do with nature in the city, something natural growing in a very urban place?

YS: I'm interested in the plants growing in a town and city now because I'm living here now. Until I was eighteen years old I was living in the mountains, in nature. But for me, for the subjects of my artworks I rather prefer the plants that grow in the city.

LBN: Could you talk me through your working process, from where you buy the wood all the way through to the end of the process?

YS: I buy Japanese magnolia wood as a log, from a wood store, and make 10-centimeter slices from it. Usually you leave it to dry for more than five years but if you slice it like this it dries much faster, and you can use it in two or three years.

LBN: Where do you dry it?

YS: In the flat.

LBN: Just up against the wall?

YS: No need to bring it to a particular place, I just leave it! As long as it is somewhere sheltered from the rain, it can dry naturally. After it is dry I cut it into blocks, as much as I want. Sometimes I use a knife or a machine. And then I carve. I don't draw anything on the wood, I just look at the blocks and start carving. I don't sketch. I just have the picture or the real thing in front of me and the block and start carving.

LBN: Do you use particular blocks of wood for particular plants because of the veins in the wood?

YS: I always use the same magnolia wood, so it doesn't matter what I'm making. Because of the grain of the wood, there is one direction that is easy to carve. But it is not the pattern of the design, as I will paint it afterward so that you can't see it. So to choose the wood, this is more a technical reason rather than a pattern.

LBN: So it's very different from the way you sculpt marble in terms of veins. Presumably you start with larger chisels and then get smaller and smaller for the fine work?

YS: My method is that I divide the piece into parts. For example, if it has six petals, I make each petal individually and I must finish each petal, then combine them together with glue. I don't roughly finish the petals and then put them together. Your next question is how long it takes me to make this?

LBN: Yes!

YS: Probably four or five hours for one petal up to the same stage, probably two petals a day if I work a long day.

LBN: So all in all, for it to be finished and painted?

YS: Five days to a week for a flower, but for a small weed maybe one or two days.

LBN: Now that I have seen your pieces with my own eyes, they are so well made, so perfect, they have stopped looking handmade. Why do you do all of this painstaking work to make something that is not obviously made by a human?

YS: Simply, I want to know how detailed I can make it, how real I can make it. This is the goal, the objective. This is an old-fashioned way of thinking, to make something that is so real that it looks like the original. It is not the fashion now, to observe something and make it very real, but the idea itself is very deep. To make this kind of copy, the technique is very important. There are no goals as such, just the idea that I can make it better next time.

LBN: Is your work inspired by the traditions of trompe l'oeil or still life?

YS: I don't think I am inspired by trompe l'oeil, but maybe you could say the idea is something similar. Often people think that my work may be in the trompe l'oeil style. But actually my artwork includes the installation itself. Before I make artworks, most of the time I will see the location, the location is very important—for example, I am not interested in putting my works on a display table, it is not interesting to me. In a museum or a gallery I like to see the space first, as the location itself is also part of my artwork.

LBN: To an international audience, what can be read as particularly Japanese about your work?

YS: I feel that my artworks are not strongly Japanese. The Japanese feeling of the work is in my attraction to traditional things, and their inherence in my work.

LBN: What about traditions of culture, or lifestyle?

YS: Not lifestyle, but cultural traditions: Japanese art, historic artworks such as netsuke. Not only in wood, but also in painting.

LBN: You say it is as important where the work is installed, so you are interested in creating spectacle— an interesting combination of making something ordinary and everyday and the spectacle—a clash. What do you think?

YS: Even though the scale of my work is small, if people find them, they can change people's feelings. . . . If you can take an interest in even the small things, it

can change the atmosphere and the feeling of your surroundings. It makes you feel different from before.

LBN: There is an interesting combination of the real and the fictional—weeds don't really live in museums . . .

YS: I don't intend to surprise. Mostly when I see a spot I like at the location then I decide what to put there. I don't have such a strong meaning in mind. I don't want to make people feel something like surprise, something against a place's natural feeling. That is not important. . . . I like people to smile when they find my work. That is what I want. To make people smile, as they would naturally. Not to try and teach them anything.

LBN: To get the joke—to understand it?

YS: To relish it—yes . . . a very natural smile.

Yoshihiro Suda
Morning Glory, 2010. Paint on wood.
Size varies according to site.

RITUAL VESSELS FROM KOREA

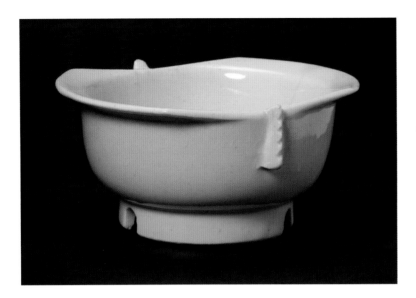

Ritual bowl, approx. 1700–1900.
Korea; Joseon dynasty (1392–1910).
Porcelain with bluish gray glaze.
H. 2½ × DIAM. 5⅝ in.

**Jar with plum blossoms, bamboo,
and trigrams**, approx. 1800–1900.
Korea; Joseon dynasty (1392–1910).
Porcelain with underglaze decoration.
H. 5⅝ × DIAM. 7¼ in.

Ritual plate, approx. 1800–1900.
Korea; Joseon dynasty (1392–1910).
Glazed porcelain. H. 3⅝ × DIAM. 8 in.

Ritual plate, approx. 1800–1900.
Korea; Joseon dynasty (1392–1910).
Glazed porcelain. H. 3⅜ × DIAM. 7⅜ in.

ABOVE
Ritual dish, approx. 1800–1900.
Korea; Joseon dynasty (1392–1910).
Glazed porcelain. H. 4 × DIAM. 5½ in.

ABOVE RIGHT
Ritual dish, approx. 1800–1900.
Korea; Joseon dynasty (1392–1910).
Glazed porcelain. H. 6½ × DIAM. 8¼ in.

RIGHT
Ritual plate, approx. 1800–1900.
Korea; Joseon dynasty (1392–1910).
Glazed porcelain. H. 4⅝ × DIAM. 10¼ in.

CEREMONIAL VESSELS FROM CHINA

Ceremonial vessel in the shape of a phoenix.
China; Ming dynasty (1368–1644).
Bronze with silver inlay, gilded copper inlay,
and painted lacquer-simulated patina.
H. 11⅝ × W. 8½ × D. 4½ in.

Ritual object (*zun*) in the shape
of a goose, approx. 1800–1900.
China; Qing dynasty (1644–1911).
Bronze with gold and silver inlay.
H. 12 × W. 16½ in.

ADRIAN WONG

With a background in developmental psychology, Adrian Wong researches his chosen subjects for months in preparation for the final work. This intense process—which includes conducting interviews and delving into historical archives, photographs, and video memorabilia—gives his work a rich layer of historical and emotional context, while also allowing him to be exceptionally precise in his execution. For *Phantoms of Asia*, this activity involved multiple visits at the Asian Art Museum with local feng shui experts in order to determine the construction of his site-specific installation: two rooms, one auspicious and one inauspicious, that explore the effects of manipulations of space. In his words, he "came to see feng shui as a concretization of metaphor, a beautifully crafted structure within which adherents are given a means to reflect on the inherent harmonies and disharmonies of their surroundings."[1] His deference to the feng shui practitioners reveals his commitment to uncover our ability to perceive the effects of the slightest, nearly imperceptible, changes to a space, and how that in turn affects our experience. His incorporation of the museum's Korean ritual objects into the installation—ceremonial food dishes, bell cups, and ritual offering bowls—emphasizes not only the ritual nature of feng shui but also his meticulous, research-based process. A.H.

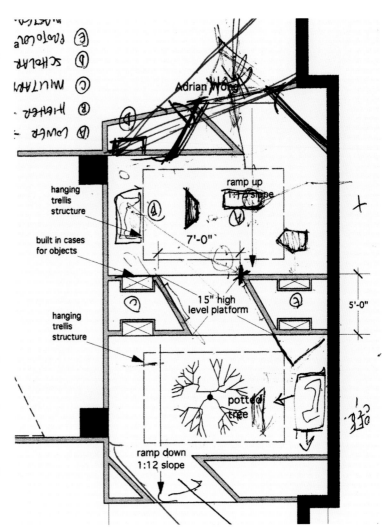

Sketches for *Geomantic Intervention I, II*, 2012.

1 Adrian Wong, "A Study of the Poetics of Negative Space," which appears elsewhere in this catalogue.

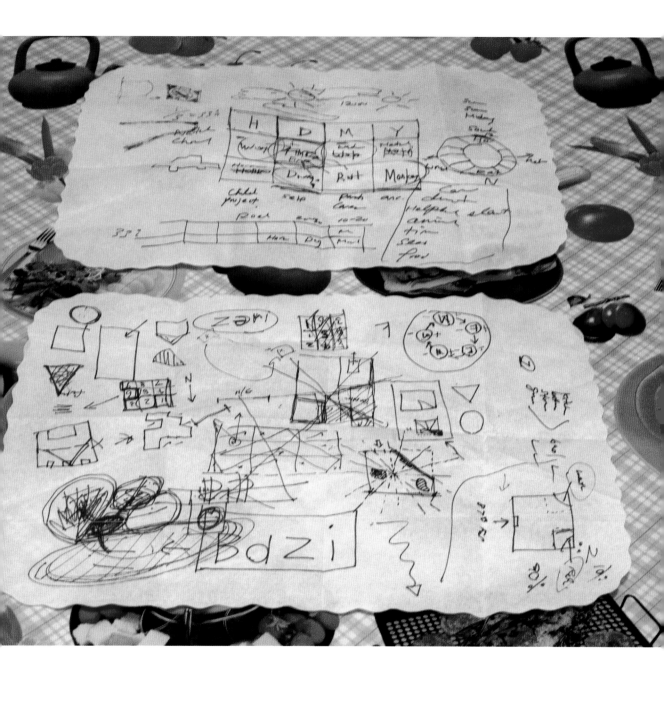

A STUDY OF THE OBJECTIVE POETICS OF NEGATIVE SPACE

Adrian Wong

Imagine a square room, 100 meters by 100 meters, centered at 37 degrees, 46 minutes 49 seconds north and 122 degrees, 24 minutes 59 seconds west. The corners of the room intersect at the compass bearings northeast, southeast, southwest, and north-west so that each wall runs either east-to-west or north-to-south. If a single chair were placed in this room, what would be its optimal position and orientation?

This is the scenario I presented to a number of feng shui practitioners in the Bay Area, aiming to use a minimalist approach to reveal the mechanics of traditional Chinese geomancy. Given the range of approaches and schools that the consulting practitioners subscribed to, I wanted to establish an objective starting point—with as few variables as possible—to isolate the effects of their prescriptive manipulations of space.

I soon discovered that there were some fundamental problems with my scenario. Almost immediately, I was informed that my room needed doors. According to the Xingshi Pai (the Form school), doors allow chi to enter, and without them analyses would be moot due to the absence of flowing energy. And so my initial two variables became three: room, door, chair.

But the introduction of a door brought with it a few other practical considerations. Placement of the chair has to be considered in relation to the entry point of the room, and its orientation has to take into consideration the sitter's position relative to the entryway. Further, what type of chair is it? An office chair? A rocking chair? A La-Z-Boy recliner? Less concerned with the remedial functions and more with the experiential effects of feng shui, I decided to respond to these requests for clarification with arbitrary details—"a standard wooden armchair used for reading the newspaper."

In the Ba Zhai (Eight House) method, the space's energy configuration is calculated in relation to its primary occupant, and so the individual who would be sitting in this chair must be specified—"a forty-year-old man born on December 23." And in the Xuan Kong Fei Xing (Flying Star) method, the date of the building's construction is critical—"February 26, 1982." And so three generic variables became four specific ones: twenty-nine-year-old room, south-facing door, wooden armchair, forty-year-old man. And when I considered that this scenario left our hypothetical sitter reading in the dark, it became five: twenty-nine-year-old room, south-facing door . . . one-and-a-half-meter brass floor lamp.

Before long, I found myself describing the plight of a lonely software engineer with a penchant for experimental jazz, seeking the company of an outdoorsy life partner to share his peculiarly spartan one-bedroom apartment with. While I tried to keep the details straight, my lunch companions furiously scribbled on their placemats, making calculations and overlaying grids atop complicated diagrams of this increasingly absurdist scenario.

The thought exercise was a failure, insofar as the cleanliness of my sandbox-model of furniture placement proved untenable. I'd hoped that it would yield a systematic method for placing a set of items within a bounded space, based on rules laid out in classical Taoist texts. What I got was far from clean, and though the practitioners' methods were ostensibly mathematical, their calculations could be reproduced only if

identical input data were used. Their approaches emphasized diverse aspects of the environment (surrounding landforms, underground water sources, electromagnetic fields, and so on), and even when the same aspects were attended to, they were subject to the effects of interpretation—as were the implications of their diagnoses. If metal's wandering star is being controlled by the fire palace, earth is required to remedy the situation, because earth simultaneously diminishes fire and produces metal. But what exactly are we talking about here?

According to Taoist cosmology, the universe (the *tao*) is composed of primordial energy (or *chi*). This primordial energy can be divided into two opposing, but complementary types, passive energy (or *yin*) and active energy (or *yang*). Yin and yang occur in varying combinations as the five elements (fire, water, earth, wood, and metal), which are then subdivided into the eight trigrams (or *pa-k'ua*: *li, kun, dui, qian, kan, gen, zhen,* and *xun*) and further subdivided into sixty-four hexagrams, each with its own characteristics. "Earth" is not limited to potting soil—it includes that which carries the seasonal association of late summer; the directions northeast, southwest, and center; wetness; the colors brown and yellow; and the numbers 2, 5, and 7. It is a signifier for a constellation of signifieds. This system of categorization and assessment neatly functions from a theoretical standpoint, but how do we translate from theory-based abstraction to concrete objects? For example, if we were to consider replacing our current chair with an IKEA POÄNG lounger, would it introduce a counterproductive wood element (by virtue of its material construction), an overpowering water element (by virtue of its dominant shape), or the desired earth element (by virtue of its surface handling)?

My feeble attempts to approach the field of feng shui empirically were set aside quite early on in my research. Whether the result of my natural skepticism, the lingering effects of my postmodernist indoctrination, or the crippling specificity of the calculations required for classical analysis (for example, creating the ideal spot for lonely forty-year-old men to read the *Wall Street Journal*), universal solutions to problems of

space remained evasive. Once I stopped scrutinizing the seemingly random associations of effects and characteristics assigned to the various subcategories of chi, I came to the realization that I had inadvertently expanded my vocabulary for describing what happens *in* space. Upon analyzing the movements of energy through a room, I could give labels to my physical sensations while traversing it and, further, modulate those sensations through predetermined gestures—whether these sensations occurred physically or metaphorically (or some combination of the two) made little difference. The POÄNG *felt* wet (earthy); just as the NORD-MYRA felt cold (watery), and the AGEN, windy (woody).

The more I delved into the literature on feng shui, the less I cared about the system's efficacy. From Emperor Yu's discovery of the Lo-Shu on the back of a magical turtle in approximately 2000 BCE to identification of animal protector spirits in surrounding landforms (the Azure Dragon, White Tiger, Vermillion Phoenix, and Black Tortoise), I came to see feng shui as a concretization of metaphor, a beautifully crafted structure within which adherents are given a means to reflect on the inherent harmonies and disharmonies of their surroundings. The generation of discursive meanings is made possible by the establishment of rules that include a shared lexicon of specific terms, assigning language to spatial (qua energetic) operations. But these meanings remain essentially open, due to contemporary feng shui's absorption of various philosophies and methods over the past four thousand years. In its protracted development, countless methods have been subsumed, leading to inevitable contradictions and contraindications. What's unique is that these are embraced rather than redacted. A Flying Star analysis might indicate that the northeast sector of the house is particularly prosperous, while the Ba Zhai points to the southwest. Each subsequent analysis increases complexity, rather than reducing it, and is resolved through a process more akin to poetic compromise than clinical diagnosis—a negotiation between humans and the metaphysical constituents of the material world.

Adrian Wong
Sketch for *Geomantic Intervention I, II*, 2012.

HYON GYON

Hello! Another Me, 2011–2012.
Acrylic and Japanese paper
on panels. Overall H. 86⅝ × W. 189 in.

FACING
Dohatsu Shoten, 2010.
Satin on panel. DIAM. 70⅞ in.

Hyon Gyon paints energetic depictions of female shamans to explore themes of identity and tradition. Shamanism is still practiced in Korea; female shamans, called *mudangs*, mediate between the spirit and human worlds. These shamans are also consulted for their powers to heal, tell fortunes, and enlist help from spirits. Traditionally, female shamans were given power and autonomy outside of the patriarchal Confucian family structure, making them potent feminist symbols. Hyon Gyon frequently encircles her vibrant shamans with swirling forms of traditional objects and windswept hair that conceal their identities, not only to "make viewers puzzled and anxious"[1] but also to visualize the spiritual energy that surrounds them. As the artist tells us, the effects of this energy emanate beyond the surface of her paintings: "Shamanism healed Korean women. It works not only for me, who paints, but also for the mind of viewers."[2]

A.H.

1 Francesca Gavin, *100 New Artists* (London: Laurence King Publishing, 2011), 100.
2 Ibid.

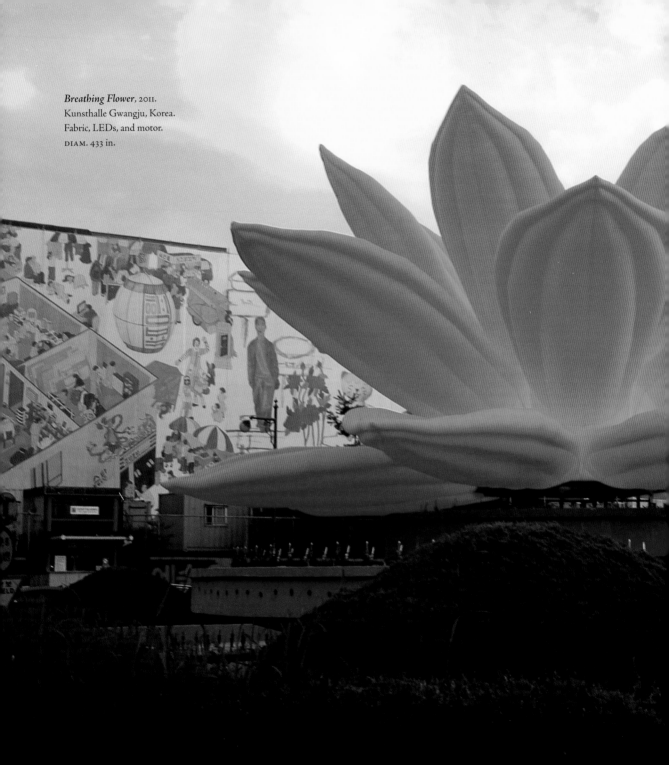

Breathing Flower, 2011.
Kunsthalle Gwangju, Korea.
Fabric, LEDs, and motor.
DIAM. 433 in.

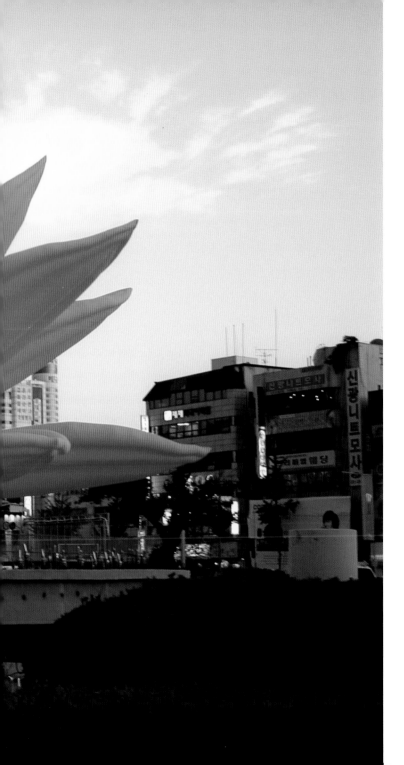

CHOI JEONG HWA

Choi Jeong Hwa uses everyday objects such as garbage, real and fake food, recyclable supplies, and mass-produced plastic—all sourced from the sites of his installations—to create large-scale, colorful installations with a Pop sensibility. The seeming contradiction between these commonplace, even cheap, materials and what is typically considered art is not a conflict for Choi. By using such materials, he invites viewers to reconsider their notions of what makes something a work of art, who can be an artist, and to whom art belongs. More specifically, he tries to find the difference between art and garbage and, in that space between the two, pinpoint what inspires people. As he explains, "I help you to feel and you find the art yourself."[1]

For *Phantoms of Asia*, Choi created a larger-than-life lotus blossom from sheets of inflatable fabric. Via a motor, the blossom opens and closes, simulating the movement of a live lotus flower, which in turn symbolizes the spiritual path a person takes through life toward enlightenment. That a symbol of enlightenment is made from ordinary materials highlights Choi's idea that anything can be art, while it also underscores subtle political messages regarding global consumerism and the environment.

A.H.

1 From an interview with Choi Jeong Hwa; http://thecreatorsproject.com/creators/choi-jeong-hwa.

193

SACRED MOUNTAINS *encountering the gods*

THE MOUNTAIN SPIRIT

Gary Snyder

Ceaseless wheel of lives
ceaseless wheel of lives

red sandstone;
gleaming dolomite

ceaseless wheel of lives

red sandstone and white dolomite.

Driving all night south from Reno
through cool-porched Bridgeport,
past Mono Lake's pale glow,
past tongues of obsidian flow stopped chill,
and the angled granite face
of the east Sierra front—

 Ah. Here I am arrived in Bishop,
Owens Valley, called Payahu Nadu not so long ago.

Ranger Station on main street,
"I'm a traveler.
I want to know the way

to the White Mountains,
& the bristlecone pines."
She gives me maps. "Here. The trail
to the grove at timberline
where the oldest living beings
thrive on rock and air."

"—Thank you for your help."

 I go to the pass, turn north,
end of day, climbing high,
find an opening where a
steep dirt side road halts.
A perch in the round dry hills,
prickly pinyon pine boughs shade,
a view to the Last Chance range,
& make a camp.

Nearby, a rocky point.
 Climb it,
passing a tidy scat-arrangement on a ledge,
stand on a dark red sandstone strata outcrop at the edge.

Plane after plane of desert ridges
darkening eastward into blue-black haze.

A voice says

"You had a bit of fame once in the city
for poems of mountains,
 here it's real."

What?

"Yes. Like the lines

 Walking on walking
 under foot earth turns

But what do you know of minerals and stone.
For a creature to speak of all that scale of time—what for?

Still, I'd like to hear that poem."

 I answer back,
"—Tonight is the night of the shooting stars,
Mirfak the brilliant star of Perseus
 crosses the ridge at midnight

I'll read it then."

 Who am I talking to? I think,
walk back to camp.

 *

Mountain village, 1832 or 1892.
China; Qing dynasty (1644–1911). Ink and colors
on silk. H. 83½ × w. 29⅜ in.

Evening breeze up from the flats
from the valleys "Salt" and "Death"—
Venus and the new moon sink in a deep blue glow
 behind the Palisades to the west,
needle-clusters shirring in the wind—
listen close, the sound gets better.

Mountain ranges violet haze back fading in the east
puffs of sailing dark-lit cloud, a big owl's
swift soft whip between the trees,
unroll the bedding, stretch out blankets on the
crunchy dry pine needles sun-warm
 resinous ground.

Formations dip and strike my sleep.

.

—Approaching in a dream:

"Bitter ghosts that kick their own skulls like a ball
happy ghosts that stick a flower
 into their old skull's empty eye—
'good and evil'
 —that's another stupid dream—
for streams and mountains
 clouds and glaciers,
 is there ever an escape?

Erosion always wearing down;
shearing, thrusting, deep plates crumpling,

still uplifting—ice-carved cirques
dendritic endless fractal streambed riffs on hillsides

—bitter ghosts that kick their own skulls like a ball
what's it all for?"

 A meteor swift and streaking
like a tossed white pebble
 arcing down the sky—

the Mountain Spirit stands there.
 Old woman? white ragged hair?
 in the glint of Algol, Altair, Deneb,
Sadr, Aldebaran—saying, "I came to hear—"

I can't say no: I speak

The Mountain Spirit

 Walking on walking,
 under foot earth turns

Streams and mountains never stay the same.

 Walking on walking,
 under foot earth turns

Streams and mountains never stay the same.

Into earth rock dives.

As the mountains lift and open
underground out,
 dust over seashell, layers of ooze,
display how it plays.

Buttresses fractured, looming,
friction only, soon to fall, each face

a heap of risks
talus slopes below
flakes weathered off the buried block,
 tricked off an old pluton,
and settle somewhere, ever lower down—
gives a glimpse
of streaks and strains, warp and slide,
abraded gritty mudwash glide
 where cliffs lean
 to the raven-necklace sky—

 Calcium spiraling shells,
no land plants then when
sands and stones flush down the
barren flanks of magma-swollen uplands
slurry to the beach,
ranges into rubble, old shores buried by debris
a lapping trough of tide flats and lagoons
lime-rich wave-wash soothing shales and silts
a thousand miles of chest-deep reef
seabottom riffled, wave-swirled, turned and tilled
by squiggly slime-swimmers many-armed,
 millions of tiny different tracks
 crisscrossing through the mud—

Peach Blossom Idyll, 1750–1784.
By Ike Gyokuran (Japanese, 1728–1784).
Ink and colors on paper.
H. 44 × W. 19½ in.

The prophet Muhammed in the cave of
1720. Northern India. Opaque watercolo
gold on paper. H. 19⅜ × W. 10⅞ in.

trilobite winding salt sludge,
calcite ridges, diatom babies drifting home,
swash of quartzy sand
 three hundred million years
 be rolling on and then

ten million years ago an ocean floor
glides like a snake beneath the continent crunching up
old seabed till it's high as alps.
Sandstone layers script of winding tracks
 and limestone shines like snow
 where ancient beings grow.

"When the axe-strokes stop
 the silence grows deeper—"

Peaks like Buddhas at the heights
 send waters streaming down
to the deep center of the turning world.

And the Mountain Spirit always wandering
 hillsides fade like walls of cloud
 pebbles smoothed off sloshing in the sea

 old woman mountain hears
shifting sand
 tell the wind
 "nothingness is shapeliness"

Mountains will be Buddhas then

 when—bristlecone needles are green!
 Scarlet penstemon
 flowers are red!

(Mountains feed the people too
stories from the past
 of pine-nut gathering baskets quickly full
 of help at grinding, carrying, healing—)

Ghosts of lost landscapes
 herds and flocks,
 towns and clans,
great teachers from all lands
tucked in Wovoka's empty hat,
 stored in Baby Krishna's mouth,
 kneeling for tea
in Vimalakīrti's one small room.

Goose flocks
 crane flocks
 Lake Lahontan come again!

 Walking on walking,
 under foot earth turns.

 *

The Mountain Spirit whispers back:
"All art and song
is sacred to the real.
As such."

Bristlecone pines live long
on the taste of carbonate,
 dolomite,

spiraled standing coiling
dead wood with the living,

four thousand years of mineral glimmer
spaced out growing in the icy airy sky
white bones under summer stars.

—The Mountain Spirit and me

like ripples of the Cambrian Sea

dance the pine tree

old arms, old limbs, twisting, twining

scatter cones across the ground

stamp the root-foot DOWN

 and then she's gone.

Ceaseless wheel of lives
red sandstone and white dolomite.

 A few more shooting stars
 back to the bedroll, sleep till dawn.

Shiva and family consisting of Parvati, Ganesha, and Kartikeya
preparing soma on Mount Kailasha, approx. 1800.
India; Himachal Pradesh, Kangra, or Guler.
Opaque watercolors on paper. H. 9⅞ × W. 7¼ in.

ABOVE
Meditating Buddhist figure, approx. 1900–1949.
China. Qing dynasty (1644–1911).
Nephrite. H. 5¼ × W. 2¾ in.

RIGHT
The Buddha descending from Indra's heaven,
approx. 1700–1900. Laos or Northern Thailand.
Bronze. H. 22 × W. 5¼ × D. 9 in.

LIN XUE

Lin Xue's artistic practice begins on solitary hikes in the hills of Hong Kong, where he studies and records the landscape, creating a vocabulary of organic forms that he combines from memory in his drawings. Lin applies ink to paper with a sharpened branch, maintaining his connection to nature and to an ancestry of artists who have sought to understand nature's forces through their representation. A self-taught artist, Lin produces images that seem both real and imagined,

earthly and otherworldly, familiar and un-
familiar. His work documents a personal
journey yet, at the same time, explores
universal themes of growth and decay,
spirituality, and humanity's place within
the natural world. A.H.

Untitled (2010-0), 2009–2010.
Ink on paper. H. 25¼ × W. 71¾ in. (framed).

Untitled (2010-5), 2010.
Colored ink on paper.
H. 27¾ × W. 14½ in.
(framed).

Untitled (2010-6), 2010.
Colored ink on paper.
H. 27¾ × W. 14½ in.
(framed).

Untitled (2010-7), 2010.
Colored ink on paper.
H. 27¾ × W. 14½ in.
(framed).

Untitled (2010-8), 2010.
Colored ink on paper.
H. 27¾ × W. 14½ in.
(framed).

LIN XUE The Writing of Painting and the Spiritual Condition

Kathy Yim-king Mak
Translated by Robin Peckham

Lin Xue's *Untitled* series exhibits a succession of astonishing worlds. Within the clarity of the picture plane we see in the central or lower portion an agglomeration of black ink produced through the brushwork of the rubbing block unconstrained by the principles of painting: line and image undulate with uncertainty, sometimes settling toward the bottom of the piece but at other times floating up into the painting and extending in all directions, conveying a generally queer sensation. Upon closer inspection we discover in the painted surface an innumerable amount of details, some figures resembling animals and others plants, while between these images large trees and small alleys provide routes for travel. The thin frame becomes at once a visual playground into which we viewers can move in order to dig out and ponder its wonders. Such paintings, in terms of both content and modes of viewing, diverge not only from tradition but also from the art of today. How should we understand this work? The matter requires serious investigation.

ODDITIES OF THE PICTURE PLANE

In many ways, Lin Xue's *Untitled* series lends the audience a form of perception that surpasses reality. We see, in the earlier work *Untitled* (*1991-1*), a grouping of patterns at the center of the plane that includes two human-shaped organisms with normal facial features and warped

limbs. Adjacent images are based on both real organisms and imagined creatures. This work incorporates a relatively tight central structure surrounded by sparsely populated space, appearing in some way innocent. The lower left corner is covered with inscriptions and chops similar to those of traditional Chinese painting, forming an interesting juxtaposition with the more modern human figures and patterns of the work.

This semiabstract method of production remains visible in the work of later years, though the forms within Lin Xue's paintings have tended toward increasing complexity, as in the work *Untitled (1996-1)*. An accumulation of brushwork sits in the lower central position of the painting, its structure dense and layers of transformation many, while the forms toward the exterior are more scattered. Flying objects are placed to three sides of these brushstrokes while the top persists in blank emptiness, forming a sharp contrast with the ink forms of the lower portion. A similar composition appears in work of the same period, such as *Untitled (1995-4)*, and again in later work such as *Untitled (2009-2)*, both of which differ from *Untitled (1996-1)* only in the size and form of the ink shapes. The latter forms are not based on any clear object but rather appear as conglomerations of a slowly growing black mass that extends in all directions and induces an indescribable terror.

Aside from composition, the constituent components of the *Untitled* series are rather peculiar. Upon close inspection we discover no small number of mountain and forest scenes, including plants, lakes, mountain roads, and caves. Within these wooded hillsides we also find bugs, water creatures, and climbing and flying beings. These animals are given smiling faces and share space harmoniously with the plants of the painting, naturally forming a system like an ecological paradise.

These plants and animals appear to be composed of typical organisms, but, looking more closely, we discover that a portion of these scenes' components diverges from reality. When these odd constructions are brought together, they appear as extraterrestrial life forms. Aside from this, the picture plane contains no small amount of incomprehensible space. Lin Xue draws together the surface layer, structural layer, and transversal layer of the lake or cave in the same painted space in a way that clashes with our typical conception of space, thus exhibiting a peculiar spatial structure. Furthermore, the objects of the *Untitled* series sometimes appear to exist in a state of anti-gravity, exploring an alternative logic of spatial relations.

In terms of composition, content, and spatial structure, the images of the *Untitled* series generally violate our everyday concepts, but their interior worlds do seem to develop systematically according to certain laws. This situation cannot help but leave us in doubt: is this the ecological system of an alien planet? Or some utopian land?

WRITING NATURE FROM WITHIN THE MIND

The scenes expressed in the *Untitled* series are actually the results of the artist's explorations and productions of nature. Lin Xue has had an abiding love of nature since childhood. Envious of the methods

Lin Xue
Untitled (2010-9), 2010. Ink on paper.
H. 30¾ × W. 20⅝ in. (framed).

of existence of plants and other organisms, he has been impelled to paint natural scenes with sprigs of bamboo. That technique differs from working with traditional forms of calligraphic and painting brushwork: the twigs do not retain water or liquid ink, making it difficult to produce transformations of moistness or effects of *feibai*, in which streams of blank space are left within lines of ink. But bamboo is delicate, able to produce fine effects that make Lin Xue's painting an exercise in subtle visuality. Through the use of this material the artist adopts primitive tools to write out a version of nature within the mind. As such, his painting exhibits a plain and unaffected side of the material abundance of contemporary society.

Aside from creating these innovations in the tools of painting, Lin Xue enjoys spending his leisure time hiking in the mountains, carefully observing the structures of plant and animal life before making graphic notes based on their actual forms and his own imagination. In his sketchbook we discover all manner of natural scenes, including plants, climbing organisms, flying creatures, and bizarre life forms. Some structures tend toward the complex, while others exist in various dynamic states, revealing his explorations of and love for nature. This sketchbook also contains patterns and exercises in typography as well as groupings of animals and plants that aid Lin's artistic vocabulary and language.

Perhaps it is because Lin Xue has already mastered his own artistic language that, during his pro-

ductive process, he does not require any images for imitation but rather brandishes at will the stick of bamboo. He notes that, when beginning a painting, he gazes silently at the white paper until his mind is filled with floating images, only then moving the brush to produce line and finally gradually adding color. When the painting is completed, he then adds seals of his own production to indicate that he is at rest. Lin jokes that this latter practice is comparable to the way God finalized the creation of the world in Genesis with the Sabbath, or day of rest, to indicate its completion. Artistic production thus becomes a space for thinking, exploring the relationship between the universe and the artist.

Looking carefully again at the picture planes of the *Untitled* series, we find that the vast majority of areas dominated by ink shapes are structurally quite complex, particularly at the intersections of lines that compose rock and mountain landscapes. Structures range from the square and solid to the round and mellow, making it difficult for us to read rationally the compositional methods of the work. This situation reflects the working methods of the artist, who brackets to the side logical thinking in favor of intuition as a guide to producing the natural world of his own mind.

EXHIBITING A SPIRITUAL LIKENESS

A shift in composition emerges in a portion of Lin Xue's later works in which he employs comparatively minimal line structures to depict scenery while at the

Lin Xue
Untitled (2010-10), 2010. Ink on paper.
H. 30¾ × W. 20⅝ in. (framed).

same time placing each scene within the painting, as if it were another boulder within the primary composition surrounded by flying objects. Because no clear spatial relationship exists between the image and the boundaries of the frame, Lin produces a visual effect of floating and grace. This compositional strategy causes us to think of the late Ming and early Qing–era painter Bada Shanren, whose swimming fish and large rocks were placed within the situation of the painting. If we consider Lin Xue's productive methods we can further develop this compositional mode that pays no mind to the definition of the border, freeing the artist from considerations of the frame during his process and allowing him to paint at will his own spiritual likeness.

This type of creative mode, conforming only to nature itself, reflects the artist's views of art and the universe: "Painting is not for the expression of social likeness or for the maintenance of tradition but rather displays its own spiritual world." Lin Xue believes that he lives in a realm between meditation and fantasy. In the late 1990s he abandoned his practice in favor of employment out of the demands of real life, causing him also to discard his spiritual pursuits as if he were entering a grand dream. In recent years he has resumed the use of bamboo to produce paintings of natural scenes, again bringing himself closer to nature in order to seek his own spiritual world through nature. For him, painting consists of feeling and experience alongside fantasy, a tool for the cultivation of the self and soul. While working he believes that he is not painting but rather "seeking the ultimate spiritual condition through painting."

A NEW LANGUAGE OF PAINTING

With a primal love of nature, Lin Xue enters nature and makes sketches in order to produce his own artistic language, even producing his own textual system for use within his paintings. It is as if he does not require the understanding of the audience, never objecting to the misunderstanding of his art. Perhaps because Lin Xue received no traditional artistic training in the academy he is impelled to proceed through his own methods, but this does not imply that his practice lacks for technique or aesthetic consideration. We see in his work that the application of ink is sometimes heavier and sometimes lighter, that the arrangement of images is sometimes ordered and at other times chaotic—generally rich with a sense of rhythm. It is precisely these visual transformations in his work that, by revealing a sense of innocence and love for nature, exhibit the mature visual effects that constitute an individual artistic language.

FACING
Double-tiered offering container, 1875–1925. Thailand. Lacquered and gilded bamboo and wood with mirrored glass. H. 16 × DIAM. 16 in.

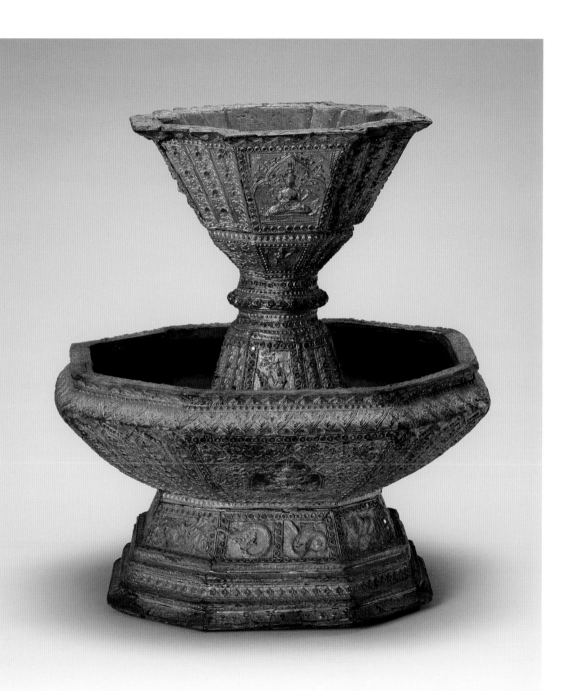

Verdant Mt. Jhuzih and a cloud, 2010.
Oil on canvas. H. 47¼ × W. 106¼ in.

LIN CHUAN-CHU

Lin Chuan-chu paints mountainous land-scapes he describes as "visualizations of [his] inner-spirit."[1] His sketches of Taiwan inspire painted compositions that translate experiences of nature into symbols of unconscious feelings and thoughts. Depicting the mountain as a site of self-reflection and transcendence, Lin Chuan-chu follows classical Chinese aesthetics, not by emulating traditional masters but by using their refined vocabulary to represent his meditative dialogue with the land. If one's state of mind shapes an interpretation of the landscape, Lin Chuan-chu's compositions project a sense of spiritual longing and a connection to nature's sublime power within a contemporary world that continually encroaches upon tradition.　　A.H.

1 Lin Chuan-chu, "Divine Inspiration: Artist State-ment," in *Divine Inspiration: Lin Chuan-chu's Solo Exhibition*, exh. cat. (Taipei: Lin & Keng Gallery, 2009), 6. A portion of the statement appears in this catalogue.

DIVINE INSPIRATION

Lin Chuan-chu

I have liked painting and drawing directly from nature for a long time. I always carry a sketchbook and charcoal pencil so that when I encounter something—whether it is Taiwan's tall mountains and deep ravines, the forests or gardens of mainland China, or a scene in an enchanting little town when traveling in the West—I can sketch it on the spot. Drawing outdoors has given me two different experiences. The first is the feeling that nature possesses inexhaustible abundance, from its widely distributed vegetation to the earth's rocky crust and to its mutable clouds and mists. The second is that drawing from nature is like a dialogue. Through this dialogue, I don't simply paint the object that is in front of me, nor do I paint what is in my mind; nature causes me to unconsciously paint unexpected compositions of landscapes and brush-strokes, which don't arise when I am closed up in the studio. Examples include *A View from Huoran Pavilion*, which I created in Taroko National Park, and the powerful mountains in *Towering*, which I painted from the limestone rock formations in Guilin.

Landscape painting is an ancient art form. For me, Chinese landscape painting definitely contains abstract aspects—such as the sum total of the painter's taste, temperament, and thinking—and this is no different from how it was in ancient times. I enjoy reading and listening

Lin Chuan-chu
Jade-like mountain I, 2009.
Oil on canvas. H. 70⅞ × W. 74¾ in.

to music and opera on a daily basis. These cultural activities have fostered the intellectual atmosphere that surrounds my landscape painting. Through landscape painting, people can escape their everyday lives and find a haven from society, or it can serve as a place of refuge for their souls, because it refers to a place of unique beauty and charm that isn't of our world.

Furthermore, our lives are undergoing rapid change in these turbulent times. The disappointment that has accumulated over the years can sometimes be eased with Li Bai's lines, "The warm spring invites us with misty landscapes, nature provides us with lovely scenes." Other times I turn to drinking, like Ruan Ji, to dissipate my gloom. These works express my inner thoughts and feelings, my aspirations, and the contours of my heart. The two unusual-looking stones that merge into one piece in *Rock V* are an example of this.

After I spent six years on *Family Stories*, from 2002 through 2007, I continued by painting landscapes. After I spent ten years of caring for my small child, we can finally ride our bicycles together and go on little roads through the mountains. This freedom has allowed me to rent a cabin as a studio near the ocean in Jinshan and reinspire myself. So these landscape paintings reflect my real life and changes of mind. Chinese landscape painting isn't limited to scenery; it also reveals the individual spirit.

Lin Chuan-chu
Rock V, 2008.
Oil on canvas. H. 78¾ × W. 78¾ in.

CHINESE INCENSE BURNERS

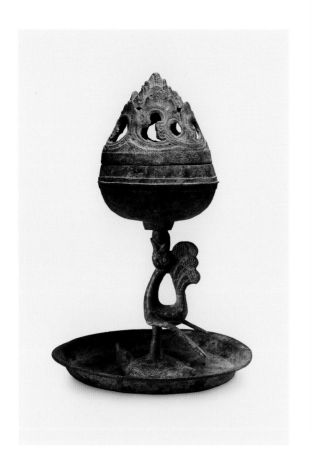

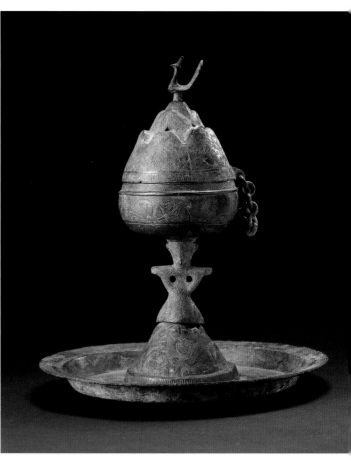

Incense burner (*boshanlu*).
China; probably Shanxi province. Western Han dynasty
(206 BCE–9 CE). Bronze. H. 10 × DIAM. 6½ in.

Incense burner (*boshanlu*) with dragons and phoenix.
China; Western Han dynasty (206 BCE–9 CE).
Bronze. H. 10¾ × DIAM. 9 in.

MOUNTAIN GODS

Aki Kondo

The Yamagata region, which is part of the To-hoku area in northeastern Japan, is known for its large mountains. This is where I now reside.

Once I heard a story from a man who stays in the mountains as part of his religious practice.

> Since ancient times, mountain deities have always been female, and men who practice asceticism in these mountains have likened them to birth canals and felt a female presence there. Some say that the mountain deities are uncomely. Women may be prohibited from entering the mountain deities' domains. Or people might pray for rich harvests and fertility by enshrining phallic images. To this day, mountain worship is often described using sexual metaphors.

People also consider the mountains as a boundary between "here" and "there"—that is, between the world of humans and the realm of deities. Some believe that mountains soothed people's agony and distress with a kind of eternal mind. So people still place countless stone guardian deities alongside mountain paths, to keep the divinity there.

On March 11, 2011, I experienced an incredible tremor that made me think the world was ending. The tsunami didn't reach Yamagata, even though we were not too far from the seismic center. Maybe our mountain deity protected us, as the locals conserve the mountain well. Truly, many lives were lost on the other side of the mountain.

Sometimes the stream of mountain energy seems to be a heartbeat of the earth. Water gave birth to mountains and created life forces. Ironically, this same water took many lives. Since the time that the earth was made, the mountains have been watching. They know everything.

AKI KONDO

The forces within the landscape that surrounds Aki Kondo's home inspire her paintings of mountains and mountain deities. Large compositions of bold color and dynamic brushstrokes express the mountains' powers to shape and give life to the earth; they also reflect the mountains as a realm of the gods where humans can commune with the vast spiritual world. Kondo's paintings remind us as well of the mountains' profound ability to both protect and destroy— a paradox with specific contemporary resonances in the aftermath of the March 2011 earthquake and tsunami devastation in Japan. As Kondo was painting a new work for *Phantoms of Asia*, Japan was in recovery, undoubtedly looking to the ancient mountain deities for guidance and protection. Yet, as the artist's words suggest, the eternal power of the mountains offers both comfort and humility: "Since the time that the earth was made, the mountains have been watching. They know everything."[1]

A.H.

1 From Aki Kondo's artist's statement (October 2011), reprinted here on page 221.

Mountain Gods, 2011.
Oil on panels. Overall H. 59⅝ × W. 401¼ in.

BAE YOUNG-WHAN

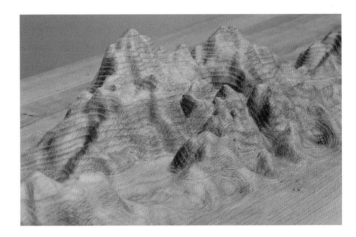

Terra Incognita-Theta, 2010.
CNC-milled and hand-finished oak.
H. 33½ × W. 63¾ × D. 23⅝ in.

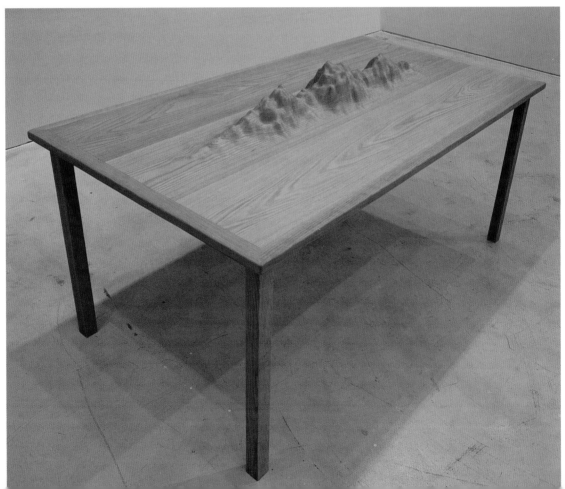

Bae Young-whan's *Frozen Waves* explores the spiritual connections between nature, the mind, and the body. Hand-kneaded ceramic objects arranged in rows create a mountainous landscape that recalls both the sensibilities and the motifs of Korean ceramic and painting traditions as well as Chinese landscape painting, all art forms in which the artist is formally trained. Graphs of the artist's brain waves inspire the shape of his ceramic forms, thus connecting two symbolic, vast expanses. Bae Young-whan's ceramic landscape is a topological map of an introspective journey to the inner self, a search for the divine within the artist's mind. His forms depict, simultaneously, a literal image of the mind and an interpretation of nature imagined within the mind. Together with his hand-finished oak table, *Terra Incognita-Theta*,

the artist's installation examines his notion of "Autonumina," which borrows from German theologian Rudolf Otto's mystical concept of "the numinous," the power or presence of a divinity. Fusing the numinous with automatism, the surrealist idea that the subconscious can manifest itself visually in art, Bae Young-whan's introspective practice creates conditions for self-initiated encounters with the sacred. A.H.

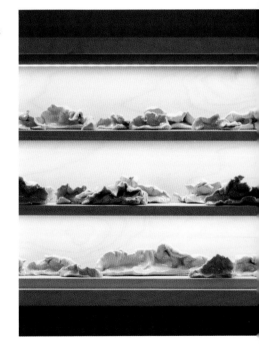

Frozen Waves, 2010.
Celadon objects in artist's cabinets of plywood, glass, and LEDs. Three cabinets, each H. 14⅞ × W. 94½ × D. 4¾ in.

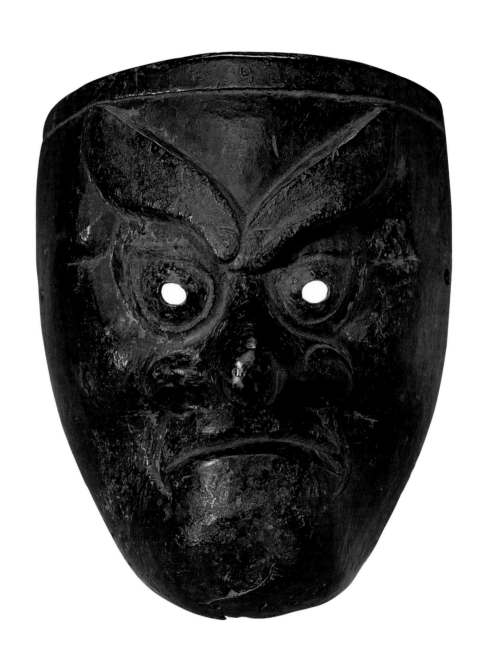

List of Works

WORKS BY CONTEMPORARY ARTISTS

Works in the Exhibition

Poklong Anading
Anonymity, 2008–2011
Series of nine light boxes; black-and-white
Duratrans print, exhibition copy
Light boxes, each
H. 24⅝ × W. 19⅝ × D. 7⅞ in.
Courtesy of Galerie Zimmermann
Kratochwill, Graz, Austria
© Poklong Anading, 2011
Photos courtesy of Galerie Zimmermann
Kratochwill, Graz, Austria
[Pages 24, 58, 59, front cover]

Bae Young-whan
Frozen Waves, 2010
Celadon objects in artist's cabinets of
plywood, glass, and LEDs
Three cabinets, each
H. 14⅞ × W. 94½ × D. 4¾ in.
Courtesy of PKM | Bartleby Bickle &
Meursault
© Bae Young-whan
[Page 225]

FACING

Gyōdō processional mask of the Ōmai type,
1400–1600. Japan. Wood with traces of
lacquer and colors. H. 8¾ × W. 7⅛ in.

Terra Incognita-Theta, 2010
CNC-milled and hand-finished oak
H. 33½ × W. 63¾ × D. 23⅝ in.
Courtesy of PKM | Bartleby Bickle &
Meursault
© Bae Young-whan
[Page 224]

Ringo Bunoan
Passage: The Blanket Project, 2007
Duratrans prints and light boxes
Courtesy of the artist
© Ringo Bunoan
Photo courtesy of the artist
[Page 117]

Choi Jeong Hwa
Breathing Flower, 2012
Site-specific installation (Civic Center
Plaza); fabric, LEDs, and motor
DIAM. 433 in.
Courtesy of the artist

Heman Chong
Calendars (2020–2096), 2004–2010
Offset prints on paper
1,001 sheets, each H. 11¾ × W. 11¾ in.
Courtesy of Vitamin Creative Space,
Motive Gallery, and STPI

© Heman Chong
Photos courtesy of Vitamin Creative Space,
Motive Gallery, and STPI
[Pages 84–85, 88]

Kryptonite, from the series *Surfacing*, 2008
3,000 self-adhesive stickers applied directly
onto the wall
Dimensions variable
Courtesy of the artist, Motive Gallery,
STPI, and Vitamin Creative Space
© Heman Chong
Photo courtesy of Vitamin Creative Space,
Motive Gallery, and STPI

Star(Burst), 2012
3,000 self-adhesive stickers applied
directly onto the wall
Dimensions variable
Courtesy of the artist, Motive Gallery,
STPI, and Vitamin Creative Space
© Heman Chong
Photo courtesy of Vitamin Creative Space,
Motive Gallery, and STPI
[Page 83]

Guo Fengyi
Ear, 1990
Mixed media on paper

H. 39⅛ × W. 29½ in.
Courtesy of Long March Space, Beijing
Photo courtesy of Long March Space,
Beijing
[Page 68]

*Energy Channel Decomposition
Diagram #1*, 1989
Mixed media on paper
H. 47¼ × W. 21¼ in.
Courtesy of Long March Space, Beijing
Photo courtesy of Long March Space,
Beijing
[Page 10]

Jingming Point, 1990
Colored ink on found calendar paper
H. 82⅝ × W. 56¾ in.
Courtesy of Long March Space, Beijing
Photo courtesy of Long March Space,
Beijing
[Page 69]

Hyon Gyon
Dohatsu Shoten, 2010
Satin on panel
DIAM. 70⅞ in.
Courtesy of the artist
© Hyon Gyon
Photo courtesy of g³/gallery
[Page 191]

Hello! Another Me, 2011–2012
Acrylic and Japanese paper on panels
Overall H. 86⅝ × W. 189 in.
Courtesy of the artist and g³/gallery
© Hyon Gyon
Photo courtesy of g³/gallery
Photograph by Rui Mizuki
[Page 190]

NS Harsha
Distress call from Jupiter's neighborhood, 2011
Acrylic on canvas and gold foil on processed
leather, with wood
H. 114⅛ × W. 66⅛ in.
Courtesy of the artist and Victoria Miro
Gallery, London

© NS Harsha
Photo courtesy of the artist and Victoria
Miro Gallery, London
[Page 78]

Distress call from Saturn's neighborhood, 2011
Acrylic on canvas and gold foil on processed
leather, with wood
H. 114⅛ × W. 66⅛ in.
Courtesy of the artist and Victoria Miro
Gallery, London
© NS Harsha
Photo courtesy of the artist and Victoria
Miro Gallery, London
[Page 79]

Pouran Jinchi
Prayer Stones, 2011
Collection of eight works; baked clay and
lacquer paint
Prayer Stone 1: H. 3½ × W. 6 × D. ¾ in.
Prayer Stone 2: H. 4 × W. 4 × D. ¾ in.
Prayer Stone 3: H. 3 × W. 3 × D. ½ in.
Prayer Stone 4: H. 2¼ × W. 3 × D. ½ in.
Prayer Stone 5: H. 2 × W. 2 × D. ½ in.
Prayer Stone 6: H. 1¾ × W. 1¾ × D. ¼ in.
Prayer Stone 7: H. 1¾ × W. 1½ × D. ½ in.
Prayer Stone 8: H. 1½ × W. 1½ × D. ¼ in.
Courtesy of the artist and Art Projects
International, New York
© Pouran Jinchi
Photos courtesy of the artist and Art
Projects International, New York
[Pages 17, 172]

Jompet
Anno Domini, 2011
Wooden pillars, sound installation, text,
soldier figures, and video components
H. 98¾ × W. 275⅝ in.
Courtesy of the artist
© Agustinus Kuswidananto "Jompet"
[Pages 112, 115]

Aki Kondo
Mountain Gods, 2011
Oil on panels
Overall H. 59⅝ × W. 401¼ in.

Private collection, Taiwan
© Aki Kondo
[Pages 222–223]

Sun K. Kwak
Untying Space_Asian Art Museum, SF, 2012
Site-specific installation; black masking tape,
mixed media
Courtesy of the artist

Lin Chuan-chu
Book, 2008
Oil on canvas
H. 79⅞ × W. 17⅜ in.
Courtesy of the artist and MOT/ARTS
© Lin Chuan-chu
Photo courtesy of MOT/ARTS
[Page 20]

Jade-like mountain I, 2009
Oil on canvas
H. 70⅞ × W. 74¾ in.
Courtesy of the artist and MOT/ARTS
© Lin Chuan-chu
Photo courtesy of MOT/ARTS
[Page 217]

Rock V, 2008
Oil on canvas
H. 78¾ × W. 78¾ in.
Courtesy of the artist and MOT/ARTS
© Lin Chuan-chu
Photo courtesy of MOT/ARTS
[Page 218]

Verdant Mt. Jhuzih and a cloud, 2010
Oil on canvas
H. 47¼ × W. 106¼ in.
Courtesy of the artist and MOT/ARTS
© Lin Chuan-chu
Photo courtesy of MOT/ARTS
[Pages 214–215]

Lin Xue
Untitled (2010-0), 2009–2010
Ink on paper
H. 25¼ × W. 71¾ in. (framed)
AEVE Collection

© Lin Xue
Photo courtesy of the artist and Gallery EXIT
[Pages 204–205]

Untitled (2010-5), 2010
Colored ink on paper
H. 27¾ × w. 14½ in. (framed)
Lent by Felita Hui
© Lin Xue
Photo courtesy of the artist and Gallery EXIT
[Page 206]

Untitled (2010-6), 2010
Colored ink on paper
H. 27¾ × w. 14½ in. (framed)
Private collection
© Lin Xue
Photo courtesy of the artist and Gallery EXIT
[Page 206]

Untitled (2010-7), 2010
Colored ink on paper
H. 27¾ × w. 14½ in. (framed)
Private collection
© Lin Xue
Photo courtesy of the artist and Gallery EXIT
[Page 207]

Untitled (2010-8), 2010
Colored ink on paper
H. 27¾ × w. 14½ in. (framed)
Lent by Felita Hui
© Lin Xue
Photo courtesy of the artist and Gallery EXIT
[Page 207]

Untitled (2010-9), 2010
Ink on paper
H. 30¾ × w. 20⅝ in. (framed)
Collection of Caroline Chiu and Paul Aiello
© Lin Xue
Photo courtesy of the artist and Gallery EXIT
[Page 210]

Untitled (2010-10), 2010
Ink on paper
H. 30¾ × w. 20⅝ in. (framed)
Lent by Jennifer Yu

© Lin Xue
Photo courtesy of the artist and Gallery EXIT
[Page 211]

Fuyuko Matsui
Crack in the Ashes, 2006
Hanging scroll; colored pigment on silk
H. 14¾ × w. 32¼ in.
Courtesy of the artist and Gallery
Naruyama, Tokyo
© Fuyuko Matsui
Photo courtesy of the artist and
Gallery Naruyama, Tokyo
[Page 129]

Daily Consumptions of Smooth Affections, 2007
Hanging scroll; colored pigment on silk
H. 22⅞ × w. 16⅞ in.
Lent by Keita Arisawa
© Fuyuko Matsui
Photos courtesy of the artist and
Gallery Naruyama, Tokyo
[Pages 126, 127]

Narcissus, 2007
Hanging scroll; colored pigment on silk
H. 52⅜ × w. 19⅜ in.
Lent by Kaoru Hanafusa
© Fuyuko Matsui
Photo courtesy of the artist and
Gallery Naruyama, Tokyo
[Page 126]

Nyctalopia, 2005
Hanging scroll; colored pigment on silk
H. 54⅜ × w. 19½ in.
Courtesy of the artist and Gallery
Naruyama, Tokyo
© Fuyuko Matsui
Photo courtesy of the artist and
Gallery Naruyama, Tokyo
[Page 125]

The Parasite Will Not Abandon the Body, 2011
Hanging scroll; colored pigment on silk
H. 11¾ × w. 31½ in.
Courtesy of the artist and Gallery
Naruyama, Tokyo

© Fuyuko Matsui
Photo courtesy of the artist and
Gallery Naruyama, Tokyo
[Page 129]

Scattered Deformities in the End, 2007
Hanging scroll; colored pigment on silk
H. 49 × w. 38⅜ in.
Courtesy of the artist and Gallery
Naruyama, Tokyo
© Fuyuko Matsui
Photo courtesy of the artist and
Gallery Naruyama, Tokyo
[Page 128]

Spiral of Thought, 2005
Hanging scroll; colored pigment on silk
H. 77½ × w. 13½ in.
Lent by Tadao Suzuki
© Fuyuko Matsui
Photo courtesy of the artist and
Gallery Naruyama, Tokyo
[Page 124]

Prabhavathi Meppayil
Untitled—CU1—2011, 2011
Copper wire embedded in lime gesso panel
H. 48 × w. 72 in.
Courtesy of the artist
© Prabhavathi Meppayil
Image courtesy of the artist
Photograph by Manoj Sudhakaran
[Pages 168–169]

Untitled—CU2—2011, 2011
Copper wire embedded in lime gesso panel
H. 48 × w. 72 in.
Courtesy of the artist
© Prabhavathi Meppayil
Image courtesy of the artist
Photograph by Manoj Sudhakaran
[Page 170]

Untitled—CU3—2011, 2011
Copper wire embedded in lime gesso panel
H. 48 × w. 72 in.
Courtesy of the artist
© Prabhavathi Meppayil

Image courtesy of the artist
Photograph by Manoj Sudhakaran
[Page 171]

Motohiko Odani
SP Extra: Malformed Noh-Mask Series:
San Yujo, 2008
Wood, natural mineral pigment, and
Japanese lacquer
Set of three; each H. 8⅞ × w. 4⅞ × D. 2¾ in.
Private collection
© Motohiko Odani
Photo courtesy of Yamamoto Gendai
Photograph by Keizo Kioku
[Pages 148–149]

Jagannath Panda
The Cult of Appearance III, 2012
Acrylic, fabric, plywood, glue, and paper,
with glass and plastic gems on canvas
Diptych; overall H. 81 × w. 165 in.
Courtesy of Nature Morte, New Delhi,
and Frey Norris Contemporary & Modern,
San Francisco
© Jagannath Panda
Photo courtesy of Nature Morte, New Delhi,
and Frey Norris Contemporary & Modern,
San Francisco
[Pages 152–153]

The Cult of Survival II, 2011
Plastic pipe, auto paint, acrylic, fabric, glue,
rexine, and plastic flowers
H. 105 × w. 74 × D. 69 in.
Courtesy of Nature Morte, New Delhi,
and Frey Norris Contemporary & Modern,
San Francisco
© Jagannath Panda
Photos courtesy of Nature Morte, New Delhi,
and Frey Norris Contemporary & Modern,
San Francisco
[Pages 16, 40]

Araya Rasdjarmrearnsook
The Class, 2005
Single-channel video
16 min., 25 sec.

Courtesy of the artist and 100 Tonson Gallery
© Araya Rasdjarmrearnsook
Photos courtesy of 100 Tonson Gallery
[Pages 106, 109]

Varunika Saraf
Ankhon Hi Ankhon Mein, 2010
Watercolor on rice paper overlaid on
found textile
H. 7 × w. 7 in.
Lent by Ashiesh Shan, Mumbai
© Varunika Saraf
Photo courtesy of Galerie Mirchandani +
Steinruecke, Mumbai, India
[Page 80]

Cloudburst, 2010
Watercolor, metal tacks, and plastic eyes
on rice paper overlaid on cotton cloth
H. 68½ × w. 70¾ in.
Private collection, Mumbai
© Varunika Saraf
Photo courtesy of Galerie Mirchandani +
Steinruecke, Mumbai, India
[Page 27]

Island, 2010
Watercolor on rice paper and cotton cloth
H. 73¾ × w. 62½ in.
Lent by Ranjana Steinruecke, Mumbai
© Varunika Saraf
Photo courtesy of Galerie Mirchandani +
Steinruecke, Mumbai, India
[Page 81]

Untitled, 2010
Watercolor on rice paper overlaid
on canvas
H. 7 × w. 7 in.
Lent by Pallavi Swadi, Mumbai
© Varunika Saraf
Photo courtesy of Galerie Mirchandani +
Steinruecke, Mumbai, India
[Page 28, back cover]

Raqib Shaw
Absence of God VII, 2008

Acrylic, glitter, enamel, and rhinestones
on board
H. 96 × w. 60 in.
Courtesy of Terence and Katrina Garnett
© Raqib Shaw
Photo courtesy of White Cube, London
Photograph by Todd-White Art Photography
[Pages 156, 157]

Ode to the Lost Moon of the Lesser Himalayas
on the Banks of the Lidder, 2009
Watercolor, acrylic, enamel, glitter, and
rhinestones on paper mounted on panels
One panel: H. 32¹³⁄₁₆ × w. 43⅝ × D. ½ in.
Two panels: each H. 43⅝ × w. 32¹³⁄₁₆ × D. ½ in.
Courtesy of the artist and White Cube,
London
© Raqib Shaw
Photo courtesy of White Cube, London
Photograph by Ellen Broughton
[Pages 158–159]

Jakkai Siributr
Karma Cash & Carry, 2010–2012
Bamboo, eucalyptus, found objects, gold leaf,
and cheesecloth with embroidery
Approx. H. 59 × w. 47 × D. 39 in.
Lent by the artist
© Jakkai Siributr
Photos courtesy of Tyler Rollins Fine Art
[Pages 14, 116]

Yoshihiro Suda
Flower, 2012
Paint on wood
Size varies according to site
Courtesy of Gallery Koyanagi, Tokyo

Flower, 2012
Paint on wood
Size varies according to site
Courtesy of Gallery Koyanagi, Tokyo

Flower, 2012
Paint on wood
Size varies according to site
Courtesy of Gallery Koyanagi, Tokyo

Leaf, 2012
Paint on wood
Size varies according to site
Courtesy of Gallery Koyanagi, Tokyo

Weeds, 2012
Paint on wood
Size varies according to site
Courtesy of Gallery Koyanagi, Tokyo

Hiroshi Sugimoto
Five Elements: Baltic Sea, Rugen, 2011
Optically clear glass with black-and-white
film (from *Seascapes* series, 1996)
Plinth: unvarnished cypress with metal base
H. 59 × W. 11¾ × D. 11¾ in.
Private collection
© Hiroshi Sugimoto
Photo courtesy of the artist
[Page 47]

*Five Elements: English Channel,
Weston Cliff*, 2011
Optically clear glass with black-and-white
film (from *Seascapes* series, 1994)
Plinth: unvarnished cypress with metal base
H. 59 × W. 11¾ × D. 11¾ in.
Private collection
© Hiroshi Sugimoto
Photo courtesy of the artist
[Page 47]

Five Elements: Indian Ocean, Bali, 2011
Optically clear glass with black-and-white
film (from *Seascapes* series, 1990)
Plinth: unvarnished cypress with metal base
H. 59 × W. 11¾ × D. 11¾ in.
Private collection
© Hiroshi Sugimoto
Photo courtesy of the artist
[Page 47]

Five Elements: Irish Sea, Isle of Man, 2011
Optically clear glass with black-and-white
film (from *Seascapes* series, 1990)
Plinth: unvarnished cypress with metal base
H. 59 × W. 11¾ × D. 11¾ in.

Private collection
© Hiroshi Sugimoto
Photo courtesy of the artist
[Page 47]

*Five Elements: Mediterranean Sea,
La Ciotat*, 2011
Optically clear glass with black-and-white
film (from *Seascapes* series, 1989)
Plinth: unvarnished cypress with metal base
H. 59 × W. 11¾ × D. 11¾ in.
Private collection
© Hiroshi Sugimoto
Photo courtesy of the artist
[Page 49]

Five Elements: Sea of Okhotsk, Hokkaido, 2011
Optically clear glass with black-and-white
film (from *Seascapes* series, 1989)
Plinth: unvarnished cypress with metal base
H. 59 × W. 11¾ × D. 11¾ in.
Private collection
© Hiroshi Sugimoto
Photo courtesy of the artist
[Page 45]

Five Elements: Tasman Sea, Ngarupupu, 2011
Optically clear glass with black-and-white
film (from *Seascapes* series, 1990)
Plinth: unvarnished cypress with metal base
H. 59 × W. 11¾ × D. 11¾ in.
Private collection
© Hiroshi Sugimoto
Photo courtesy of the artist
[Page 45]

Adeela Suleman
Untitled 1 (*Peacock with Missiles*), 2010
Steel
Edition 1 of 3
Dimensions variable
Courtesy of Adeela Suleman and Aicon
Gallery
© Adeela Suleman
Photo courtesy of the artist and Aicon Gallery
[Pages 160–161]

Charwei Tsai
Bamboo Mantra, 2012
Black ink on bamboo
Installation area H. 87 × W. 72 in.
Courtesy of the artist

*A Pilgrimage through Light and Spells—
Bamboo Mantra I and II*, 2012
Lithographs with handwriting in black ink
Pair; each H. 37⅜ × W. 26⅜ in.
Courtesy of the artist
© Charwei Tsai
[Pages 74, 75]

Howie Tsui
*Mount Abundance and the TipToe
People #1*, 2010
Chinese pigments, acrylic, and ink on
mulberry paper
H. 75 × W. 37 in.
Courtesy of the artist
© Howie Tsui
Photo courtesy of the artist
[Page 122]

*Mount Abundance and the TipToe
People #2*, 2010
Chinese pigments, acrylic, and ink on
mulberry paper
H. 75 × W. 37 in.
Courtesy of the artist
© Howie Tsui
Photo courtesy of the artist
[Page 123]

Apichatpong Weerasethakul
Phantoms of Nabua, 2009
Single-channel video installation
Digital, 16:9/Dolby 5.1/Color
10:56 min.
Commissioned by Animate Projects, Haus
der Kunst, Munich, and FACT (Foundation
for Art and Creative Technology), Liverpool
Produced by Illumination Films
Courtesy of Jacqui Davies, Animate Projects,
and Apichatpong Weerasthkul
© Kick the Machine Films

Photos courtesy of the artist
[Pages 118–119]

Palden Weinreb
Astral Invert, 2011
Encaustic, wood, and LEDs
H. 22½ × w. 17½ in.
Courtesy of the artist and Rossi & Rossi Ltd.
© Palden Weinreb
Photo courtesy of Rossi & Rossi Ltd.
[Page 39]

Entry (Gradation), 2011
Graphite and encaustic on paper and board
H. 80 × w. 40 in.
Private collection, courtesy of
Rossi & Rossi Ltd.
© Palden Weinreb
Photo courtesy of Rossi & Rossi Ltd.
[Page 61]

Envelop (Current Sweeping), 2011
Graphite and encaustic on board
H. 50 × w. 80 in.
Courtesy of the artist and
Rossi & Rossi Ltd.
© Palden Weinreb
Photo courtesy of Rossi & Rossi Ltd.
[Page 60]

Adrian Wong
Geomantic Intervention I, II, 2012
Site-specific installation, including objects
from the Asian Art Museum collection
Courtesy of the artist

Takayuki Yamamoto
What Kind of Hell Will We Go, 2012
Video and mixed-media models
Dimensions variable
Courtesy of the artist
© Takayuki Yamamoto
Photos courtesy of the artist
[Page 120]

Works Not in the Exhibition

Choi Jeong Hwa
Breathing Flower, 2011
Kunsthalle Gwangju, Korea
Fabric, LEDs, and motor
DIAM. 433 in.
© Choi Jeong Hwa
Photo courtesy of the artist
[Pages 192–193]

Sun K. Kwak
Untying Space_Sala Alcalá 31, 2007
Masking tape, adhesive vinyl, and
wooden panel
Installed at Sala Alcalá 31, Madrid
© Sun K. Kwak
Photo courtesy of the artist and Sala Alcalá 31
[Pages 64–65]

Untying Space_Salvatore Ferragamo, 2007
Masking tape and mixed media
Installed at Salvatore Ferragamo Gallery,
New York
© Sun K. Kwak
Photo courtesy of the artist
[Page 67]

Yoshihiro Suda
Morning Glory, 2010
Paint on wood
Size varies according to site
© Yoshihiro Suda
Photo courtesy of Gallery Koyanagi, Tokyo
[Page 179]

Tulip, 2007
Paint on wood
Size varies according to site
© Yoshihiro Suda
Photo courtesy of Gallery Koyanagi, Tokyo
[Page 175]

Weeds, 2008
Paint on wood

Size varies according to site
© Yoshihiro Suda
Photo courtesy of Gallery Koyanagi, Tokyo
[Page 176]

Adeela Suleman
**Sketch of *Untitled 1* (*Peacock with Missiles*)
with added elements**, 2011
Ink on paper
© Adeela Suleman
Photo courtesy of Adeela Suleman and
Aicon Gallery
[Page 163]

Charwei Tsai
Bonsai III from the Bonsai Series, 2011
Black ink on lithograph
H. 10¼ × w. 12¼ in.
© Charwei Tsai
Photo courtesy of the artist
[Page 71]

Olive Tree Mantra, 2006
Black ink on olive tree
Bratsera Hotel, Hydra School Project,
Hydra, Greece
© Charwei Tsai
Photo courtesy of the artist
Photograph by Grigoris Tsolakis
[Page 73]

Adrian Wong
Sketches for *Geomantic Intervention I, II*, 2012
© Adrian Wong
Photos courtesy of the artist
[Pages 184, 185, 189]

HISTORICAL WORKS

The bodhisattva Avalokiteshvara in the
form of the wish-fulfilling Chintamani-
chakra (Japanese: Nyoirin Kannon),
900–1000
Japan

Gilding and pigments on wood
H. 43½ × DIAM. 34 in.
Gift of Mr. and Mrs. George F. Jewett, Jr.,
the Museum Society Auxiliary, and museum
purchase, B71S3
[Page viii]

**The bodhisattva Avalokiteshvara
(Guanyin),** approx. 1900–1940
China; Dehua, Fujian province
Late Qing dynasty (1644–1911) or
Early Republic period
Porcelain with creamy glaze
H. 21¼ × W. 12¾ × D. 11½ in. (figure)
The Avery Brundage Collection, B60P2302
[Page 7]

**The Hindu god Shiva slaying the elephant
demon,** approx. 1850
India; Mysore, Karnataka state
Opaque watercolors on paper
H. 8¾ × W. 7 in.
Gift of Denise B. Fitch in memory of
George Hopper Fitch, 2010.322
[Page 8]

**Hanging container with mountain-shaped
lid,** 1000–1500
Indonesia; East Java
Bronze
H. 8 × DIAM. 7 in.
Gift of Mr. Johnson S. Bogart, 2010.348.A–B
[Page 18]

The cosmic Buddha Amitayus, 1800–1900
Central Tibet
Colors on cotton
H. 31½ × W. 22¾ in. (unmounted)
Transfer from the Fine Arts Museums
of San Francisco, Gift of Katherine Ball,
B72D47
[Page 22]

**Asian Cosmologies:
Envisioning the Invisible**

Bell cup with handles, approx. 400–500
Korea
Stoneware
H. 7⅜ × W. 5¾ × D. 4⅜ in.
Acquisition made possible by Forrest
Mortimer, 1991.50
[Page 32]

Cosmological painting, approx. 1750–1850
India; Rajasthan
Opaque watercolors on cloth
H. 94¼ × W. 90½ in.
From the Collection of William K.
Ehrenfeld, M.D., 2005.64.54
[Page 34]

**A mandala of the Buddhist deity
Vajravarahi,** 1869
Nepal
Colors on cotton
H. 21½ × W. 16½ in.
The Avery Brundage Collection, B60D11+
[Page 42]

Mirror with four mountains, approx.
400–300 BCE
China; Warring States (475–221 BCE)
Bronze
DIAM. 5½ in.
The Avery Brundage Collection, B60B544
[Page 50]

**Mirror with cosmological designs and
inscriptions**
China; Western Han dynasty (206 BCE–9 CE)
Bronze
DIAM. 5⅜ in.
The Avery Brundage Collection, B66B21
[Page 52]

TLV mirror with twelve early branches
China; Xin Mang (9–25) or Eastern Han
dynasty (25–220)

Bronze
DIAM. 5⅝ in.
The Avery Brundage Collection, B60B541
[Page 52]

Mirror with cosmological designs, approx.
100 BCE–9 CE
China; Western Han dynasty
(206 BCE–9 CE)
Bronze
DIAM. 3¼ in.
The Avery Brundage Collection, B60B558
[Page 53]

**Mirror with cosmological designs and
inscriptions,** approx. 9–100 CE
China; Xin Mang (9–25) or early Eastern
Han dynasty (25–220)
Bronze
DIAM. 7½ in.
The Avery Brundage Collection, B60B579
[Page 53]

Mirror with a celebration by Taoist deities,
approx. 200–220
China; Eastern Han dynasty (25–220)
Bronze
DIAM. 7¾ in.
The Avery Brundage Collection, B60B582
[Page 54]

Mirror with interlaced dragons designs,
approx. 300–200 BCE
China; Warring States (475–221 BCE)
Bronze
DIAM. 5½ in.
The Avery Brundage Collection, B60B554
[Page 54]

**Mirror with Taoist deities, mythical beasts,
and inscriptions**
China; Eastern Han dynasty (25–220)
Bronze
DIAM. 8¼ in.
The Avery Brundage Collection, B60B597
[Page 55]

Mirror with Taoist deities and mythical beasts, approx. 196–280
China; Late Eastern Han dynasty
(25 BCE–220 CE) or Three Kingdoms period
(221 BCE–419 CE)
Bronze
DIAM. 4½ in.
The Avery Brundage Collection, B60B539
[Page 55]

Mirror with designs of eight trigrams and twelve animals of the zodiac
China; Five Dynasties (907–960)
Bronze
DIAM. 6 in.
The Avery Brundage Collection, B60B586
[Page 56]

Krishna overcoming the serpent Kaliya, 1850–1950
Southern India
Wood
H. 19½ × W. 12½ × D. 4½ in.
The Avery Brundage Collection, B61S51+
[Page 90]

Vishnu on the serpent in the cosmic ocean, with Lakshmi, Hanuman, and other figures, 1850–1950
Southern India
Wood
H. 19 × W. 11½ × D. 4½ in.
The Avery Brundage Collection, B61S56+
[Page 91]

Two of a set of four seated guardian figures, approx. 1550–1600
China; Ming dynasty (1368–1644)
Copper
H. 7⅝ × W. 5⅛ × D. 3¼ in. (B60B223)
H. 7¾ × W. 5⅜ × D. 3¾ in. (B60B226)
The Avery Brundage Collection, B60B223
and B60B226
[Page 92]

The Hindu deities Vishnu and Lakshmi on Garuda, approx. 1500–1700
India; perhaps Arthuna, Rajasthan state
Stone; enameled metal modern eyes
H. 31½ × W. 18 × D. 9½ in.
The Avery Brundage Collection, B60S108
[Page 93]

Female figure, 1250–1300
India; Belur, Karnataka state
Chloritic schist
H. 32 × W. 11½ × D. 9 in.
The Avery Brundage Collection, B66S4
[Page 94]

The bodhisattva Avalokiteshvara, approx. 1180–1220
Cambodia; former kingdom of Angkor
Bronze
H. 14¼ × W. 6¼ × D. 4 in.
Gift of Dr. and Mrs. David Buchanan, 2006.50
[Page 94]

Monk in worshipful posture, 1600–1800
Burma
Dry lacquer with traces of gilding
H. 23¾ × W. 12 × D. 15 in.
The Avery Brundage Collection, B60S13+
[Page 95]

Bodhisattva, approx. 600–700
Thailand; Plai Bat Hill, Buriram province
Bronze
H. 9 in.
Museum purchase, B68S9
[Page 96]

Seated Buddha, perhaps 1400–1500
Thailand
Rock crystal with gold and ruby
H. 4¼ × W. 1¾ × D. 1½ in.
Gift from Doris Duke Charitable
Foundation's Southeast Asian Art
Collection, 2006.27.38
[Page 97]

Mythical bird-man, approx. 1775–1850
Central Thailand
Wood with remnants of lacquer, gilding, and mirrored-glass inlay
H. 50½ × W. 11 × D. 25 in.
Gift from Doris Duke Charitable
Foundation's Southeast Asian Art
Collection, 2006.27.23
[Page 97]

Standing bodhisattva Avalokiteshvara (Shō Kannon), approx. 1300–1400 or 1700–1800
Japan
Wood with gilding and lacquer
H. 40 × W. 13 in. (figure)
H. 12 × W. 22 in. (base)
The Avery Brundage Collection, B60S133+
[Page 98]

Standing Amida Buddha, 1200–1300
Japan
Light-colored wood
H. 32⅞ × W. 10½ in.
The Avery Brundage Collection, B63S27+
[Page 99]

The bodhisattva Avalokiteshvara, approx. 1400–1500
Nepal
Painted ash wood
H. 18⅞ × W. 6¼ × D. 3¼ in.
Museum purchase, B68S12
[Page 99]

Standing crowned and bejeweled Buddha, 1600–1700
North-central Thailand
Bronze or other copper alloy with mother of pearl and glass inlay and traces of lacquer
H. 29½ × W. 8¾ × DIAM. 7¼ in.
Museum purchase, 1999.41.A–B
[Page 100]

The guardian kings of the four directions presenting begging bowls to the Buddha, approx. 1650–1750

Burma
Bronze
H. 4⅛ × w. 5½ × D. 2½ in.
Gift of the Donald W. Perez Family in
memory of Margaret and George W.
Haldeman, 2010.513
[Page 100]

**The Hindu deity Vishnu reclining on
the serpent in the cosmic ocean**, perhaps
1150–1250
Cambodia; Northeastern Thailand
Sandstone
H. 13 × w. 34 × D. 5 in.
The Avery Brundage Collection, B60S383
[Page 101]

**World, Afterworld:
Living Beyond Living**

A King of Hell, approx. 1600–1700
Korea; Joseon dynasty (1392–1910)
Hanging scroll; ink and colors on silk
H. 45¼ × w. 34¼ in. (image)
H. 86 × w. 46 in. (overall)
Gift of Dr. and Mrs. Sun-Hak Choy in
honor of Mr. James Dong-wu Kim,
Mrs. Choy's father, B86D4
[Page 105]

**Myth, Ritual, Meditation:
Communing with Deities**

Dakini, approx. 1600–1800
Nepal
Gilded bronze
H. 7¼ × w. 5 in.
The Avery Brundage Collection,
B60S502
[Page 132]

Bugaku dancers, 1408
By Abe Suehide (Japanese, 1361–1411)
Handscroll; ink and colors on paper

H. 11⅛ × w. 165 in.
Gift and Purchase from the Harry G.C.
Packard Collection Charitable Trust in
honor of Dr. Shujiro Shimada; The Avery
Brundage Collection, 1991.60
[Pages 134–139]

Gigaku mask of the Suikojū type,
approx. 1868–1926
Japan
Wood with colors
H. 10 × w. 7¾ in.
The Avery Brundage Collection, B60S183
[Page 140]

Gigaku mask of the Suikojū type, approx.
1868–1926
Japan
Wood with colors
H. 10 × w. 6½ in.
The Avery Brundage Collection, B60S179
[Page 142]

Gigaku mask of the Konron type, approx.
1868–1926
Japan
Wood with colors
H. 9½ × w. 7⅝ in.
The Avery Brundage Collection, B60S182
[Page 142]

**Bugaku mask of the Emimen type for the
Ninomai dance**, approx. 1800–1900
Japan
Wood with colors
H. 11¾ × w. 7¾ in.
The Avery Brundage Collection, B60S188
[Page 143]

**Tengu-type mask, possibly Sarutahiko
Enmei**, 1700–1850
Japan
Wood with colors
H. 11⅝ × w. 6¾ in.
The Avery Brundage Collection, B60S192
[Page 143]

Kyōgen mask of the Oto type, approx.
1868–1926
Japan
Wood with colors
H. 9⅛ × w. 7⅛ in.
The Avery Brundage Collection, B60S181
[Page 144]

Noh mask of the Beshimi type, approx.
1600–1800
Japan
Wood with colors
H. 9⅛ × w. 7⅜ in.
The Avery Brundage Collection, B60S185
[Page 145]

Demon mask, approx. 1868–1926
Japan
Wood with colors
H. 9⅓ × w. 7⅛ in.
The Avery Brundage Collection, B60S186
[Page 145]

Noh mask of the Chujō type, approx.
1868–1926
Japan
Wood with colors
H. 8 × w. 5¼ × D. 3 in.
The Avery Brundage Collection, B60S218
[Page 146]

Noh mask of the Semimaru type, approx.
1868–1926
Japan
Wood with colors
H. 8 × w. 5¼ × D. 2¾ in.
The Avery Brundage Collection, B60S219
[Page 146]

Noh mask of the Kagekiyo type, approx.
1868–1926
Japan
Wood with colors
H. 8½ × w. 5⅛ × D. 3 in.
The Avery Brundage Collection, B60S217
[Page 147]

Noh mask of the Yaseotoko type, approx.
1868–1926
Japan
Wood with colors
H. 8¼ × W. 5¼ × D. 3 in.
The Avery Brundage Collection, B60S220
[Page 147]

Animal mask, approx. 1800–1900
Probably India
Wood
H. 8½ × W. 8 × D. 4 in.
Gift of Georgia Sales, F2001.63.1
[Page 150]

Human mask, approx. 1800–1900
Probably India
Wood
H. 9 × W. 8 × D. 6½ in.
Gift of Georgia Sales, F2001.63.2
[Page 150]

Animal head mask, 1700–1800
Tibet
Wood
H. 14½ × W. 9½ × D. 10½ in.
The Avery Brundage Collection, B60S189
[Page 151]

Blue lion mask, approx. 1700–1800
Tibet
Painted wood
H. 12½ × W. 9¼ × D. 11½ in.
The Avery Brundage Collection, B60S190
[Page 151]

**The encounter between the Hindu
god Krishna and the serpent Kaliya,
from a manuscript of the Bhagavata
Purana (the story of Lord Vishnu)**,
approx. 1800
India; Madhya Pradesh state, former
kingdom of Datia
Opaque watercolors on paper
H. 12 × W. 15¼ in.

From the Collection of William K.
Ehrenfeld, M.D., 2005.64.39
[Page 154]

**The gods and demons churn the ocean of
milk**, approx. 1800
India; Mysore, Karnataka state
Opaque watercolors on paper
H. 7¼ × W. 14¾ in.
Gift of George Hopper Fitch, B87D13
[Page 155]

**Vishnu asleep on the serpent in the cosmic
ocean**, 1850–1900
India or Pakistan; Kashmir region
Opaque watercolors on paper
H. 2⅜ × W. 3½ in.
Gift of George Hopper Fitch, B86D15
[Page 155]

Kasuga deer deity
Deer: Heian period, pigment on wood;
Monju Bosatsu: Kamakura period, pigment
on wood; Negoro lacquer tray: Kamakura
period, the second year of Tokuji (1307),
former collection of Sankei Hare; Sakaki
plant and antlers, 2010, by Yoshihiro Suda,
pigment on wood
H. 13⅜ × W. 16½ × D. 11⅝ in.
Private collection
Photo courtesy of private collection
[Page 173]

Ritual bowl, approx. 1700–1900
Korea; Joseon dynasty (1392–1910)
Porcelain with bluish gray glaze
H. 2½ × DIAM. 5⅝ in.
Gift of Arthur J. McTaggart, 1998.20
[Page 180]

**Jar with plum blossoms, bamboo, and
trigrams**, approx. 1800–1900
Korea; Joseon dynasty (1392–1910)
Porcelain with underglaze decoration
H. 5⅝ × DIAM. 7¼ in.

Gift of Arthur J. McTaggart, 1998.22
[Page 180]

Ritual plate, approx. 1800–1900
Korea; Joseon dynasty (1392–1910)
Glazed porcelain
H. 3⅝ × DIAM. 8 in.
Gift of Arthur J. McTaggart, 1999.5.47
[Page 181]

Ritual plate, approx. 1800–1900
Korea; Joseon dynasty (1392–1910)
Glazed porcelain
H. 3⅜ × DIAM. 7⅜ in.
Gift of Arthur J. McTaggart, 1998.27
[Page 181]

Ritual dish, approx. 1800–1900
Korea; Joseon dynasty (1392–1910)
Glazed porcelain
H. 4 × DIAM. 5½ in.
Acquisition made possible by
Frank S. Bayley, 2010.3
[Page 182]

Ritual dish, approx. 1800–1900
Korea; Joseon dynasty (1392–1910)
Glazed porcelain
H. 6½ × DIAM. 8¼ in.
Acquisition made possible by
Frank S. Bayley, 2010.2
[Page 182]

Ritual plate, approx. 1800–1900
Korea; Joseon dynasty (1392–1910)
Glazed porcelain
H. 4⅝ × DIAM. 10¼ in.
Gift of Arthur J. McTaggart, 1999.5.46
[Page 182]

Ceremonial vessel in the shape of a phoenix
China; Ming dynasty (1368–1644)
Bronze with silver inlay, gilded copper inlay,
and painted lacquer-simulated patina
H. 11⅝ × W. 8½ × D. 4½ in.

Museum purchase, 2003.11
[Page 183]

Ritual object (*zun*) in the shape of a goose, approx. 1800–1900
China; Qing dynasty (1644–1911)
Bronze with gold and silver inlay
H. 12 × W. 16½ in.
The Avery Brundage Collection, B60B62
[Page 183]

**Sacred Mountains:
Encountering the Gods**

Mountain village, 1832 or 1892
China; Qing dynasty (1644–1911)
Ink and colors on silk
H. 83½ × W. 29⅜ in.
The Avery Brundage Collection, B60D87
[Page 197]

Peach Blossom Idyll, 1750–1784
By Ike Gyokuran (Japanese, 1728–1784)
Ink and colors on paper
H. 44 × W. 19½ in.
Museum purchase, B76D3
[Page 199]

The prophet Muhammed in the cave of Hira, 1720
Northern India
Opaque watercolors and gold on paper
H. 19⅜ × W. 10⅞ in.
Gift of George Hopper Fitch, B87D17
[Page 200]

Shiva and family consisting of Parvati, Ganesha, and Kartikeya preparing soma on Mount Kailasha, approx. 1800
India; Himachal Pradesh, Kangra, or Guler

Opaque watercolors on paper
H. 9⅞ × W. 7¼ in.
Gift of Dr. Stephen A. Sherwin and Merrill Randol Sherwin, 2010.16
[Page 202]

Meditating Buddhist figure, approx. 1900–1949
China
Qing dynasty (1644–1911)
Nephrite
H. 5¼ × W. 2¾ in.
The Avery Brundage Collection, B60J1
[Page 203]

The Buddha descending from Indra's heaven, approx. 1700–1900
Laos or Northern Thailand
Bronze
H. 22 × W. 5¼ × D. 9 in.
Gift of Dr. Sarah Bekker, 2010.516
[Page 203]

Double-tiered offering container, 1875–1925
Thailand
Lacquered and gilded bamboo and wood with mirrored glass
H. 16 × DIAM. 16 in.
Gift from Doris Duke Charitable Foundation's Southeast Asian Art Collection, 2006.27.106
[Page 213]

Incense burner (*boshanlu*)
China; probably Shanxi province
Western Han dynasty (206 BCE–9 CE)
Bronze
H. 10 × DIAM. 6½ in.
The Avery Brundage Collection, B60B969.A–B
[Page 220]

Incense burner (*boshanlu*) with dragons and phoenix
China; Western Han dynasty (206 BCE–9 CE)
Bronze
H. 10¾ × DIAM. 9 in.
The Avery Brundage Collection, B60B131
[Page 220]

Gyōdō processional mask of the Ōmai type, 1400–1600
Japan
Wood with traces of lacquer and colors
H. 8¾ × W. 7⅛ in.
Gift and Purchase from the Harry G.C. Packard Collection Charitable Trust in honor of Dr. Shujiro Shimada; The Avery Brundage Collection, 1991.72
[Page 226]

Five-chambered cup, approx. 400–500
Korea
Stoneware
H. 5⅝ × DIAM. 3⅝ in.
Acquisition made possible by the Walter and Phyllis Shorenstein Foundation, 1991.52
[Page 248]

Bell cup, approx. 400–500
Korea
Stoneware
H. 5⅞ × DIAM. 3⅛ in.
Gift of Robert Wm. Moore, 1988.60
[Page 267]

Artists' Biographies

Compiled by Cristin McKnight Sethi

Biographical information is current through 2011.

POKLONG ANADING

Born in Quezon City, Philippines.
Lives and works in Quezon City

Education

1999 College of Fine Arts, University of the Philippines,
 Quezon City

Selected Solo Exhibitions

2011 Mo_Space Gallery, Manila, Philippines
 Osage Gallery Soho, Hong Kong, China
2010 Finale Art Gallery, Makati City, Philippines
 Galerie Zimmermann Kratochwill, Graz, Austria
2009 Ateneo Art Gallery, Quezon City, Philippines
2008 Mag:net Gallery Katipunan, Quezon City,
 Philippines
2007 Ateneo Art Gallery, Quezon City, Philippines
2006 The Cross Arts Projects, Sydney, Australia
 Future Prospects, Quezon City, Philippines
2005 Theo Gallery, Makati City, Philippines

Selected Group Exhibitions

2011 *14th Jakarta Biennale*, Jakarta, Indonesia
 Complete and Unabridged, Part II, Osage Kwun Tong,
 Kowloon, Hong Kong, China
 The Sta. Mesa Diaries, Centre for Contemporary
 Photography, Fitzroy, Australia
 I Miss the 20th Century, Manila Contemporary,
 Makati City, Philippines
 Between Signs, Silverlens Gallery, Makati City,
 Philippines
2010 *Rainbow Asia, Pearl of the World*, Hangaram Art
 Museum, Seoul, Korea
 Bastards of Misrepresentation, Freies Museum, Berlin,
 Germany
 Minimum Yields Maximum, Monte Vista Projects,
 Los Angeles, California, USA
2009 *Thrice Upon A Time*, Singapore Art Museum,
 Singapore
 This and That, Triple Base Gallery, San Francisco,
 California, USA
 Stick with the Enemy, Mo_Space Gallery, Taguig,
 Philippines

Magnetic Power, Lee C Gallery, Seoul, Korea

Fluid Zones: Jakarta Biennale, Jakarta, Indonesia

2008 *Beyond Frame: Philippine Photomedia*, UTS Gallery,
 Sydney, Australia

Galleon Trade, Yerba Buena Center for the Arts,
San Francisco, California, USA

Coffee, Cigarettes, and Pad Thai, Eslite Gallery, Taipei,
Taiwan

Sentimental Value, Soka Contemporary Space, Beijing,
China

Room 307: Inkling, Gutfeel and Hunch, National Art
Gallery, Manila, Philippines

CUT: New Photography from Southeast Asia,
Valentine Willie Fine Art, Kuala Lumpur,
Malaysia

2007 *Pocket Monsters*, Prose Gallery, Makati City,
 Philippines

Ars Erotica, Sison Art Gallery, Manila, Philippines

2006 *Manila Envelope*, Worth Ryder Gallery, Berkeley,
 California, USA

Metropolitan Mapping, Hong Kong Cultural Centre,
Hong Kong, China

2005 *2005 Daejeon FAST*, Daejeon Museum of Art,
 Daejeon, Korea

Flippin' Out: Maynila to Williamsburgh, Goliath
Visual Space, Brooklyn, New York, USA

2004 *Cancelled Metaphors*, The Art Center, Mandalugyong
 City, Philippines

2003 *Satellite*, Cantin Plate Gallery, Quezon City,
 Philippines

2002 *Video Programme 2002*, Nikolaj Contemporary Art
 Center, Copenhagen, Denmark

Pause: The 4th Gwangju Biennale, Gwangju, Korea

2000 *Paper Over*, Ayala Museum, Makati City, Philippines

Selected Publications

Aragona, Alexis, and Beatriz Robles. "Lucky 13," *Bluprint* 1
 (2007): 108.

Banal, Yason. "Sleepwalking: Tasks About Anything."
 The Philippine Star, September 2, 2005.

Evangelista, Carina. "The Collector." *MUSE* 1, no. 3 (2007): 30.

Fairley, Gina. "Fresh Nuances in Narrative." *Asian Art News*
 19, no. 24 (March/April 2009): 73.

Gibson, Prue. "Beyond Frame: Philippine Photomedia." *Art
 Monthly Australia*, no. 216 (December 2008–February
 2009): 31–33.

Manahan, Juana. "Saturday Seven: Poklong's Power Play."
 Philippine Daily Inquirer, February 2, 2008.

Ng, Elaine. *ArtAsiaPacific: Almanac 2007*. Hong Kong, China:
 ArtAsiaPacific, 2007.

Ocampo Flores, Karen. "13 Goes 36." Sunday Magazine sec.,
 The Philippine Star, September 24, 2006.

Reyes, Eric Estuar. "Fictions of Return in Filipino America."
 Social Text 107 (Summer 2011): 99–117.

BAE YOUNG-WHAN

Born in Seoul, Korea. Lives and works in Seoul

Education

1990 BFA, Oriental Painting, Hongik University, Seoul,
 Korea

Selected Solo Exhibitions

2010 PKM Gallery, Seoul, Korea

2009 Artsonje Center, Seoul, Korea

2008 PKM Gallery, Seoul, Korea

2005 Alternative Space Pool, Seoul, Korea

2002 Ilju Art House, Seoul, Korea

1999 Kumho Museum of Art, Seoul, Korea
1997 Namu Gallery, Seoul, Korea

Selected Group Exhibitions

2011 *Medi(t)ation: 3rd Asian Art Biennial*, National Taiwan
 Museum of Fine Arts, Taichung, Taiwan
2010 *Plastic Garden*, Minsheng Art Museum, Shanghai,
 China
 K-Art Archive Room, Seoul Art Space Seogyo, Seoul,
 Korea
 The Infinite Starburst of Your Cold Dark Eyes, PKM
 Gallery, Seoul, Korea
 Art Now #3: Video Tale, Gyeonggi Museum of
 Modern Art, Ansan, Korea
2009 *Peppermint Candy: Contemporary Art from Korea*,
 National Museum of Contemporary Art,
 Gwacheon, Korea; Museo Nacional de Bellas
 Artes, Buenos Aires, Argentina; and Museum of
 Contemporary Art, Santiago, Chile
 Discoveries: ShContemporary 09, Shanghai Exhibition
 Center, Shanghai, China
 Emporium: A New Common Sense of Space, Museo
 Nazionale della Scienza e della Tecnologia
 Leonardo da Vinci, Milan, Italy
 Unconquered: Critical Visions from South Korea,
 Museo Tamayo Arte Contemporáneo, Mexico
 City, Mexico
 Void of Memory, Platform Seoul 2009, KIMUSA,
 Seoul, Korea
 Museum as Hub: In and Out of Context, New
 Museum, New York, New York, USA
 Made in Korea—Leisure, a Disguised Labor?, Kestner
 Gesellschaft, Hanover, Germany
 A Different Similarity: Towards the Sea,
 Santralistanbul, Istanbul, Turkey

Foregrounded, PKM Gallery, Seoul, Korea
Conversion, PKM Gallery, Seoul, Korea
2008 *TransPOP: Korea Vietnam Remix*, Arko Art Center,
 Seoul; San Art and Galerie Quynh, Ho Chi Minh
 City, Vietnam; University Art Gallery of UC
 Irvine, Irvine, California, USA; and Yerba Buena
 Center for the Arts, San Francisco, California, USA
 Art Basel 39, Basel, Switzerland
2007 *Hermès Korea Missulsang*, Atelier Hermès, Seoul,
 Korea
 Activating Korea: Tides of Collective Action, Govett-
 Brewster Art Gallery, New Plymouth, New
 Zealand
 Fast Break, PKM Gallery Beijing, Beijing, China
2006 *Somewhere in Time*, Artsonje Center, Seoul, Korea
 Drawn to Drawing, SOMA Museum of Art, Seoul,
 Korea
 Symptom of Adolescence, Rodin Gallery, Samsung
 Museum of Art, Seoul, Korea
 Public Moment, Ssamzie Art Space, Seoul, Korea
 Three Stories, PKM Gallery, Seoul, Korea
2005 *The Battle of Visions*, Kunsthalle Darmstadt,
 Darmstadt, Germany
 Secret Beyond the Door, 51st Venice Biennale, Korean
 Pavilion, Venice, Italy
2004 *A Grain of Dust, A Drop of Water, 5th Gwangju
 Biennale*, The May 18 Memorial Park, Gwangju,
 Korea
 'Bom' Outing to Museum, Seoul Museum of Art,
 Seoul, Korea
2003 *Yangguang Canlan*, Biz Art Center, Shanghai, China
 The Present of Asia, Marronnier Art Center, Seoul,
 Korea
 Facing Korea: Demirrorized Zone, De Appel Arts
 Centre, Amsterdam, The Netherlands

Park-ing, Marronnier Art Center, Seoul, Korea

Discovery of Life in Seoul, Ssamzie Space, Alternative Space Loop, Seoul, Korea

People Who Walk on Water: Project Chunggye Stream, Seoul Museum of Art, Seoul, Korea

2002 *Culture Meets Culture: 2nd Busan Biennale*, Busan Museum of Art, Busan, Korea

Digital Video Diary, Jeonju International Film Festival, Jeonju, Korea

Image, Text, Typo, Busan Museum of Art, Busan, Korea

P_a_u_s_e: Project 3—Stay of Execution, The 4th Gwangju Biennale, Gwangju, Korea

2001 *The Sun and the Moon: Videography*, Ilju Art House, Seoul, Korea

Dispersed, Marronnier Art Center, Seoul, Korea

Crossover, Sungkok Museum, Seoul, Korea

Good Morning, The Han River, Seoul Subway No. 1 Line, Seoul, Korea

2000 *Relay-Relay*, Insa Art Space of Arts Council Korea, Seoul, Korea

Media Festival, 3rd Gwangju Biennale, Gwangju Folk Museum, Gwangju, Korea

Korean Contemporary Art, Expression of Time: Eyes and Hands Exhibition, Seoul Arts Center, Seoul, Korea

Selected Publications

Young-whan, Bae. *Bae Young-whan*. Seoul, Korea: Space for Contemporary Art, 2008.

Chan-kyong, Park, ed. *Fast Break*. Beijing, China: PKM Gallery, 2007.

Lee, James B. "Interview with Young-whan Bae." *ART iT* (Spring/Summer 2007).

RINGO BUNOAN

Born in Manila, Philippines.
Lives and works in Makati City

Education

1997 College of Fine Arts, University of the Philippines, Quezon City

Selected Solo Exhibitions

2010 Ishmael Bernal Gallery, Quezon City, Philippines

Finale Art Gallery, Makati City, Philippines

2008 Silverlens Gallery, Makati City, Philippines

Mo_Space Gallery, Taguig, Philippines

Selected Group Exhibitions

2011 *Complete and Unabridged*, Part II, Osage Kwun Tong, Kowloon, Hong Kong, China

I Miss the 20th Century, Manila Contemporary, Makati City, Philippines

Support > System, Luckman Fine Arts Complex, Los Angeles, California, USA

Chabet in Three and Four Dimensions, Osage Kwun Tong, Kowloon, Hong Kong, China

Imagined Geographies, Osage Gallery SoHo, Central, Hong Kong, China

To Be Continued—Hong Kong, Osage Kwun Tong, Kowloon, Hong Kong, China

2010 *The River Project*, Campbelltown Arts Centre, Sydney, Australia

Blind Field, Silverlens Gallery, Makati City, Philippines

The Unnamable, Manila Contemporary, Makati City, Philippines

Minimum Yields Maximum, Monte Vista Projects, Los Angeles, California, USA

2009 *Everyday Miracles (Extended)*, REDCAT, Los
 Angeles, California, USA
 Everyday Miracles (Extended): Phase 2, San Francisco
 Art Institute, San Francisco, California, USA
2008 *Busan Biennale Sea Art Festival*, Busan, Korea
 Beyond Frame: Philippine Photomedia, UTS Gallery,
 Sydney, Australia
 Strain Extension, Mo_Space Gallery, Taguig, Philippines
 Pillow Talk, Silverlens Gallery, Makati City,
 Philippines
2007 *I Have Nothing to Paint and I'm Painting It*,
 Mo_Space Gallery, Manila, Philippines
 Shoot Me, Mo_Space Gallery, Manila, Philippines
 Pocket Monsters, Prose Gallery, Makati City,
 Philippines
2006 *Blank*, West Gallery, Quezon City, Philippines
 Missing Vocabularies, Green Papaya Art Projects,
 Quezon City, Philippines
2004 *Homefronts*, Singapore Art Museum, Singapore
 Cancelled Metaphors, Finale Art Gallery, Makati City,
 Philippines
2003 *The Thirteen Artists Award*, Cultural Center of the
 Philippines, Manila, Philippines
 Picture This, Finale Art Gallery, Makati City,
 Philippines
2002 *Conversation*, Finale Art Gallery, Makati City,
 Philippines
 PAUSE: The 4th Gwangju Biennale, Gwangju, Korea
2001 *Suitcase Studies*, 1A Space, Hong Kong, China
 Cool Pieties, Finale Art Gallery, Makati City, Philippines
 Space Meeting Place, Ayala Museum, Makati City,
 Philippines
 Double Wall, Surrounded By Water—Pied Piper
 Place, EDSA, Mandaluyong City, Philippines
2000 *True Confessions: Words, Thoughts, Acts*, Finale Art
 Gallery, Makati City, Philippines

USEBy: Asia Pacific Artist Initiative Project, Centre for
 Contemporary Photography, Fitzroy, Australia
 Faith + the City, Valentine Willie Fine Art, Kuala
 Lumpur, Malaysia
1999 *M.M.Y.*, Museo ng Maynila, Manila, Philippines
 Cracks and Abysses, Finale Art Gallery, Makati City,
 Philippines
 Dumb Drawings, The Drawing Room, Makati City,
 Philippines
 100% Idiot Proof Camera, West Gallery, Quezon City,
 Philippines
 Peripheral Visions, Ayala Museum, Makati City,
 Philippines
 *Topology of Signs: Surfaces, Shapes and Signs of
 Meaning*, Cultural Center of the Philippines,
 Manila, Philippines
 *Kaka: Extended Diversions from California and
 Manila*, Cultural Center of the Philippines,
 Manila, Philippines
1998 *Remote Viewing*, Brix Gallery, Makati City,
 Philippines
 Views from Elsewhere, Finale Art Gallery, Makati City,
 Philippines
1997 *Digging the Same Hole*, West Gallery, Quezon City,
 Philippines
 Wittgenstein's Duck-Rabbit, West Gallery, Quezon
 City, Philippines

Selected Publications

Gibson, Prue. "Beyond Frame: Philippine Photomedia." *Art
 Monthly Australia*, no. 216 (December 2008–February
 2009): 31–33.
Sahakian, Marlyne. "Where I Work: Ringo Bunoan."
 ArtAsiaPacific 62 (March / April 2009).
Xiao, An. "The Father of Filipino Conceptual Art."
 Hyperallergic, November 29, 2011.

CHOI JEONG HWA
Born in Seoul, Korea. Lives and works in Seoul

Education

1987 BFA, Hong Ik University, Seoul, Korea

Selected Solo Exhibitions

2010 Aando Fine Art, Berlin, Germany

2009 Korean Cultural Centre, London, UK
 Towada Art Center, Towada, Japan

2008 Point Éphémère, Paris, France
 Pekin Fine Arts, Beijing, China

2007 REDCAT, Los Angeles, California, USA
 Wolverhampton Art Gallery, Wolverhampton, UK
 Kunsthalle Wien, Vienna, Austria

1997 Kukje Gallery, Seoul, Korea

1996 Oz Gallery, Paris, France

Selected Group Exhibitions

2011 *Lingua Franca*, St. Moritz Art Masters 2011, St. Moritz, Switzerland
 Welcome, EcoLand, Jeju, Korea; and Wolverhampton Art Gallery, Wolverhampton, UK
 Revive: Gwangju Biennale, Gwangju, Korea
 My own private neon oasis, Museum of Brisbane, Brisbane, Australia
 Whatchamacallit, Kunsthalle, Gwangju, Korea
 Gala Party, REDCAT Gallery, Los Angeles, California, USA
 Happy Happy, Pohang Museum, Pohang, Korea

2010 *Roppongi Art Night*, Mori Art Museum, Tokyo, Japan
 By Day, By Night, Rockbund Art Museum, Shanghai, China
 SHContemporay 10th, Shanghai, China
 Art HK 10, Hong Kong, China

Plastic Garden, Minsheng Art Museum, Shanghai, China
17th Biennale of Sydney, Sydney, Australia

2009 *Your Bright Future*, The Museum of Fine Art, Houston, Texas, USA; and the Los Angeles County Museum of Art, Los Angeles, California, USA

2008 *Opening Exhibition*, Bangkok Art and Culture Centre, Bangkok, Thailand
 D'art Contemporain au Chateau D'Oiron, Oiron, France
 Spring Art Show, Space-c, Seoul, Korea
 New Project, Pekin Fine Arts, Beijing, China
 Seoul Design Olympic 2008, Zamsil Olympic Stadium, Seoul, Korea
 Gala Party, REDCAT Gallery, Los Angeles, California, USA

2007 *Peppermint Candy*, Santiago, Chile
 Tomorrow, Kumho Museum of Art, Seoul, Korea
 Trace Root, Arco, Madrid, Spain
 Activating Korea, The Govett-Brewster Art Gallery, New Plymouth, New Zealand

2006 *Gwangju Biennale: Trace Root*, Gwangju, Korea
 Special Project—*Vivocity, Singapore Biennale*, Singapore
 Believe it or not, Ilmin Museum, Seoul, Korea
 Art&Industry: SCAPE Biennale, Christchurch, New Zealand
 Open-Air Exhibition, Middleheim Museum, Antwerp, Belgium
 Through the Looking Glass, Asian House, London, UK

2005 *Dressing Ourselves*, Milano Triennale, Milan, Italy
 Design Edge, Korean Pavilion, Suntec City, Singapore
 Until Now, Charlottenburg, Copenhagen, Denmark
 Secret Beyond the Door, 51st Venice Biennale, Korean Pavilion, Venice, Italy
 CP Biennale, CP Center, Jakarta, Indonesia
 Roomscape, Ssamziegil Gallery, Seoul, Korea

2004 *Kim Jonghak and Choi Jeong-Hwa*, Garam Gallery, Seoul, Korea

Liverpool Biennale, Lime Station, Liverpool, UK
Happy Happy, Kirkby Gallery, Liverpool, UK
Melbourne Art Fair, Melbourne, Australia
This is not a love letter, Korean Cultural Foundation
 Center, Seoul, Korea
The Tale of Seoul, Korean Cultural Foundation
 Center, Seoul, Korea
2003 *Happiness*, Mori Art Museum, Tokyo, Japan
Lyon Biennale, Lyon, France
Flower Power, Palais des Beaux-Arts, Lille, France
Yang Gwang Chan Ran, Biz Art Center, Shanghai,
 China
Virgin Road, Ssamzie Space, Seoul, Korea
Time after Time, Yerba Buena Center for the Arts,
 San Francisco, California, USA
2002 *Happy Together*, Kagoshima Open Air Museum,
 Kagoshima, Japan
The 8th Baltic Triennial of International Art,
 Contemporary Art Center, Vilnius, Lithuania
Orient, Extreme, Le Lieu Unique, Nante, France
Korean & Japanese Contemporary Prints Exhibition,
 Gallery OM, Osaka, Japan
Gwangju Biennale, Gwangju, Korea
2001 *Yokohama Triennial*, Yokohama Station, Yokohama,
 Japan
Lunapark/Contemporary Art from Korea,
 Wurttembergischer Kunstverein, Stuttgart,
 Germany
2000 *Bar epicurus*, Mitsubishi-Jisho Atrium, Hukuoka,
 Japan
Let's Entertain, Walker Art Center, Minneapolis,
 Minnesota, USA; Centre Georges Pompidou,
 Paris, France
AIR AIR, Grimaldi Forum, Monaco, Monaco
1999 *Lord of the Rings*, Hasselt Museum, Hasselt, Belgium
Tachigawa Festival, Tachigawa Station, Tokyo, Japan

Hot Air, Grandship Convention and Art Center,
 Shizuoka, Japan
Slowness Speed, National Gallery of Victory,
 Melbourne, Australia
Between the Unknown Straits, The Korean Culture &
 Arts Foundation Art Center, Seoul, Korea
1998 *São Paulo Biennale*, Ciccillo Matarazzo Pavilion,
 São Paulo, Brazil
Seamless, De Appel Center, Amsterdam,
 The Netherlands
Taipei Biennale: Site of Desire, Taipei Museum, Taipei,
 Taiwan

Selected Publication

Muchnic, Suzanne. "'Your Bright Future' Spotlights Korean
 Artists at LACMA." *Los Angeles Times*, June 21, 2009.

HEMAN CHONG

Born in Muar, Malaysia.
Lives and works in Singapore and New York City

Education

2002 Royal College of Art, London, UK
1997 Temasek Polytechnic, Singapore

Selected Solo Exhibitions

2011 NUS Museum, Singapore
2010 Kunstverein, Milan, Italy
 Motive Gallery, Amsterdam, The Netherlands
2009 TV2, ION Orchard, Singapore
2008 Third Floor-Hermès, Singapore
2007 Deckard and Pei, Singapore
 Art in General, New York, New York, USA
 Vitamin Creative Space, Guangzhou, China
2006 Deckard and Pei, Singapore

Cityroom Gallery, Singapore
Projektraum Deutscher Künstlerbund, Berlin,
 Germany
Project Arts Centre, Dublin, Ireland
Rathaus Kreuzberg / HAU Theater, Berlin, Germany
2005 Deckard and Pei, Singapore
 Ellen de Bruijne Projects, Amsterdam,
 The Netherlands
2004 The Substation Gallery, Singapore
 Galerieraum KunstBank, Berlin, Germany
2003 Künstlerhaus Bethanien, Berlin, Germany
 Sparwasser HQ, Berlin, Germany
2002 The Substation Gallery, Singapore
2001 The Blue Room, Royal College of Art, London, UK
2000 Alliance Française de Singapour, Singapore
 (with Tan Kai Syng)
1999 The Substation Gallery, Singapore
1997 The Substation Gallery, Singapore

Selected Group Exhibitions

2011 *Momentum 2011—6th Nordic Biennial for Nordic*
 Contemporary Art, Galleri F15, Moss, Norway
 Agency of Unrealized Projects (AUP), Kopfbau
 (e-flux), Basel, Switzerland
 Homo Ludens—Act I + II, Motive Gallery,
 Amsterdam, The Netherlands
 Commercial Break, Garage Projects / POST, 54th
 Venice Biennale, Venice, Italy
 A Wedding, Para / Site Art Space, Hong Kong, China
 Dancing to the Rhyme, Kumho Museum of Art, Seoul,
 Korea
 MiArt, Pavilion 3, Milan Fair, Milan, Italy (with
 Kunstverein Milano)
2010 *Christmas in July*, Yvon Lambert, New York, New
 York, USA
 King Rat, Project Arts Centre, Dublin, Ireland

expo zéro by Musée de la Danse, BAK, Utrecht,
 The Netherlands
Trickster Makes This World, Nam June Paik Art
 Center, Seoul, Korea
e-flux video rental, Fondazione Giuliani per l'Arte
 Contemporanea, Rome, Italy
Art HK 10, Hong Kong Convention Center, Hong
 Kong, China
Artissima 17, Lingotto Fiere, Turin, Italy
 (with MACBA)
A Map Bigger Than Its Surface, Gallery Rotor I,
 Gothenburg, Sweden
Surface Depth, Gallery H, Bangkok, Thailand
Cabinet of Curiosities, Artspace @ Helutrans,
 Singapore
Flying Circus Project Platform 3: Superintense, *Bophana*,
 Phnom Penh, Cambodia / 72-13, Singapore
2009 *The Demon of Comparisons*, Stedelijk Museum
 Bureau, Amsterdam, The Netherlands
 In Search of the Unknown, Netherlands Media Art
 Institute, Amsterdam, The Netherlands
 Weak Signals, Wild Cards, De Appel / Amsterdam
 Noord, The Netherlands
 The Malady of Writing, Museu d'Art Contemporani
 de Barcelona (MACBA), Barcelona, Spain
 Portrait of Self-Exile (Part I), the shop, Vitamin
 Creative Space, Beijing, China
 Discoveries: ShContemporary 09, Shanghai Exhibition
 Center, Shanghai, China
 And the difference is, Gertrude Contemporary,
 Melbourne, Australia
 Bunnies, It Must Be Bunnies, Lautom Contemporary,
 Oslo, Norway
 booksmart, Okay Mountain, Austin, Texas, USA
 No Bees, No Blueberries, Harris Lieberman Gallery,
 New York, New York, USA

2008 *Singapore Biennale 2008*, South Beach Development, Singapore

The Possibility of an Island, Museum of Contemporary Art, North Miami, Florida, USA

A Question of Evidence, Thyssen-Bornemisza Art Contemporary, Vienna, Austria

Eurasia, Museo di arte moderna e contemporanea di Trento e Rovereto, Rovereto, Italy

Like an Attali Report, but Different, Kadist Art Foundation, Paris, France

And the Difference Is (The Independence Project), NUS Museum, Singapore

How to talk about utopia without saying utopia, PLAY-SPACE Gallery, San Francisco, California, USA

2007 *Frieze Art Fair*, Regent's Park, London, UK (with Vitamin Creative Space)

Video Killed the Painting Star, The Center for Contemporary Art, Glasgow, Scotland

TransRobota, National Museum of Szczecin, Szczecin, Poland (with Saim Demircan)

Encounters, National Art Museum of China, Beijing, China

The Use of the World, Museum of Modern and Contemporary Art, Rijeka, Croatia

Rio, Artnews Projects, Berlin, Germany

Friends and Enemies, Gagosian Gallery, Berlin, Germany (with Tilman Wendland)

2005 *City/Observer*, New Museum of Contemporary Art/Rhizome.org, New York, New York, USA

Insomnia: The Global Soul, Institute of Contemporary Arts (ICA), London, UK

FAST 2005: Urbanity—4 Takes, Daejeon Museum of Art, Daejeon, Korea

Boxen für den Frieden, Deutsch-Russisches Museum, Berlin, Germany

Mirror Worlds, Australian Centre for Photography, Sydney/Institute of Modern Art, Brisbane, Australia

Water Event, Astrup Fearnley Museum, Oslo, Norway/Migros Museum, Zürich (as part of Yoko Ono performance)

BoundLess, Stenersenmuseet, Oslo, Norway (with Jan Christiensen)

2004 *Busan Biennale 2004*, Busan Metropolitan Art Museum, Busan, Korea

LAB, Kröller Müller Museum, Otterlo, The Netherlands

Along the Gates of the Urban, Oda Projesi, Istanbul, Turkey

Depicting Love, Reina Sofia, Madrid, Spain/Centro Párraga, Murcia, Spain

2003 *50th Venice Biennale*, Singapore Pavilion, Venice, Italy

Blood: Lines and Connections, Museum of Contemporary Art, Denver, Colorado, USA

Ars Electronica 2003 (Not to Scale), Kunstraum Linz, Linz, Austria

CP Open Jakarta Biennale, National Art Gallery, Jakarta, Indonesia

15 Tracks, Tama Art University Museum, Tokyo/Fukuoka Asian Art Museum, Fukuoka, Japan

36 Ideas from Asia, The National Museum, L'Aquila, Italy

2002 *Sonic Process*, Centre Georges Pompidou, Paris, France

Single Screen, Nikolaj Contemporary Art Center, Copenhagen, Denmark

2001 *10th India Triennale*, Lalit Kala Akademi, New Delhi, India

2000 *Video-Take*, Openbare Bibliotheek De Tweebronnen, Leuven, Belgium

1999 *BrainStorm: What's that in your head?*, Singapore Art
 Museum, Singapore

Selected Publications

Aasan, Øystein. "That's Roger Wilco, Over and Out."
 Spike Art, no. 14 (Winter 2007).

Chew, Boon Leong. "Singapore's Wong Kar Wai?" *Lianhe
 Zaobao*, March 12, 2006.

Chow, Clara. "Beware of Heman." *The Straits Times*,
 December 9, 2004.

Chua, Emily. "Heman Chong." *Broadsheet* 34, no. 1
 (March 2005).

Davis, Jacquelyn. "Imagine Being Here Now." Critics' Picks,
 Artforum.com, September 2, 2011.

Hu, Fang. "There Are Already Thousands of Exhibitions in
 the World." *Yishu* 6, no. 2 (June–July 2007): 67.

Lam, Yishan. "Surface Tension." *Blueprint Asia* 2, no. 6
 (December 2008–January 2009).

La Rocco, Claudia. "People Who Mistook Life for a Museum,
 and Vice Versa." *The New York Times*, November 8, 2011.

Lee, Rachel. "Heman Chong." *Cubes* (January 2007).

Maerkel, Andrew, and Alexie Glass. "Heman Chong: You
 have reached Domestic. How can I assist you today?"
 ArtAsiaPacific 60 (September/October 2008).

Nayar, Paravathi. "Moving Images." *The Business Times*,
 September 8, 2001.

Nungesser, Michael. "Vom Ankommen und Abheben." *Die
 Tageszeitung*, April 8, 2003.

Wee, Brandon. "DENSE & the Politics of Dynamic
 Paradigms." *iSh* (2000).

Wendland, Johannes. "Ein Nomade Im Elften Stock." *Zitty*,
 March 16–29, 2006.

Ziherl, Vivian. "Heman Chong: Island (Covers)." *LEAP* no. 6
 (December 2010).

GUO FENGYI (1942–2010)
Born in Xi'an, Sha'anxi Province, China.
Lived and worked in Xi'an

Selected Solo Exhibitions

2009 Long March Space, Beijing, China
2008 Barbara Gross Galerie, Munich, Germany
2005 Long March Space, Beijing, China

Selected Group Exhibitions

2011 *Spring Group Exhibition*, Long March Space, Beijing,
 China
2010 *10,000 Lives: Gwangju Biennale*, Gwangju, Korea
2009 *China in Four Seasons*, Govett Brewster Art Gallery,
 Taranaki, New Zealand
 Exhibition Number One, The Museum of Everything,
 London, UK
 *The Kaleidoscopic Eye: Thysse-Bornemisza Art
 Contemporary Collection*, Mori Art Museum,
 Tokyo, Japan
2007 *Long March Project—Yan'an*, Long March Space,
 Beijing, China
 *China Welcomes You . . . Desires, Struggles, New
 Identities*, Kunsthaus, Graz, Austria
2006 *2006 Taipei Biennial: Dirty Yoga*, Taipei Fine Arts
 Museum, Taipei, Taiwan
 *Ink, Life Taste—To Sugar Add Some Salt—5th
 Shenzhen International Ink Painting Biennial*, He
 Xiangning Museum of Art, Shenzhen, China
 Long March Capital, Long March Space, Beijing,
 China
 Building Code Violations I, Long March Space,
 Beijing, China
2005 *Art Circus—Jumping from the Ordinary—2nd
 Yokohama Triennial*, Yokohama, Japan
 Inaugural Exhibition, Long March Space, Beijing, China

Five-chambered cup, approx. 400–500.
Korea. Stoneware. H. 5⅝ × DIAM. 3⅝ in.

2nd Prague Biennale: A Second Sight, National Gallery,
 Prague, Czech Republic
2004 *Le Moine et Le Demon: Contemporary Chinese Art*,
 The Museum of Contemporary Art, Lyon, France
2003 *The Power of the Public Realm, Phase I*, Long March
 Space, Beijing, China

Selected Publications

Peiry, Lucienne. "Guo Fengyi." *L'Art Brut* 23 (2011).
Rookes, Felicity. "Artist's Body of Work on Show." *Taranaki
 Daily News*, September 21, 2009.
Tsongzung, Johnson, and Shiming Gao, eds. *Who Is Guo
 Fengyi?* Beijing, China: Long March Space, 2005.

HYON GYON

Born in Korea. Lives and works in Kyoto, Japan

Education

2011 PhD, Kyoto City University of Arts, Kyoto, Japan
2008 MA, Kyoto City University of Arts, Kyoto, Japan
2002 BA, MokWon University, Daejeon, Korea

Selected Solo Exhibitions

2011 Kyoto Art Centre, Kyoto, Japan
2010 g3 / gallery, Tokyo, Japan
2009 Gallery EXIT, Hong Kong, China
2008 Tokyo Wonder Site, Tokyo, Japan

Selected Group Exhibitions

2008 *New Beginning—The Show Must Go On!*, Magical
 Artroom, Tokyo, Japan
2007 *Worm Hole Episode 7*, Magical Artroom, Tokyo, Japan
 Tokyo Wonder Wall 2007, Museum of Contemporary
 Art, Tokyo, Japan

Hello, Chelsea! 2007, PS35 Gallery, New York,
New York, USA

Art Award Tokyo, Gyoko Underground Gallery,
Tokyo, Japan

Brilliant Works, art project room ARTZONE, Kyoto,
Japan

2006 *Art Camp*, Gallery Yamaguchi Kunst-Bau, Osaka,
Japan

NS HARSHA

Born in Mysore, India. Lives and works in Mysore

Education

1995 MFA, Painting, Faculty of Fine Arts, Baroda, India
1992 BFA, Painting, CAVA, Mysore, India

Selected Solo Exhibitions

2009 Victoria Miro Gallery, London, UK
2008 Maison Hermès, Tokyo, Japan
Bodhi Art, New York, New York, USA
2006 Gallery Chemould, Mumbai, India
Max Mueller Bhavan, Bangalore, India

Selected Group Exhibitions

2011 *Asia Triennial Manchester*, University of Manchester,
Manchester, UK
Yokohama Triennale, Yokohama, Japan
2010 *In the Company of Alice*, Victoria Miro Gallery,
London, UK
Touched: *Liverpool Biennial*, Liverpool, UK
29th São Paulo Biennale, São Paulo, Brazil
2009 *Indian Highway*, Serpentine Gallery, London, UK;
Astrup Fearnley Museum of Modern Art, Oslo,
Norway; Herning Museum of Contemporary

Art, Herning, Denmark; and Musée d'Art
Contemporain, Lyon, France

9th Sharjah Biennial, Sharjah, United Arab Emirates

Chalo! India: A New Era of Indian Art, Essl Museum,
Klosterneuburg, Austria; National Museum of
Contemporary Art, Seoul, Korea; and Mori Art
Museum, Tokyo, Japan

2008 *Artes Mundi 3*, National Museum Cardiff, Cardiff,
Wales, UK
Santhal Family, Muhka Museum, Antwerp, Belgium
India Moderna, Valencia Institute of Modern Art,
Valencia, Spain

2007 *Future* (organized by Bamboo Culture International),
Deng Kong Elementary School, Tamsui, Taiwan
Prospects, Auditorium Parco della Musica, Rome, Italy
Horn Please, Museum of Fine Arts, Bern, Switzerland
SH Contemporary, Sakshi Gallery, Shanghai, China
New Narratives: Contemporary Art from India,
Chicago Cultural Center, Chicago, Illinois, USA
A Mirage, Kala Ghoda Art Festival, presented by
Bodhi Art, Mumbai, India
Private/Corporate IV, Daimler Chrysler Collection,
Berlin, Germany
New Space, Sakshi Gallery, Mumbai, India

2006 *Cosmic Orphans*, Singapore Biennale, Singapore

2005 *The Artist Lives and Works* (organized by The Fine
Art Resource Mural, Project Art Space, Dublin,
Ireland), The House of World Cultures, Berlin,
Germany
Indian Summer, École Nationale des Beaux-Arts,
Paris, France

2004 *Another Passage to India*, Ethnography Museum,
Geneva, Switzerland
Artists-in-Labs, Center for Microscopy (ZMB),
University of Basel, Basel, Switzerland

Edge of Desire: Recent Art in India, Art Gallery of
 Western Australia, Perth, Australia; Asia Society
 and Queens Museum, New York, New York, USA;
 and Berkeley Art Museum, Berkeley, California,
 USA
Subtlety-Minimally, Lalit Kala Academy (presented by
 Sakshi Gallery), Delhi, India
Anticipation, The Fine Art Resource, Mumbai, India

2003 *Crossing Generations: diVERGE, 40 Years of Gallery
 Chemould*, National Gallery of Modern Art,
 Mumbai, India
Highlights, Sakshi Gallery, Mumbai, India
City Park, Project Art Space, Dublin, Ireland
Enchanting the Icon, Sakshi Gallery, Bangalore, India
bha bha bha, a collaborative project with Joan
 Grounds, supported by Asia Link, Melbourne,
 Australia
Portraits of a Decade, CIMA Gallery, Kolkata, India

2002 *Creative Space*, Sakshi Gallery, New Delhi, India
2nd Fukuoka Asian Art Triennial, Fukuoka, Japan
Aar Paar 2002, India-Pakistan Art Exchange Project,
 Mumbai, India, and Karachi, Pakistan
Brahma to Bapu: Icons and Symbols in Indian Art,
 CIMA Gallery, New Delhi, India

2001 *Drawing Space*, Angel Row Gallery, Nottingham, UK
10 Years of Sakshi, Chitrakalaparishat, Bangalore, India
Edge of the Volume, Sakshi Gallery, Bangalore, India
Works on Paper, CIMA Gallery, Kolkata, India

2000 *Aar Paar 2000, India-Pakistan Art Exchange Project*,
 Mumbai, India, and Karachi, Pakistan
Drawing Space, Beaconsfield Gallery in association
 with Victoria and Albert Museum, London, UK
Embarkations, Sakshi Gallery, Mumbai, India

1999 *apt3: The Third Asia Pacific Triennial of Contemporary
 Arts*, Brisbane, Australia

1998 *Terrains Vagues: Between Local and the Global*,
 Grandes Galleries, Rouen, France; and Herbert
 Read Gallery, Kent, UK
Cryptograms, Lakeeren Gallery, Mumbai, India

1997 *Chinnaramela*, Rangayana Theatre Repertory,
 Mysore, India

1996 *Fire & Life*, Sakshi Gallery, Bangalore, India
Arcos-da-Lapa, Rio de Janeiro, Brazil

1995 *Young Baroda*, Art Today Gallery, New Delhi, India
Excavation 95, CIMA Gallery, Kolkata, India
Postcards to Gandhi, Sahmat, New Delhi, India

1993 *National Graphic Art Exhibition*, Lalit Kala Academy,
 Bangalore

Selected Publications

Fibicher, Bernhard, and Suman Gopinath, eds. *Horn Please:
 Narratives in Contemporary Indian Art*. Bern, Switzerland:
 Hatje Cantz, 2007.
Grau, Donatien. "An Intellectual Fashion: NS Harsha."
 AnOther, May 4, 2011.
The Guardian. "Artist NS Harsha on How He Paints."
 September 20, 2009.
Miki, Akiko, ed. *Chalo! India: A New Era of Indian Art*.
 Tokyo, Japan: Mori Art Museum, 2008.

POURAN JINCHI
Born in Mashhad, Iran. Lives and works in New York City

Education

1993 Art Students League, New York, New York, USA
1989 University of California, Los Angeles, California,
 USA
1982 George Washington University, Washington, D.C.,
 USA

Selected Solo Exhibitions

2010 Leila Heller Gallery, New York, New York, USA
 The Third Line, Dubai, United Arab Emirates
2008 The Vilcek Foundation, New York, New York, USA
 Art Projects International, New York, New York,
 USA
 The Third Line, Dubai, United Arab Emirates
2007 M.Y. Art Prospects, New York, New York, USA
2005 M.Y. Art Prospects, New York, New York, USA
2004 511 Gallery, New York, New York, USA
2003 511 Gallery, New York, New York, USA
2002 Macy Gallery, Columbia University, New York,
 New York, USA
2001 M.Y. Art Prospects, New York, New York, USA
 Shibata Etsuko Gallery, Tokyo, Japan
2000 M.Y. Art Prospects, New York, New York, USA
 Art Projects International, New York, New York, USA
1999 Nikolai Fine Arts, New York, New York, USA

Selected Group Exhibitions

2010 *Light of the Sufis: The Mystical Arts of Islam*, Museum
 of Fine Arts, Houston, Texas, USA; and Brooklyn
 Museum of Art, New York, New York, USA
2009 *Iran Inside Out*, Chelsea Art Museum, New York,
 New York, USA
 Tarjama/Translation, Queens Museum of Art, New
 York, New York, USA; and Johnson Museum,
 Cornell University, Ithaca, New York, USA
 *Selseleh/Zelzeleh: Movers and Shakers in
 Contemporary Iranian Art*, Leila Heller Gallery,
 New York, New York, USA
 Unknown Territory—New York, Art Projects
 International, New York, New York, USA
2008 *East West Dialogues*, Leila Heller Gallery, New York,
 New York, USA

2007 *Culture Village, Flashback/Forward*, The Third Line,
 Dubai, United Arab Emirates
2006 *A Distant Mirror*, M.Y. Art Prospects, New York,
 New York, USA
2003 *Art Miami*, Miller/Geisler Gallery, Miami, Florida, USA
2002 *Art Miami*, M.Y. Art Prospects, Miami, Florida, USA
 Flag Art Festival, Poetry of the Winds, 2002 FIFA World
 Cup, Seoul, Korea
2001 *Art Miami*, M.Y. Art Prospects, Miami, Florida, USA
2000 *The Rose and the Nightingale*, Columbia University,
 New York, New York, USA
 The Learning Project, The Craft Museum, New York,
 New York, USA
 Group Show, Vibrant Gallery, New York, New York, USA
1998 *Third Annual Exchange Show*, Nikolai Fine Arts,
 New York, New York, USA
 Artists for Gardens, The Puck Building, New York,
 New York, USA
1997 *Two Artists Show*, Gallery Stendhal, New York,
 New York, USA
1996 *Art Exhibition*, The Federal Reserve Bank, New York,
 New York, USA

Selected Publications

Akbarnia, Ladan. "Pushing Boundaries: Pouran Jinchi."
 Canvas Magazine 5, no. 5 (2009): 145–50.
Cotter, Holland. "The Many Voices of Enlightenment."
 The New York Times, June 12, 2009.
Cotter, Holland, Ken Johnson, and Karen Rosenberg.
 "Tarjama/Translation." *The New York Times*, August 14,
 2009.
Galligan, Gregory. "Pouran Jinchi." *ArtAsiaPacific* 62 (March/
 April 2009).
Goodman, Jonathan. "Pouran Jinchi at M.Y. Art Prospects." *Art
 in America* 90, no. 10 (October 2002): 163.

JOMPET

Born in Yogyakarta, Indonesia.
Lives and works in Yogyakarta and Bali

Education

1999 Gadjah Mada University, Faculty of Social and
 Political Science, Yogyakarta, Indonesia

Selected Solo Exhibitions

2011 Selasar Sunaryo Art Space, Bandung, Indonesia
 Gervasuti Art Foundation, *Venice Biennale*, Venice,
 Italy
2010 Para/Site Art Space, Hong Kong, China
 Osage Kwun Tong, Hong Kong, China
2009 Osage Singapore, Singapore

Selected Group Exhibitions

2011 *Negotiating Home, Nation and History*, Singapore Art
 Museum, Singapore
 Closing the Gap, MIFA, Melbourne, Australia
 Influx, Ruang Rupa, Jakarta, Indonesia
2010 *Media Landscape, Zone East*, Korean Cultural Centre,
 London, UK
 *Manifesto of the New Aesthetic: Seven Artists from
 Indonesia*, Institute of Contemporary Arts
 Singapore, Singapore
 Kuandu Biennale 2010: Memories and Beyond, Taipei,
 Taiwan
 Contemporaneity: Contemporary Art of Indonesia,
 MOCA Shanghai, Shanghai, China
 Loss of the Real, Selasar Sunaryo Art Space, Bandung,
 Indonesia
 ARS—Artists in Residence Show, Fondazione Arnaldo
 Pomodoro, Milan, Italy

The Tradition of the New, Sakshi Gallery, Mumbai,
 India
 Art HK 10, Hong Kong, China
2009 *Beyond the Dutch: Indonesia, the Netherlands, and the
 Visual Arts, from 1900 until Now*, Centraal Museum,
 Utrecht, The Netherlands
 10e Biennale de Lyon: The Spectacle of the Everyday, Lyon,
 France
 Magnetic Power, Coreana Museum of Arts, Seoul, Korea
 Kompilasi, Bus Gallery, Melbourne, Australia
 Biennale Cuvée 09: Weltauswahl der Gegenwarts-kunst,
 OK Offenes Kulturhaus OÖ, Linz, Austria
 Jogjakarta Biennale X, Jogja National Museum, Jakarta,
 Indonesia
 Perang, Kata dan Rupa, Salihara Gallery, Jakarta,
 Indonesia
2008 *Yokohama Triennale 2008: Time Crevasse*, Central and
 Waterfront Sites in Yokohama, Yokohama, Japan
 Landing Soon, Erasmus Huis, Jakarta, Indonesia
 Manifesto, National Gallery, Jakarta, Indonesia
2007 *Equatorial Rhythms*, Stenersenmuseet, Oslo, Norway
2005 *The 3rd Fukuoka Art Triennale*, Fukuoka, Japan
 Urban/Culture: 2nd CP Biennale, Museum Bank
 Indonesia, Jakarta, Indonesia
2004 *ARTSCOPE: Inside of Myself/Outside of Yourself*,
 Selasar Sunaryo Art Space, Bandung, Indonesia
 Insomnia 48, Arts House, Singapore
 Move on Asia, SBS 1st Floor Atrium, Seoul, Korea
 Identities vs. Globalization, Chiang Mai Art Museum,
 Chiang Mai, Thailand; Bangkok National Art
 Gallery, Bangkok, Thailand; and Dahlem Museum,
 Berlin, Germany
2003 *Modernization & Urbanization*, Marronnier Art Center,
 Seoul, Korea

Transit: 8 Views of Indonesia, Umbrella Studio
 Contemporary Arts, Townsville, Australia
Urban Art Project, Subway Stations, Melbourne,
 Australia

Selected Publications

Bangkok Post. "A Thai Gem in the Creative City of Seoul."
 April 20, 2010.
Bianpoen, Carla. "Jompet's Open Structures: A Response to
 Critical Issues Today." *The Jakarta Post*, April 14, 2011.
Maerkle, Andrew. "We Are the System: Jompet Kuswidananto."
 ART iT, April 1, 2011.
Nafas. "Java's Machine: Phantasmagoria." March 2009.

AKI KONDO

Born in Hokkaido, Japan. Lives and works in Yamagata

Education

Present MFA, Tokohu University of Art and Design,
 Yamagata, Japan

Selected Solo Exhibition

2010 Enoma Gallery, Sendai, Japan

Selected Group Exhibitions

2011 *Group Show*, Imura Art Gallery, Tokyo, Japan
 Tokyo Frontline, 3331 Arts Chiyoda, Tokyo, Japan
2010 *De De Mouse x TUAD Live Paint*, Tokohu University
 of Art and Design, Yamagata, Japan
 Nippon Art Next 2010, Tokyo, Japan
 Wakaten, AYu:M, Yamagata, Japan
 Iwaki Art Triennial 2010, Fukushima, Japan
 Korea International Art Fair 2010, Seoul, Korea
2008 *Kanayama-machi*, Yamagata, Japan

SUN K. KWAK

Born in Korea. Lives and works in New York City

Education

1997 MA, Studio Art, New York University, New York,
 New York, USA
1988 BFA, Painting, Sook Myung University, Seoul, Korea

Selected Solo Exhibitions

2010 The New Art Gallery, Walsall, UK
2009 Brooklyn Museum of Art, Brooklyn, New York, USA
2007 Gallery Skape, Seoul, Korea
2006 Hyundai Window Gallery, Seoul, Korea
2005 Brain Factory, Seoul, Korea
2004 Causey Contemporary Art, New York, New York, USA
2001 Queens Museum of Art at Bulova Center, New York,
 New York, USA

Selected Group Exhibitions

2010 *Works & Process*, Guggenheim Museum, New York,
 New York, USA
 Memories of the Future, Leeum, Samsung Museum of
 Art, Seoul, Korea
2009 *Animal Art*, New Children's Museum, San Diego,
 California, USA
 Re-Imagining Asia, The New Art Gallery, Walsall, UK
2008 *Synthetic Supernova*, Mixed Green Gallery, New York,
 New York, USA
 Re-Imagining Asia, Haus der Kulturen der Welt, Berlin,
 Germany
 Brain Factory Benefit Show, Total Museum of Art,
 Seoul, Korea
2007 *Abbondanza*, Salvatore Ferragamo Gallery, New York,
 New York, USA; and Bridge Art Fair, London,
 Chicago, and Miami

Buscando la raíz, Sala Alcalá 31, Madrid, Spain
Life Force, Samsung Life Building (commissioned by
Leeum Museum), Seoul, Korea

2006 *6th Gwangju Biennale: Fever Variation*, Gwangju,
Korea

2005 *Wall to Wall Drawing*, The Drawing Center,
New York, New York, USA

2003 *637 Running Feet*, Queens Museum of Art, Queens,
New York, USA

2002 *Spunky*, Exit Art Gallery, New York, New York, USA
Peripheral Vision, Korean Cultural Center, Los
Angeles, California, USA
Flurry, Rotunda Gallery, Brooklyn, New York, USA

2001 *Time and Space III: Tidal Wave*, Queens Museum of
Art at Bulova Center, New York, New York, USA

Selected Publications

Conde, Ernesto. "Sun K. Kwak: Experiencing 280 Hours."
Wynwood: The Art Magazine 2, no. 5 (Summer 2009).

Cotter, Holland. "Where Drawing Is What Counts."
The New York Times, June 25, 2006.

Hammond, John. "Dive into Sun K. Kwak's Ocean at the
Brooklyn Museum." *The Museum Gazetteer*, April 1, 2009.

Herrup, Katharine. "Curating Outside the Gallery Space."
The New York Sun, March 27, 2007.

Lane, Anthony. "Flurry." *The New Yorker* 21, no. 28 (February
2000): 50.

Loon, Lisa. "Eastern Existencialismo." *La Revista Mensual
del Siglo* (February 2007).

Mohan, Mukta. "Sun K. Kwak." *Title*, no. 5 (December 2009/
January 2010): 45–49.

Shahdadpuri, Deepak. "Berlin Exhibition Explores
Perceptions of Asia." *Indian Art News*, April 16, 2008.

Tilmann, Christina. "What Do We Know of Asia?" *Der
Tagesspiegel* (2008).

LIN CHUAN-CHU

Born in Taipei, Taiwan. Lives and works in Taipei

Education

2003 MFA, Interdisciplinary Arts at Goddard College,
Plainfield, Vermont, USA

1991 Fine Arts Academy of China, Beijing, China

1990 Fine Arts Department, Chinese Cultural University,
Taipei, Taiwan

Selected Solo Exhibitions

2009 Lin & Keng Gallery, Taipei, Taiwan

2008 *Rice for Thoughts* (public performance), Taipei,
Taiwan

2006 Taishin Bank Arts Foundation, Taipei, Taiwan
Red Gate Gallery, Beijing, China

2005 Accton Arts Foundation, Hsinchu, Taiwan

2004 Institute of Visual Arts, University of Wisconsin–
Milwaukee, Milwaukee, Wisconsin, USA
Galerie UQO, Université du Quebec en Outaouais,
Gatineau, Canada

2003 National Hsinchu Teachers College Art Center,
Hsinchu, Taiwan

2000 Providence University Art Center, Taichung, Taiwan

1999 National Tsing Hua University Art Center, Hsinchu,
Taiwan

1998 Caves Gallery, Taipei, Taiwan

1996 Tanshui Art and Cultural Center, Taipei, Taiwan

Selected Group Exhibitions

2011 *Medi(t)ations: 3rd Asian Art Biennial*, National
Taiwan Museum of Fine Arts, Taichung, Taiwan

2006 *Contemporary Ink Painting*, Ju Ji-Jan Museum,
Shanghai, China
*The Educational Exhibition of Taiwan Contemporary
Arts*, Taipei Museum of Contemporary Arts,
Taipei, Taiwan

The New Dimension of Ink Painting, Kuandu Museum
of Fine Arts, Taipei, Taiwan

Taipei Ink Painting Biennial, Dr. Sun Yi-sun Memorial
Hall, Taipei, Taiwan

2005 *Kuandu Extravaganza: Exhibition of Modern Art in
Taiwan*, Kuandu Museum of Fine Arts, Taipei,
Taiwan

*Gu: The 4th Taiwan International Performance Art
Festival*, Taipei Artists Village, Taiwan

Literati Esthetics in Contemporary Calligraphy,
Tong-hai University Art Center, Taipei, Taiwan

Qin, Tea, Calligraphy and Painting, Chi-wen Gallery,
Taipei, Taiwan

2004 *Through Masters' Eyes* (Lee Mingwei Contemporary
Art Project 8), Los Angeles County Museum of
Art, Los Angeles, California, USA

Group Show of Wasanii International Workshop,
Lamu Fort of National Museums, Lamu, Kenya

*Group Show of Taipei Fine Art Museum Annual
Award*, Taipei Fine Art Museum, Taipei,
Taiwan

Paddy Field: Taipei Arts Festival, Taipei, Taiwan

The Memories, Taipei Artists Village, Taiwan

2003 *The Dialog between Yu-peng and Chuan-chu*,
Mulan Art Co., Taipei, Taiwan

The Possibility of Ink, Dong-hai University and
Providence University Art Center, Taizhong,
Taiwan

The Scale of Time: Art Today in Taiwan after WWII,
Chang-lui Fine Art Museum, Taiyuan, Taiwan

The Literati Aesthetics in the 21st Century, Jeff Hsu's
Art Gallery, Taipei, Taiwan

2002 *Taiwan Avant-Garde Documentary Exhibition*,
Chinese Cultural Association, Taipei, Taiwan

Red River Film Festival, New Hampshire Technical
Institute, Concord, New Hampshire, USA

2001 *The 3rd National Book & Paper Arts Biennial*

Exhibition, Columbia College, Chicago, Illinois,
USA

2000 *Exhibition of Asian American Heritage Month*, James R.
Thompson Center, Chicago, Illinois, USA

1999 *Visions of Pluralism: Contemporary Art in Taiwan,
1988–1999*, China Art Gallery, Beijing, China; and
the National History Museum, Taipei, Taiwan

Contemporary Art of the Oriental Soul, Art Center of
Komushen Foundation, Taipei, Taiwan

Exhibition of Artist in Residence, Niojiao Village,
Mazu Nangan, Taiwan

Memo for the Next Chinese Painting, Caves Art
Center, Taipei, Taiwan

Flying Island, Eslite Gallery, Taipei, Taiwan

Peacefully Crossing the Millennium, Art Square of
China Times, Taipei, Taiwan

Selected Publications

Andersen, William J. *Gu (grain)—Lin Chuan-chu's Ink
Painting and Animation*. Milwaukee, Wis.: University of
Wisconsin, 2004.

Divine Inspiration: Lin Chuan-chu's Solo Exhibition. Taipei,
Taiwan: Lin & Keng Gallery, 2009.

Hu, Sean C. S., et al. *Museum of Tomorrow: "Rice for
Thoughts."* Taipei, Taiwan: JUT Foundation for Arts and
Architecture, 2009.

Kendzulak, Susan. "Oedipus Stalks the Countryside—Lin
Chuan-chu's Interdisciplinary Works." *Taipei Times*,
December 1, 2005.

LIN XUE

Born in Fujian, China. Lives and works in Hong Kong

Selected Solo Exhibitions

2011 Gallery EXIT, Hong Kong, China

2010 Tokyo International Forum, Tokyo, Japan

2009 Hong Kong Convention and Exhibition Centre,
 Hong Kong, China
2008 Gallery EXIT, Hong Kong, China

Selected Group Exhibitions

2010 *The Linear Dimension—Contemporary Hong Kong
 Art*, Grotto Fine Art, Hong Kong, China
1998 *Hong Kong Biennial Exhibition*, Hong Kong Museum
 of Art, Hong Kong, China
1995 *Manulife Young Artists Series*, Hong Kong Art Centre,
 Hong Kong, China

Selected Publication

Lin Xue: The Sixth Day. Hong Kong, China: Gallery EXIT,
 2011.

FUYUKO MATSUI

Born in Tokyo, Japan. Lives and works in Tokyo

Education

2007 PhD, Japanese Painting, Tokyo University of the
 Arts, Tokyo, Japan
2004 MFA, Japanese Painting, Tokyo University of the
 Arts, Tokyo, Japan
2002 BFA, Japanese Painting, Tokyo University of the Arts,
 Tokyo, Japan

Selected Solo Exhibitions

2011 Yokohama Museum of Art, Yokohama, Japan
2010 Galerie DA-END, Paris, France
 Gallery Naruyama, Tokyo, Japan
2009 Gallery Naruyama, Tokyo, Japan
2008 Hirano Museum of Art, Shizuoka, Japan
 Gallery Naruyama, Tokyo, Japan
2007 Gallery Naruyama, Tokyo, Japan

2005 Gallery Naruyama, Tokyo, Japan
2004 Gallery Naruyama, Tokyo, Japan
 Ginza Surugadai Art Gallery, Tokyo, Japan

Selected Group Exhibitions

2011 *Images of Woman: Strength, Fragility, Ambiguity*,
 The Museum of Modern Art, Ibaraki, Japan
2010 *Koizumi Yakumo—The Secret of Lafcadio Hearn*,
 Contemporary Art Museum, Kumamoto, Japan
 *Medicine and Art: Imagining a Future for Life and
 Love*, Mori Art Museum, Tokyo, Japan
2009 *2009 International Incheon Women's Artists' Biennale*,
 Jung-gu, Incheon, Korea
 Chilling in the Summer, Gallery Naruyama, Tokyo,
 Japan
 The Latest Arts for 50 Years, Hirano Museum of Art,
 Shizuoka, Japan
 An Exhibition from the Permanent Collection, Gallery
 Naruyama, Tokyo, Japan
 21st Century Exhibition—Creation from Tradition,
 Tokyo Bijutsu Club, Tokyo, Japan
 Recently, Gallery Naruyama, Tokyo, Japan
2008 *Form, Idea, Essence, and Rhythm: Contemporary East
 Asian Ink Painting*, Taipei Fine Arts Museum,
 Taipei, Taiwan
 *2008 Contemporary Art Biennale of Fukushima:
 Mountain, Forest, Soul, Pile, Coal Mine*, Fukushima,
 Japan
2007 *Testimony of the Self-Portraits*, Chinretsukan Gallery,
 University Art Museum, Tokyo National
 University of Fine Arts and Music, Tokyo, Japan
 Gallery Naruyama Parade, Gallery Naruyama, Tokyo,
 Japan
 21st Century Exhibition—Creation from Tradition,
 Tokyo Bijutsu Club, Tokyo, Japan
2006 *Yaso/Tanbi*, Studio Parabolica, Tokyo, Japan

The 15th Scholarship Student Art Exhibition, The Sato Museum of Art, Miyagi, Japan

Sketch, Chinretsukan Gallery, University Art Museum, Tokyo National University of Fine Arts and Music, Tokyo, Japan

Nihonga Painting: Six Provocative Artists, Yokohama Museum of Art, Yokohama, Japan

MOT Annual 2006: No Border, Museum of Contemporary Art, Tokyo, Japan

2005 *Art Fair Tokyo*, Gallery Naruyama, Tokyo, Japan

Selected Publications

Eubank, Donald. "Tilting the Balance Back to Darkness: Artist Fuyuko Matsui Turns Her Back on the Cute and Quirky for the Mysterious." *The Japan Times*, January 31, 2009.

Fuyuko Matsui: Becoming Friends with All the Children in the World (exh. cat.). Yokohama, Japan: Yokohama Museum of Art, 2011.

Liddell, C. B. "Pinpricks in the Darkness: The Beautiful and Disturbing Art of Fuyuko Matsui." *Culture Kiosque*, October 9, 2007.

Matsui Fuyuko, vol. 1. Tokyo, Japan: Edition Treville, 2008.

Ueno, Chizuko, and Matsui Fuyuko. *Matsui Fuyuko*, vol. 2. Tokyo, Japan: Edition Treville, 2008.

PRABHAVATHI MEPPAYIL

Born in Bangalore, India. Lives and works in Bangalore

Education

1995 Studio Residency, Kanoria Centre for Arts, Ahmedabad, India

1992 Diploma in Fine Arts, Ken School of Art, Bangalore, India

1986 BA, Bangalore University, Bangalore, India

Selected Solo Exhibitions

2010 Vadehra Art Gallery, New Delhi, India

2007 Sakshi Gallery, Mumbai, India

2001 Forum Schlossplatz, Aarau, Switzerland

1999 Chitra Art Gallery, Bangalore, India

Selected Group Exhibitions

2009 *Chalo! India: A New Era of Indian Art*, Essl Museum, Klosterneuburg, Austria; National Museum of Contemporary Art, Seoul, Korea; and Mori Art Museum, Tokyo, Japan

2007 *Horn Please: Narratives in Contemporary Indian Art*, Kunstmuseum, Bern, Switzerland

Soft Spoken, Bombay Art Gallery, Mumbai, India

2006 *Double-Enders*, Jehangir Art Gallery and The Museum Gallery, Mumbai; Vadhera Art Gallery, New Delhi; Gallery Sumukha, Bangalore; and Durbar Hall, Kochi, India

The Inverted Tree, Gallery Threshold, Delhi, India

2005 *Span*, Sakshi Gallery, Mumbai, India

Ten Years of Gasteatelier Krone Ararau 1995–2005, Aarau, Switzerland

South Asian Women Artists Show, Finomenal Gallery, Colombo, Sri Lanka

Are We Like This Only?, Vadehra Gallery, Delhi, India

2004 *Subtlety-Minimally*, Lalit Kala Academy (presented by Sakshi Gallery), Delhi, India

2003 *Recent Works*, Gallery Threshold, Delhi, India

Highlights, Sakshi Gallery, Mumbai, India

2002 *Fragments*, Heritage Gallery, Mumbai; and Chitrakala Parishat, Bangalore, India

2001 *Figures in My Mind*, Gallery Espace, Delhi, India

On the Edge of Volume, Sakshi Gallery and Alliance Française, Bangalore, India

2000 *Exile and Longing*, Lakeeren Gallery, Mumbai, India

Bhoomi Geetha—Song of the Earth, Red Chair Gallery,
 Kansas City, Missouri, USA

1998 *Show at NIAS*, Bangalore, India

1997 *Glimpses of Contemporary Arts*, Karnataka Images Art
 Gallery, Bangalore, India

*Chetana—Group Show of Women Artists from
 Karnataka*, Chitrakala Parishat, Bangalore, India

1992 *Annual Show*, Ken School of Art, Bangalore, India

1991 *Annual Show*, Karnataka Youth Centre, Bangalore,
 India

1990 *Lalit Kala All India Graphics Exhibition*, Venkatappa
 Art Gallery, Bangalore, India

Selected Publications

Ananth, Deepak. *Prabhavathi Meppayil—Recent Work*.
 New Delhi, India: Vadehra Art Gallery, 2010.

Fibicher, Bernhard, and Suman Gopinath, eds. *Horn Please:
 Narratives in Contemporary Indian Art*. Bern, Switzerland:
 Hatje Cantz, 2007.

Miki, Akiko, ed. *Chalo! India: A New Era of Indian Art*. Tokyo,
 Japan: Mori Art Museum, 2008.

MOTOHIKO ODANI

Born in Kyoto, Japan. Lives and works in Tokyo

Education

1997 MFA, Tokyo University of the Arts, Tokyo, Japan

1995 BA, Tokyo University of the Arts, Tokyo, Japan

Selected Solo Exhibitions

2011 Shizuoka Prefectural Museum of Art, Shizuoka, Japan
 Takamatsu City Museum of Art, Takamatsu, Japan
 Contemporary Art Museum Kumamoto, Kumamoto,
 Japan

2010 Mori Art Museum, Tokyo, Japan

2009 Yamamoto Gallery, Tokyo, Japan

2007 Yamamoto Gallery, Tokyo, Japan

2004 Kirin Plaza Osaka, Osaka, Japan
 Yamamoto Gallery, Tokyo, Japan
 Takahashi Collection, Tokyo, Japan
 Moderna Museet, Stockholm, Sweden

2002 Gallery Raku, Kyoto University of Art and Design,
 Kyoto, Japan

2001 Marella Arte Contemporanea, Milan, Italy
 Fine Art Rafael Vostell, Berlin, Germany

1998 Rötgen Kunstraum, Tokyo, Japan

1997 P-House, Tokyo, Japan

Selected Group Exhibitions

2011 *Pop Art in Korea, China, Japan*, National Museum
 of Contemporary Art, Seoul, Korea
 Bye Bye Kitty!!!, Japan Society, New York, New York,
 USA
 BAD Exhibition, PIN Gallery, Beijing, China
 Chengdu Biennale 2011, Chengdu Industrial
 Civilization Museum, Chengdu, China

2010 *The Doors of Perception*, Toyota Municipal Museum
 of Art, Aichi, Japan
 Resonance, Suntory Museum Tenpozan, Osaka, Japan
 Go Figure: Five Contemporary Videos, Asia Society,
 New York, New York, USA
 Tokyo Art Meeting Transformation, Museum of
 Contemporary Art Tokyo, Tokyo, Japan

2009 *MI VIDA: From Heaven to Hell*, Mücsarnok (Palace
 of Exhibitions), Budapest, Hungary
 New Collection, Shizuoka Prefectural Museum of
 Art, Shizuoka, Japan
 What Lurks in Wood, The National Museum of
 Modern Art, Tokyo, Japan

Dorodoro Doron—The Uncanny World in Folk and Contemporary Art in Asia, Hiroshima City Museum of Contemporary Art, Hiroshima, Japan

Parabiosis, Soka Art Center Beijing, Beijing, China

TWIST and SHOUT: Contemporary Art from Japan, Bangkok Art and Culture Center, Bangkok, Thailand

2008 *When Lives Become Form*, Museu de Arte Moderna de São Paulo, São Paulo, Brazil

MOT Collection, Museum of Contemporary Art Tokyo, Tokyo, Japan

Tezuka Gane—Light in the Darkness, PARCO, Tokyo, Japan (traveling)

2007 *Skin of/in Contemporary Art*, The National Museum of Art, Osaka, Japan

Beautiful New World: Contemporary Visual Culture of Japan, 798 Art Zone, Beijing, China; and Guangzhou Museum of Art, Guangzhou, China

Sculpture of Story, Tokyo National University of Art and Music, Tokyo, Japan

2006 *ARS06*, Museum of Contemporary Art KIASMA, Helsinki, Finland

Chikaku: Time and Memory in Japan, The Taro Okamoto Museum of Art, Kanagawa, Japan

Hybridity: The Evolution of Species and Spaces in 21st-Century Art, 21C Museum, Louisville, Kentucky, USA

Art and Object: Affinity of the Jomon and the Contemporary, Aomori Museum of Art, Aomori, Japan

2005 *The World Is a Stage: Stories Behind Pictures*, Mori Art Museum, Tokyo, Japan

Next Project at Site, Site Gallery, Sheffield, UK

Becoming Animal, Massachusetts Museum of Contemporary Art, North Adams, Massachusetts, USA

Chikaku: Time and Memory in Japan, Kunsthaus, Graz, Switzerland; and Museum of Contemporary Art, Vigo, Vigo, Spain

Visions of the Body 2005, Seoul Museum of Art, Seoul, Korea

The difference between you and me, The Ian Potter Museum of Art, Melbourne, Australia

Chimerical Garden, Yamamoto Gallery, Tokyo, Japan

Kyoto International, Manga Museum, Kyoto, Japan

2004 *Roppongi Crossing*, Mori Art Museum, Tokyo, Japan

Mediarena, The Govett-Brewster Art Gallery, Taranaki, New Zealand

Strategies of Desire, Kunsthaus Baselland, Basel, Switzerland

Happy-Go-Lucky, VHDG Foundation, The Hague, Netherlands

Collapsed Bodies, Yamamoto Gallery, Tokyo, Japan

2003 *50th Venice Biennale, Heterotopias*, Japanese Pavilion, Venice, Italy

Kunst Film Biennale, Cologne, Germany

The Petting Zoo, Buena Vista Building, Miami, Florida, USA

Bloom, The Govett-Brewster Art Gallery, Taranaki, New Zealand

2002 *Gwangju Biennale*, Gwangju, Korea

Cast Cycle, Scai the Bathhouse, Tokyo, Japan (traveling)

Private Luxury, Manno Art Museum, Osaka, Japan

2001 *Sonsbeek 9 Locus*, Focus, Eusebius Church, Arnhem, The Netherlands

Translated Acts, Haus der Kulturen der Welt, Berlin, Germany; and Queens Museum of Art, New York, USA

7th International Istanbul Biennale, Istanbul, Turkey

2000 *ICON*, Gallery Celler, Nagoya, Japan

5th Biennale de Lyon, Art Contemporain, Halle Tony Garnier, Lyon, France

Department Store of Contemporary Art, Yamanashi
 Prefectural Museum of Art, Yamanashi,
 Japan

1999 *VOCA*, The Ueno Royal Museum, Tokyo, Japan
 Fancy Dance, Art Sonje Museum, Seoul, Korea
 Guarene Arte 99, Fondazione Sandretto Re
 Rebaudengo per l'Arte, Turin, Italy
 Net_Condition, NTT InterCommunication Center,
 Tokyo, Japan
 Ground Zero Japan, Contemporary Art Gallery,
 Art Tower Mito, Ibaragi, Japan

1998 *Reality—Tama Vivant '98*, Tama Art University,
 Tokyo, Japan
 Presumed Innocence, Marella Arte Contemporanea,
 Milan, Italy

1997 *Tanagokoro 2*, Rötgen Kunstraum, Tokyo, Japan
 Martin, Atlantis, London, UK
 Potential of Sculpture, Tokyo National University
 of Art and Music, Tokyo, Japan

1996 *Morphe '96*, Spiral, Tokyo, Japan

1995 *Pool 2*, Rötgen Kunstraum, Tokyo, Japan

Selected Publications

Burke, Gregory. "Inside Mediarena: Contemporary Art from
 Japan in Context." *New Zealand Journal of Media Studies*
 9, no. 1 (2006).

Caruso, Hwa Young, and John Caruso Jr. "Bye Bye Kitty!
 Hello Chaos!" *International Journal of Multicultural
 Education* 13, no. 1 (2011).

Imafuku, Ryuta, Toshiharu Ito, and Makoto Sei Watanabe.
 Chikaku: Time and Memory in Japan. Cologne, Germany:
 Verlag der Buchhandlung Walther Konig, 2005.

Kim, Yu Yeon, Cho Sun Rae, and Andrew Eom, eds.
 *Translated Acts: Performance and Body Art from East Asia,
 1992–2001*. Berlin, Germany: Haus der Kulturen der Welt;
 New York, N.Y.: Queens Museum of Art, 2001.

Livett, Kate. "Becoming Animal in Contemporary Visual Arts."
 Cultural Review 13, no. 1 (March 2007): 228–232.

Natsumi, Araki, ed. *Odani Motohiko: Phantom Limb*. Tokyo,
 Japan: Bijutsu Shuppan-Sha Co., Ltd., 2011.

Schaefer, Owen. "Fleshing Out Motohiko Odani's Phantom
 Limbs." *Tokyo Weekender*, December 16, 2010.

Thompson, Nato. *Becoming Animal: Contemporary Art
 in the Animal Kingdom*. Cambridge, Mass.: MIT Press,
 2005.

Uchida, Mayumi, and Yayoi Kojima, eds. *Neoteny Japan:
 Contemporary Artists After 1990s from Takahashi Collection*.
 Tokyo, Japan: Bijutsu Shuppan-Sha, 2008.

JAGANNATH PANDA

Born in Bhubaneshwar, India. Lives and works in Gurgaon

Education

2002 MA, Sculpture, Royal College of Art, London, UK

1994 MFA, Sculpture, Faculty of Fine Arts, M.S. University,
 Baroda, India

1991 BFA, Sculpture, B.K. College of Arts and Crafts,
 Bhubaneshwar, India

Selected Solo Exhibitions

2011 Nature Morte, New Delhi, India
 Nature Morte, Berlin, Germany

2009 Alexia Goethe Gallery, London, UK
 Nature Morte, New Delhi, India

2007 Gallery Chemould, Mumbai, India

2006 Berkeley Square Gallery, London, UK

2005 Nature Morte, New Delhi, India

2000 Gallery Chemould, Mumbai, India
 Hungarian Culture and Information Centre,
 New Delhi, India

1998 Za Moca Foundation Gallery, Tokyo, Japan

Selected Group Exhibitions

2011 *American Dream*, Gallery Bonoma, Rome, Italy
 Indian Highway IV, Lyon Museum of Contemporary
 Art, Lyon, France
2010 *Transformation*, Museum of Contemporary Art,
 Tokyo, Japan
 Inside India, Palazzo Saluzzo, Turin, Italy
 Looking Glass, Religare Arts Initiative, New Delhi,
 India
 Commonwealth Games Exhibition, Lalit Kala
 Akademi, New Delhi, India
 Astonishment of Being, Birla Academy, Kolkata, India
 Midnight's Children, Studio La Citta, Verona, Italy
 At the Edge, Gallery Maya, London, UK
2009 *Beyond Globalization*, Beyond Art Space, Beijing, China
 India Xianzai, MOCA, Shanghai, China
 Chalo! India: A New Era of Indian Art, Mori Art
 Museum, Tokyo, Japan; National Museum
 of Contemporary Art, Seoul, Korea; and Essl
 Museum, Klosterneuburg, Austria
2008 *Where in the World*, Devi Art Foundation, New
 Delhi, India
 Urgent Conversations, Art Alive, New Delhi, India
 Sub-Architecture-Continental, Gallery LeGaillard,
 Paris, France
2007 *Frame, Grid, Room, Cell*, Bodhi Art, Mumbai, India
 Here and Now, Young Voices from India, Grosvenor
 Gallery, London, UK
 Private/Corporate IV, Daimler Chrysler
 Contemporary, Berlin, Germany
2006 *Shadow Lines*, Vadehra Art Gallery, New Delhi, India
 India on Canvas, Khushi, New Delhi, India
2005 *Paths of Progression*, Bodhi Art, New Delhi; and
 Saffron Art, Mumbai, India
 Negotiating Matters, Anant Art Gallery, New Delhi,
 India

2004 *Generation-I*, Saffron Art, Mumbai, India
2003 *Dots and Pixels*, Gallery Espace, New Delhi, India
2002 *Graduate Show*, Royal College of Art, London, UK
2000 *Khoj International Exhibition*, British Council, New
 Delhi, India
1999 *Edge of the Century*, Art Inc., New Delhi, India
1997 *The Sight of Asia*, Asian Art Museum, Fukuoka, Japan
1995 *Beyond the Shores*, Lalit Kala Akademi, New Delhi, India

Selected Publications

Chakravarty, Jayashree. *Indian Art III: Here and Now, Young
 Voices from India*. New Delhi, India: Vadehra Art Gallery,
 2006.
Miki, Akiko, ed. *Chalo! India: A New Era of Indian Art*. Tokyo,
 Japan: Mori Art Museum, 2008.
Nath, Deeksha, and Peter Nagy, eds. *Jagannath Panda*. New
 Delhi, India: Nature Morte, 2005.

ARAYA RASDJARMREARNSOOK

Born in Trad, Thailand. Lives and works in Chiang Mai

Education

1994 Meisterschuelerin, Hochschule Für Bildende Künste
 Braunschweig, Braunschweig, Germany
1990 Diplom Für Bildende Künste, Hochschule Für
 Bildende Kuenste Braunschweig, Braunschweig,
 Germany
1986 MFA, Graphic Arts, Silpakorn University, Bangkok,
 Thailand

Selected Solo Exhibitions

2011 Gimpel Fils Gallery, London, UK
2009 Ardel Gallery, Bangkok, Thailand
2008 Gimpel Fils Gallery, London, UK
2007 100 Tonson Gallery, Bangkok, Thailand

2003 Tensta Konsthall, Stockholm, Sweden
2002 The National Gallery, Bangkok, Thailand
2000 Faculty of Fine Art Gallery, Chiang Mai, Thailand
 Art Gallery of Chulalongkorn University, Bangkok,
 Thailand
1999 Faculty of Fine Art Gallery, Chiang Mai, Thailand
1998 ArtPace, San Antonio, Texas, USA
1995 The National Gallery, Bangkok, Thailand
1991 Atelier Forsthaus, Gifhorn, Germany
1990 Vereins—und Westbank, Hanover, West Germany
 Atelier Forsthaus, Gifhorn, West Germany
1987 Goethe-Institut, Bangkok, Thailand
 The National Gallery, Bangkok, Thailand

Selected Group Exhibitions

2011 *The Global Contemporary: Art Worlds After 1989*,
 Zentrum für Kunst und Medientechnologie,
 Karlsruhe, Germany
 *MDE11: Teaching and Learning: Places of Knowledge
 in Art*, Medellín, Colombia
 TRA—Edge of Becoming, Palazzo Fortuny, Venice,
 Italy
 Video: An Art: A History, 1965–2010, Singapore Art
 Museum, Singapore
 *Kaza Ana/Air Hole: Another Form of Conceptualism
 from Asia*, National Museum of Art, Osaka, Japan
 Speech Objects, Musée de l'Objet, Blois, France
 Changwon Asian Art Festival, Gyeongnam, Korea
 Roving Eye, SKMU Sørlandets Kunstmuseum,
 Kristiansand, Norway
2010 *Des Corps des Fins*, Ethnology Museum, Béthune,
 France
 Border District, Haugar Art Museum, Tønsberg,
 Norway
 5th International Video Art Biennial in Israel, Center
 for Contemporary Art, Tel Aviv, Israel

1st Ural Industrial Biennale of Contemporary Art,
 National Center for Contemporary Arts,
 Ekaterinburg, Russia
_And_Writers_: 1st Nanjing Biennial, Jiangsu
 Provincial Art Museum, Nanjing, China
Rainbow Asia, Hangaram Art Museum of Seoul
 Arts Center, Seoul, Korea
Realism in Asian Art, The National Art Gallery,
 Singapore
Beauty of Distance: 17th Biennale of Sydney, Sydney,
 Australia
The museum as a pretext in contemporary art, Museu
 de l'Empordà, Spain
Hors du Commun, Abbaye aux Dames, Caen, France
Close Encounter, Jeju Museum of Art, Korea
2009 *The Quick and the Dead*, Ivan Dougherty Gallery,
 Paddington, Australia
 Forbidden Death, The Center for Contemporary Arts
 Celje, Stajerska, Slovenia
 VIFF "Pacific Meridian," Ussuri Movie Theatre,
 Vladivostok, Russia
 *Alternative States of Reality—Dreaming, Sleepwalking,
 Imagination, Transformation*, Gimpel Fils Gallery,
 London, UK
 Unreal Asia: The 55th International Short Film Festival,
 Oberhausen, Germany
 Dreaming in Public, Gallery Soulflower, Bangkok,
 Thailand
 *International Exhibition Incheon Women Artists
 Biennale*, Incheon, Korea
2008 *Dreaming/Sleeping*, Passage de Retz Gallery, Paris,
 France; and The Petach Tikva Museum of Art,
 Petach Tikva, Israel
2007 *Six Feet Under: Autopsy of Our Relation to the
 Dead*, Deutsches Hygiene-Museum, Dresden,
 Germany

Thermocline of Art, Zentrum für Kunst und Medientechnologie, Karlsruhe, Germany

Tridimensional Scene: International Video Art Exhibition, Platform China Contemporary Art Institute, Beijing, China

Thresholds of Tolerance, The Australian National University, Canberra, Australia

Unsung, Nicole Klagsbrun Gallery, New York, New York, USA

Wind from the East: Perspectives on Asian Contemporary Art, Kiasma Museum of Contemporary Art, Helsinki, Finland

2006 *Dirty Yoga: The 2006 Taipei Biennial*, Taipei, Taiwan

Six Feet Under, Fine Arts Museum Berne, Berne, Switzerland

Trace Root: Unfolding Asian Stories, 6th Gwangju Biennale, Gwangju, Korea

2005 *51st Venice Biennale*, Thai Pavilion, Venice, Italy

The Pantagruel Syndrome, Castello di Rivoli, Turin, Italy

Spaces and Shadows, Haus der Kulturen der Welt, Berlin, Germany

54th Carnegie International, Carnegie Museum of Art, Pittsburgh, Pennsylvania, USA

Insomnia, Institute of Contemporary Arts, London, UK

2004 *Living Art*, Queen's Gallery, Bangkok, Thailand

2003 *Diyarbakir Video Exhibition*, Diyarbakir Arts Center, Diyarbakir, Turkey

Poetic Justice: The 8th International Istanbul Biennial, Istanbul, Turkey

Subverted Boundaries, Sculpture Square, Singapore

Time After Time, Yerba Buena Center for the Arts, San Francisco, California, USA

2002 *EV+A 2002*, Limerick, Ireland

Small World, Silpakorn University Art Gallery, Bangkok, Thailand

2001 *ARS 01: Unfolding Perspectives*, Kiasma, Helsinki, Finland

2000 *Glocal Scents of Thailand*, Edsvik, Sollentuna, Sweden

1998 *Deserted and Embraced—Revisited*, Goethe-Institut, Bangkok, Thailand

1996 *Traditions/Tensions*, Asia Society, New York, New York, USA

The 10th Biennale of Sydney, Sydney, Australia

1995 *The 1st Johannesburg Biennale*, Johannesburg, South Africa

Thai Tensions, Chulalongkorn Art Gallery, Bangkok, Thailand

Art and Environment III, The National Gallery, Bangkok, Thailand

1993 *The 1st Asia-Pacific Triennial Exhibition*, Brisbane, Australia

Selected Publications

Araeen, Rasheed, ed. *Africus: Johannesburg* Biennale. Johannesburg, South Africa: Greater Johannesburg Metropolitan Council, 1995.

Bakargiev, Carolyn Christov. *The Pantagruel Syndrome*. Turin, Italy: Castello di Rivoli Museo, 2005.

Boissier, Annabelle O. *Wind from the East*. Helsinki, Finland: Finnish National Gallery/KIASMA Museum of Contemporary Art, 2007.

Cameron, Dan. *Taipei Biennial: Dirty Yoga*. Taipei, Taiwan: Taipei Fine Art Museum, 2006.

Clark, John. *Modern Asian Art*. Honolulu, Hawaii: University of Hawaii Press, 1998.

Cooke, Lynne. *Jurassic Technologies Revenant: 10th Biennale of Sydney*. Sydney, Australia: Art Gallery of New South Wales, 1996.

———. "New York: Contemporary Art in Asia." *Burlington Magazine* 139 (March 1997): 223–224.

Curtin, Brian. "Araya Rasdjarmrearnsook." *frieze*, no. 102 (October 2006).

Elliot, David. *The Quick and the Dead*. Sydney, Australia: Ivan Dougherty Gallery, 2009.

Fibicher, Bernhard. *Six Feet Under*. Bern, Switzerland: Kunstmuseum Bern, 2006.

Grounds, Joan D. *Araya Rasdjarmrearnsook*. Bangkok, Thailand: The National Gallery, 1992.

Heartney, Eleanor. "Asia Now." *Art in America* 35 (February 1997): 70–75.

Karjalainen, Tuula. "Mae Maha Chamrern—suureksi kasvanut jumalatar." *Taide*, no. 2/07 (2007).

Kirker, Anne. *Asia-Pacific Triennial of Contemporary Art*. Brisbane, Australia: Queensland Art Gallery, 1993.

Michaelsen, Helen. "Traces of Memory." *Asian Women Artists*. Sydney, Australia: Craftsman House/G+B Arts International, 1996.

Pettifor, Steven. *Flavours Thai Contemporary Art*. Bangkok, Thailand: Amarin Printing, 2003.

Poshyanade, Apinan. "Araya Rasdjarmrearnsook." *ArtAsiaPacific* 3, no. 3 (1995).

Russell, Jarboe. *Araya Rasdjarmrearnsook*. San Antonio, Texas: ArtPace, 1999.

Shimizu, Toshio. *Vision of Happiness*. Tokyo, Japan: The Japan Foundation, 1995.

Teh, David. *Video, an Art, a History, 1965–2010*. Singapore: Singapore Art Museum, 2011.

Tiravanija, Rirkrit, and Laura Haupman. *Carnegie International* 54. Pittsburgh, Penn.: Carnegie Museum of Art, 2004.

Toop, Leigh. *Thresholds of Tolerance*. Canberra, Australia: Research School of Humanities, The Australian National University, 2007.

Yang Eunhee. *Close Encounter*. Jeju, South Korea: Jeju Museum of Art, 2010.

VARUNIKA SARAF

Born in Hyderabad, India. Lives and works in New Delhi

Education

Present	M.Phil, School of Arts and Aesthetics, JNU, New Delhi, India
2006	MFA, Painting, University of Hyderabad, Hyderabad, India
2004	BFA, Painting, J.N.T.U. College of Fine Art, Hyderabad, India

Selected Solo Exhibitions

2010	Galerie Mirchandani + Steinruecke, Mumbai, India
2008	Kashi Art Gallery, Cochin, India

Selected Group Exhibitions

2011	*5th Anniversary Exhibition*, Galerie Mirchandani + Steinruecke, Mumbai, India
	India Inclusive: Contemporary Art from India, World Economic Forum, Davos, Switzerland
2009	*Unfaithfully Yours*, Gallery SKE, Bangalore, India
2008	*India Art Summit*, Shrine Gallery and Empire Art, New Delhi, India
2007	*Emerging India*, Art Alive Gallery, New Delhi, India; and Royal College of Art, London, UK
	Reading Paint, Gallery Soulflower, Bangkok, Thailand
	Soft Spoken, Bombay Art Gallery, Mumbai, India
	Meandering Membranes, Shrine Empire Gallery, Kolkata, India
2006	*KAVA2 Winners Exhibition*, Kashi Art Gallery, Cochin, India
	Kalahita Gallery Inaugural Group Show, Nagarjuna Foundation, Hyderabad, India

2003 *A Walk of Art*, Daira Art Gallery, Hyderabad, India
 Telugu University Annual Exhibition, Hyderabad, India
2002 *J.N.T.U. Annual Exhibition*, Hyderabad, India

Selected Publication

Kapoor, Kamala. *Varunika Saraf: The Chair in the Cloud.*
 Mumbai, India: Galerie Mirchandani and Steinruecke, 2010.

RAQIB SHAW

Born in Calcutta, India. Lives and works in London

Education

2002 MFA, Central Saint Martins College of Art and
 Design, London, UK
2001 BFA, Central Saint Martins College of Art and
 Design, London, UK

Selected Solo Exhibitions

2011 White Cube, London, UK
2009 Karlsplatz Project Space, Kunsthalle Wien, Vienna,
 Austria
 White Cube, London, UK
2008 Metropolitan Museum of Art, New York, New York,
 USA
2006 Museum of Contemporary Art, Miami, Florida, USA
 Tate Britain, London, UK
2005 Deitch Projects, New York, New York, USA
2004 Victoria Miro Gallery, London, UK

Selected Group Exhibitions

2011 *A Dream of Eternity*, Villa Empain, Brussels, Belgium
 Painting Between the Lines, CCA Wattis Institute for
 Contemporary Arts, San Francisco, California, USA
 East ex East, Brand New Gallery, Milan, Italy

2010 *Kupferstichkabinett: Between Thought and Action*,
 White Cube, London, UK
 The Beauty of Distance: 17th Biennale of Sydney, Sydney,
 Australia
2009 *Nightmare Full of Unspeakable Things*, Concept V, New
 York, New York, USA
 Taswir: Pictorial Mappings of Islam & Modernity,
 Martin-Gropius Bau, Berlin, Germany
 The Power of Ornament, Belvedere (Orangery, Lower
 Belvedere), Vienna, Austria
2007 *Panic Room—Works from the Dakis Joannous Collection*,
 Deste Foundation, Centre for Contemporary Art,
 Athens, Greece
2006 *6th Gwangju Biennale*, Gwangju, Korea
 Without Boundary: Seventeen Ways of Looking,
 Museum of Modern Art, New York, New York,
 USA
 Around the World in Eighty Days, Institute of
 Contemporary Arts, London, UK
 Passion for Paint, The National Gallery, London;
 Bristol City and Art Gallery, Avon; and Laing Art
 Gallery, Newcastle, UK
2005 *Expanded Painting, Prague Biennale*, Prague, Czech
 Republic
2004 *Plantmania! Art and the World of Plants*, Sunderland
 Museum and Winter Gardens, Tyne and Wear, UK
2003 *Nation and Nature: Vaster Than Empires*, Hastings
 Museum and Art Gallery, Hastings; Worcester
 City Art Gallery, Worcester; The Yard Gallery,
 Nottingham; and Lethaby Gallery, London, UK
2002 *Direction 2002*, The London Institute Gallery,
 London, UK
 Chancellor's Forum, London College of Fashion,
 London, UK
2001 *Future Map 2001*, Lethaby Gallery, London, UK

Selected Publications

Bhabha, Homi K. "An Art of Exquisite Anxiety." In *Raqib Shaw: Absence of God*. London: White Cube and Kunsthalle Wien, 2009.

Daftari, Fereshteh, ed. *Without Boundary: Seventeen Ways of Looking*. New York, N.Y.: Museum of Modern Art, 2006.

Dyer, Richard. "Raqib Shaw in Conversation." *Wasafiri* 19, no. 42 (2004): 68–77.

Herbert, Martin. "Raqib Shaw: Against Nature." *Modern Painters* (September 2006): 74–79.

Hughes, Meredith. "The Global Dimension of Cloth: The 17th Biennale of Sydney." *Craft Australia* (July 13, 2010).

Rogers, Sarah. "Exhibition Review: Haunting Preconceptions." *The Arab Studies Journal* 14, no. 2 (Fall 2006): 213–218.

Rosenberg, Karen. "Starting from Holbein, Then Taking Flight." *The New York Times*, January 2, 2009.

JAKKAI SIRIBUTR
Born in Bangkok, Thailand. Lives and works in Bangkok

Education
1996 MS, Textile Design, Philadelphia University, Philadelphia, Pennsylvania, USA
1992 BA, Fine Arts, Indiana University, Bloomington, Indiana, USA

Selected Solo Exhibitions
2011 The Art Center, Chulalongkorn University, Bangkok, Thailand
2010 Tyler Rollins Fine Art, New York, New York, USA
2008 Tyler Rollins Fine Art, New York, New York, USA
2005 ArtPosition, Murten, Switzerland
 H Gallery, Bangkok, Thailand

2004 The Intercontinental, Bangkok, Thailand
2003 BMW Meets Arts III and H Gallery, Bangkok, Thailand
2002 H Gallery and Eat Me, Bangkok, Thailand
2001 Eat Me, Bangkok, Thailand
 2 Oceans 23, Bangkok, Thailand
1998 2 Oceans 23, Bangkok, Thailand

Selected Group Exhibitions
2011 *Bangkok*, DOB Hualamphong Gallery, Bangkok, Thailand
 Here/Not Here: Buddha Presence in Eight Recent Works, Asian Art Museum of San Francisco, San Francisco, California, USA
2010 *Artists Scarecrow Rice Paddy*, Chiang Mai, Thailand
2009 *Viewpoints and Viewing Points: The 2009 Asian Art Biennial*, National Taiwan Museum of Fine Arts, Taipei, Taiwan
 Truly Truthful, Art Asia, Miami, Florida, USA
 Asian Contemporary Art Week, Open Portfolio, Rubin Museum of Art, New York, New York, USA
 Dreaming in Public, Gallery Soulflower, Bangkok, Thailand
2007 *Perversion/Subversion, Bangkok International Art Festival*, Playground Gallery, Bangkok, Thailand
1999 *Crossroads of Thailand*, 2 Oceans 23, Bangkok, Thailand
1997 *Festival of Woven Arts*, Goethe-Institut, Bangkok, Thailand
1996 *Printed Fabric Show*, Golden Pailey Design Center, Philadelphia, Pennsylvania, USA

Selected Publications
Aydt, Rachel. "Southeast Asia's Fresh Palette." *TIME Global Advisor*, December 8, 2008.

Curtin, Brian. "Jakkai Siributr." *Frieze*, October 28, 2011.

Galligan, Gregory. "In the New Siam." *Art in America* 98, no. 6 (June/July 2010): 67–72.

Gereben, Janos. "Modern 'Buddha Presence' at Asian Art Museum." *San Francisco Examiner*, September 28, 2011.

Pettifor, Steven. *Karma Cash and Carry: New Art by Jakkai Siributr*. New York, N.Y.: Tyler Rollins Fine Art, 2010.

Pollack, Barbara. "Critic's Pick: Jakkai Siributr." *ARTNews* (June 2011).

YOSHIHIRO SUDA

Born in Yamanashi, Japan. Lives and works in Tokyo

Education

1992 BA, Graphic Arts, Tama Art University, Kaminoge, Japan

Selected Solo Exhibitions

2010 Asia Society, New York, New York, USA

2009 Contemporary Museum, Honolulu, Hawaii, USA

2007 Gallery Koyanagi, Tokyo, Japan

2006 Chung King Project, Los Angeles, California, USA

Marugame Genichiro–Inokuma Museum of Contemporary Art, Kagawa, Japan

PKM Gallery, Seoul, Korea

2004 Palais de Tokyo, Paris, France

D'Amelio Terras, New York, New York, USA

2003 Art Institute of Chicago, Chicago, Illinois, USA

2002 Museum of Modern Art, Gunma, Japan

Asahi Beer Oyamazaki Villa Museum, Kyoto, Japan

2001 Entwistle, London, UK

2000 Galerie René Blouin, Montreal, Canada

D'Amelio Terras, New York, New York, USA

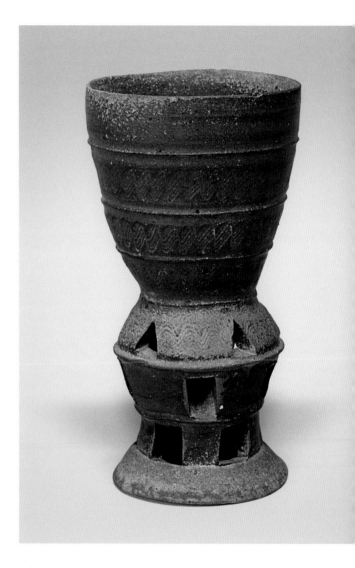

Bell cup, approx. 400–500. Korea. Stoneware. H. 5⅞ × DIAM. 3⅛ in.

ON Gallery, Osaka, Japan
Caisse des Dépôts et Consignations, Paris, France
1999 Gallery Wohnmaschine, Berlin, Germany
Hara Museum of Contemporary Art, Tokyo, Japan
Gallery Koyanagi, Tokyo, Japan
1997 Gallery Wohnmaschine, Berlin, Germany
Gallery Koyanagi, Tokyo, Japan
1996 Gallery K, Tokyo, Japan
Gallery 360°, Tokyo, Japan
1995 Gallery K, Tokyo, Japan

Selected Group Exhibitions

2009 *Out of the Ordinary: Spectacular Craft*, Museum
Sheffield, Sheffield, UK
2007 *Out of the Ordinary: 21st Century Craft*, Victoria and
Albert Museum, London, UK
*Die Erfüllte Leere: Minimalistsiche Ästhetik in der Kunst
Japans und des Westens*, Kunstmuseum Wolfsburg,
Wolfsburg, Germany
Naoshima Standard 2, Benesse Art Site, Naoshima,
Japan
Gärten: Ordnung, Inspiration, Glück, Lenbachhaus,
Munich, Germany
2006 *Gärten: Ordnung, Inspiration, Glück*, Städelmuseum,
Frankfurt, Germany
*Three Individuals: Zon Ito, Hajime Imamura, Yoshihiro
Suda*, The National Museum of Art, Osaka, Japan
Rising Sun, Melting Moon, Israel Museum, Jerusalem,
Israel
Public/Private, Kunstverein Hildesheim, Hildesheim,
Germany
Deceleration, Kemper Museum of Contemporary Art,
Kansas City, Missouri, USA
Three Person Show, The National Museum of
Contemporary Art, Osaka, Japan

2005 *Chikaku—Zeit und Erinnerung in Japan*, Kunsthaus
Graz, Camera; and The Japan Foundation, Graz,
Austria
*The Elegance of Silence: Contemporary Art from East
Asia*, Mori Art Museum, Tokyo, Japan
*Blumenstück Künstlers Glück—Vom Paradiesgartlein
zur Prilblume*, Museum Morsbroich, Leverkusen,
Germany
Blumenmythos—Van Gogh bis Jeff Koons, Fondation
Beyeler, Basel, Switzerland
2004 *Skulptur, Prekärer Realismus Zwischen Melancholie
und Komik*, Kunsthalle Wien, Vienna, Austria
So Weit Japan, Kunstallianz, Berlin, Germany
Ostwind, Museum Franz Gertsch, Burgdorf,
Switzerland
Flower as an Image—From Monet to Jeff Koons,
Museum Louisiana, Humlebaek, Kopenhagen,
Denmark; and 21st Century Museum of
Contemporary Art, Kanazawa, Japan
Petites Natures?, Maison de la Culture du Japon,
Paris, France
MA, Douglas Hyde Gallery, Dublin, Ireland
Officina Asia, Galleria d'Arte Moderna, Bologna,
Italy
2003 *Kokoro No Arika/Location of the Spirit*, The Japan
Foundation and Museum Ludwig, Budapest,
Hungary
Flower Power, Palais des Beaux-Arts, Lille, France
Springtime, Luitpold Lounge, Munich, Germany
Life/Art 03, Shiseido Gallery, Tokyo, Japan
Slowness, Kyoto Biennale, Kyoto, Japan
2002 *Un Monde Rêvé de la Main*, Maison Hermès 8F
Forum, Tokyo, Japan
New Edition!, Yamanashi Prefectural Museum of
Modern Art, Yamanashi, Japan

Fukuoka Asia Triennale 2002, Fukuoka Asian Art
Museum, Fukuoka, Japan
The Essential, Chiba City Museum of Art, Chiba,
Japan
The Eye of the Beholder, Dundee Contemporary,
Dundee, UK
Bliss, Confederation Center of the Arts, Prince
Edward Island, Canada
Life/Art 02, Shiseido Gallery, Tokyo, Japan
A History of Happiness, Melbourne Festival 2002,
Melbourne, Australia
2001 *Home*, Douglas Hyde Gallery, Dublin, Ireland
Elusive Paradise, National Gallery of Ottawa, Ottawa,
Canada
Standard, Naosshima Contemporary Museum,
Kagawa, Japan
Facts of Life, Hayward Gallery, London, UK

Selected Publications

Artner, Alan G. "Hide and Seek: Suda's Timeless Sculptures
Take Patrons Throughout the Art Institute." *Chicago
Tribune*, June 12, 2003.
Camper, Fred. "Art Imitates Nature," *Chicago Reader*, July 17,
2003.
Johnson, Ken. "Yoshihiro Suda." *The New York Times*, March
17, 2000.
Jones, Ronald. "Yoshihiro Suda." *frieze*, no. 53 (Summer
2000).
Kasuya, Akiko, ed. *Three Individuals: Zon Ito, Hajime
Imamura, Yoshihiro Suda*. Osaka, Japan: The National
Museum of Art, 2006.
Koplos, Janet. "Yoshihiro Suda at D'Amelio Terras." *Art in
America* 88, no. 6 (June 2000): 116.
Richard, Frances. "Yoshihiro Suda." *Artforum* 38, no. 10
(Summer 2000).

Schulze, Sabine, ed. *Gärten, Ordnung, Inspiration, Glück*.
Frankfurt, Germany: Städel Museum, 2006.

HIROSHI SUGIMOTO

Born in Tokyo, Japan.
Lives and works in New York City and Tokyo

Education

1974 Art Center College of Design, Pasadena, California,
USA
1970 Saint Paul's University, Tokyo, Japan

Selected Solo Exhibitions

2011 Pace/MacGill Gallery, New York, New York, USA
Scottish National Gallery of Modern Art, Edinburgh,
UK
2010 Marugame Genichiro–Inokuma Museum of
Contemporary Art, Kagawa, Japan
2009 Izu Photo Museum, Mishima, Japan
National Museum of Art, Osaka, Japan
2008 Gagosian Gallery, New York, New York, USA
Museum der Moderne, Salzburg, Germany
Neue Nationalgalerie, Berlin, Germany
Kunstmuseum Luzern, Lucerne, Switzerland
21st Century Museum of Contemporary Art,
Kanazawa, Japan
2007 Fine Arts Museums of San Francisco–de Young
Museum, San Francisco, California, USA
Villa Manin Centro d'Arte Contemporanea, Udine,
Italy
Asian Art Museum of San Francisco, San Francisco,
California, USA
Royal Ontario Museum, Toronto, Canada
Sonnabend Gallery, New York, New York, USA

2006 Galerie de l'Atelier Brancusi, Centre Georges
 Pompidou, Paris, France
 Marian Goodman Gallery, Paris, France
 Arthur M. Sackler Gallery, Washington, D.C., USA
 Hirshhorn Museum and Sculpture Garden,
 Washington, D.C., USA
2005 Mori Art Museum, Tokyo, Japan
 Gagosian Gallery, London, UK
2004 Fondation Cartier pour l'Art Contemporain, Paris,
 France
2003 Serpentine Gallery, London, UK
 Museum of Contemporary Art, Chicago, Illinois,
 USA
2002 Stills Gallery/Fruit Market Gallery, Edinburgh, UK
2001 Kunsthaus Bregenz, Bregenz, Austria
 White Cube, London, UK
 Guggenheim Museum SoHo, New York, New York,
 USA
 DIA Art Center, New York, New York, USA
2000 Guggenheim Museum, Bilbao, Spain
1999 Gallerie Ulrich Fiedler, Cologne, Germany
 Galerie Claude Berrie, Paris, France
1998 La Caixa, Madrid, Spain
 Centro Cultural de Belem, Lisbon, Portugal
 Center for Contemporary Art, Kitakyushu, Japan
1997 Sainsbury Centre, University of East Anglia,
 Norwich, UK
 Berkeley Art Museum, Berkeley, California, USA
1996 Angles Gallery, Santa Monica, California, USA
 Galleri Faurschou, Copenhagen, Denmark
 Contemporary Arts Museum, Houston, Texas, USA
 Studio Guenzani, Milan, Italy
1995 Metropolitan Museum of Art, New York, New York,
 USA
 Centre International d'Art Contemporain de
 Montréal, Montreal, Canada

 RENN Espace d'Art Contemporain, Paris, France
1994 Museum of Contemporary Art, Los Angeles,
 California, USA
 Museum of Contemporary Art, Chicago, Illinois,
 USA
1993 Virginia Museum of Fine Arts, Richmond, Virginia,
 USA
 Palais des Beaux-Arts, Charleroi, Belgium
1992 CAPC Museé d'Art Contemporain, Bordeaux, France
1991 Gallery Kasahara, Osaka, Japan
 Hosomi Gallery, Tokyo, Japan
1990 St. Louis Art Museum, St. Louis, Missouri, USA
 Galerie Jahn und Fusban, Munich, Germany
1989 National Museum of Art, Osaka, Japan
 Cleveland Museum of Art, Cleveland, Ohio, USA

Selected Group Exhibitions
2011 *Yokohama Triennial 2011*, Yokohama, Japan
2010 *Faraday Cage, 17th Biennale of Sydney*, Sydney, Australia
 Sexuality and Transcendence, PinchukArtCentre, Kiev,
 Ukraine
2009 *Element of Photography*, Museum of Contemporary Art,
 Chicago, Illinois, USA
 The Third Mind, Guggenheim Museum, New York,
 New York, USA
2008 *Reality Check: Truth and Illusion in Contemporary
 Photography*, Metropolitan Museum of Art, New
 York, New York, USA
 *Untitled (Vicarious): Photographing the Constructed
 Object*, Gagosian Gallery, New York, New York, USA
 Seascapes: Tryon and Sugimoto, Sackler Gallery,
 Washington, D.C., USA
2007 *KANNON*, Museum Rietberg, Zurich, Switzerland
2006 *Dark Matter*, White Cube, London, UK
2005 *Sophie Calle and Hiroshi Sugimoto*, Gallery Koyanagi,
 Tokyo, Japan

2004 *Singular Forms (Sometimes Repeated)*, Guggenheim
 Museum, New York, New York, USA

2003 *Supernova: Art of the 1990s from the Logan Collection*,
 San Francisco Museum of Modern Art, San
 Francisco, California, USA

 Happiness—A Survival Guide for Art and Life, Mori
 Art Museum, Tokyo, Japan

 Liquid Sea, Museum of Contemporary Art, Sydney,
 Australia

2002 *Moving Pictures*, Guggenheim Museum, New York,
 New York, USA

 *American Standard: (Para)Normality and Everyday
 Life*, Barbara Gladstone Gallery, New York,
 New York, USA

2001 *Give & Take*, Victoria and Albert Museum, London,
 UK

 I Am a Camera, Saatchi Gallery, London, UK

2000 *Expanding Horizons*, Whitney Museum of American
 Art, New York, New York, USA

1999 *Regarding Beauty: A View of the Late Twentieth
 Century*, Hirshhorn Museum, Washington, D.C.,
 USA

 The Third Asia-Pacific Triennial of Contemporary Art,
 Queensland Art Gallery, Brisbane, Australia

 The Museum as Muse: Artists Reflect, Museum of
 Modern Art, New York, New York, USA

1998 *At the End of the Century: One Hundred Years of
 Architecture*, Museum of Contemporary Art,
 Tokyo, Japan (traveling)

1997 *Blueprint*, De Appel Foundation, Amsterdam,
 The Netherlands

1996 *By Night*, Fondation Cartier pour l'Art Contempo-
 rain, Paris, France

1995 *Private/Public*, Museum of Contemporary Art,
 Helsinki, Finland

1994 *Photography and Beyond in Japan: Space, Time and
 Memory*, Hara Museum of Art, Tokyo, Japan
 (traveling)

1993 *In die Felsen bohren sich Zikadenstimmen:
 Zeitgenössische japanische Photographie*, Kunsthaus
 Zurich, Zurich, Switzerland

1992 *Hidden Reflections*, Israel Museum, Jerusalem, Israel

1991 *Carnegie International*, The Carnegie Museum of Art,
 Pittsburgh, Pennsylvania, USA

1990 *The Past and Present of Photography*, The National
 Museum of Modern Art, Tokyo, Japan; and
 The National Museum of Modern Art, Kyoto,
 Japan

1989 *Continuum and the Moment: Rita Myers, Hiroshi
 Sugimoto, Bill Viola*, Visual Arts Center, California
 State University, Fullerton, California, USA

1987 *Contemporary Japanese Art in America (I): Arita,
 Nakagawa, Sugimoto*, Japan Society Gallery, New
 York, New York, USA

1985 *The Art of Memory/The Loss of History*, New
 Museum of Contemporary Art, New York,
 New York, USA

Selected Publications

Bonami, Francesco. "Hiroshi Sugimoto: Zen Marxism." *Flash
 Art* (Milan) 28, no. 180 (January–February 1995): 71–73.

Hagen, Charles. "Hiroshi Sugimoto." *New York Times*,
 February 21, 1992.

Huser, France. "Hiroshi Sugimoto: l'empereur des rêves."
 L'Officiel de la Mode (December 2004): 276–279.

Meinhardt, Johannes. "Hiroshi Sugimoto: The Architecture
 of Time." *Kunstforum International* 157 (November–
 December 2001): 379–380.

Morgan, Robert C. "Sugimoto: Dreams Within Space."
 NY Arts 6, no. 11 (November 2001): 22–23.

Pagel, David. "Photography." *The New Yorker* 68, no. 1
 (February 24, 1992): 13.

Panzer, Mary. "Demons into Angels: Hiroshi Sugimoto's Miniature Fireworks." *British Journal of Photography*, no. 7789 (June 2011): 40–46.

Richard, Paul. "A Fossil-Fueled Aesthetic." *Washington Post*, April 23, 2006.

Sand, Michael L. "Hiroshi Sugimoto Portraits." *Aperture* 166 (Spring 2002): 11–13.

Seward, Keith. "Hiroshi Sugimoto: Sonnabend." *Artforum* 33, no. 8 (April 1995): 90.

Wilson, William. "Sugimoto's Sea of Meditation at MOCA." *Los Angeles Times*, March 4, 1994.

Yamashita, Yuji. "L'histoire de l'histoire." *Asahi Shimbun*, September 19, 2004.

ADEELA SULEMAN

Born in Karachi, Pakistan. Lives and works in Karachi

Education

1999 BFA, Sculpture, Indus Valley School of Art and Architecture, Karachi, Pakistan

1999 MA, International Relations, University of Karachi, Karachi, Pakistan

Selected Solo Exhibitions

2011 Aicon Gallery, London, UK

2010 Aicon Gallery, New York, New York, USA

2008 Rohtas 2, Lahore, Pakistan
 Canvas Gallery, Karachi, Pakistan

2007 Commune Artist Colony, Karachi, Pakistan

Selected Group Exhibitions

2011 *Asia Triennial Manchester 11*, Manchester Cathedral, Manchester, UK

2009 *Failing States*, Aicon Gallery, London, UK

Hanging Fire: Contemporary Art From Pakistan, Asia Society, New York, New York, USA

Signs Taken for Wonders: Recent Art from India and Pakistan, Aicon Gallery, London, UK

Steel Life, La Triennale, Milan, Italy

2008 *Farida Batool, Adeela Suleman and Tazeen Qayyum*, Aicon Gallery, New York, New York, USA

Tradition, Technique, Technology II: Contemporary Artists from Pakistan, Aicon Gallery, Palo Alto, California, USA

Women of Light, Galerie Davide Gallo, Berlin, Germany

2007 *Preview Berlin: The Emerging Art Fair*, Berlin, Germany

An Intensity of Space & Substance, National Art Gallery, Islamabad, Pakistan

Love, National Art Gallery, Islamabad, Pakistan

Articulating the Subtext, Alliance Française, Karachi, Pakistan

2006 *Flights of Fancy*, Royaat Gallery, Lahore, Pakistan

Body, Amin Gulgee Gallery, Karachi, Pakistan

Calligraphy, Amin Gulgee Gallery, Karachi, Pakistan

2005 *Urban/Culture*, CP Open Biennale, Jakarta, Indonesia

Beyond Borders, National Gallery of Modern Art, Mumbai, India

2004 *Spielen mit geladenem Gewehr (Playing with the Loaded Gun)*, Kunsthalle Fridericianum, Kassel, Germany

2003 *Twenty-four Shots per Second*, Kara Film Fest, Karachi, Pakistan

43rd Premio Suzzara, Associazione Galleria Del Premio Suzzara, Suzzara, Italy

Playing with the Loaded Gun, Apex Art, New York, New York, USA

Group Show, Canvas Gallery, Karachi, Pakistan

2002 *Imagined Workshop*, 2nd Fukuoka Asian Art Triennial, Fukuoka, Japan

2001 *The Thakhti Show*, Freer Hall, Karachi, Pakistan

2000 *Art Festival: Urban Voices*, Karachi, Pakistan

Selected Publications

Ali, Amra. "Marketing to a Global Audience: New Trajectories in Contemporary Art in Pakistan." *Nukta Art* 1, no. 2 (2006).

Ali, Atteqa, ed. *Playing with a Loaded Gun: Contemporary Art in Pakistan*. New York: apexart; Kassel, Germany: Kunsthalle Fridericianum, 2004.

Ambyo, Rani, ed. *Urban/Culture*. Jakarta, Indonesia: PT Jayakarta Agung Offset, 2005.

Genocchio, Benjamin. "Pakistan: Report on the Verge." *Art in America* 97, no. 1 (January 2009): 59–69.

Hashmi, Salima. *Unveiling the Visible: Lives and Works of Women Artists of Pakistan*. Pakistan: ActionAid, 2002.

———. "Women Artists and Institution-Builders Are Agents of Positive Change." *Art India* 9, no. 4 (2004): 70–76.

Martin, Emma. "Developing and Defining Migratory Practice for the Museum." *craft + design enquiry* 1 (2009).

Rahman, Laila Mehreen. "An Uncertain World." *Nukta Art* 4, no. 1 (November 2009).

Rosenberg, Karen. "Art in Review: Farida Batool, Adeela Suleman and Tazeen Qayyum." *The New York Times*, January 11, 2009.

CHARWEI TSAI

Born in Taipei, Taiwan. Lives and works in Paris and Taipei

Education

2010 L'École Nationale Supérieure des Beaux-Arts, Paris, France

2002 Rhode Island School of Design, Providence, Rhode Island, USA

Selected Solo Exhibitions

2011 The Guild, Mumbai, India
 TKG+, Taipei, Taiwan
 Atelier 7, Paris, France
 Deyrolle, Paris, France
 The Tunnel, The Esplanade, Singapore

2009 Galleria Casas Riegner, Bogotá, Colombia
 Sherman Contemporary Art Foundation, Sydney, Australia
 L'Église Saint Severin, Paris, France
 Osage Gallery, Hong Kong, China

2008 Gallery Sora, Tokyo, Japan
 CIGE Fair, Beijing, China

Selected Group Exhibitions

2011 *Project Room*, Chile Arte Contemporáneo, Santiago, Chile
 Arrival—Searching for Now, Ruhrtriennale, Jahrhunderthalle, Bochum, Germany
 Buddha's Trace, Kunstmuseum Bochum, Bochum, Germany
 Think Cool, TKG+, Taipei, Taiwan
 Art Taipei, TKG+, Taipei, Taiwan
 Our Magic Hour, Yokohama Triennale, Yokohama, Japan
 Eattopia: 2nd Taiwan International Video Art Exhibition, Taitung Art Museum, Taitung, Taiwan
 Art HK 11: Hong Kong International Art Fair, Osage Gallery, Hong Kong, China
 Physical Video, Queensland Art Gallery, Brisbane, Australia
 Silent Significance, LMD Galerie, Paris, France
 Art Dubai, The Guild (Mumbai/New York), Dubai, UAE
 ARCO Madrid, Galerie Mor-Charpentier (Paris), Madrid, Spain

Dust on the Mirror, Institute of Contemporary Art, Singapore

Myth-Reality: Constructing Cult-u're, The Guild, Mumbai, India

2010 *Carnet d'Inspiration*, Musée d'Art Moderne de la Ville de Paris, Paris, France

2nd Taiwan International Video Art Exhibition, Hong-Gah Museum, Taipei, Taiwan

Dust on the Mirror, Djanogly Gallery, University of Nottingham, Nottingham, UK

Mantras, Moqueries, Monstres et Mutations, Galerie Martine et Thibault de la Châtre, Paris, France

Forum Biennale, Taipei Contemporary Art Center, Taipei, Taiwan

Emerging Asian Artists, Art Gwangju, Gwangju, Korea

Art HK 10: Hong Kong International Art Fair, Osage Gallery, Hong Kong, China

Reshaping History: Chinese Art from 2000–2009, Today Art Museum, Beijing, China

Graouw, Galerie Intuiti, Paris, France

The Seven Day Weekend, Museum of L'École Nationale Supérieure des Beaux-Arts, Paris, France

The Tradition of the New, Sakshi Gallery, Mumbai, India

2009 *Perpetual Dialogue*, Andrea Rosen Gallery, New York, New York, USA

6th Asia-Pacific Triennial, Queensland Art Gallery, Brisbane, Australia

Art Taipei 2009, Taipei, Taiwan

Beautifully Banal, Smack Mellon, New York, New York, USA

Art HK 09: Hong Kong International Art Fair, Osage Gallery, Hong Kong, China

Taiwan.Doc, Museum of L'École Nationale Supérieure des Beaux-Arts, Paris, France

THE LA LA, LASALLE College of the Arts, Singapore

Circle, Fondation Cartier, Paris, France

2008 *NADA Art Fair*, Gallery Sora, Miami, Florida, USA

Nature Fragile, Museum of Hunting and Nature, Paris, France

Traces of the Sacred, Centre Georges Pompidou, Paris, France

2007 *How Far Would You Go for Love?*, Fondation Cartier, Paris, France

Étrangère, Transversal, Restaurant du Musée d'Art Contemporain du Val-de-Marne, Paris, France

Thermocline of Art: New Asian Waves, ZKM Center for Art and Media, Karlsruhe, Germany

Destroy Athens Biennale, Bettina, Athens, Greece

Animamix Biennale, Shanghai MoCA, Shanghai, China

21 Cities at Once Performed, Conflux Festival, New York, New York, USA

Frolic: Humor and Mischief in New Taiwanese Art, 2X13 Gallery, New York, New York, USA (traveling)

EAT/ART, Monkey Town, New York, New York, USA

2006 *Belief: Singapore Biennale*, Singapore

Summer Hot, Taipei Economic and Cultural Center, New York, New York, USA

PostER, Hydra Old High School, Hydra Island, Greece

2005 *J'en Rêve*, Fondation Cartier, Paris, France

Selected Publications

Brener, Julie. "Bean Curd and Nothingness: Cai Guo-Qiang Admires Charwei Tsai's Inscriptions on Lemons, Trees, and Rotting Slabs of Tofu as Meditations on the Ephemerality of Life." *ArtNEWS* 105, no. 10 (2006): 156–157.

Cree, Laura Murray. "Charwei Tsai's Art of Liberation." *Art and Australia* 48, no. 1 (Spring 2010): 136–143.

Dalal, Sayantan. "Understanding Thought Forms; Taiwanese Artist Charwei Tsai's New Exhibition Explores the Intricate Nature of Our Mind." *Daily News and Analysis*, October 18, 2011.

Godfrey, Tony, and Neil Walker, eds. *Dust on the Mirror*. Nottingham, UK: Djanogly Gallery, 2010.

McDougall, Ruth. "Charwei Tsai: A Space of Contemplation." *The 6th Asia Pacific Triennial of Contemporary Art*. South Brisbane, Australia: Queensland Art Gallery, 2009.

Raffel, Suhanya, ed. *Charwei Tsai: Water, Earth, and Air*. Paddington, New South Wales: Sherman Contemporary Art Foundation, 2009.

Ugiomoh, Frank. "Dak'art 2006: Yawning Cultural Gaps in Fusing Landscapes." *Third Text* 21, no. 1 (January 2007): 91–101.

Wong, Jill. "Charwei Tsai: The Art of Change." *Asian Contemporary Art and Culture*, August 6, 2009.

HOWIE TSUI

Born in Hong Kong, China. Lives and works in Ottawa

Education

2002 Bachelor of Fine Arts, Painting, University of Waterloo, Waterloo, Canada

Selected Solo Exhibitions

2011 Centre A, Vancouver, Canada
2010 Gallery Jones, Vancouver, Canada
2009 Ace Art Inc., Winnipeg, Canada
2008 Le Gallery, Toronto, Canada
2007 G+ Gallery, Toronto, Canada
2006 Gallery 101, Ottawa, Canada
2004 Wurm Gallery, Ottawa, Canada
2003 Wurm Gallery, Ottawa, Canada

Selected Group Exhibitions

2011 *Picture Book 1*, Interurban Gallery, Vancouver, Canada
Place and Circumstance, City Hall Art Gallery, Ottawa, Canada

2010 *Exploded View*, The Ottawa Art Gallery, Ottawa, Canada
Monster, West Vancouver Museum, Vancouver, Canada
Made in Canada, Shenkman Arts Centre, Orleans, Canada
Par Chemin, Yves Laroche Galerie d'Art, Montreal, Canada

2009 *Life Drawing*, Narwhal Art Projects, Toronto, Canada

2008 *Hut on an Island*, Grasshut Gallery, Portland, Oregon, USA
Crazians, World of Wonder Gallery, Hollywood, California, USA
Listen to Your Heart, MOHS Exhibit, Copenhagen, Denmark
Parcours et Perspectives, Musée d'Art Contemporain de Baie-Saint-Paul, Quebec, Canada

2007 *The Pleasure*, Jaime Torres Bodet Cultural Centre, Mexico City, Mexico
20 Minutes Away from Happiness, Gallery 1313, Toronto, Canada
Contemporary Arts Festival, Gallery 101, Ottawa, Canada

2006 *Paper Pushers*, Gallery 1988, Los Angeles, California, USA
Fresh Start, Arena 1 Gallery, Santa Monica, California, USA
I Am 8-Bit, Gallery 1988, Los Angeles, California, USA
G Hunting, G+ Galleries, Toronto, Canada
Give a Little Bit, Magic Pony, Toronto, Canada

Said and Done, Antisocial Gallery, Vancouver,
 Canada

2005 *Enjoy Relax Happy*, Niagara Gallery, Toronto, Canada
 My Culture Includes My Scene, The Ottawa Art
 Gallery, Ottawa, Canada
 Then and Now, Gene Siskel Film Center of the
 Chicago Institute of Art, Chicago, Illinois, USA
 Semi-Permanent 05: Sketchel, Sydney Convention and
 Exhibition Centre, Sydney, Australia
 Art4Tibet, Juice Design, San Francisco, California,
 USA

2004 *Coming Soon*, Gene Siskel Film Center of the Chicago
 Institute of Art, Chicago, Illinois, USA
 Fresh Produce 04, Gallery Anno Domini, San Jose,
 California, USA
 Vazaleen, Galerie SAW Gallery, Ottawa, Canada

2003 *Scatalogue: 30 Years of Crap in Contemporary Art*,
 Galerie SAW Gallery, Ottawa, Canada
 Affordable Art Fair, Pier 92, New York, New York,
 USA
 Toronto Outdoor Art Exhibition, Nathan Phillips
 Square, Toronto, Canada

2002 *Luck Be a Weirdo Tonight*, Zero to One Studios,
 Kitchener, Canada
 Waiting Room, University of Waterloo Art Gallery,
 Waterloo, Canada
 And, University of Waterloo Art Gallery, Waterloo,
 Canada

Selected Publications

Barrett, Rosanne. "Long-Distance Call: Howie Tsui." *South
 China Morning Post*, December 13, 2009.
Boissonneault, Aaron. "Horror Fables." *PaperWait* 12 (2010):
 34–41.
Cook, Morgan A. "Sex, Death, Fear and Fairy Tales." *Upfront
 Magazine* (April 2009): 14–15.

Euteneier, Anita. "Packing a Punch: Artswatch." *Ottawa Xpress*,
 September 16–22, 2004.
Falvey, Emily, and Sandra Dyck. *Howie Tsui's Horror Fables*.
 Ottawa, Canada: Carleton University Art Gallery, 2009.
Griffin, Kevin. "Howie Tsui: A Bestiary of Horror Stories."
 Vancouver Sun, July 1, 2011.
Halkes, Petra. "Exploded View." *Border Crossings* 29, no. 3,
 Issue 115 (2010): 131–132.
Low, Joni. "Evoking Past into Present: The Spectral
 Imagination of Howie Tsui." *Yishu: Journal of Contemporary
 Chinese Art* 10, no. 6 (November / December 2011): 67–86.
Martin, Tony. "Chan vs. Tsui: An Epic Conversation." *Get
 Guerilla*, no. 19 (March 2009).
Tsui, Howie. *Of Shunga & Monsters*. North Pender Island,
 Canada: Islands Fold Publishing, 2008.
Wadsley, Helena. "Of Manga & Mongrels." *Galleries West* 9,
 no. 3 (Fall / Winter 2010).

APICHATPONG WEERASETHAKUL
Born in Bangkok, Thailand. Lives and works in Bangkok

Education

1997 MFA, Filmmaking, The School of the Art Institute of
 Chicago, Chicago, Illinois, USA
1994 Architecture, Khon Kaen University, Khon Kaen,
 Thailand

Selected Short Films

2009 *Phantoms of Nabua*
 A Letter to Uncle Boonmee
 Primitive Installation
2008 *Mobile Men*
 Vampire
2007 *Emerald*
 Luminous People

2006	*The Anthem*
2005	*Worldly Desires*
	Ghost of Asia, in collaboration with Christelle Lheureux
2003	*This and a Million More Lights*
2002	*Second Love in Hong Kong*, in collaboration with Christelle Lheureux
2001	*Haunted Houses*
2000	*Boys at Noon / Girls at Night*
1999	*Malee and the Boy*
	Windows
1994	*Kitchen and Bedroom*
	0116643225059
1993	*Bullet*

Selected Feature Films

2011	*Utopia*
2010	*Uncle Boonmee Who Can Recall His Past Lives*
2007	*Unknown Forces* (installation)
2006	*Syndromes and a Century / Sang Sattawat*
2004	*Tropical Malady / Sud Pralad*
2003	*The Adventure of Iron Pussy / Huajai Toranong*
2002	*Blissfully Yours / Sud Sanaeha*
2000	*Mysterious Object at Noon / Dokfar Nai Meu Marn*

Selected Publications

Ingawanji, May Adadol, and Richard Lowell MacDonald. "Blissfully Whose? Jungle Pleasures, Ultra-Modernist Cinema and the Cosmopolitan Thai Auteur." *New Cinemas: Journal of Contemporary Film* 4, no. 1 (May 1, 2006): 37–54.

Kataoka, Mami, ed. *Under Construction: New Dimensions of Asian Art.* Tokyo, Japan: Kōryū Kikin Ajia Sentā, 2002.

Quandt, James, ed. *Apichatpong Weerasethakul.* Vienna, Austria: Austrian Film Museum, 2009.

Romers, Holger. "Creating His Own Cinematic Language: An Interview with Apichatpong Weerasethakul." *Cineaste* 30, no. 4 (September 2005).

PALDEN WEINREB

Born in New York City, New York, USA.
Lives and works in New York City

Education

2004	Skidmore College, Sarasota Springs, New York, USA

Selected Solo Exhibition

2011	Hanart Square, Hong Kong, China

Selected Group Exhibitions

2011	*What's So Funny About Peace, Love and Understanding?*, Rossi & Rossi, London, UK
	Beyond the Mandala—Contemporary Art from Tibet, Volte Gallery, Mumbai, India
2010	*Works on Paper*, Rossi & Rossi, London, UK
	Scorching Sun of Tibet, Songzhuang Art Center, Beijing, China
	Boys and Girls Come Out to Play, Rossi & Rossi, London, UK
2008	*New Works by Tenzing Rigdol and Palden Weinreb*, Dinter Fine Art, New York, New York, USA
	SH Contemporary 08, Rossi & Rossi, Shanghai, China
2007	*Past and Present: Tibetan Art 13th–21st Century*, Christopher Farr, Los Angeles, California, USA
	Consciousness and Form: Contemporary Tibetan Art, Rossi & Rossi, London, UK
	Written on the Wind: The Flag, Rubin Museum of Art, New York, USA
	Tibetan Encounters, Heidi Neuhoff Gallery, New York, New York, USA

2006 *Lhasa Express*, Rossi & Rossi, London, UK

2005 *The Print Show*, Gallery 402, New York, New York, USA

2004 *Thesis Exhibition*, Francis Young Tang, New York, New York, USA

Selected Publications

Harris, Clare. *Generation Exile: Exploring New Tibetan Identities–Kesang Lamdark and Palden Weinreb*. London, UK: Rossi & Rossi, 2011.

Nagree, Zeenat. "New Occupation." *Time Out Mumbai 7*, no. 15 (March 18–31, 2010): 76.

O'Dea, Madeleine. "Scorching Sun of Tibet." *Art Info*, October 14, 2010.

Rossi, Anna Maria, and Fabio Rossi. *Consciousness and Form: Contemporary Tibetan Art*. London: Rossi & Rossi, 2007.

Rossi, Fabio, and H.G. Masters. *Palden Weinreb—This World Is Flat*. London, UK: Rossi & Rossi, 2010.

"Tibetan Contemporary Art: Beyond the Cultural Mask." *ArtAsiaPacific*, no. 57 (March/April 2008).

Winchester, Simon, and Katherine Anne Paul. *The Flag Project: Contemporary Artists Celebrate the Opening of a New Museum*. New York, N.Y.: Rubin Museum of Art, 2007.

ADRIAN WONG

Born in Chicago, Illinois, USA.

Lives and works in Los Angeles and Hong Kong

Education

2005 MFA, Sculpture, Yale University, New Haven, Connecticut, USA

2003 MA, Developmental Psychology, Stanford University, Stanford, California, USA

BA, Art and Art History, Stanford University, Stanford, California, USA

2002 BA, General Psychology, Stanford University, Stanford, California, USA

Selected Solo Exhibition

2007 1A Space, Hong Kong, China

Selected Group Exhibitions

2011 *The Border Show*, Society for Experimental Cultural Production, Shenzhen, China

Double Happiness, Meet Factory, Prague, Czech Republic

39 Art Day 9, Asia Art Archive, Hong Kong, China

Black Margarita (performance), Sotheby's, Hong Kong Convention and Exhibition Centre, Hong Kong, China

Troglodyte See the Light (Redux), LTD Los Angeles, Hollywood, California, USA

Staged Fictions, Osage Kwun Tong, Hong Kong, China

Writing Off the Wall, Art HK11, Hong Kong Convention and Exhibition Centre, Hong Kong, China

Troglodyte See the Light, Osage Kwun Tong, Hong Kong, China

2010 *This Is Hong Kong*, Kuandu Museum of Art, Taipei, Taiwan

A Box in the Theatre of the World, Hong Kong Jockey Club, Hong Kong, China

/Umbrellahead, I Will Find You (theatrical production), Fmr. Married Police Quarters, Hong Kong, China

FAX, Drawing Center, New York, New York, USA

Ursula Blickle Archiv Programme, Kunsthalle Wien, Vienna, Austria

City as Play, Museum of Contemporary Art Tokyo, Tokyo, Japan

Back to the Future?, Osage Soho, Hong Kong, China

Place, Meinblau e.V., Berlin, Germany

Life, K11, Tsim Sha Tsui, Hong Kong, China

0 Budget, What If Space, Hong Kong, China

Not Guilty, Hong Kong Design Week, Victoria Prison, Hong Kong, China

Against Easy Listening, 1a Space, Hong Kong, China

The Butcher's Deluxe, Angela Li Gallery, Soho, Hong Kong, China

Homemade from Hong Kong, SESC São Paolo, São Paolo, Brazil

2009 *A Passion for Creation*, Louis Vuitton Fondation pour la Création, Hong Kong Art Museum, Hong Kong, China

Video Programme, LOOP Media Center, Seoul, Korea

Video Programme, Kunstverein, Hamburg, Germany

All You Need Is Love, Post Museum, Singapore

This Is Hong Kong, Chalk Horse Gallery, Sydney, Australia

This Is Hong Kong, Casa Asia, Barcelona, Spain

Abstract Cabinet, East Side Gallery, Birmingham, UK

Video Programme, IFA Gallery, Berlin, Germany

Video Programme, MAP Office, Hong Kong, China

Pecha Kucha 8, Ambassadors of Design, Hong Kong, China

2008 *Fotanian 6*, Wah-Luen Industrial Centre, Hong Kong, China

Dis Play, Para/Site Art Space, Hong Kong, China

Anarchitecture Bananas, Artists' Commune, Hong Kong, China

Bangkok Experimental Film Festival, Bangkok, Thailand

A Tree Without Roots, Olympian City Plaza, Hong Kong, China

4x4, Kowloon Technical College, Hong Kong, China

Where the Lions Are, Sheung Wan Civic Centre, Hong Kong, China

Hong Kong Sculpture Biennial, Hong Kong, China

Ten Workers, W.L. Projekt, Berlin, Germany

Super Art Team HK: Hooray, 1A Space, Hong Kong, China

2007 *Stable*, Para/Site Art Space at Embassy Projects, Hong Kong, China

Autobibliophiles, Studio Bibliotheque, Hong Kong, China

Moh Goh Yeung, Wan Goh Yeung, Sai Wan Ho Civic Centre, Hong Kong, China

Perpetual Art Machine, Circa Art Fair, San Juan, Puerto Rico

Dialogue With the Ghosts, Get It Louder, Guangzhou, China

Ritual for the Ghosts, Para/Site Art Space, Hong Kong, China

Reversing Horizons, Shanghai Museum of Contemporary Art, Shanghai, China

Restore, October Contemporary, Hong Kong, China

14QK, Para/Site Art Space, Hong Kong, China

Overseas Exhibition: Video Programme, Kubus, Munich, Germany

2006 *Fotanian 4*, Wah-Luen Industrial Centre, Hong Kong, China

Sleepover Psychedelia, Kapok, Hong Kong, China

2005 *Community Theater*, ArtSpace Annex, New Haven, Connecticut, USA

MFA Thesis Exhibition, Holcombe T. Green Gallery, New Haven, Connecticut, USA

Monstrously Tranquil, Ingalls and Associates Gallery, Miami, Florida, USA

2004 *Adapt and Overcome!*, Holcombe T. Green Gallery, New Haven, Connecticut, USA

2003 *Crosstown Traffic*, John Slade Ely Center for Contemporary Art, New Haven, Connecticut, USA

Teetering, Nathan Cummings Art Center, Stanford, California, USA

Selected Publications

Abbas, Nadim. "New Work By Adrian Wong." *ArtAsiaPacific*, no. 53 (May/June 2007).

Chan, Timothy. "Opening October Contemporary." *Sing Pao Daily News*, October 11, 2007.

Cornell, Lauren, Laura Hoptman, and Massimiliano Gioni, eds. *New Museum of Contemporary Art: Younger Than Jesus Artist Directory*. New York, N.Y.: Phaidon Press, 2009.

Henri, Gerard. "Une Exploration de l'Altérité." *Paroles*, no. 213 (May 2008).

Ho, Luen. "Turning Fear Into Fun." *Ming Pao Weekly*, March 10, 2007.

Lai, Yvonne. "Long Distance Call." *South China Morning Post*, Post Magazine sec., April 3, 2010.

Lam, Bourree. "A Conversation with Adrian Wong and Magdalen Wong." *Time Out Hong Kong*, no. 6 (September 2008).

Lau, Doretta. "Seven Wonders." *Time Out Hong Kong*, no. 29 (May 2009).

Lee-Duffy, Jade. "A Fear Is This." *South China Morning Post*, March 8, 2007.

Peckham, Robin. "Excavated Apocrypha: The Art of Adrian Wong." *Leap*, no. 5 (October 2010).

Seno, Alexandra A. "A City and a Fashion Empire Come Together Over Art." *New York Times*, May 27, 2009.

Zhang, Jing. "We Share" (interview). *West East*, no. 30 (Summer 2010).

TAKAYUKI YAMAMOTO

Born in Aichi, Japan.
Works in Nagoya City, Aichi Prefecture, Japan

Education

2002 MFA, Chelsea College of Art and Design, London, UK

2001 PG Diploma, Fine Art, Byam Shaw School of Art, London, UK

1999 MA, Art Education, Aichi University of Education, Kariya, Aichi Prefecture, Japan

1997 BA, Art Education, Aichi University of Education, Kariya, Aichi Prefecture, Japan

Selected Solo Exhibitions

2011 Max Artfesta, Zagreb, Croatia

2010 Japan Foundation Gallery, Hanoi, Vietnam

2009 Himming Art Centre, Toyama, Japan

2008 Art & River Bank, Tokyo, Japan

2006 Muzz Program Space, Kyoto, Japan

1998 T's Gallery, Nagoya, Japan

Selected Group Exhibitions

2011 *O Date 2011*, Omachi, Akita, Japan

ARTZUID 2011, Amsterdam, The Netherlands

2010 *Aichi Triennale 2010*, Tamaya Building, Chojamachi-Site, Nagoya, Japan

Asian Invasion, NEST, Den Haag, The Netherlands
The Good Things, Muzz Program Space, Kyoto, Japan
Tokyo Story, Tokyo Wander Site Hongo, Tokyo, Japan
Beppu Project 2010, Beppu City Hall, Oita, Japan
2009 *Chojamachi Project*, Chojamachi, Nagoya, Japan
15th Ishida Foundation Encouraging Prize Memorial Exhibition, Denki Bunka Hall, Nagoya, Japan
2008 *Kankyo/jutsu*, Daikanyama Hillside Terrace, Tokyo, Japan
AFTER HOURS—New Institutionalism in Asia, Shinko Building, Tokyo University of the Arts, Yokohama, Japan
Video Relay, Muzz Program Space, Kyoto, Japan
2007 *documenta12—Living Newspaper*, documenta-Halle, Kassel, Germany
/seconds. Issue 7 sci-fi, utopia, roadside picnics, E:vent Gallery, London, UK
Future Academy in Yamaguchi, Akiyoshidai International Art Village, Yamaguchi, Japan
Avatar of Sacred Discontent, T1+2 Gallery, London, UK
All About Laughter—Humor in Contemporary Art, Mori Art Museum, Tokyo, Japan
2005 *very very human*, Toyota Municipal Museum of Art, Toyota, Japan
Iimawashi in Edinburgh Art Festival, MERZ, Edinburgh, UK
2004 *First Step*, Papyrus, Tokyo, Japan
Autotopia, NERV, Athens, Greece
2003 *E.T.NBSL*, NERV, Athens, Greece
Sharjah International Biennial 6, Sharjah Expo Centre, Sharjah, UAE
Science Fiction Double Feature, AAS, Birmingham, UK

2002 *Two Stories*, IOSA, London, UK
LA JALOUSIE, Institut Français, London, UK
2001 *Transmission*, Las Palmas, Rotterdam, Germany
Sub-Art House, Chelsea College of Art, London, UK
2000 *Philip Morris Art Award 2000*, Ebisu Garden Hall, Tokyo, Japan
Challenge, Plot, Nagoya, Japan

Selected Publications

Akiba, Shiten. "Encounter." *Bijutsutecho* (December 2005).

Annear, Judy. "The Semantics of Spooning—The Paranormal Art of Takayuki Yamamoto and Exonemo." *ART iT* (June 1, 2010).

Aono, Shoko. "Believing." *Vogue Nippon* (January 2006).

Hedges, Ruth. "Rising Suns and Daughters of Japan." *The Times*, August 6, 2005.

Hioki, Takashi. "8 Flesh Artists." *Nagoya Times*, December 13, 2005.

Kataoka, Mami, ed. *All About Laughter: Humor in Contemporary Art*. Tokyo, Japan: Mori Art Museum, 2007.

Konishi, Nobuyuki. "What Is Important?" *Bijutsutecho* (May 1998).

Maekawa, Kyoji. "Dealing with Human." *The Daily Yomiuri*, December 22, 2005.

Nishioka, Kazumasa. "Adult Daily Life with Children's Point of View." *Asahi Shimbun*, December 18, 2010.

Sawaragi, Noi. "New Movement in Nagoya." *High Fashion* (February 2006).

Tatehata, Akira, ed. *Aichi Triennale 2010*. Nagoya, Japan: Aichi Art Centre, 2010.

Turner, Grady T. "Regime Change Takes Effect at a Persian Gulf Biennial." *The New York Times*, May 4, 2003.

Contributors

Qamar Adamjee serves as associate curator of South Asian art at the Asian Art Museum, San Francisco. A specialist in South Asian paintings, she recently received her PhD from the Institute of Fine Arts, New York University; her dissertation focused on a group of early-sixteenth-century North Indian illustrated manuscripts. Prior to her appointment at the museum, Ms. Adamjee worked for eight years as a curatorial research assistant in the Islamic art department at the Metropolitan Museum of Art in New York. She has taught several undergraduate-level courses on Indian art and Islamic art and architecture. She holds an MA in art history and an MBA in marketing.

Laurie Britton Newell is a curator of contemporary programs at the Victoria and Albert Museum in London. Working at the interface between contemporary art and design and the museum's historic collections, she has curated exhibitions and projects such as *Make Lab* (2011), *1:1, Architects Build Small Spaces* (2010), *Hats: An Anthology by Stephen Jones* (2009), *Out of the Ordinary: Spectacular Craft* (2008), and events such as "Subterranea: Architecture Goes Underground" (2008) and "One of a Kind: Design and the One-Off" (2008), both part of the Friday Late view series. She has written about craft and design for catalogues, magazines, and newspapers and is the architectural editor of the Anglo-French magazine *The Play Ground*. Ms. Britton Newell champions connecting museums with broad audiences through contemporary cultural practice.

Dany Chan serves as assistant curator for exhibition projects at the Asian Art Museum, San Francisco. She received a BA in East Asian studies (Chinese) from Colby College and holds an MA in the history of art and architecture (China) from Brown University. Prior to joining the museum, Ms. Chan completed a year of teaching English in a private academy in Shenyang,

China. She has also served as curatorial assistant to the Chinese art department and assistant curator of Chinese art at the museum.

Thomas Christensen is director of Creative Services at the Asian Art Museum, San Francisco. His most recent book is *1616: The World in Motion*. His translation of selected poems of José Ángel Valente will be published by Archipelago Press.

Jeffrey S. Durham is assistant curator of Himalayan art at the Asian Art Museum, San Francisco. Trained in classical Buddhology at the University of Virginia, Dr. Durham specializes in Tibetan Vajrayana paintings and Indian Mahayana texts. Prior to joining the museum in 2011, he served as professor of religious studies at three East Coast colleges: George Mason University in Washington, D.C., St. Thomas Aquinas College in New York, and the University of North Carolina at Wilmington. During that time, he created classes designed to explore the manufacture, use, and interpretation of sacred art across cultures. In his new curatorial role, Dr. Durham is developing a thematic rotation focused on visualization and body image in Tibetan *thangka* paintings. He also envisions creating the West Coast's first multimedia, cross-cultural exhibition of Vajrayana art.

Allison Harding is assistant curator of contemporary art at the Asian Art Museum, San Francisco. As the museum's first in-house curator of contemporary art, she has developed a program of large- and small-scale exhibitions, including *Here/Not Here: Buddha Presence in Eight Recent Works* and *Phantoms of Asia: Contemporary Awakens the Past*. She holds an MA in the history of art from Williams College/Clark Art Institute and a BA in the history of art from Yale University. She previously worked at Williams College Museum of Art, the Dedalus Foundation, and Gagosian Gallery.

David Hinton studied Chinese at Cornell and in Taiwan. His translations include works by Tu Fu, Li Po, T'ao Ch'ien, Meng Chiao, Po Chü-i, and Hsieh Ling-yün, as well as the contemporary poet Bei Dao. He has also translated the four central masterworks of Chinese thought: Chuang Tzu, Mencius, *The Analects*, and the *Tao Te Ching*. He has held fellowships from the NEA and NEH, as well as the Witter Bynner and Ingram Merrill foundations. His work has received the Landon Translation Award from the Academy of American Poets. He lives in Vermont.

Mami Kataoka has been chief curator at the Mori Art Museum in Tokyo since its inauguration in 2003. At the Mori, she has curated *Roppongi Crossing: New Visions in Contemporary Japanese Art 2004* (2004); *Ozawa Tsuyoshi* (2004); *All about Laughter* (2006); *Ai Weiwei: According to What?* (2009); and *Sensing Nature: Yoshioka Tokujin, Shinoda Taro, Kuribayashi Takashi* (2010). She also served as an international curator between 2007 and 2009 at the Hayward Gallery

in London, where she curated *Laughing in a Foreign Language* (2008) and *Ujino and the Rotators* (2009) and co-curated *Walking in My Mind* (2009). Prior to these positions, she served from 1998 to 2002 as the first chief curator at Tokyo Opera City Art Gallery, where she curated *Tatsuo Miyajima* (2000), *JAM: Tokyo-London* (2001), and *Rirkrit Tiravanija* (2002), among other exhibitions, making the institution internationally known. In addition to *Phantoms of Asia*, her projects for 2012 include preparing an exhibition on the work of Lee Bul and working as co-artistic director, with five other Asian women curators, for the *Ninth Gwangju Biennale* in South Korea.

Li Ho (Pinyin: Li He; 790–816) was a Chinese poet of the late Tang dynasty. Sometimes referred to as the "Poet Ghost," he often wrote poems that dealt with the world of spirits. His style was seen as strange, unsettling, and evocative. Translator David Hinton has characterized him as a "ghostly genius."

Lesley Ma is a PhD candidate in art history, theory, and criticism at the University of California, San Diego. Her research topics include postwar Taiwan Modernist painters, women artists in 1930s Shanghai, and contemporary art of the Pacific Rim. Currently she is a curatorial coordinator at the Museum of Contemporary Art, Los Angeles, for Cai Guo-Qiang's upcoming solo exhibition; an editor of *Lovely Daze*, an artists' magazine founded by artist Charwei Tsai in 2005; and a writer for *Chuan*, a new art publication in Taipei. The CUE Foundation in New York selected Ma as a Young Critic in 2010 for the solo exhibition of San Diego–based painter Raul Guerrero, for which she wrote a catalogue essay. From 2005 to 2009, she was a project director at Cai Guo-Qiang's studio and managed numerous exhibitions, outdoor explosion projects, and catalogues, most notably *I Want to Believe*, the artist's career retrospective at the Guggenheim Museum in New York in 2008, which traveled to Beijing and Bilbao. Ma has a BA in history and science from Harvard College and an MA in museum studies from New York University.

Kathy Yim-king Mak is a doctoral student in art history at the University of California, Los Angeles, where she specializes in modern and contemporary Chinese art. Prior to beginning her graduate study at UCLA, she received her master's degree in the history of Chinese art from the Chinese University of Hong Kong in 2009, and wrote about art exhibitions and related events in the city.

Ahmad Mashadi is currently head of the NUS Museum, National University of Singapore. Before joining the NUS Museum in 2006, he served as senior assistant director and senior curator at the Singapore Art Museum, heading the museum's programming development. Exhibitions he curated include *Seni: Art and the Contemporary* (Singapore Art Museum, 2004), Singapore's participation in the *São Paolo Biennale* (2004), *Cubism in Asia*

(Japan Foundation, 2005–2006), *Telah Terbit—Out Now* (Singapore Art Museum, 2006), and Singapore's participation in the *Venice Biennale* (2011). *Camping and Tramping Through the Colonial Archive: The Museum in Malaya* (2011) is one of his recent curatorial projects. Publications include an essay in *Third Text'*s special issue on contemporaneity and art in Southeast Asia (2011).

Ernesto Menéndez-Conde received his PhD in Latin American literature from Duke University (2009). His research has focused on aesthetic ideologies and theories of the image. He has collaborated with Sotheby's, New York, and has published in magazines in New York, Havana, Miami, and elsewhere. He created *Art Experience: NYC*, an online magazine that offers updated information, insights, and recommendations about shows and artistic trends in the city. It also focuses on the interests of Spanish-speaking artists, collectors, scholars, art lovers, and art critics from Latin America, Spain, and Hispanic communities of the United States.

Quddus Mirza is an artist, art critic, and independent curator based in Pakistan. He teaches at the National College of the Arts, Lahore, and has exhibited, curated, and written extensively, both in Pakistan and abroad. He attended National College of the Arts, Lahore, and Royal College of Art, London.

Melissa M. Rinne is associate curator of Japanese art at the Asian Art Museum, San Francisco. She received her BA (Honors) from Brown University, her MA from Kyoto City University of Arts, and completed her doctoral coursework at Kyoto University. During her fifteen-plus years in Japan, she was the first foreigner on the staff of the Kyoto National Museum (1996–2002) and then the Nara National Museum (1999–2005). She served as Stanford University's overseas lecturer in Japanese art history at the Kyoto Center for Japanese Studies and senior research associate at the Inamori Foundation. Ms. Rinne has curated or co-curated seven exhibitions of Japanese art at the Asian Art Museum since 2005. Her publications include *Masters of Bamboo: Artistic Lineages in the Lloyd Cotsen Japanese Basket Collection* (2007) and *Lords of the Samurai: Legacy of a Daimyo Family* (co-author, 2009). She is currently preparing a catalogue on the Grabhorn Ukiyo-e Collection.

Cristin McKnight Sethi focuses on South Asian art of the early modern to contemporary periods. Her interests include global histories of collecting and exhibiting South Asian objects, art made during the British Raj, and the politics and art historical predicament of craft. She is currently a PhD candidate in the History of Art Department at the University of California, Berkeley, researching and writing her dissertation on *phulkari* embroidery from Punjab.

Gary Snyder is the author of more than twenty collections of poetry and prose. Winner of the Pulitzer Prize in 1975 and a finalist for the National Book Critics Circle Award in 1992 and 2005, he has been awarded the Bollingen Poetry Prize, the Robert Kirsch Lifetime Achievement Award, and the 2004 Japanese Masaoka Shiki International Haiku Grand Prize. He has lived in the foothills of the Sierra Nevada since 1970.

John Stucky is the librarian at the Asian Art Museum, San Francisco. Since 1994, he has reorganized and expanded the museum's research collections and opened the library to outside users for the first time. Prior to joining the museum, Mr. Stucky held a number of positions at Stanford University Libraries. He also assisted the registrar and the curator of the Asian collections at the Stanford Museum of Art (now the Cantor Center for Visual Arts) doing research on Asian artworks, updating registration records of Asian material, and translating colophons and inscriptions on Chinese and Japanese artworks in the museum's collection. While a graduate student, Mr. Stucky began working in Stanford's art library, then moved to the main library, where he was awarded a scholarship from Stanford University Libraries to attend library school and earn his master's degree in library and information science.

Yudi Ahmad Tajudin is a founding member and artistic director of Teater Garasi, a multidisciplinary artists' collective based in Yogyakarta, Indonesia. His performing art works have been presented in Indonesia, Singapore, Germany, and Japan. As part of his interest in interdisciplinary projects, he has been working with Jompet (Agustinus Kuswidananto) for more than a decade; he also has collaborated with Rin Ko Gun and KuNauka Theatre Company in Japan on cross-cultural theater projects, with Mella Jaarsma on a visual art project, and with Tony Prabowo and Goenawan Mohamad on contemporary operas. He was selected as Director of the Year 2006 by *Tempo* magazine, and awarded a six-month grant from the Asian Cultural Council to conduct research on New York's theater scene during the fall and winter of 2011–2012.

José Ángel Valente (1929–2000) was one of the leading twentieth-century poets of Spain, as well as a distinguished essayist and translator. His awards include the Adonais Prize (1954), Critics Award (1960 and 1980), Pablo Iglesias Foundation Award (1984), Prince of Asturias Prize for Literature (1988), National Poetry Prize (1993), Queen Sofía Prize for Ibero-American Poetry (1998), and National Poetry Prize (2001, posthumous). A video documentary of his work and life (in Spanish) can be found at www.29letras.com.

Index

Page numbers in **bold** *refer to illustrations.*

The editors and publisher are grateful to the following persons and organizations for permission to excerpt from or reprint previously published materials (some of which appear here in slightly different form): Excerpts from *Calendars (2020–2096): Ahmad Mashadi in Conversation with Heman Chong*, from the National University of Singapore Museum exhibition catalogue, 2011, reprinted by permission. "Third Realm" by Jompet and Yudi Ahmad Tajudin, printed by permission of the authors. "Sun K. Kwak" by Ernesto Menéndez-Conde, originally published in *Wynwood: The Art Magazine* 2, no. 5 (Summer 2009), reworked by the author and reprinted by permission. "Endless-Peace Arrowhead Song" by Li Ho, translated by David Hinton from *Classical Chinese Poetry*, translated and edited by David Hinton. Copyright © 2008 by David Hinton. Reprinted by permission of Farrar, Straus and Giroux, LLC. "Divine Inspiration," artist's statement by Lin Chuan-chu, from the Lin & Keng Gallery exhibition catalogue for *Lin Chuan-chu*, 2009, reprinted by permission. "Lin Xue: The Writing of Painting and the Spiritual Condition," copyright © 2011 by Kathy Yim-king Mak, reprinted by permission from a publication by Gallery EXIT, Hong Kong, on the occasion of the exhibition *Lin Xue: The Sixth Day*, February 18–March 19, 2011. "The Class" by Araya Rasdjarmrearnsook, translated by Jan Theo De Vleeschauwer, from *Art and Words*, Krung Thēp: Matichon, 2006, reprinted by permission. "The Mountain Spirit," copyright © 1996 by Gary Snyder from *Mountains and Rivers Without End*. Reprinted by permission of Counterpoint. "Yoshihiro Suda," conversation with Laurie Britton Newell and Toru Senso (translator), first published in *Out of the Ordinary: Spectacular Craft*, V&A Publications, 2007, reprinted by permission of Laurie Britton Newell. "Five Elements in Optical Glass" by Hiroshi Sugimoto, reprinted by permission. "Death and the Maiden," Quddus Mirza in conversation with Adeela Suleman, from the Aicon Gallery exhibition catalogue for *Adeela Suleman: After All, It's Always Somebody Else . . .* , 2010, reprinted by permission. "Excerpts from an Interview with Charwei Tsai," by Lesley Ma, http://www.charwei.com/interview.1.lesley.ma.html, reprinted by permission. "The Sign" by José Ángel Valente, from *Selected Poems of José Ángel Valente*, translated by Thomas Christensen, forthcoming from Archipelago Press, printed in advance of book publication by permission of the publisher. Artist's statement for *Phantoms of Nabua* by Apichatpong Weerasethakul, reprinted by permission of the artist and kickthemachine.com.

Phantoms of Asia: Contemporary Awakens the Past
was produced under the auspices of the
Asian Art Museum—Chong-Moon Lee Center
for Asian Art and Culture
Museum Director Jay Xu
Director of Creative Services Thomas Christensen

Produced by Wilsted & Taylor Publishing Services
Project manager Christine Taylor
Production assistant LeRoy Wilsted
Copy editor Melody Lacina
Designer and compositor Jody Hanson
Proofreader Nancy Evans
Indexer Andrew Joron
Color supervisor Susan Schaefer
Printer's devil Lillian Marie Wilsted

The book was composed in Adobe Jenson and
Frutiger with Trade Gothic and Adobe Jenson
display. The paper is 157 gsm China Gold East
matte art paper. It was printed and bound by Regal
Printing Ltd. in Hong Kong through Michael
Quinn of QuinnEssentials Books and Printing, Inc.